To identify a tree, match its scales, needles, or leaves with one of these 15 groups. Then determine the species by looking through the pages with the same group number.

Group 1

Scales overlapping, short; evergreen

Group 2

Needles sing... soft; evergre... deciduous

Group 4

Needles in bundles of 2, 3, or 5; evergreen

Group 5

Needles single, stiff, 4-sided; evergreen

Group 6

Leaves fan-shaped, simple; parallel veins

Ginkgo only species in group.

Group 7

Leaves in opposite pairs, simple, lobed

Group 8

Leaves in opposite pairs, simple, unlobed, smooth edges

Group 9

Leaves in opposite pairs, simple, unlobed, rounded teeth

Katsuratree only species in group.

Group 10

Leaves in opposite pairs, palmately compound

Group 11

Leaves in opposite pairs, compound

Group 12

Leaves alternately arranged, compound

Group 13

Leaves alternately arranged, simple, lobed

Group 14

Leaves alternately arranged, simple, unlobed, toothed

Group 15

Leaves alternately arranged, simple, unlobed, smooth edges

CENTRAL PARK

TREES and LANDSCAPES

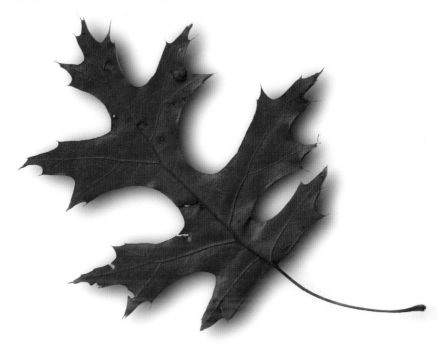

The scarlet oak leaf! What a graceful and pleasing outline! a combination of graceful curves and angles. These deep bays in the leaf are agreeable to us as the thought of deep and smooth and secure havens to the mariner. …It is a shore to the aerial ocean, on which the windy surf beats. How different from the white oak leaf with its rounded headlands, on which no lighthouse need be placed!

Henry David Thoreau
Journal, November 11, 1858

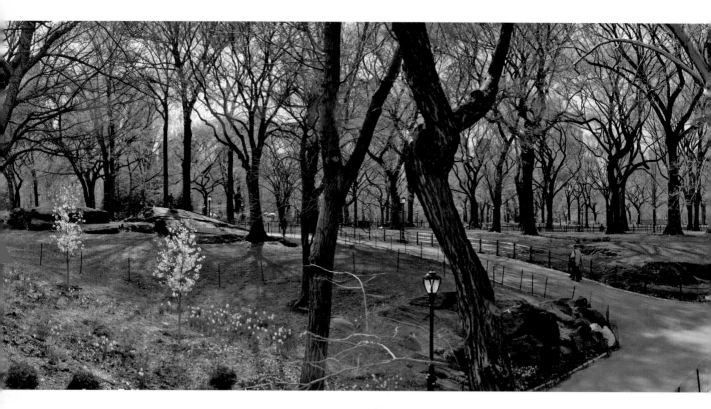

What artist, so noble, has often been my thought, as he, who with far-reaching conception of beauty and designing power, sketches the outline, writes the colours, and directs the shadows of a picture so great that nature shall be employed upon it for generations, before the work he has arranged for her shall realize his intentions.

Frederick Law Olmsted
Walks and Talks of an American Farmer in England

CENTRAL PARK
TREES and LANDSCAPES

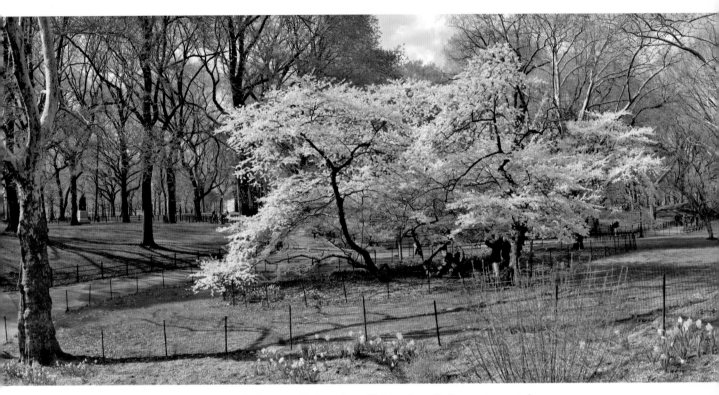

A Guide to New York City's Masterpiece

Edward Sibley Barnard and Neil Calvanese

Columbia University Press
New York

Columbia University Press
Publishers Since 1893
New York Chichester, West Sussex

Text and Photographs by Edward Sibley Barnard
Copyright © 2016 Edward Sibley Barnard
All rights reserved.

Central Park Maps Copyright © 2016 by Ken Chaya
All rights reserved.

Library of Congress Cataloging-in-Publication Data

Names: Barnard, Edward Sibley, 1936– author. |Calvanese, Neil, author.
Title: Central Park trees and landscapes : a guide to New York City's
 masterpiece / Edward Sibley Barnard and Neil Calvanese.
Description: New York : Columbia University Press, [2016] |
 Includes bibliographical references and index.
Identifiers: LCCN 2015045073 (print) | LCCN 2015041402 (e-book) |
 ISBN 9780231526616 | ISBN 9780231152877 (pbk. : alk. paper)
Subjects: LCSH Trees—New York (State)—New York—Identification. |
 Shrubs—New York (State)—New York—Identification. | Central Park (New
 York, N.Y.)
Classification: LCC SB435.52.N7 (print) | LCC SB435.52.N7 B37 2016 (e-book) |
 DDC 634.909747/1—dc23
LC record available at http://lccn.loc.gov/2015045073

Columbia University Press books are printed on permanent and durable, acid-free
paper.
Printed in China
p 10 9 8 7 6 5 4 3 2 1

"Central Park … ah, that's religion"
Neil Calvanese

PRESIDENT'S INTRODUCTION

This quote sums it up. Neil, my friend and partner at the Central Park Conservancy for more than 30 years, has dedicated his life to the care and beautification of Central Park. I trusted and relied on Neil, as vice president of operations, for guidance during those difficult early years as we took back the park an acre at a time. We agreed on all things—well almost all things—and I understood that Neil knew more than anyone else about Central Park's trees and that he loved them beyond measure.

Edward "Ned" Sibley Barnard is dedicated to the idea that every species of tree has a story and every individual tree has a history. For nearly 20 years, I have learned to count on that dedication. Ned has come to know most of the trees in Central Park with the assistance of his partner Ken Chaya. I thoroughly enjoyed watching Neil, Ned, and Ken debate when a tree was perhaps mislabelled or misidentified but agreeing in the end after further research.

I am grateful to my friends Neil and Ned for creating this wonderful guide to Central Park's majestic trees. It is the perfect companion for exploring and discovering your own "favorite tree." Whether it is the London plane just north of the Metropolitan Museum, the English elm at East 90th Street, or the ginkgo on the West Side at the Ramble near the West Drive and 77th Street, *Central Park Trees and Landscapes* will help you explore and enjoy the park as never before.

The Central Park Conservancy has managed and maintained all the park's landscapes and infrastructure for over 35 years while raising nearly $800 million for its numerous restoration projects. Many prestigious awards have been given to the Central Park Conservancy for its work restoring and maintaining the park. Those awards, like this guide, honor the incredible job done by the men and women who care for Central Park. From the arborists and tree crews to the inspectors and climbers, the collective vision, dedication, and knowledge of the entire staff play an integral role in the conservancy's care of the great masterpiece that is Central Park. This book is for them as much as it is for you!

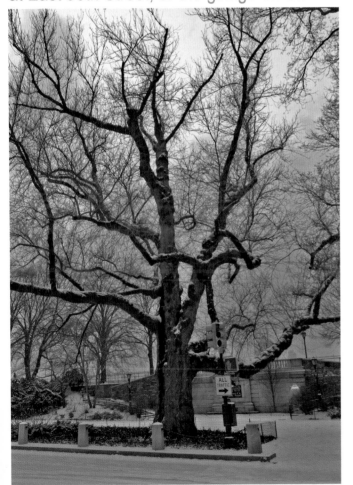

The great English elm at 90th Street and Fifth Avenue may be the oldest elm in the park.

Douglas Blonsky
President, CEO, and Park Administrator
Central Park Conservancy

5

CONTENTS

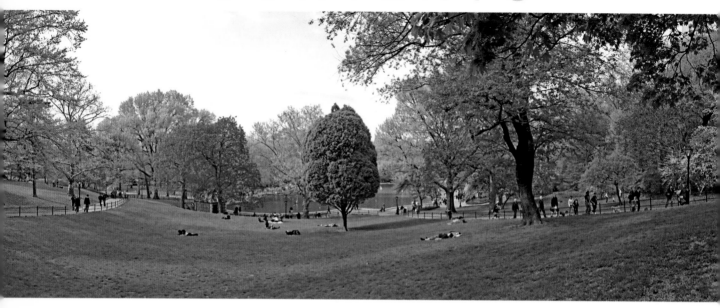

The Tree Guide

Conifers

Broadleaf Trees

Notes and Sources

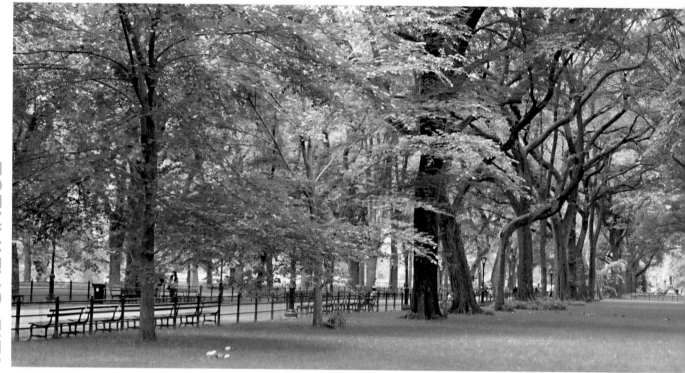

The Central Park Conservancy was founded in 1980. I joined the staff a year later, not knowing that I was embarking on a 33-year journey and love affair with Central Park's trees. Back then, the entire staff was composed of 16 people. Armed with shovels and pruners, we headed into the field every day to tackle one small project at a time. A mixture of youth and idealism protected us from being overwhelmed and discouraged by the reality that there was not one spot in this vast park that was not in dire need of attention.

The park had suffered from neglect and underfunding for several decades. Trees were seldom pruned, and replanting was not even considered. Landscapes were left to endure the ravages of unrestricted use and lack of maintenance. Those not worn down to dirt had been taken over by invasive weed species. Central Park's famed stands of American elms that lined Fifth Avenue, the Mall, and various landscapes throughout the park were falling victim to unchecked Dutch elm disease. We were losing them at a rate of 100 a year. Visitors who

dared to enter the park were hard-pressed to recognize a mere glimpse of what had been the magnificent vision of the park's designers, Frederick Olmsted and Calvert Vaux.

However, one person in particular would not give up on that vision and what it meant for the city. Elizabeth Barlow Rogers was the first park administrator appointed by Mayor Ed Koch in 1980. Elizabeth breathed new life into the park by tirelessly advocating that successful park management requires expertise in arboriculture, turf care, horticul-

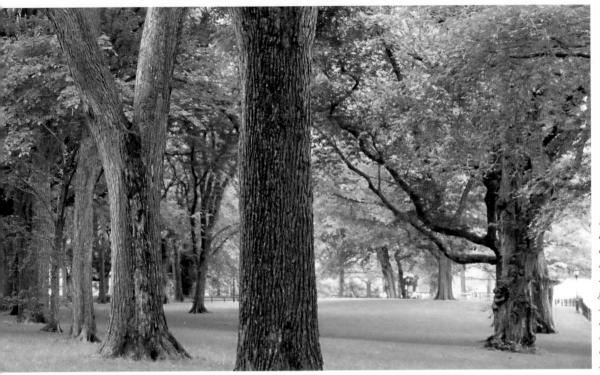

If Olmsted were alive today and could return to the Mall, he would surely find that this great assemblage of American elms has indeed realized his far-reaching conception and intentions.

ture, infrastructure, planning, design, and construction. The conservancy was born, and from humble beginnings continues to the present day. Now under the direction of Doug Blonsky, president and administrator, the conservancy holds to the same commitment, which has allowed it to become a leader in urban-park management.

I started out as an arborist, and though my responsibilities grew through the years, trees remained my passion, and I watched over them throughout my tenure at Central Park. Their survival and growth required a dedicated team and a vast array of resources. We scrambled to take action when waves of exotic beetles hit and when storms tore through and destroyed or damaged trees by the thousands. Everyday tasks included preventive measures to protect trees from the pressures resulting from the millions of annual visitors. What we all know now is that the future well-being of this great resource depends on vigilant oversight and education of park visitors.

It was my great fortune to have been part of the renaissance of Central Park and to have been entrusted with the care of its phenomenal stand of trees. This book details the diversity of the park's trees, how they came to be introduced into cultivation, and the important role they play in framing its picturesque landscapes. The trees of Central Park embody the vision of Olmsted and Vaux, a vision that Ned Barnard beautifully captures in this book's pages.

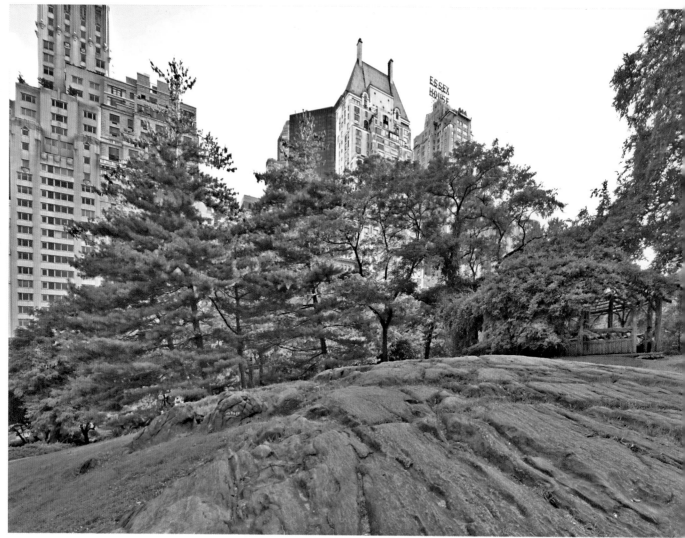

The Cop Cot at the summit of a rocky outcropping overlooking 59th Street is one of my favorite places in Central Park. Here a rustic gazebo draped with wisteria and surrounded by white pines is overshadowed by a wall of tow-ering buildings. It's as if a bit of New England has been trans-ported to the heart of Manhat-tan. And, indeed, there is a New England connection here. The dark-gray rock outcropping in front of the Cop Cot's shelter is related to the rocks of Connecti-cut, Massachusetts, and Maine. Known as Hartland Schist, it is the product of 500 million years of titanic collisions, uprisings, subductions, and rupturings of ancient landmasses. Beginning about 100,000 years ago, a series of glaciers ground over this

10

schist repeatedly, creating grooves that are still visible.

When I look up across this ancient outcropping at the buildings lining 59th Street, I wonder what the future holds in store. All these buildings will eventually disappear, perhaps followed by others, perhaps not. Will this bit of rock, once covered by an ice sheet a mile thick, be inundated by water once again, perhaps in liquid form the next time? How long will this beautiful park exist?

I have been fortunate to have undertaken this project at a time when the Central Park Conservancy has restored the park to very good condition, even though it is visited by millions more people than ever before in its history.

This book describes the park in the early part of the 21st century when I was living close to it and visiting it almost every day. I had considered writing a book about the natural history of New York City. I explored the idea with Mike Feller, a gifted naturalist with the Department of Parks & Recreation, but I concluded that it was too big a job, especially for someone in his seventies. However, it seemed that a book on Central Park's trees and landscapes was a project that I could undertake and finish in a reasonable period of time, which has turned out to be 10 years.

My purpose in writing this book was to delve deeper into the history of the various tree species that I wrote about in my previous book, *New York City Trees*; to describe species that I had not treated before; to find out where each species comes from; and to examine the role of trees in the park's superb series of landscapes. Doug Blonsky, president of the Central Park Conservancy, and Patrick Fitzgerald, my editor at Columbia University Press, agreed that the project was worthwhile. I knew that I would need help, so I persuaded Neil Calvanese, who had spent more time working with Central Park's trees than anyone else, to join me as coauthor. Later I also recruited Ken Chaya, an inspired graphic artist, to create a tree map for the book. He spent three years producing the most detailed map of a center-city park ever published and became, in the process, very knowledgeable about the park's trees. The result of our efforts is a book that I hope will enhance readers' enjoyment and appreciation of Olmsted and Vaux's masterpiece.

Edward Sibley Barnard

11

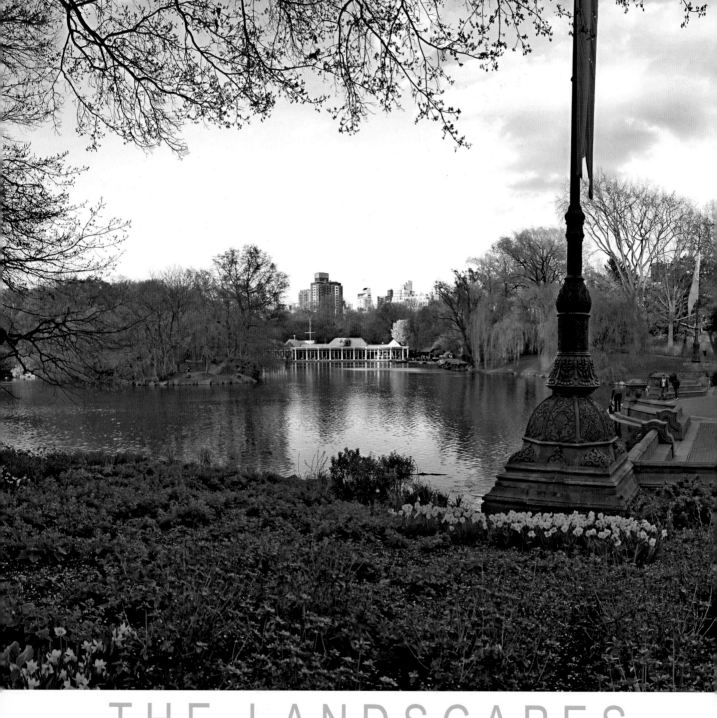

THE LANDSCAPES

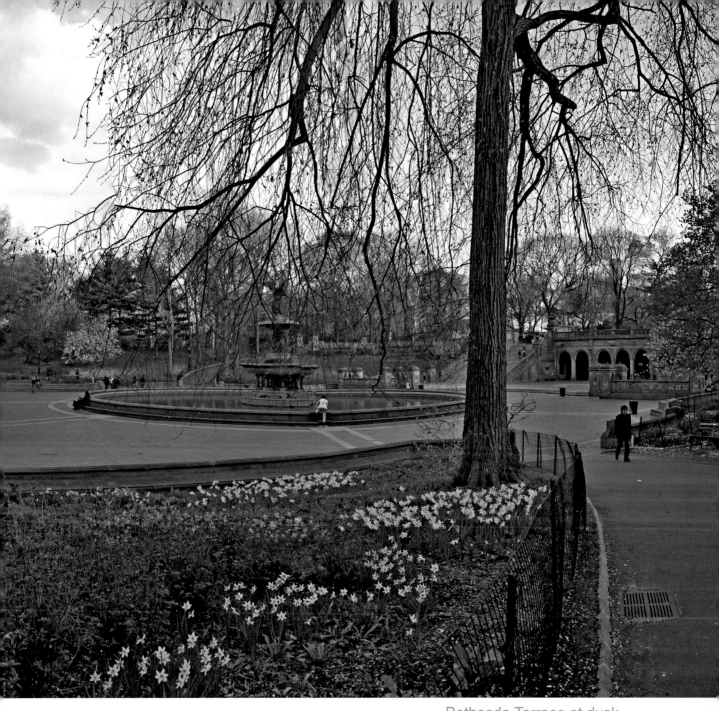
Bethesda Terrace at dusk

Central Park is a tiny green rectangle surrounded by tall buildings, a tree-covered opening in concrete canyons, a place where the geological origins of Manhattan Island can still be glimpsed. It is a walled garden seemingly natural but actually largely artificial, with more exotic plants than native. It is a metaphor, perhaps, for the "natural world" on an increasingly urbanized planet, a place maintained and manicured with great effort and expense to withstand the wear and tear of more than 40 million annual visitors. It is where people come to exercise, to play, to relax, to renew their spirits, to watch other people, and to walk their dogs. It is where residents can breathe fresher, cooler air; feel the breeze; enjoy a bit of sunlight; stretch their legs and maintain their sanity amid the city's noise, confusion, and conflict. What gives this 843-acre rectangle at Manhattan's center its special character? In part, it is its exceptionally rocky topography, created by an astonishing series of transformations.

Five hundred million years ago, the place that would become Central Park was underwater south of the equator at the edge of the ancient North American continent, which included Greenland and portions of Canada and the eastern United States. Millions of years passed, and titanic subterranean upheavals thrust this bit of ocean floor above the sea, embedding it in an island chain, which eventually crashed into North America. Millions more years passed. A vast continent moving northwestward collided with North America, creating a supercontinent. The rocks that would become Manhattan were folded downward far underground, subjected to enormous pressures, and transformed from sedimentary shales to metamorphic schists deep under an inland mountain range. More millions of years passed. The mountain range was slowly worn down by weathering, and the supercontinent began to split apart. By 150 million years ago, the Atlantic Ocean was forming between North America and Africa. The place that would become Manhattan was again at the ocean's edge but now well north of the equator. North America had been slowly drifting north at the rate of a growing fingernail. As the Atlantic Ocean expanded, this place remained at the ocean's edge, sometimes underwater but more often high and dry.

About 100,000 years ago, a series of glaciers advanced from polar areas south, then contracted north again. At times, some 30 percent of Earth was ice covered. At least four glacial advances and retreats occurred in North America.

About 15,000 years ago, the last great ice sheet began to melt. A thousand feet thick in places, it had blanketed eastern North Amer-

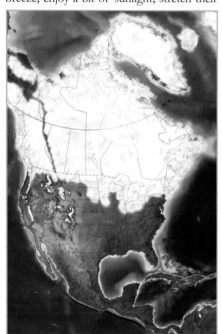

▲ This map shows the Laurentide Ice Sheet at its greatest extent about 15,000 years ago. (The location of Manhattan Island is indicated by the red dot.) Grooves carved by glaciers are still quite visible on Central Park rocks.

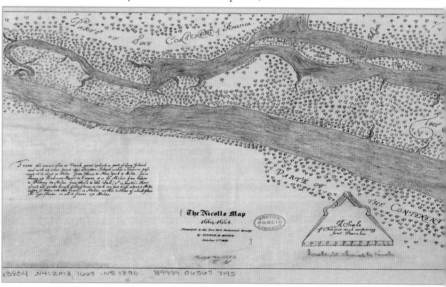

ica from the Canadian Arctic to Staten Island. At first, only lichens and mosses grew on the newly exposed, glacier-scoured landscape of Manhattan, but gradually grasses and trees created a subarctic range dotted with lakes and ponds. Frigid winds blowing from melting ice fields diminished. Balsam fir and spruce moved in with mammals, including mastodons, woolly mammoths, caribou, and saber-toothed tigers. By about 9000 years ago, these great animals were gone. Stands of balsam fir and spruce receded northward, replaced by forests of oak, beech, chestnut, tuliptree, hickory, maple, and hemlock.

Six thousand years ago, Native Americans were living in the forests of the area that is now New York City. Hunters and fishermen, the Lenape ate venison, wild turkey, fish, clams, oysters, nuts, and berries. They were cultivating squash over 2000 years ago; by 1000 years ago, they were also raising beans, corn, cucumbers, and tobacco.

The Lenape moved from one campsite to another as the seasons progressed. Their needs for firewood and space for farming and their habit of burning the stubble off fields produced large, grassy open areas. They also burned forest underbrush to make game hunting easier, creating park-like stretches of widely spaced older trees.

When European settlers arrived in the 17th century, they drastically altered the landscape of their Native American predecessors. Henry Hudson sailed into the harbor in 1609 and sent back to his employers in Holland reports of abundant natural resources. The Dutch East India Company set up a fur-trading post in lower Manhattan, and the settlement came to be called New Amsterdam. Between 1625 and 1776, Dutch and English colonists cleared Manhattan's forest to meet a growing demand for lumber and firewood and to make way for crops, pastures, streets, and buildings. They filled in waterways, killed beavers and minks, and pushed bears, wolves, and cougars to less populated regions.

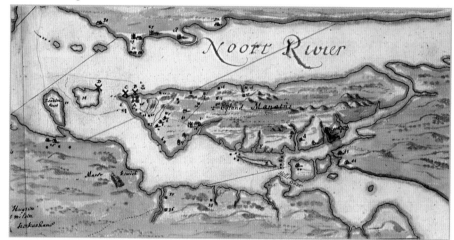

▲ The Manatus Map, a Dutch map of Manhattan drawn in 1639, is the first to outline fairly accurately the shape of the island including the Harlem River and channels on the eastern shore, some fed by streams crossing what would become Central Park.
◄ The Nicolls Map, drawn by military surveyors between 1664 and 1668 after Manhattan was captured by English troops, shows the island's shape accurately. The map also roughly depicts the extent of deforestation up to that time. An inset details the town's streets and fort.

When Dutch colonists first began clearing Manhattan's southern tip in 1625, 85 percent of the island's more than 13,000 acres was blanketed by stands of oak, maple, beech, chestnut, sassafras, birch, black tupelo, pine, cedar, and dozens of other woody plants, including shrubs such as blueberry, huckleberry, witchhazel, and spicebush. It was an incredibly rich forest mosaic, unlike anything the newly arrived Europeans had ever seen, edged here and there by salt meadows, punctuated by swamps and bogs, and crisscrossed by streams and creeks. Of the eight major Manhattan watercourses, six ran southeastward from high ground near the Hudson River across the island to the East River. And four of the six ran through sections of what was to become Central Park.

The stream with the largest watershed was the Saw Kill. It flowed from a west side ridge through Central Park to an outlet on the East River near 75th Street. A sawmill manned by slaves, located on the Saw Kill near York Avenue and 75th Street, operated until at least 1639. It probably produced much of the lumber used to build the 80 to 90 structures occupied by some 400 colonists on Manhattan in the late 1630s, and many of the trees along the Saw Kill must have been cut in the process.

By the mid-1650s, the population of Dutch Manhattan had climbed to 1500. In 1664, when the British took over the poorly defended colony of New Amsterdam without firing a shot, the population stood at 1900. Under British rule, the island's population expanded to almost 5000 by 1698 and to nearly 11,000 by 1737.

As the industrial revolution progressed through the 1740s to 1760s, Manhattan's population ballooned. In 1771, it stood at nearly 20,000. The wealthiest citizens had established country seats north of town. Mansions lined the island's west side up to 29th Street. Estates on Park Avenue extended into the Murray Hill district. A splendid Georgian mansion built by Colonel Roger Morris on the Harlem Heights afforded a view of the entire island to the south.

On September 18, 1776, in the Revolutionary War's early days, British and Hessian soldiers were battling George Washington's troops in lower Harlem. A wounded Hessian soldier, Lieutenant Hinrich, described the

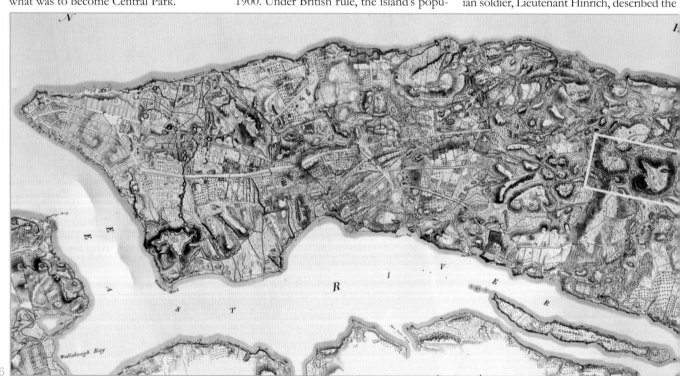

country near the East River at 89th Street: "The island of New York is the most beautiful island I have ever seen....Projecting fruitful hillocks, surrounded by orchards, meadows, and gardens full of fruit trees, single ones scattered over the hills, with houses attached, [*sic*] line both sides of the river, and present to the eye a beautiful scene."

Almost eight years of British occupation during the Revolution totally ravaged bucolic upper Manhattan. Bivouacking soldiers and desperate civilians cut down almost every tree in order to survive a succession of severe winters. Observing Manhattan from the New Jersey Palisades on July 18, 1781, Washington noted in his journal: "The island is totally stripped of Trees, & wood of every kind; but low bushes (apparently as high as a mans waste [*sic*]) appear in places which were covered in wood in the year 1776."

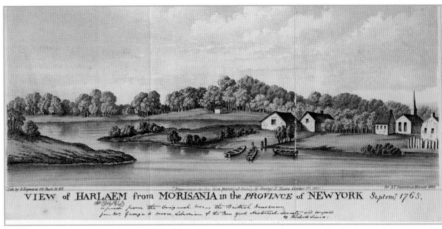

VIEW of HARLAEM from MORISANIA in the *PROVINCE* of NEWYORK Septem: 1765.

▼ *A portion of the British Headquarters Map, drawn around 1782. The entire map measures 37½ by 125 inches. It depicts Manhattan's topography in amazing detail, including rock outcroppings, most buildings, and the gardens and orchards of fruit trees surrounding country houses. Few other trees are indicated because there were none left by 1782. The area that would become Central Park is bounded by a yellow rectangle.*

▲ *This 1765 view of Harlem from Morrisania in the South Bronx resembles the northern Manhattan landscape that Lieutenant Hinrich described a decade later at the beginning of the Revolutionary War. Northern Manhattan retained many of its trees until the Revolution because it was probably cheaper to raft firewood and lumber from Long Island or New Jersey than to bring it down the length of Manhattan Island.*

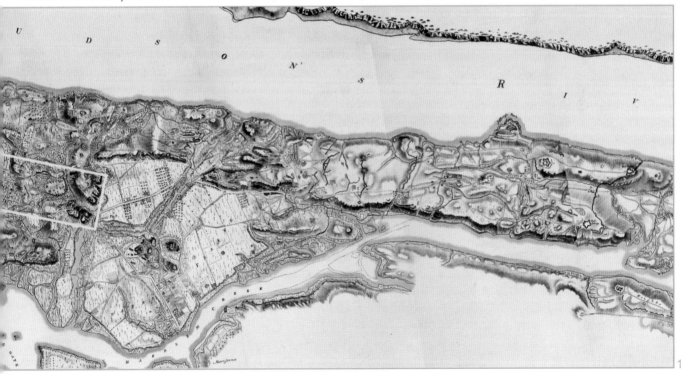

Late in 1783, after the British withdrawal, the city's population stood at 12,000, but within two years it had jumped to 24,000, and by 1800 it had nearly tripled to 60,000. The mayor and the aldermen were acutely aware that the city must expand north of Canal Street into lands then occupied by only small farms, hamlets, and estates of the rich.

A commission was appointed in 1807 to determine how streets could be laid out in a manner "most conducive to the public good." The first step was to undertake a careful survey of the entire island of Manhattan. A young surveyor named John Randel, who had drafted military maps for George Washington during the Revolutionary War, was hired for this huge task.

Randel began supervising a team of workers in the spring of 1808. Periodically,

he would bring sectional maps drafted by his team to meetings of the commissioners, who were deciding exactly how roads would be laid out on the newly surveyed lands. The commissioners settled on a grid of a dozen north–south avenues 200 feet wide crossed at a right angle every 200 feet by 155 numbered streets. By the fall of 1810, Randel had finished his survey and created a single topographical map of the island on which the commissioners' avenues and streets were superimposed. This rigid grid of streets—laid down with no attention whatever to Manhattan's hills, valleys, streams, and rock outcroppings—remains little changed to the present day.

From 1811 to 1821, Randel was employed by the city to calculate elevations for the grid's streets and avenues and to place mark-

ers, either marble slabs or steel bolts, at all future intersections. Upon completing this job, he began work on a huge topographical map, the crowning achievement of his career. Consisting of 92 sheets that would form a map 11 feet by 50 feet if pieced together, it is known as the Randel Farm Map. It was based on all the field notes that Randel made while working on his first map of the island, but also includes, he proudly proclaimed, "all the avenues, streets [many not built], places, monumental stones, dwelling and out-houses, fences…all hills, creeks, rocks, swamps, marshes, meadows & c." It also delineates every individual lot and the name of its owner. The section of the map devoted to land that was to become Central Park is broken into several dozen plots owned by individuals or by the city. It is

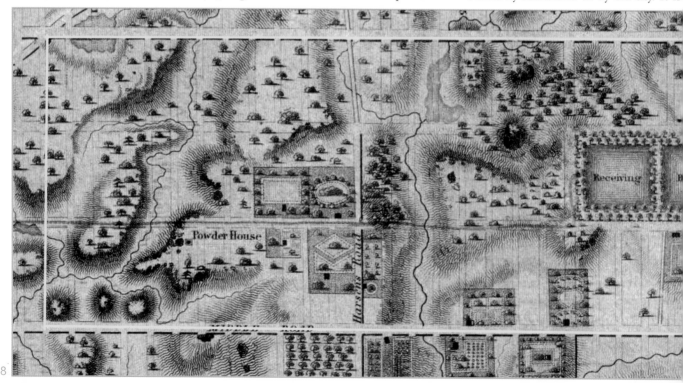

thinly dotted with some 40 structures—mostly private houses and outbuildings but also military fortifications and at least one public house, Catharine McGown's tavern. Several streams are shown and marshy lands around the Harlem Creek, where the Harlem Meer is now located.

In 1836, J. H. Colton and Company published a new topographical map of Manhattan, based in part on Randel's earlier maps but containing recent features in the land that would become Central Park, such as the Croton Receiving Reservoir and an adjacent marshy basin where a new reservoir was to be constructed. Clusters of little tree icons spread thinly or clumped more closely suggest places with a scattering of trees or even bits of woodland that had regenerated after the British occupation. Although Manhattan's population had risen to nearly 300,000 by 1836, this rugged terrain was still largely undeveloped.

▲ A section of the Randel Farm Map of 1819 details the topography of the terrain that was to become Central Park—hills, rock outcroppings, streams, positions of the grid's future streets, boundaries of private plots with their owners' names, and the few structures on it at the time—but it does not indicate the marshes and stands of young trees and shrubs that covered some areas of the land.

▼ The Colton Map of Manhattan of 1836 provides a reasonably accurate depiction of the rugged landscape of Central Park a dozen years before it was established as well as a rough impression of where trees may have been growing. It was based in large part on Randel's work.

1870: The Greensward Plan Realized

In the first half of the 19th century, the population of New York City increased tenfold. By 1840, there were more than 300,000 people living in a crowded, grimy lower Manhattan. The streets were rank with animal and human waste. Water was stagnant and contaminated with sewage. Dust and smoke hung in the air. Living conditions in the brick tenements on the Lower East Side were deplorable. Cholera epidemics in 1798 and 1805 and again at mid-century heightened the unsanitary conditions of urban life. By 1856, the mortality rate in New York City had exceeded the birth rate.

Prominent New Yorkers, led by poet and editor of the *Evening Post* William Cullen Bryant, began calling for a set-aside of open space in the city where the classes could mingle. Frederick Law Olmsted, a writer and gentleman farmer, returned from a trip to Europe in 1844 and noted that America had no "people's park," such as the new egalitarian and naturalistic Birkenhead Park in Liverpool, England. Andrew Jackson Downing, the nation's preeminent landscape architect, proposed in 1848 the creation of a park to be the "lungs of the City."

By the 1850s, Brooklyn's Green-Wood Cemetery, with its meandering pathways and gracious, arching canopy of trees, had become a principal destination for open-air leisure seekers of all classes from both Brooklyn and Manhattan. But New Yorkers needed a central public space dedicated exclusively to their outdoor social and recreational use.

▶ On October 18, 1862, work was proceeding but was far from finished on a section of 97th Street transverse near Central Park West, or Eighth Avenue as it was then called. Walls made of cut schist blocks bordering the roadway, which was 8 feet below ground level, are visible in the upper right. The four transverses cut through many rock outcroppings and required a great deal of blasting.

In 1853, New York State designated 778 acres (later increased to 843 acres) in Manhattan for Central Park. In April 1857, a legislative commission selected the Greensward Plan of Frederick Law Olmsted and architect Calvert Vaux from among several plans. Olmsted and Vaux envisioned the park as a rustic sanctuary from the surrounding city, "a beautiful open space, in which quiet drives, rides, and strolls may be had."

The transformation of a swampy boulder-strewn wasteland into a verdant landscaped park was a herculean task. Between late 1857 and 1866, thousands of workers were employed, digging, ditching, grubbing out undesirable plants, laying drainage pipes, crushing stones, blasting rock ledges, and constructing buildings, paths, roads, bridges, and retaining walls. They moved some 2.5 million cubic yards of stone and soil around the park, raising, lowering, and smoothing almost every square foot. Then they topped off the new contours with more than 40,000 cubic yards of manure and compost and planted 270,000 trees and shrubs under the direction of Ignaz Pilat, a Viennese landscape gardener. Pilat had taken over the job of finishing the look of the park when Olmsted temporarily left for Washington, D.C., to serve on the U.S. Sanitary Commission during the Civil War.

▶ A map from the Second Annual Report of the Commissioners of the Central Park, dated January 1859, shows the topography of the park a year after work got under way. Unbuilt roads are indicated by dotted lines. Contour lines in red (barely visible here) denote 10-foot intervals of elevation. Many roads and walkways in the southern half of the park appear to have been completed, including the winding paths of the Ramble, but work had not started on most of the northern half.

▶ A map from the Fifth Annual Report of the Commissioners of the Central Park, dated January 1862, shows in green the almost completed areas in the park's southern half. Finished roads are just penetrating the northern half, although most of the North Meadow appears to be landscaped. Of the sunken transverses, only the 65th Street road appears to be fully operational.

▼ A map from the Thirteenth Annual Report of the Commissioners of the Central Park for the Year Ending December 31st 1869 shows the Greensward Plan completed with gates and a proposed Art Museum and Hall east of the Croton Receiving Reservoir.

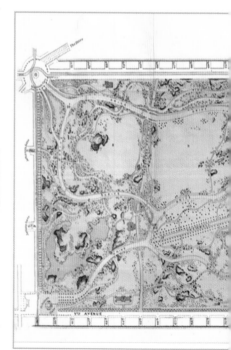

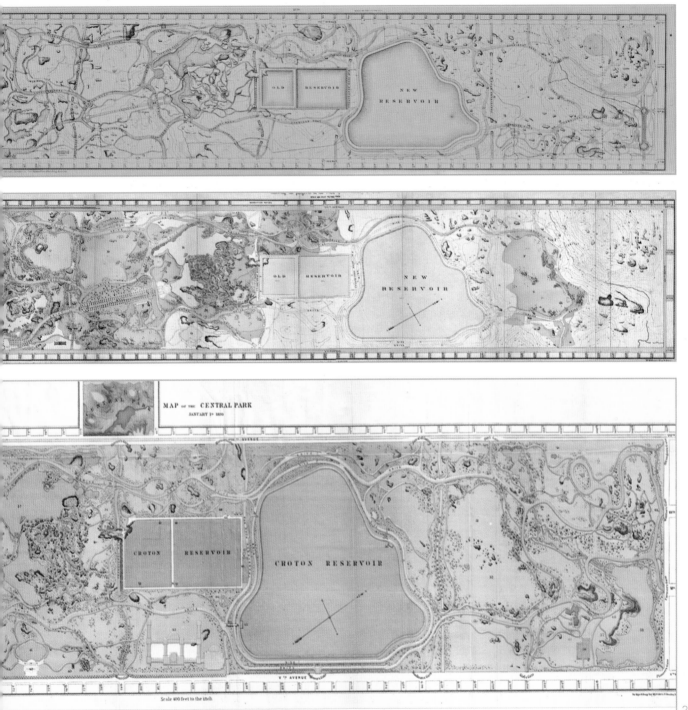

MAP OF THE CENTRAL PARK
JANUARY 1ST 1870

CROTON RESERVOIR

CROTON RESERVOIR

Scale 400 feet to the inch

A Succession of Grand Landscapes

A huge amount of digging, draining, grading, and contouring took place during the construction of Central Park, but Olmsted and Vaux respected the land's good bones—its boulder-studded hills, glacier-grooved rock outcroppings, twisting stream valleys, and swampy basins. The designers retained but enhanced many of these rugged features with layers of topsoil, miles of drainage pipes, and thousands of trees and shrubs, tying everything together with walkways, riding paths, and carriage roads to create a succession of discrete landscapes unequaled in any other center-city park.

If the map in the *Thirteenth Annual Report of the Commissioners of the Central Park*, dated January 1870, is compared with Ken Chaya's map of 2013 (below), the most apparent difference, besides the substitution of the Great Lawn for the Croton Receiving Reservoir, is that trees cover a greater portion of the park than they did in 1870. There are also more architectural introductions—buildings, skating rinks, baseball diamonds, playgrounds, statues, and monuments. But the basic plan of the park is still much the same.

Olmsted emphasized conifers in his earliest plantings. "The general ruggedness of the site…will lead to a more liberal use of evergreens," he noted. In 1857, he ordered nearly 9000 needleleaf trees, including 3000 Norway spruces, 3000 hemlocks, 1800 pines, and hundreds of larches, arborvitae, and firs. These trees, along with a variety of broadleaf trees, would screen out buildings beyond the park's borders; shade tranquil pastoral areas on flatter, less rocky ground; and create contrasting "obscurity and picturesque character of detail" in

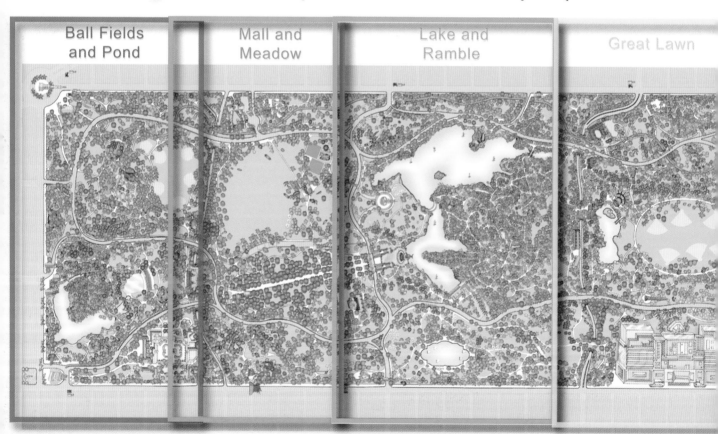

Ball Fields and Pond

Mall and Meadow

Lake and Ramble

Great Lawn

areas with uneven outcroppings and ledges.

Beginning in 1859, Olmsted's presence in the park was frequently interrupted by trips to Europe, California, and Central America and by involvement with the Sanitary Commission during the Civil War. Horticultural work proceeded through the 1860s under the direction of Olmsted's Viennese foreman, Ignaz Pilat, until his death in 1870.

In 1870 and 1871, during the Tweed administration, many trees were removed or limbed and new ones planted, often along paths, such as the London planes edging the West Drive by the Lake (where Robert Moses would plant many more London planes). In 1872, Olmsted reasserted his view that pastoral, informal plantings should predominate, that "the less anything that is seen appears to have been dressed up by human hands, the better."

By 1879, Olmsted was on a leave of absence, much involved in other projects, and never really returned. The park then experienced a succession of administrators. One of most influential was Samuel Parsons, Jr., son of the Flushing nurseryman who supplied many of the park's original plantings. Parsons oversaw the park's landscapes between 1885 and 1911, maintaining Olmsted's planting philosophy but favoring native trees over exotics. After Parsons, park administrators emphasized recreation over passive appreciation of pastoral landscapes. The thousands of people living near the park craved space for exercise and play. Robert Moses, during his tenure as parks commissioner between 1930 and 1960, tidied up the park, introduced children's playgrounds and ball fields, and planted hundreds of Norway maples, London planes, flowering cherries, crab apples, and hawthorns. After Moses, the park's plantings suffered a devastating decline that was finally halted and reversed only when the Central Park Conservancy was founded in 1980.

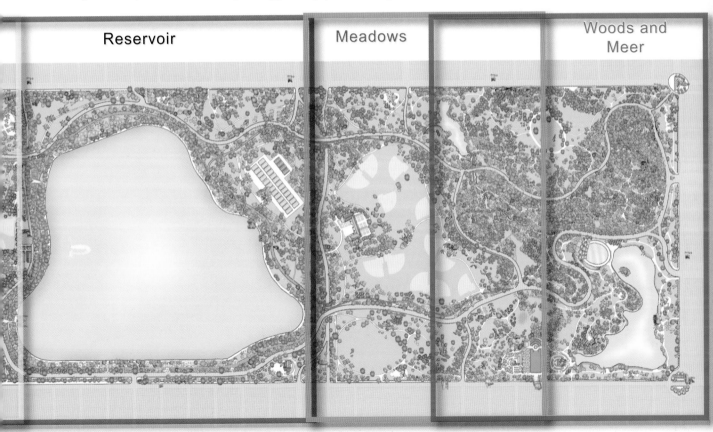

Reservoir

Meadows

Woods and Meer

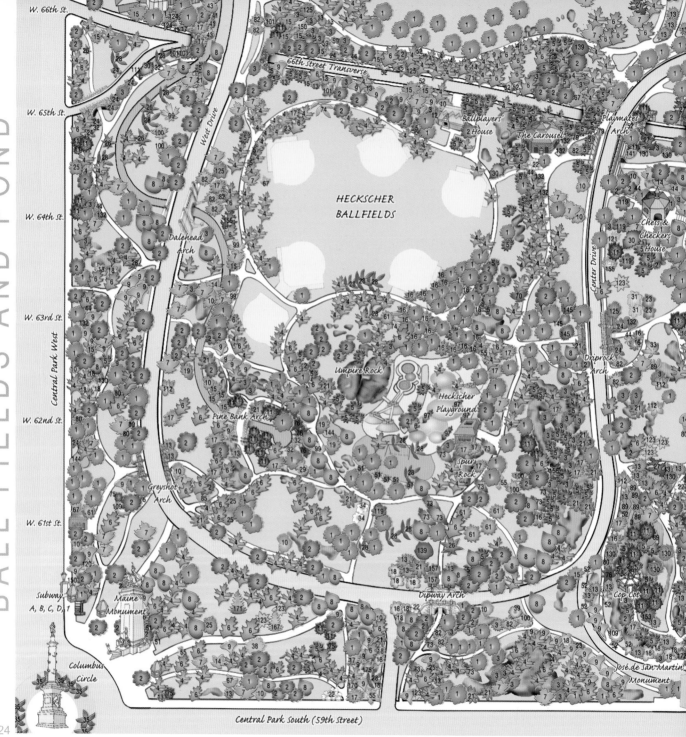

HECKSCHER
BALLFIELDS

Umpire Rock

Heckscher
Playground

Spur
Rock

Pine Bank Arch

Dalehead
Arch

Greyshot
Arch

Maine
Monument

Columbus
Circle

Subway
A, B, C, D, 1

Central Park West

West Drive

Center Drive

66th Street Transverse

Ballplayers
House

The Carousel

Playmates
Arch

Chess &
Checkers
House

Driprock
Arch

Dipway Arch

Cop Cot

José de San Martín
Monument

Central Park South (59th Street)

W. 66th St.

W. 65th St.

W. 64th St.

W. 63rd St.

W. 62nd St.

W. 61st St.

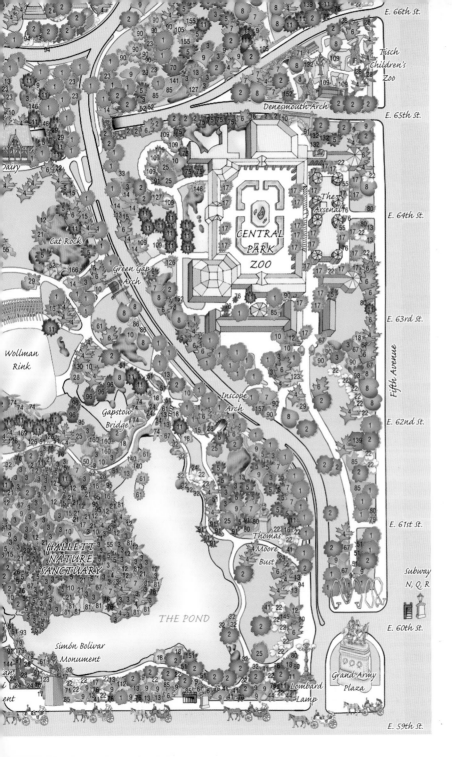

The southern end of Central Park, between 59th Street and the 65th Street transverse, is the park's most visited portion, where millions of tourists enter. It contains five popular attractions: the Central Park Zoo, Dairy, Wollman Rink, Carousel, and Heckscher Playground. It also boasts stunning and surprising landscapes, several notable trees, and the park's most imposing exposed rock outcropping. Perhaps nowhere else in the park are Olmsted's picturesque and pastoral landscapes juxtaposed so dramatically with the city's steel, glass, and concrete canyons.

Playground and Ball Fields

Olmsted and Vaux in their Greensward Plan of 1858 described "a playground about ten acres in extent" to be located south of the 65th Street transverse in the southwestern corner of the park: "We have thought it very desireable to have a cricket ground of this size near the southern boundary of the park, and not far from the Sixth and Eighth avenue railroads."

A stream and swamp were filled in and several rock ledges removed to create a flat meadow containing just one large Hartland Schist outcropping, Umpire Rock. Surrounded by irregularly spaced trees, the playground was intended mainly for children. School groups used it for a variety of activities, including cricket, softball, football, croquet, sledding, and picnics. Over the years, pedestrian paths at Sixth and Seventh Avenues were enlarged to accommodate vehicular traffic, and more walkways were constructed. All these roads and paths created a series of concentric islands around the meadow's southern side. In 1927, the Heckscher Playground was built on 4 acres of the southern section.

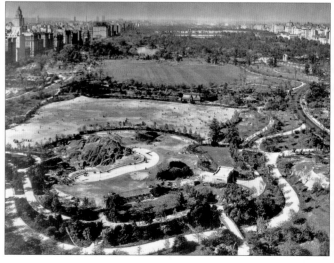

▶ *In the late 1920s, Olmsted's playground was divided into the Heckscher Playground, with Umpire Rock and the barren expanse of the softball fields bordered by a single line of young trees.*

By 1934, the remainder of the meadow included softball fields, handball courts, a horseshoe-pitching area, and even more paths. What was once a simple open field surrounded by trees had become a series of

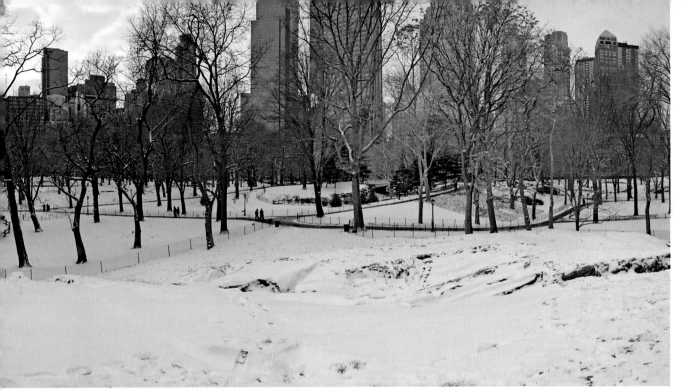

spaces devoted to specific recreational purposes, interlaced by roads and walkways. The meadow's turf was sparse and patchy, the baseball diamonds were poorly maintained, and a single row of overgrown trees lined the margins, creating a wall of foliage instead of an indeterminate pastoral border. People entering the park at Columbus Circle tended to stray off paths and trample down what little grass remained.

During the past 35 years, the Heckscher Ballfields have been renovated, the Heckscher Playground has been revamped with the addition of shade trees, and the surrounding walkways have been redesigned to keep people from trampling

▶ *The renovated Heckscher Ballfields are surrounded by randomly spaced specimen trees that provide dappled shade conducive to the growth of healthy turf, which park zone gardeners periodically protect with temporary fencing.*

the turf. Trees have been thinned between 59th Street and the Drive and around the ball fields. Irregularly spaced specimen trees—including dozens of London planes, red oaks, pin oaks, hackberries, elms, and maples—create a dappled shade on restored turf. Here and there, a few older specimen trees planted in the 19th century survive, such as an ancient Osage orange

▲ *A winter view from Umpire Rock is dominated by a skyscraper wall. Elizabeth Barlow Rogers dubbed scenes like this as a new landscape category: the "urban sublime."*

near the Drive west of the ball fields. Other tree species not found elsewhere in the park include a Chinese toon near the Seventh Avenue entrance west of Artisans' Gate and a small paperbark maple close to the 59th Street wall east of Artisans' Gate.

The Pond

In the Greensward Plan of 1858, Olmsted and Vaux outlined their plans for a pond at the park's southeastern corner: "[I]t is proposed to form a lake of irregular shape, and with an area of 8 or 9 acres. This arrangement has been suggested by the present nature of the ground, which is low and somewhat swampy." Such a body of water, Olmsted and Vaux contended, would increase "the picturesque effects of the bold bluffs that will run down to its edge."

Over the years, the Pond, which is fed by drainage water supplemented by city water, has been used for skating and boating. When malaria was a concern in 1903, its bottom was lined with cement. To make it appear more natural, its shoreline was edged with rocks in 1928. Both the Pond and the rocky, 4-acre promontory on its northwestern side became a nature sanctuary in 1934. However, despite its status as a sanctuary, the Pond's northern arm was drained in 1951 to make way for Wollman Rink.

The first trees planted around the Pond in the late 1850s and early 1860s were mostly conifers—spruces, firs, pines, and larches. The evergreen conifers, particularly, provided immediate year-round greenery in the park that young deciduous trees, bare of foliage in winter, could not. Conifers, Olmsted believed, with their stiffer forms, emphasized the rugged outlines of the rock outcropping on the Pond's northern shore.

Maybe half of the more than 40 million visitors entering the park each year come

▶ *An early 1860s photo of the Pond taken from 59th Street near Sixth Avenue shows a thick conifer planting in the foreground and the rocky evergreen-edged bluff on the northern shore partially hiding the Arsenal.*

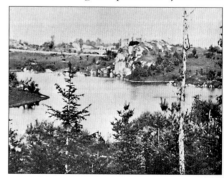

through Scholars' Gate, at 59th Street and Fifth Avenue. In summer, as they walk along the path bordering the Pond's southern and eastern shores, they confront an astonishing vista, not at all like that in the early 1860s. Instead of a rugged bluff outlined with evergreens across the Pond's rippled surface, there is a wild tangle of broadleaf trees and shrubs, edged here and there with projecting fallen trunks. It is the shore of the Hallett Nature Sanctuary, a fenced miniature 4-acre wilder-

ness. The sanctuary once consisted mainly of self-sown wild trees, such as black cherry and black locust, but it is now being planted with wildflowers, ferns, shrubs, and trees that were present on Manhattan Island before European settlement. A prospect almost tropical in its green profusion, it is just a few feet from one of the city's busiest intersections.

▲ *The wilderness that visitors see as they stroll along the paths bordering the Pond is not the landscape that Olmsted and Vaux visualized in the Greensward Plan of 1858 or that was planted in the early 1860s under the direction of Ignaz Pilat. It is partially the result of Robert Moses's decision in 1934 to set aside the Hallett Sanctuary and the benign neglect that followed. Whatever its origins, the surprising landscape that confronts today's Pond visitor is a fitting introduction to a park full of striking juxtapositions.*

▶ *A drawing by Calvert Vaux accompanying the Greensward Plan of 1858 shows how Olmsted and Vaux visualized the landscape of the Pond's bluff when they submitted their proposal. It pictures many more deciduous trees than conifers. Olmsted apparently changed his mind about this emphasis, although the drawing may have reflected Vaux's imagination more than Olmsted's.*

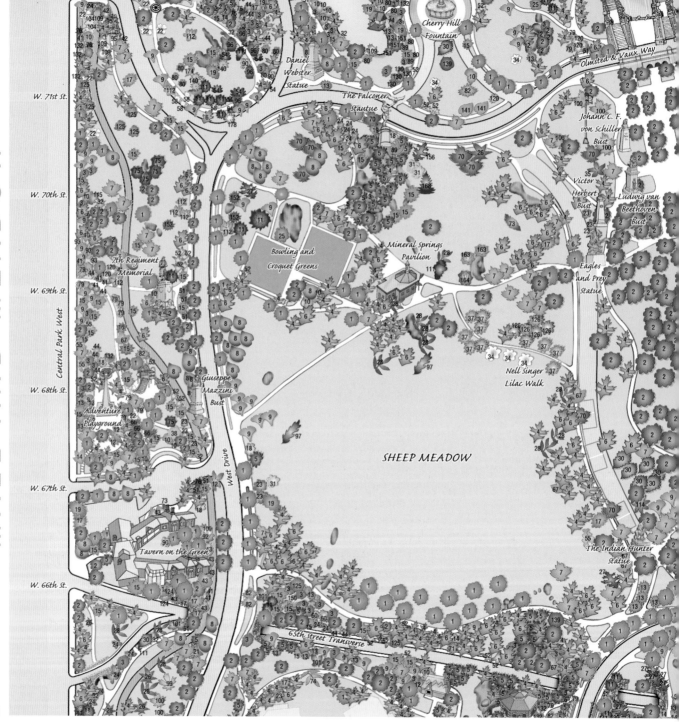

W. 72nd St.

W. 71st St.

W. 70th St.

W. 69th St.

W. 68th St.

W. 67th St.

W. 66th St.

Central Park West

Cherry Hill Fountain

Olmsted & Vaux Way

Daniel Webster Statue

The Falconer Statue

Johann C. F. von Schiller Bust

Victor Herbert Bust

Ludwig van Beethoven Bust

Eagles and Prey Statue

Bowling and Croquet Greens

Mineral Springs Pavilion

7th Regiment Memorial

Nell Singer Lilac Walk

Giuseppe Mazzini Bust

SHEEP MEADOW

Adventure Playground

West Drive

Tavern on the Green

The Indian Hunter Statue

65th Street Transverse

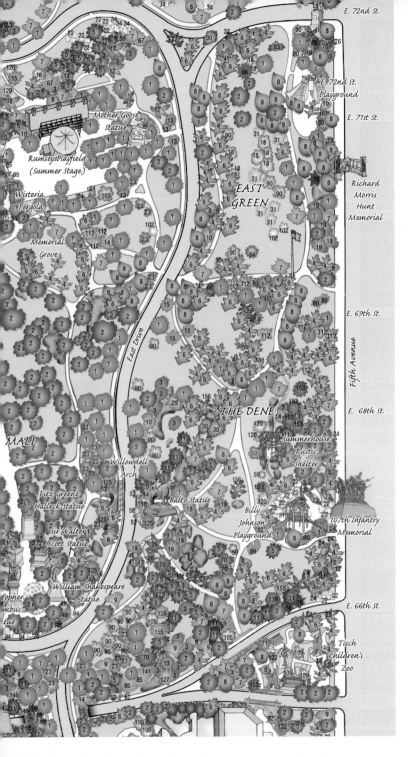

Sheep Meadow and the Mall would likely please Olmsted and Vaux if they could return and view their painstakingly constructed landscapes, which have gone through periods of rank neglect but have been restored to conform to their creators' intentions. The meadow's sheep are gone, but its turf and fringe of trees are beautifully maintained. Although the elms along the Mall experienced trampling crowds in the 1960s and 1970s and the ravages of Dutch elm disease, they have achieved in maturity the "fine effect" that Olmsted hoped for. Only the Dene, with its playgrounds and additional trees, has changed substantially, yet it is still a fine parkland consistent with the Olmstedian vision for Central Park.

31

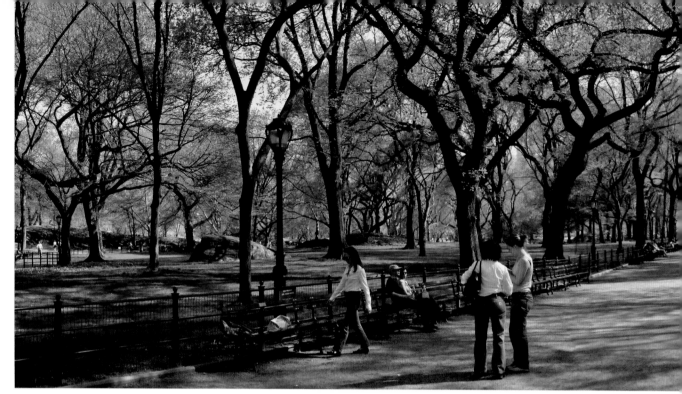

The Mall

"Although averse on general principles to a symmetrical arrangement of trees, we consider it an essential feature of a metropolitan park, that it should contain a grand promenade, level, spacious, and thoroughly shaded." So wrote Olmsted and Vaux in their Greensward Plan of 1858. They were no doubt inspired by tree-lined malls that they had encountered in England and on the Continent. Malls in 19th-century Europe, such as the one in St. James's Park, London, were often roads or promenades leading to palaces, great estates, or public buildings. Usually these malls were bordered with dou-

▶ *A 1902 photograph taken from the Mall's northern end shows a fashionable crowd with nary a bare head. Elms along the promenade appear to be about the same size as those in the photo above, taken a century later.*

ble lines of elms, lindens, or horsechestnuts. The word "mall" is derived from the name of a game popular among aristocrats and royalty in 16th- and 17th-century Europe. Played on a grass course shaded by trees with a ball and mallets, it was known in England as pall mall, in France as *palemail*, and in Italy as *palla a maglio* ("ball" to "mallet").

Olmsted and Vaux were specific about the trees to be planted along the Mall: "For pur-

poses of the avenue, the American elm naturally suggests itself at once as the tree to be used; and it is hoped that the fine effect this produces, when planted in regular lines, may in a few years be realized in the Central Park."

The double rows of American elms bordering the Mall's 1200-foot length were first planted in 1858. All the young trees died within a year, but a second planting lasted into the 20th century. Most of the older elms on

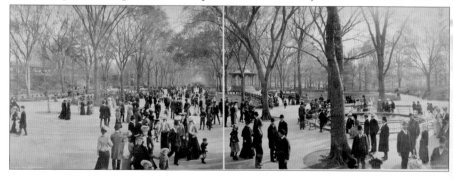

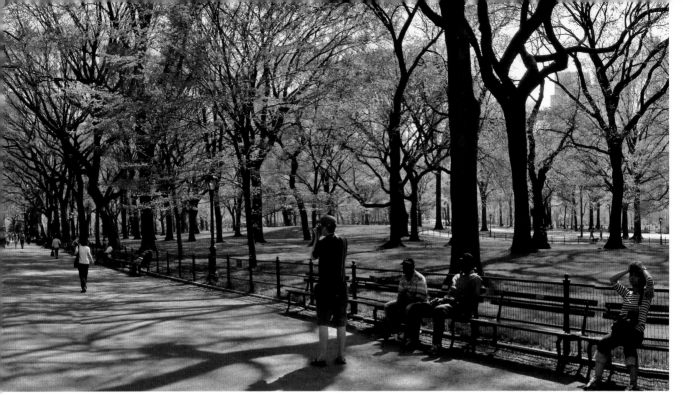

the Mall date from the third planting, in the early 1920s. A very few are older. Among the oldest are three or four English elms and wych elms, which may be distinguished from their American cousins by more upright, less vase-shaped habits.

The Mall's grove of more than 150 American elms is one of the largest in the world, but it does not compare with the American elm population of Winnipeg, Manitoba, where more than 100,000 American elms line the streets.

Olmsted and Vaux aimed the Mall on a north–south axis at an angle to the city's avenues toward the Lake, the Ramble, and Vista Rock, where Belvedere Castle now stands.

▶ *An early-spring snowfall frosts the statues of Robert Burns and Sir Walter Scott at the southern end of the Mall. Crowns of the elms lining the promenade are tinged brownish-bronze by anthers of thousands of elm flowers.*

Wealthy early park visitors could alight from carriages at the Mall's southern end; stroll north while mingling with less affluent citizens, who may have walked into the park from 59th Street; and then be picked up by their carriages at Bethesda Terrace, where they could enjoy a view of the Ramble over the Lake and glimpse Vista Rock, which is now obscured by the Ramble's mature trees.

▲ *On a late April morning at the Mall, sunlight floods the promenade. The rows of bordering elms are covered with thousands of ¼-inch samaras that will shortly drop off the trees' twigs as budding leaves unfold.*

The Mall's elms have been endangered over the years by neglect, ground compaction, and Dutch elm disease. Now they are protected by fences and by the constant attentions of the Central Park Conservancy's arborists.

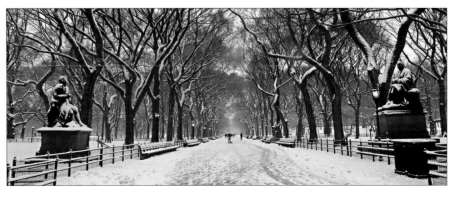

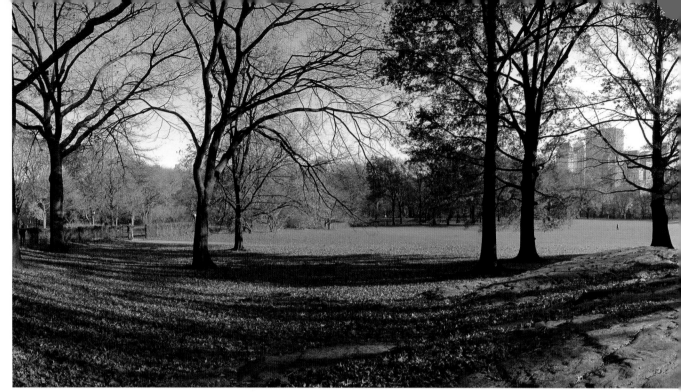

Sheep Meadow

West of the "grand promenade," as Olmsted and Vaux labelled the Mall in their Greensward Plan, they proposed to locate a "parade ground…that may, at moderate expense, be levelled and made suitable for its purpose." A parade ground was a requirement of the 1857 design competition for Central Park. "Such a broad open plane of well-kept grass would be a refreshing and agreeable feature in the general design," the plan's authors noted. However, the cost of demolishing hundreds of shanties and shacks of former inhabitants, blasting a 16-foot-tall rocky ledge, moving countless boulders large and small, laying thousands of feet of tile drainage pipes, filling low wet places and areas where rocks had been removed, and then topping off the 20-acre site for the

parade ground and another 15 acres surrounding it with 2 feet of topsoil barged and carted in from New Jersey proved to be considerably more than a "moderate expense." Acre for acre, this pleasant expanse of turf fringed with newly planted trees and shrubs and the land east of it, where the Mall bordered by rows of American elms would be located, was the most expensive section of the park to construct.

The levelled, open, turf-cov-

ered space never served as a parade ground. The park commissioners introduced 200 sheep to the site in 1864, preventing it from being used for military drills during the Civil War and pleasing Olmsted and Vaux, who

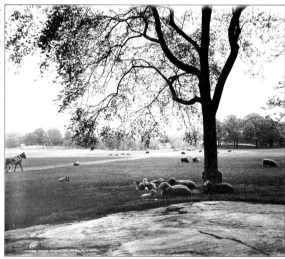

▶ *The photographer who took this 8- by 10-inch photo of Sheep Meadow about 1900 placed his tripod on almost the exact spot from which the photograph above was taken over a century later. Aside from the sheep, the views are similar. Trees are a bit larger now, and tall buildings loom above the distant trees.*

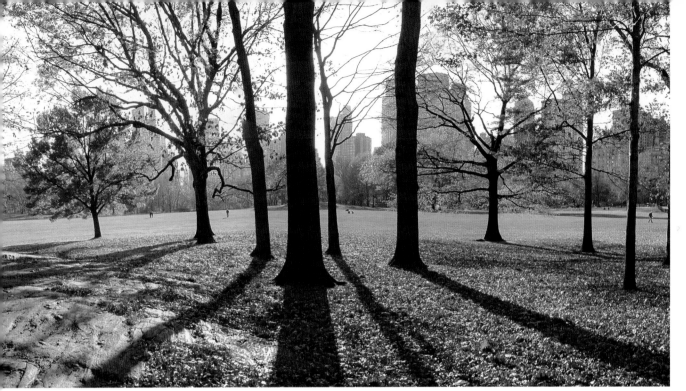

felt that the park should be a place for peaceful contemplation. From that time on, the field would be known as Sheep Meadow. The sheep cropped the meadow's grass until 1934, when Parks Commissioner Robert Moses moved them to Prospect Park.

The turf of Sheep Meadow was generally off-limits to the public in the 19th century. People were to enjoy the pastoral view, complete with a shepherd and his crook, not by walking on the grass but by looking between tree trunks along the margins.

In the 20th century, the emphasis shifted. The meadow was no longer a landscape to be contemplated from a distance but a place in which to experience mass events—

▶ *For a few thousand young city dwellers on a warm weekend afternoon in April, Sheep Meadow becomes Manhattan's backyard. Picnicking and frisbee throwing are permitted but no organized sports and or mass events.*

demonstrations, love-ins, concerts with famous artists—events that destroyed the turf. After several extensive renovations, Sheep Meadow has been restored to its former glory. Its well-watered and -drained turf is lush; its irregular fringe of trees neatly trimmed. Completely fenced and automatically irrigated, the meadow is frequently given a rest so visitors can feel healthy grass

▲ *Ashes and oaks on Sheep Meadow's northern side cast long shadows on an October afternoon. About 100 trees cluster along Sheep Meadow's edges; most are oaks, but there are others mixed in, including London planes, maples, Yoshino cherries, ginkgos, and tree lilacs.*

between their toes when gates are open and enjoy the pastoral view when gates are closed. It is among the world's most intensively managed bits of turf.

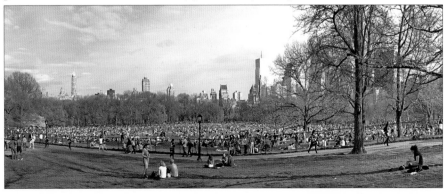

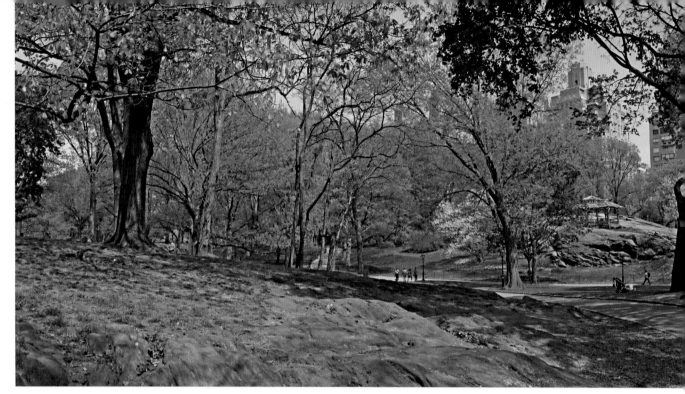

The Dene

In *Rebuilding Central Park*, Elizabeth Barlow Rogers, founding president of the Central Park Conservancy, defines parkland as "a combination of trees and turf" and notes that "it is the most common landscape type in Central Park, best represented by the Dene and the landscape around the Conservatory Water." Located east of the Mall, the Dene stretches north from the 66th Street transverse just north of the Children's Zoo to the East Green at 72nd Street.

The Dene is situated on what was originally a more or less flat area, a plateau on which Sheep Meadow and the Mall were constructed. Olmsted installed drainage pipes in the swampy, rocky southern section of the Dene; graded and seeded the entire area; and planted specimen trees here and there throughout its length. In 1891, Samuel Parsons, Jr., the park superintendent, commented that the Dene "reminds one of an English lawn. It is five or six acres of fine turf, unbroken except by a few scattered shade trees of large size." An aerial photograph taken in 1921 pretty much conforms with Parsons's description. At that time, there appears to have been no more than 70 or 80 large specimen trees, mostly concentrated in the southern section. Today, the Dene remains a very pleasant parkland with turf and trees, but there are many more trees than there were in Olmsted and Parsons's time—well over 200 large specimen trees in fact.

▶ *The Summerhouse on Dene Rock has been rebuilt several times but still looks much as it did in this 1862 lithograph by artist George Wilhelm Fasel. The rustic shelter is a pleasant spot from which to view the trees of the southern Dene, especially when they are blooming in spring.*

The Dene contains a rich and diverse collection of more than 50 broadleaf tree species. Among the larger shade trees are nearly 200 London planes, lindens, black oaks, pin oaks, and red oaks. Mixed in are black cherries, black locusts, Norway maples, sweetgums, and ginkgos as well as an old male Osage orange and a few ashes, sassafrases, mulberries, Japanese zelkovas, hackberries, and hornbeams plus several other species. The Dene's population of conifers, however, numbers fewer than 20, including about four young lacebark pines and a dozen white pines in the southern section and five Japanese black pines near the Summerhouse on Dene Rock.

Sun filtered by London plane leaves dapples East Green turf at the northern end of the Dene. At the left in the distance, appearing as a bush-like mound of leaves, is a Camperdown elm, an odd grafted wych elm cultivar.

In spring, the Dene's smaller ornamental trees provide a dazzling succession of flowers. A dozen saucer magnolias clustering close together along the bend in the Drive opposite the Mall's southern end erupt into roseate clouds in mid-April. A week later, flowering cherries and crab apples on the East Green add their contrasting whites and pinks to the park's spring extravaganza. At about the same time, branches of Carolina silverbells

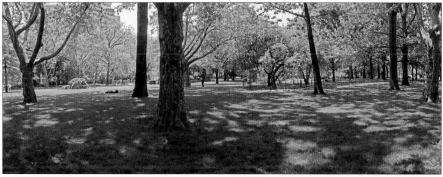

▲ *This view greets strollers in late April as they emerge from Willowdell Arch and pass by the statue of Balto. Dene Rock, topped by the Summerhouse, is flanked by three blooming Carolina silverbells.*

around Dene Rock are decked with exquisite bell-like blossoms. Then in mid-May, a Chinese fringetree at Dene Rock displays its galaxy of petals. Finally, in early June,, creamy-white, citronella-scented flowers of the Dene's two southern magnolias bloom.

shakespeare Garden

79th Street Transverse

Ramble Shed
Rest Area

Iphigene's
Walk

Maintenance
Meadow

Bonfire
Rock

BANK
ROCK
BAY

Tupelo
Meadow

THE RAMBLE

Oak
Bridge

Ramble
Stone
Arch

Balcony
Bridge

The Gull

West Drive

Central Park West

Rustic
Shelter

Ladies'
Pavilion

Willow
Rock

Hernshead

THE
OVEN

Boat
Landing

THE LAKE

Warbler
Rock

Loeb
Boathouse
Cafe

Boat Landing

The
Point

Bow Bridge

Boat
Landing

Bethesda
Fountain

Wisteria
Pergola

CHERRY
HILL

Bethesda
Terrace

Wisteria
Pergola

WAGNER
COVE

Imagine
Mosaic

Cherry Hill
Fountain

STRAWBERRY
FIELDS

Boat
Landing

Olmsted & Vaux

Daniel
Webster
Statue

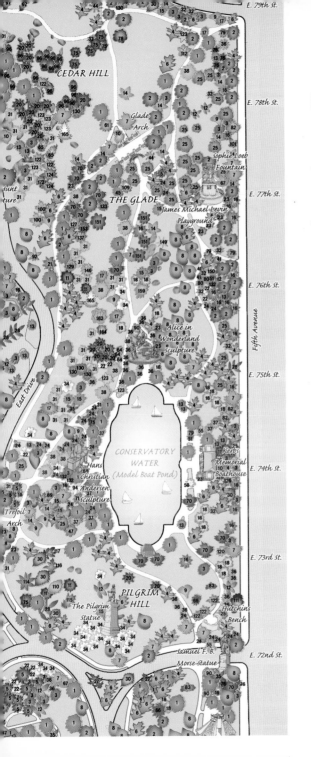

For Vaux and Olmsted, the wild southern shore of the Ramble was "the picture that people would come to see" after they walked north through the Mall's great cathedral of American elms to Bethesda Terrace.

Vaux's architectural masterpiece, the terrace, was—and is—the focal point of Central Park, the place from which visitors set off across Bow Bridge to explore the Ramble's maze of twisting paths threading through a wilderness of native and exotic trees.

The Lake appears to be entirely natural, but it is just as carefully contrived as the Ramble. To the east, south, and west of the Lake and the Ramble are several of the park's most loved and visited landscapes: Strawberry Fields, a botanical tribute to John Lennon; the Conservatory Water, with its boat pond and surprisingly varied tree collection; the Glade, a shady stretch with ancient beeches and tupelos; and Cedar Hill, a pleasant grassy slope with dozens of cedars, junipers, and pines.

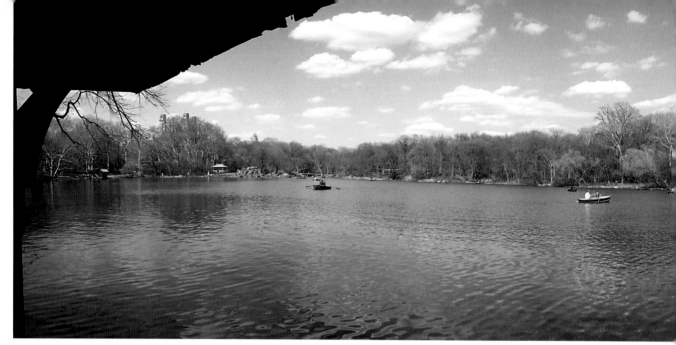

The Lake

"To the north and north-west of the promenade," Olmsted and Vaux wrote in the Greensward Plan, "a tract of low ground is proposed to be converted into the skating pond called for in our instructions; and the picturesque scenery between Vista Rock and the promenade will thus be heightened in effect, when seen from the south side of this lake, of about 14 acres." Actually the Lake, which borders the Ramble's western and southern sides, totals about 18 acres and is the second largest water body in the park.

The "low ground" that Olmsted and Vaux flooded to create the Lake was in the mid-1850s a foul-smelling swamp, polluted with effluvia from houses, tanneries, and piggeries. Probably in pre-Columbian times it had been a pond, perhaps on occasion a beaver pond. But natural ponds and lakes are temporary, tending eventually to fill in with organic debris and sediment.

The Lake has required repeated restoration efforts over the years as thousands of cubic feet of soil from an eroding shoreline and poorly maintained surrounding slopes settled on its bottom. In 1903, the Lake's natural clay floor was covered with cement and gravel. In 1929, boulders were situated along the water's edge. Beginning in 2006, the Lake and its surrounding shoreline were completely revamped once again. The Lake's silted-up coves, bays, and inlets were dredged; its bottom was stabilized with gravel; and its shoreline was reconstructed with rocks and biodegradable

netting to provide a substrate for native water plants. The island off the Ramble's western tip was rebuilt and planted with water-loving bald cypresses.

The path running next to the West Drive along the western shoreline of the Lake from Bank Rock Bay south to Wagner Cove is lined with more than 50 London planes, some planted when Frank Pollard was acting chief landscape gardener in the

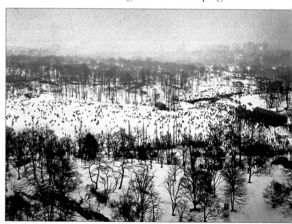

▶ *Taken in the winter of 1912 from the Dakota on Central Park West, this photograph catches hundreds of skaters enjoying the frozen Lake. In the foreground is a bit of what would become Strawberry Fields. Beyond the Lake is the Ramble, covered mostly by bare broadleaf trees. Buildings on Fifth Avenue loom in the distance.*

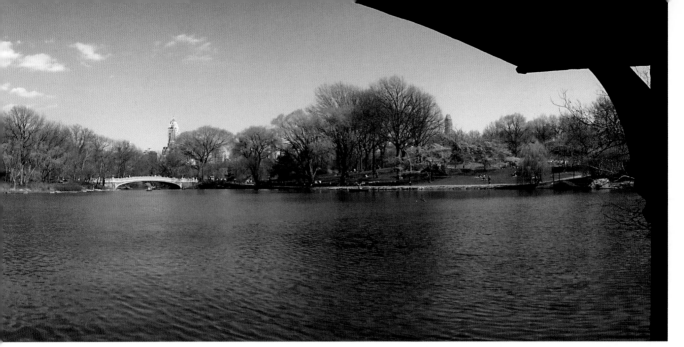

early 1870s and others in the mid-20th century when Robert Moses was parks commissioner. Just behind the boat landing south of the Ladies Pavilion there is a particularly striking copper beech, a European beech cultivar. Mostly small or medium-size, the trees edging the Lake's western shore are a mixed bunch growing close together. They include pin oaks, hackberries, elms, mulberries, and black cherries.

The Lake's southern shore is fringed with fewer trees than its western shore, but some are very arresting specimens. For example, there is a venerable cutleaf beech with a distinctly weeping habit on the circle around Cherry Hill Fountain to the left of the path leading to the Lake. Cuttings from this tree, which is over a century old, were cultivated in an Oregon nursery and then planted in

▶ A view of the Lake from Cherry Hill is framed by the boughs of Yoshino cherries blooming in mid-April. Yoshinos are clones propagated by cuttings. A green tree in the left foreground and two in the distance are willows.

other parks throughout New York City.

Nearly a dozen Yoshino cherries on the western side of Cherry Hill create a dazzling show in mid-April. The easternmost Yoshino in the group is a gnarled, very distinguished-looking tree, perhaps planted around the same time as some of the older Yoshinos on the Reservoir's eastern edge.

East of Cherry Hill Fountain is another large cutleaf beech, likely dating from the turn of the 20th century when Samuel Par-

▲ From the boat landing opposite Bow Bridge in April, most trees by the Lake shore are still brown and bare. Blooming Yoshino cherries stand out as well as willows tinged yellowish-green by flowers and budding leaves.

sons, Jr., was park administrator. Its branches sweep a large rock outcropping near the top of the hill. Along the edge of the Lake between Cherry Hill and the Loeb Boathouse are several willows, two or three quite large, and a few fine specimen oaks, including a tall swamp white oak west of Bethesda Terrace.

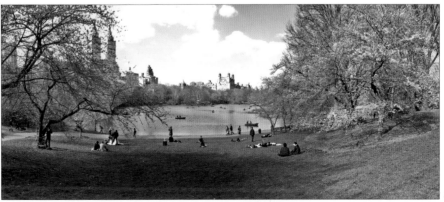

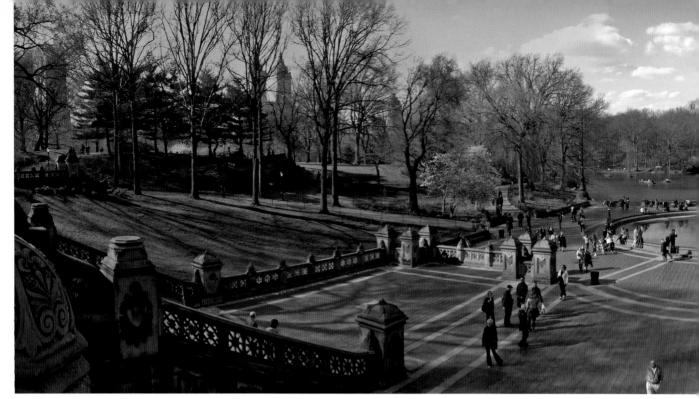

Bethesda Terrace

In the *Sixth Annual Report of the Board of Commissioners of the Central Park*, published in 1863 when the country was riven by the Civil War, Vaux wrote that the nation's flag would be displayed on a "rough stone outlook…on the direct vista line from the central walk of the Mall, and thus situated, it will also be the culminating point of interest in the view both from the upper and the lower terrace."

Vaux thus gave special patriotic importance to the view that spectators standing on the terrace at the northern end of the

Mall would enjoy. It had always been Vaux and Olmsted's intention to aim the Mall directly at Vista Rock, but they had not described the terrace as the park's primary architectural feature in their Greensward Plan of 1858. The terrace's great potential became evident to them only as they were preparing working drawings. By 1863, Vaux had submitted a master plan for the terrace that was quickly approved by the commissioners. In 1864, when work on the terrace was nearly complete, Vaux wrote, "We de

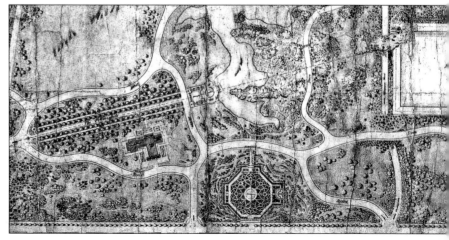

▶ *In this section of the 3- by 8-foot pen-and-ink map accompanying the Greensward Plan of 1858, Olmsted and Vaux emphasized the alignment of the Mall, the terrace, and Vista Rock by drawing a dotted line.*

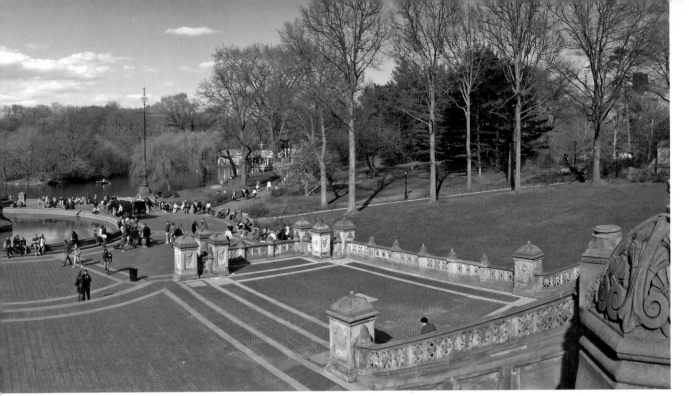

termined that the Ramble should be the picture that people would come to see." And the place to see this picture was the terrace at the Mall's upper end. It was Vaux's masterpiece of park architecture, the most ambitious and impressive example of civic art in New York City at the time.

In an 1865 letter to the author and art critic Clarence Cook, Vaux declared, "The landscape is everything, the architecture nothing—til you get to the Terrace. Here I would let the New Yorker feel that the richest man in New York or elsewhere cannot spend as freely…just for his lounge."

▶ *"The view on an autumn day from the drive across the Plaza and fountain and across the Lake to the Ramble, where the woods are flushed with crimson and gold," Samuel Parsons, Jr., wrote in his book* Landscape Gardening, *"is something to be treasured in memory above all other scenes of the park."*

As early as 1872, the Ramble's trees were obscuring Belvedere Castle, which had been built at the summit of Vista Rock in 1869. Olmsted announced, "The middle parts of the Ramble in a line from the Terrace to Vista Rock are to be cleared of trees." But these instructions have never been carried out.

▲ *Willows near the lower terrace in mid-April are turning yellow-green with flowers and sprouting leaves. Cherries and magnolias are in full bloom, but tall-trunked pin oaks lining the paths to the upper left and upper right are still bare. Across the Lake, willows in the Ramble are also turning green, but most other large deciduous trees remain brown. The crowns of a pair of willow oaks rise a bit above other Ramble trees.*

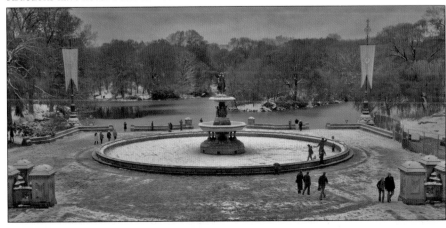

43

Strawberry Fields

It is a teardrop-shaped, 2½-acre bit of land on the western edge of the park, surrounded by roadways. Olmsted and Vaux originally proposed it as the site of a restaurant. Vaux noted that it "commands some of the finest views in the Park." However, the restaurant was never built.

It is a flat-topped plateau, steep-sided on its eastern flank, from which visitors in the park's early years—before trees partially blocked the view—could watch skaters and boaters on the Lake. Just off Central Park West, it has always been a convenient place for residents of the nearby neighborhood to enjoy a brief stroll or walk their dogs.

Until 1981, it was overlooked by most park visitors and was not even important enough to have its own name. But in that year, when it was officially designated Strawberry Fields—after the Beatles' song "Strawberry Fields Forever"—to commemorate slain singer and songwriter John Lennon, it became one of the most visited places in the park and perhaps the most famous. Nearly 2.5 million people visited Strawberry Fields in 2011, mostly to pay their respects to Lennon's memory by stopping at the Imagine mosaic on the path from Central Park West and 72nd Street. The mosaic is a Greco-Roman sunburst design donated by the city of Naples.

▶ *At Strawberry Fields' southern entrance, the left path curves past Eastern white pines, the largest trees at the time of their arrival ever planted in the park. The right path leads past Eastern red cedars. A Turkey oak's leaves shine greenish-gold (center) in the late November sunlight.*

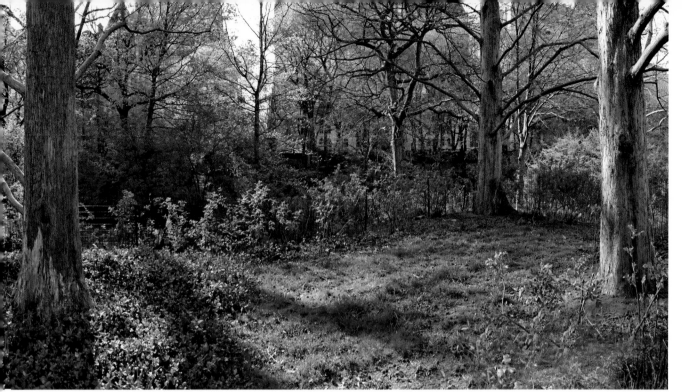

Strawberry Fields was designed by landscape architect and Olmsted scholar Bruce Kelly, who conceived it as a sequence of landscapes for visitors to explore. Underwritten by John Lennon's widow, Yoko Ono, work on the plantings was finished in 1985. More than 200 trees and shrubs—including 24 pin oaks, 23 black locusts, 17 elms, 16 American hollies, 10 ginkgos, and a Franklinia (just south of the Imagine mosaic)—surround pleasant stretches of turf.

Running along the eastern side of Strawberry Fields' upper section is a wood-chip path lined by ferns, mountain laurel, oakleaf hydrangea, rhododendrons, Carolina allspice, viburnums, jetbead, holly, and wildflowers. Probably no other space of similar size in the park includes so many plant species growing close together—a fitting memorial for a man devoted to world peace.

▲ *In mid-April, three dawn redwoods at the northern end of Strawberry Fields are beginning to sprout new needles. Deciduous conifers, they drop their needles in fall. A wood-chip path on the left leads south along the eastern edge of Strawberry Fields. The dark evergreen tree at the far end of the greensward is a female American holly.*

▼ *A mountain laurel (right) along Strawberry Fields' wood-chip path is decked with white flower clusters in early June. An oakleaf hydrangea (left) is also starting to bloom. Farther along the path, a Carolina allspice bush is displaying fragrant crimson, many-tepalled flowers (inset).*

▶ *The Imagine mosaic on the path near the 72nd Street entrance to Central Park is where most visitors enter Strawberry Fields. In the background is the Dakota on the corner of 72nd Street and Central Park West.*

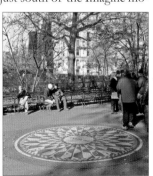

The Ramble

In the Greensward Plan of 1858, Olmsted and Vaux wrote that the Ramble was to be an "American garden," a place for the cultivation of hardy plants such as rhododendrons, azaleas, and mountain laurel. "The present growth," they noted, "consisting of sweet-gum, spicebush, tulip-tree, sassafras, red-maple, black-oak, azalea, andromeda, &c., is exceedingly intricate and interesting."

The thickly forested shore of the Ramble between the Loeb Boathouse and Bow Bridge sharply contrasts with the formal lakefront setting of Bethesda Terrace and the Mall. From the Lake's shore, the Ramble rises northward to Vista Rock and Belvedere Castle, but it is not the "American garden" that Olmsted and Vaux originally envisioned. Its many twisting paths meander through a maze of more than 2000 trees, many exotic species from Asia and Europe.

A trip that Olmsted took across the Isthmus of Panama in 1863 changed his idea of

▶ *W. H. Guild's 1864 photograph of the Ramble's Rustic Bridge number 27 shows a landscape of "minor scale" with small trees, as Olmsted specified in his letter to Ignaz Pilat. Firs and other conifers mingle with deciduous trees.*

▲ *The Ramble's Azalea Pond in June 1905 is surrounded by shrubs, herbaceous plants, and a number of tall trees with substantial trunks. The "minor scale" of the landscape (pictured in the photograph to the left) that Olmsted hoped "not to destroy" is less evident, though some smaller understory trees are still present.*

how the Ramble should be planted. In a letter to Ignaz Pilat, chief landscape gardener of Central Park, written during the journey, Olmsted observed that by "selection and special treatment, we can then produce trees, which…shall lead a man to say, 'I have seen such trees before only in the tropics.'" He urged Pilat to plant Asian trees—including ailanthus, oriental magnolias, royal paulownia, paper mulberry, and forsythia—and native species with "tropical character," such as honeylocust and sassafras. He cautioned that "we must make much of trees of the smallest size…so as not to destroy the minor scale of the landscape."

As the years passed, the "minor scale" of the Ramble's landscape became less and less apparent. Introduced exotic trees and shrubs

grew taller, crowding out and shading more desirable native plants. In the 1990s, the Central Park Conservancy began removing aggressive exotic species such as Norway maple, sycamore maple, ailanthus, and Japanese knotweed and replacing them with native trees and shrubs. Conservancy gardeners also began gradually restoring the Ramble's herbaceous ground cover, destroyed by years of compaction and erosion. The Ramble is once again becoming an "American garden."

▲ Azaleas still bloom in the Ramble in May, as they did in Olmsted's time. Tuliptrees and other native trees are being planted. Ferns and wildflowers, which had largely disappeared from the Ramble in the latter years of the 20th century, have been reestablished by conservancy gardeners.

▶ Ferns and shrubs growing in damp leaf litter near Bank Rock Bridge give the area the look of a healthy wild forest.

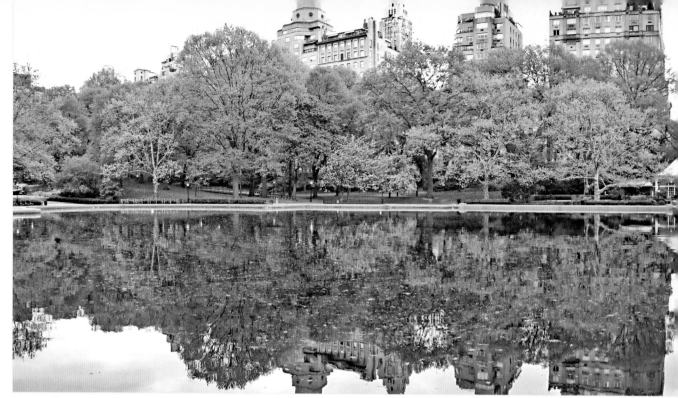

Conservatory Water

The rules of the 1857 design competition for Central Park required that all entries include a flower garden. Olmsted and Vaux situated theirs at the present site of the Conservatory Water. In their Greensward Plan of 1858, they proposed a structure level with Fifth Avenue from which people could view and then descend to a geometrical flower garden that would have at its center a "large basin for a fountain." After construction of the park began, Olmsted and Vaux were asked to design a two-story glass conserva-

tory at the site, but shortly after its foundation was laid, the project was deemed too expensive to complete. Instead of a conservatory and flower garden, Olmsted and Vaux went on to construct a hard-edged reflecting pool that eventually became known as the Model Boat Pond. Hobbyists sail their miniature boats here to this day.

The pleasant, gently sloping parkland landscapes surrounding the Conservatory Water are shaded by some of the finest specimen trees to be found anywhere in the park, and April is one of the best months of the year to enjoy them. Among the earliest trees to flower are the Yoshino cherries clustered around the statue of a Pilgrim

▶ *The Pilgrim at the summit of Pilgrim Hill stands amid more than a dozen Yoshino cherry trees that usually flower in early April. Yoshinos are clones of a single tree discovered in Japan nearly three centuries ago.*

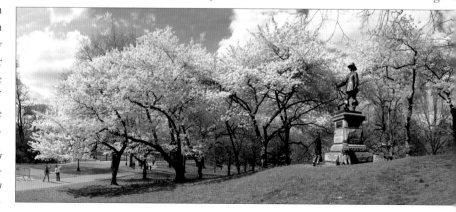

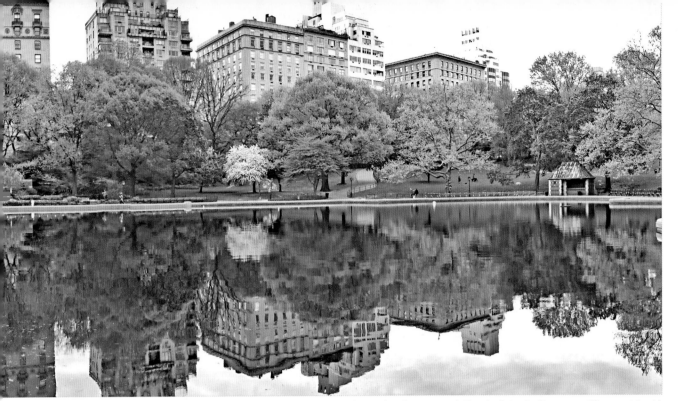

at the corner of 72nd Street and the East Drive. They are in full bloom by mid-April, displaying clouds of soft-pink blossoms before their leaves fully unfold.

Just beyond the Yoshinos to the north is a grouping of oaks that park tree enthusiasts call the Quercitum (from the Latin genus name for oak, *Quercus*). Many of them bear male pollen catkins from late April into May. Nine oak species stand side by side here: pin oak, chestnut oak, Shumard oak, shingle oak, Spanish oak, swamp laurel oak, swamp white oak, willow oak, and red oak. Most trees bear identifying placards.

Closer to Fifth Avenue on the hill descending from 72nd Street to the Conser-

▶ Trees on the slope from 72nd Street at Fifth Avenue down to the Conservatory Water are (from right to left) an old black cherry, a European hornbeam ('Fastigiata'), and two Schwedler maples flanking the refreshment house.

vatory Water are three cedars of Lebanon, a very old black cherry, a lovely globose European hornbeam, and a pair of Schwedler maples bearing coppery-crimson leaves in mid-April that later turn green.

Fringing the Conservatory Water itself are London planes planted during Robert Moses's tenure as parks commissioner as well as pin oaks, Schwedler maples, a very large red oak, and several small flowering trees.

▲ Trees bordering the Conservatory Water on either side of the Kerbs Boathouse include five London planes, two pin oaks, four red oaks, three Schwedler maples, four crab apples (flowering), two downy hawthorns, and one cockspur hawthorn. Several tall American elms stand farther back.

The Conservatory Water's beloved sculptures of Hans Christian Andersen and Alice in Wonderland and its Model Boat Pond have appealed to generations of children.

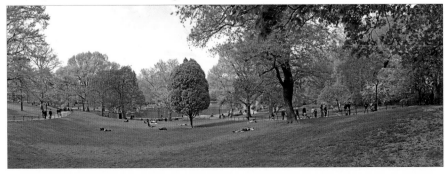

The Glade and Cedar Hill

The Glade and Cedar Hill complete a series of much loved parkland landscapes between the East Drive and Fifth Avenue, stretching from the Central Park Zoo to the Metropolitan Museum of Art. Like the Conservatory Water, the Glade and Cedar Hill have long been places for East Side residents to play with their children, walk their dogs, sunbathe on warm spring and summer afternoons, and sled when snow blankets the park.

The Glade and Cedar Hill have many more mature trees than they did a century ago. A 1921 aerial photograph of the two landscapes shows them covered mostly by turf in rather poor condition, with about 200 trees and larger shrubs scattered along the margins. Now there are more than 700 trees and shrubs.

Today a substantial portion of the Glade is populated by mature trees, particularly in its northern section. Here older black tupelos, a gathering of European beeches, a row of London planes, and an ancient hornbeam cast deep shade, too deep for grass to grow. Park gardeners keep the ground covered with wood chips to reduce compaction and erosion. A choice has been made to forgo turf and preserve fine specimen trees such as the Glade's great old quadruple-trunked black tupelo, with its graceful

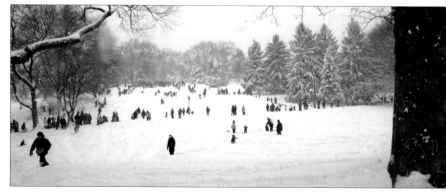

▶ As a snowstorm drops a foot of snow on the park, Cedar Hill attracts hundreds of children and their parents. Sledders line up near Eastern red cedars at the top of the slope. Tall conifers (right) are Norway spruces.

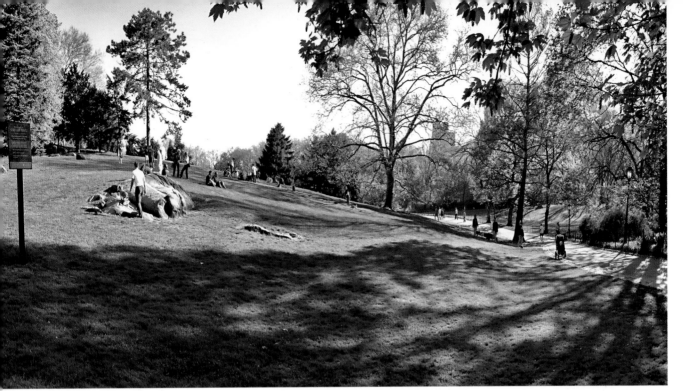

drooping lower branches laden in summer with opaque, leathery dark-green leaves that turn to brilliant shades of orange and gold every fall.

Tons of topsoil carted into the park in the late 1850s covered many rocky ledges and created Cedar Hill's sloping expanse of turf. Well named, Cedar Hill has 10 true cedars—including deodar cedars, cedars of Lebanon, and Atlas cedars—growing near its crest and more than 20 Eastern red cedars. Other prominent conifers on the hill are groups of Norway spruce and Austrian pine and a bald cypress. Among the deciduous trees are a fine copper beech along the path to the Metropolitan Museum and a very large red oak standing at the base of the hill southwest of Miners' Gate.

▲ *There is something about Cedar Hill that draws people. Its grassy slope offers comfortable places to sit from which they can look across pleasant parkland dotted with trees and rimmed by Fifth Avenue towers. The diversity of the hill's sylvan population also adds to its allure.*

▼ *At the Glade's northern end near Glade Arch are several old black tupelos, London planes, and European beeches, which create a cool, shady redoubt on warm days. Children often play games here on the wood chips and rest at the foot of the great quadruple-trunked black tupelo.*

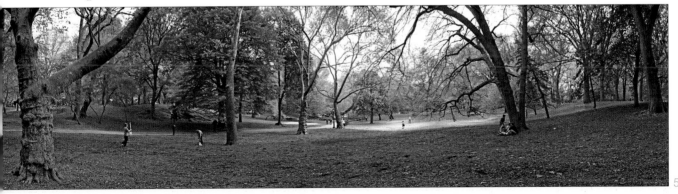

Subway
B, C

W. 86th St.

Abraham and Joseph
Spector Playground

Arthur Ross
Pinetum

Seneca
Village
Site

Mariners'
Playground

W. 85th St.

W. 84th St.

Summit
Rock

W. 83rd St.

W. 82nd St.

Diana Ross
Playground

Winterdale
Arch

W. 81st St.

Subway
B, C

Central Park West

79th Street
Yard

Swedish
Cottage

Shakespeare
Garden

Romeo and
Juliet Statue

The Tempest
Sculpture

Rest
Area

Delacorte
Theatre

Vista
Rock

Belvedere
Castle

86th Street Transverse

Central Park
Police Precinct House

Volleyball &
Basketball
Courts

THE
GREAT
LAWN

Turtle
Pond
Dock

TURTLE POND

King
Jagiello
Monument

79th Street Transverse

Frederick Olmsted and Calvert Vaux, the designers of Central Park, would not recognize much of their handiwork in the Great Lawn landscape. They would doubtless be happy that the "blank uninteresting" Croton Receiving Reservoir was removed and replaced by a 13-acre greensward and a naturalistic pond, but they might not approve of the eight baseball diamonds interrupting the turf expanse and the perfectly regular Beaux-Arts oval path surrounding it. Nor might architects Vaux and Jacob Wrey Mould be pleased that the Ruskinian Gothic Revival building that they designed for the Met has been entirely subsumed in an immense quarter-mile-long structure with a Beaux-Arts facade. Original features do remain, however, including Vaux's Belvedere Castle on Vista Rock; the curving routes of various drives and walkways; as well as the ingeniously sunken transverse roads bordering the space to the north and south. It is the most altered of all the park's landscapes, but it is also one of the most popular and often visited.

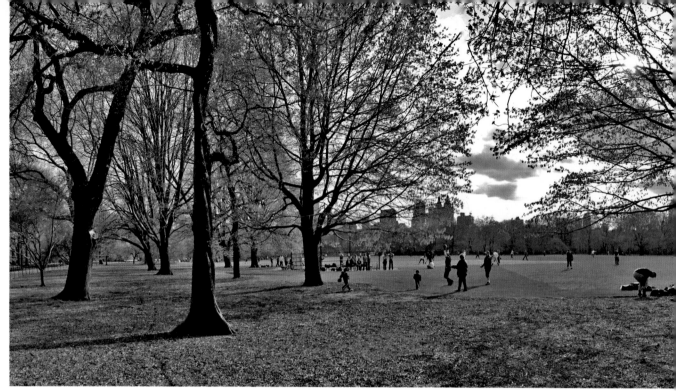

The Great Lawn

When Olmsted and Vaux prepared their Greensward Plan of 1858, they had to deal with the Croton Receiving Reservoir, completed in 1842. A rectangular fortress-like structure, 1826 feet long by 836 feet wide, it stored water piped 38 miles into the city from the Croton Dam in northern Westchester County. Complaining that it was a "blank uninteresting object, that can in no way be made particularly attractive," the designers bypassed this angular interruption to their naturalistic park vision with curving north–south pedestrian paths and drives and hid its stone masonry walls with plantings.

The steep outcropping of Vista Rock, topped by a wooden fire tower, formed the southwestern corner of the reservoir when the park was established in the late 1850s. In 1867, after the Croton Aqueduct Board transferred Vista Rock's title to the Parks Department, Vaux designed Belvedere Castle, a Victorian folly of granite and schist, which replaced the fire tower in 1869. A series of additions and changes followed. In 1877, the Swedish Cottage was moved from the Centennial Exposition in Philadelphia and placed west of Vista Rock close to the West Drive. In 1881, the Obelisk, known as Cleopatra's Needle, was installed on a platform overlooking the East Drive opposite the Metropolitan Museum. The museum had just moved into a building designed by Calvert Vaux that would be periodically expanded over the years until it occupied most of the land between Fifth Avenue and the East Drive. In 1913, the Shakespeare Garden, with pathways edged by plants mentioned in Shakespeare's works, was built west of Belvedere Castle.

▶ *This aerial view of the 150-million-gallon Croton Receiving Reservoir with Belvedere Castle at the lower left is from the Taylor Map of New York of 1879. The 31-acre reservoir had two tanks so that one tank could be full of water even when the other was emptied for repairs.*

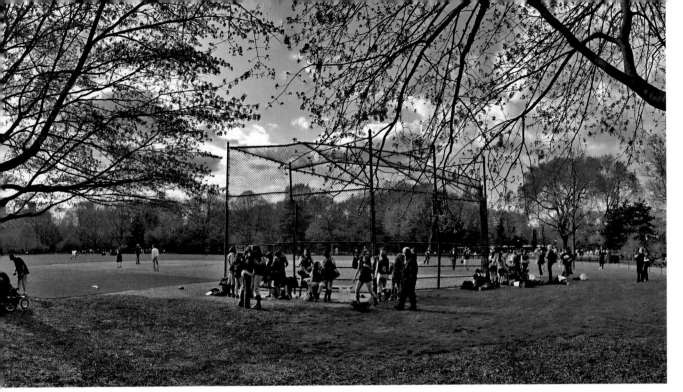

A complete transformation of the 55-acre central area occurred in 1934 when the Croton Receiving Reservoir was filled in and replaced with a lawn bordered by a Beaux-Arts oval path and a small lake at the southern end. Other significant changes followed in 1962 when the open-air Delacorte Theater, with its scaffolding background, was erected at Turtle Pond's northwestern corner and in 1971 when the Arthur Ross Pinetum was established at the Great Lawn's upper end.

Like Sheep Meadow, the Great Lawn became a place for staging huge events and needed renovation by 1997. Although it contains eight baseball diamonds, its turf is now carefully maintained. The area surrounding the oval contains over 2400 trees and shrubs, including some of the park's finest specimen trees. Among its most impressive trees are a group of Himalayan pines and a pair of weeping cherries on the oval's western side.

▲ *Trees bordering the Great Lawn's oval pathway include pin oak, bur oak, red oak, red maple, hornbeam, and several varieties of hawthorn, linden, and flowering cherry. Larger trees were planted in the mid-1930s after Robert Moses filled in the Croton Receiving Reservoir. East of the Great Lawn is a lovely grouping of magnolias, and to the west is an allée of European beeches.*

▶ *Perched on Vista Rock, whimsical Belvedere Castle offers a fine view of Turtle Pond and the oval Great Lawn beyond. Among trees bordering the pond is a beautiful grove of river birches fringing the northeastern shore.*

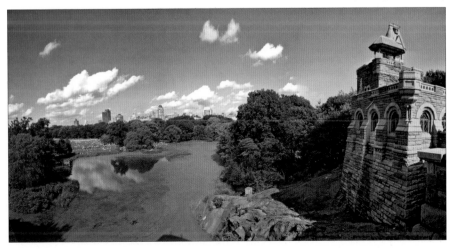

55

Arthur Ross Pinetum

In an 1862 report addressed to Andrew H. Green, chairman of the Central Park Commission, Ignaz Pilat, the superintendent of planting for the park, listed the trees being planted west of the two reservoirs: "Dense evergreen planting has been introduced along the boundary line of 8th Ave. and before the wall of the 'Old Reservoir,' for the purpose of concealing them. Several groups of evergreens and single Spruces (Abies), Pines (Pinus), Junipers (Juniperus), Arbor-vitae (Thuja), Hemlocks (Abies Canadensis), and so forth, extend toward the 'Drive' and 'Ride,' large spaces being left between many of them in which to develop themselves, thus adding character to the landscape, giving shade to visitors and presenting in winter a pleasant drive replete with objects of interest and beauty. This (the Winter Drive) is to be extended farther north along the 'West Drive,' and is intended to be combined at the most suitable point with the 'pinetum' in connection with the proposed 'Arboretum.' " (The arboretum planned for the area that is now the East Meadow was never established.)

Evergreens planted along the West Drive by Pilat and his successors were still promi-nent when a *New York Times* reporter de-scribed them on a snowy day in December 1902: "The evergreens bowed to the south-east with their heavy weights of snow driven from the northeast and stood like great ostrich plumes of such wonderful beauty that the finest feather was never so graceful. The whole Park was a study in black and white, with dashes of green here and there where the snow had fallen from the branches of evergreens."

By 1927, however, when landscape archi-tect Herman Merkel completed his report

▶ *There are more than 200 pines in the Arthur Ross Pinetum, but they are slightly outnumbered by over 250 deciduous trees, including some 70 elms (many of them Siberian elms) and over 40 London planes.*

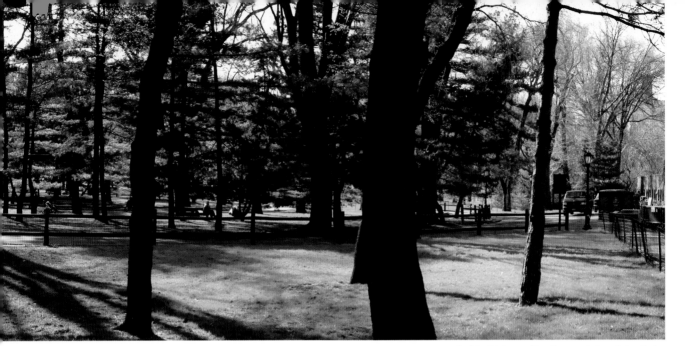

on the condition of the park, which had once contained some 50 conifer varieties, only a few remained. The situation had not improved very much when M. M. Graff commented on the conifers of the Winter Drive in her book *Tree Trails in Central Park*: "One by one, the firs, spruces, cedars, and many of the pines succumbed as air pollution reached an intolerable level. Aside from a few stalwarts that can endure city conditions—notably the Austrian, Himalayan, and Japanese black pines—most of the surviving conifers are deciduous: larch, golden larch, and bald cypress. The reason is this: deciduous trees shed their soiled leaves in fall and grow a fresh, clean crop each spring. Evergreens retain their leaves for more than one season and suffer a progressive build-up of soot."

▶ *Several large Himalayan pines in the pinetum cluster at the northwestern edge of the Great Lawn's oval path. Long, drooping needles distinguish the Himalayan pine from its American cousin, the Eastern white pine.*

After the Clean Air Act (1970) was passed, Manhattan's air quality began to improve. At just about that time, Arthur Ross, a New York philanthropist, donated funds to create a 4-acre pinetum, stretching from the West Drive to the East Drive at the Great Lawn's

▲ *The Eastern white pine population of the Arthur Ross Pinetum stands at approximately 120. Austrian pines number about 35; Himalayan pines, about 20.*

northern end. Now 17 pine species and over 200 individual pine trees are growing in the Arthur Ross Pinetum.

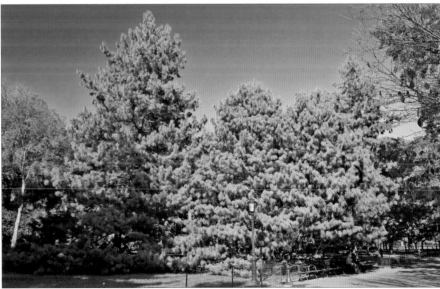

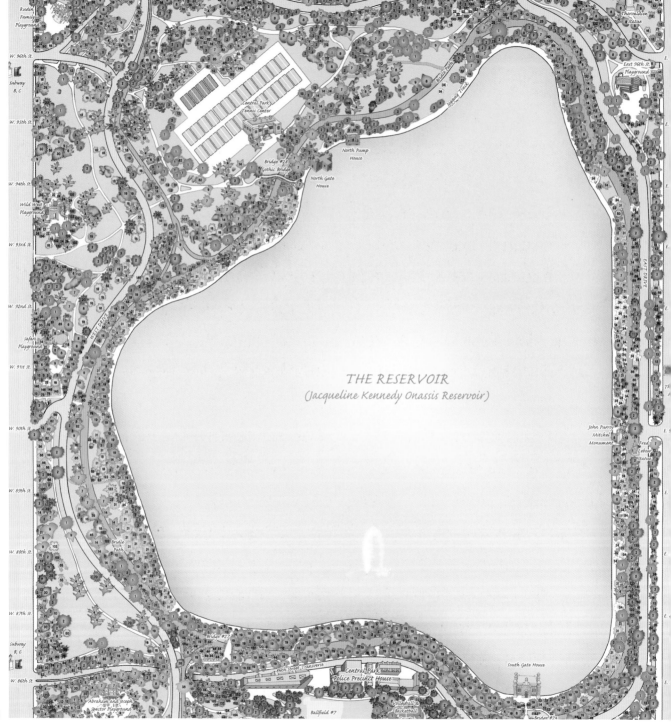

THE RESERVOIR
(Jacqueline Kennedy Onassis Reservoir)

When the Croton Receiving Reservoir was completed in 1842, New York City's daily water consumption was around 12 million gallons; by 1850, it had reached 40 million gallons. In 1852, the Croton Aqueduct Board purchased 106 acres immediately north of the Croton Receiving Reservoir in order to build a storage facility to be called Lake Manahatta, which could hold a 60-day water supply. Legal problems ensued, however, and excavation did not begin until 1859. Nearly 2000 laborers, mostly Irish, were involved in the project at times, but progress proceeded in fits and starts. Many workers, including the chief engineer, left for Civil War duty, and a financial downturn caused budget problems. When the project was finally finished in April 1862, the *New York Times* proclaimed it "the largest artificial lake in the world." Covering 96 acres at depths of nearly 40 feet, its two basins have a capacity of over 1 billion gallons.

In their Greensward Plan of 1858, Olmsted and Vaux proposed a "ride" around the new reservoir, a feature that has become Central Park's very popular jogging track: "The new reservoir, with its high banks, will take up a great deal of room in the park, and although it will offer a large sheet of water to the view, it will be at too high a level to become a landscape attraction from the ordinary drives and walks. It is suggested, therefore, that all round it a ride shall be constructed, and carefully prepared for this purpose only; and although this feature may be somewhat costly in the first instance, it is conceived that the result would be worth the outlay, for the sake of its advantages as a ride over a mile and a half in length, commanding the view of the reservoir, and uninterfered with by the regular drives, although in connection with them at different points."

The Reservoir, perhaps more than any other landscape in the park, looks now very much as it did 150 years ago.

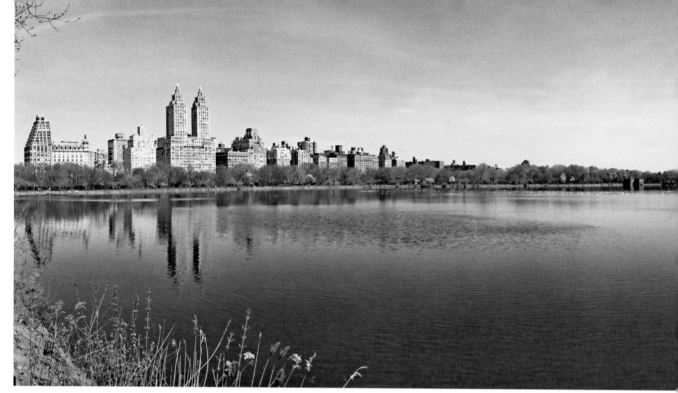

The Reservoir

The Reservoir, first dubbed Lake Manahatta and later Croton Lake, was an interruption in the series of Central Park's landscapes designed by Olmsted and Vaux. It was constructed on land purchased by the Croton Aqueduct Board in 1852, just before the city decided to appropriate land in the center of Manhattan for a park. The Reservoir might well have been another rectangular fortress, larger than but very much like the Croton Receiving Reservoir, had it not been for Egbert Ludovicus Viele, the park's first engineer-in-chief in charge of preparing the land for the new park. In 1856, Viele submitted "A Plan for the Improvement of the Central Park," which he hoped would be accepted by the park's commissioners. A map accompanying the plan included "Croton Lake," shaped almost exactly like the Reservoir as completed in 1862. Viele believed that the Reservoir should be curvilinear and natural looking. Fortunately, the Croton Aqueduct Board agreed. While Viele did not win the park design competition, his approach to the Reservoir was adopted with an addition suggested by Olmsted and Vaux—a circular "ride" entirely around it.

▶ *The 50-odd Yoshino cherries on the Reservoir's eastern side bear delicate pinkish to white flowers in mid-April. Their gnarled trunks suggest that these cherries may be quite old. Some could have been planted as early as 1912, but most date from the 1930s or later.*

The two reservoirs were never viewed with much favor by the park's designers or by their successor Samuel Parsons, Jr., a distinguished landscape designer in his own right, who wrote, "There is little of interest to be found…in the park along the reservoirs."

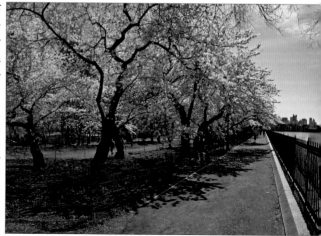

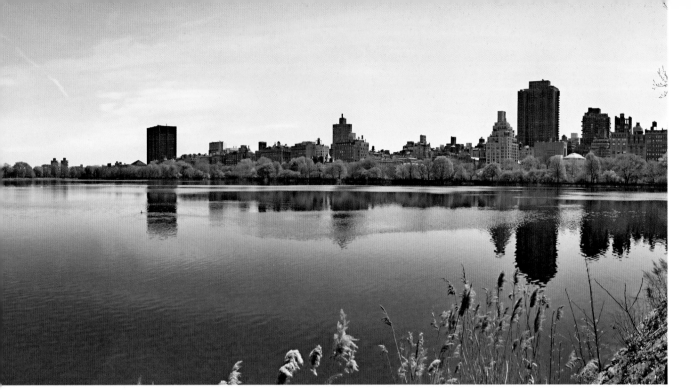

Many park visitors, though, have found quite a bit of interest. In his book *A Description of the New York Central Park*, Clarence Cook wrote, "The round of this Reservoir makes an admirable 'constitutional'; the walk is in good order in almost all weather, and a fine breeze is pretty sure to be stirring up here, no matter how calm it may be below. …From all points the view is fine, and it is a glorious place from which to see sunsets." And so it is today for those who walk or run along the Reservoir's jogging track.

The view along the Reservoir is even finer today than it was in Cook's time because of the many Yoshino and Kwanzan cherry trees planted on the eastern and western

sides over the past century. Other notable trees around the Reservoir include the great London plane at the northeastern edge by the bridle path and a stretch of more than 150 Turkey oaks along the bridle path below the southern side.

▲ *The 96-acre Reservoir is Manhattan's largest open space—large enough in fact that in this view, looking north from the southern side, even tall buildings on Central Park West and Fifth Avenue form only low jagged fringes above the trees edging the jogging track. And the track's view became even better in 2003 when a 10-foot-high chain-link fence was replaced with a 4-foot-high iron railing.*

▶ *Kwanzan cherries on the Reservoir's western side extend an extravagant pink canopy over joggers and strollers in early May. Kwanzan cherries' double-petalled, carnation-like blossoms appear two weeks after Yoshinos flower.*

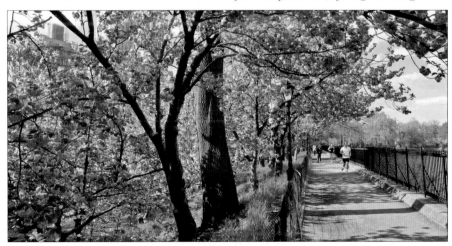

61

HILL

W. 105th St.

W. 104th St.

Subway
B, C

W. 103rd St.

The Ravine

Wildflower
Meadow

The Loch

102nd Street Cutoff

Grassy Knoll

W. 102nd St.

Glen Span
Arch

THE POOL

WEST DRIVE

W. 101st St.

NORTH MEADOW

W. 100th St.

Tarr Family
Playground

NORTH MEADOW

North
Meadow
Recreation
Center

W. 97th St.

Rudin Family
Playground

Green
Bench

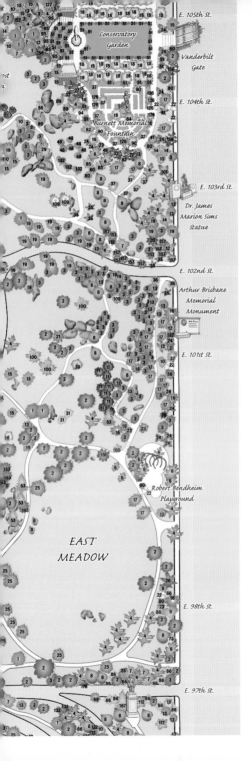

E. 105th St.

Conservatory
Garden

Vanderbilt
Gate

E. 104th St.

Burnett Memorial
Fountain

E. 103rd St.

Dr. James
Marion Sims
Statue

E. 102nd St.

Arthur Brisbane
Memorial
Monument

E. 101st St.

Robert Bendheim
Playground

EAST
MEADOW

E. 98th St.

E. 97th St.

When Samuel Parsons, Jr., contemplated the view across the North Meadow in the late 1890s, he saw "one of the best examples we have of good park-work." That was before the meadow's rolling contours were smoothed, its baseball diamonds constructed, and its turf nearly destroyed from neglect in the 1960s and 1970s. Now the meadow's grass is still smooth, but it is also lush and green. The meadow's baseball diamonds still interrupt the turf, but they are scrupulously maintained. The Central Park Conservancy has managed to preserve much of the pastoral character of the meadow that Parsons so appreciated and yet provide a place for intensive recreation. The key to the good condition of the North Meadow, the East Meadow, and Wildflower Meadow—and to the condition of the entire park—is the constant efforts of zone gardeners, tree- and turf-care crews, and dedicated volunteers. Sophisticated infrastructure, such as elaborate drainage and automatic irrigation systems, is necessary, but nothing remains intact for long in a park that welcomes over 40 million annual visitors without the daily efforts of people who love it.

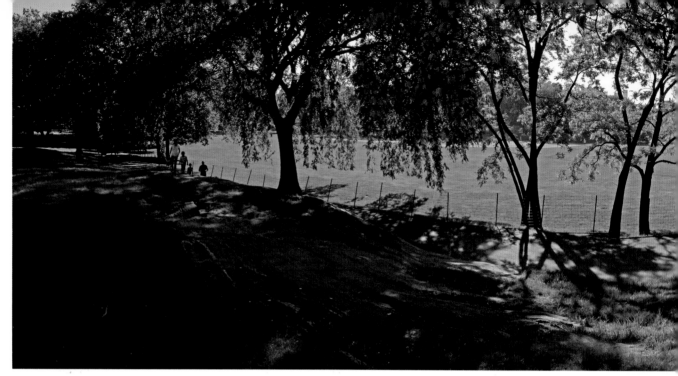

North Meadow

Olmsted and Vaux referred only briefly in their Greensward Plan of 1858 to the North Meadow, the largest of the park's meadows: "The central portion of the upper section of the park is left as open as possible, and can be levelled so far as may be required for the purposes of the playgrounds indicated on the plan." Forty-two years later, Samuel Parsons, Jr., a fine landscape architect who oversaw the park's plantings from 1885 to 1911, lavished praise on the North Meadow in his book *Landscape Gardening*: "It is a wonderful effect. Only nineteen acres, and apparently extending for miles. ...The sheen of the grass, the varied tints of the foliage sweeping the turf...the low-lying hillocks crowned with forest trees, the great boulders entirely exposed or only half submerged, the meadow beyond running back seemingly to unknown distances—who will picture it truly? There is dignity, there is breadth, repose, restfulness, and yet a sense of isolation that is not absolute. It is genuine park scenery that the eye is tempted to linger on and the foot to walk on, and presents, i viewed as a single feature, one of the bes examples we have of good park-work."

After Parsons's tenure, the North Meadow experienced ups and downs. Its rolling ex panses of turf were smoothed to make wa for ball fields. Some boulders were removed and the indistinct, random edging of tree suggesting a limitless expanse beyond wa gradually altered. Untended older trees and self-seeded new arrivals crowded against one another, creating walls of trunks and foliage

A 1921 aerial photograph shows that base

▶ *A margin of well-spaced shade trees on the North Meadow's western side includes an American elm with branches sweeping the turf, London planes, tuliptrees, and pin oaks. The North Meadow is perhaps the best place in the park to appreciate specimen trees uncompromised by crowding.*

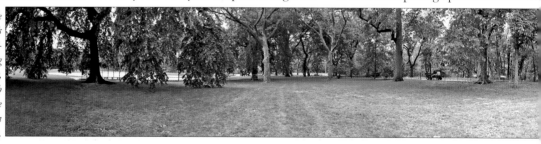

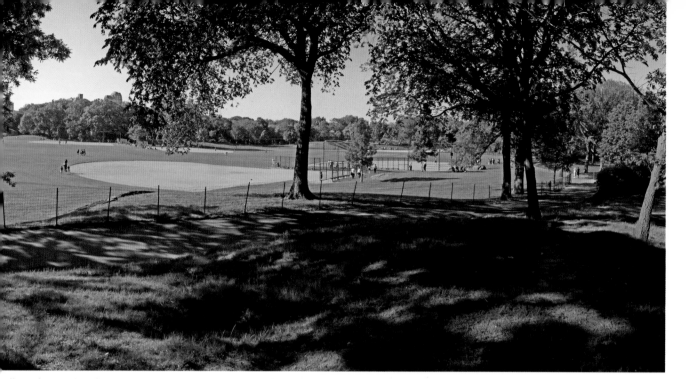

...all was being played on the North Meadow. Turf was worn away around bases, pitchers' mounds, and home plates, but no formally outlined diamonds were evident. Another aerial photograph taken in 1940 clearly shows eight softball diamonds and three baseball diamonds, constructed by order of Robert Moses, who had become parks commissioner in 1934.

After Moses, between 1960 and 1980, the North Meadow became increasingly chopped up by fences, chain-link backstops, cement bleachers, asphalt paths, and ex-panses of compacted, bare ground. When the Central Park Conservancy took over the park in 1980, it began the massive job of restoring the park, beginning with the southern sections. By the 1990s, after a major capital campaign, the North Meadow was restored to its present pristine condition, with broad expanses of well-tended, automatically irrigated turf surrounding seven baseball and five softball diamonds.

Around 800 trees ring the meadow, probably fewer than were present 30 years ago because a wall of mostly smaller, self-seeded

▲ *The most common trees growing on the North Meadow's rocky eastern edge next to the bridal path and the East Drive are pin oaks, Turkey oaks, and elms.*

black cherries and other untended trees edging the North Meadow was replaced by an irregular margin composed mainly of larger specimen trees. A group of 16 sugar maples just east of the North Meadow Recreation Center put on a brilliant display in fall.

▼ *A London plane on the left, lindens beyond, a crab apple, and several pin oaks and elms on the right frame a mid-April view of the North Meadow from the knoll on which the North Meadow Recreation Center stands.*

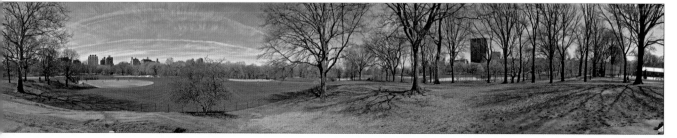

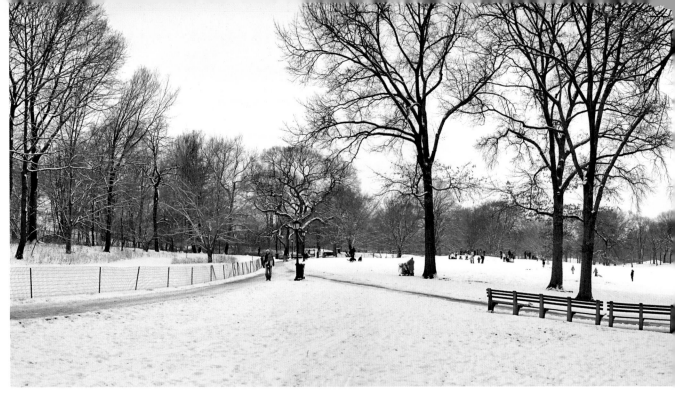

East Meadow

Olmsted and Vaux outlined their very specific vision for the area now called the East Meadow in the Greensward Plan: "The north-east section of the upper park is shown as an arboretum of American trees, so that every one who wishes to do so may become acquainted with the trees and shrubs that will flourish in the open air in the northern and middle sections of our country." They noted that the arboretum would have a pastoral, not a formal, arrangement of trees "so planned that it may present all the most beautiful features of lawn and wood-land landscape, and at the same time preserve the natural order of families, so far as may be practicable."

For better or for worse, the northeastern section of the park between 97th and 102nd Streets never became an arboretum. Elizabeth Barlow Rogers wrote in *Rebuilding Central Park*: "It became a meadow instead and was planted with beeches, oaks, and honey locusts, some of which have grown to magnificent proportions." She also observed that the area had changed little over the years except for "the expansion of its tree population."

Comparing the total tree count in a 1934 survey with the count in the mid-1980s, Rogers noted a jump from 278 trees over 6 inches in diameter to 392 trees. During the same period, the species composition changed as well. Black cherries increased from just 3 percent to 26 percent of the

total, while the percentages of oaks and beeches decreased. Some 30 years later, in the second decade of the 21st century, the total tree count in the East Meadow has changed once more and for the better. Now it is down to about 275 trees, and the black

▶ *One of the finest horsechestnuts in the park stands by the East Drive just north of the 97th Street transverse. It looks particularly handsome in mid-May when it is bedecked with hundreds of pyramidal white flower panicles.*

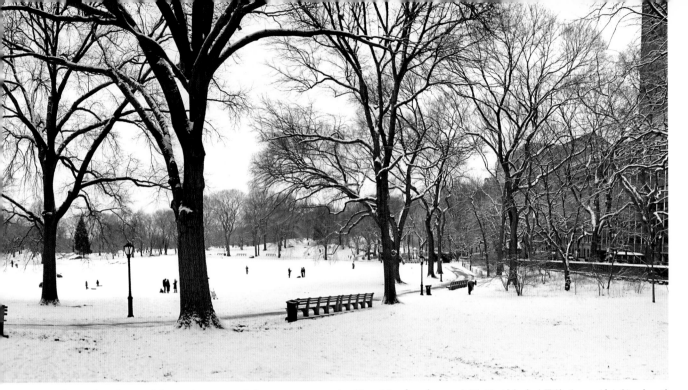

cherry population has dropped from about 101 to around 75 but still stands at over 27 percent of the total number of trees. As in the North Meadow, there are fewer straggly self-seeded invasives and more desirable trees, including 40 elms, 17 pin oaks, 14 lindens, 14 honeylocusts, 12 beeches, 11 Turkey oaks, 11 red oaks, four London planes, and three sugar maples.

Among the most impressive East Meadow trees are the horsechestnut in the southeastern corner, the American elm next to the 97th Street transverse, the fine lindens and European beeches along the path paralleling the East Drive, and a multi-trunked Kentucky coffeetree midway up the hill at the northern

end. In recent years, the East Meadow has undergone a complete restoration, including irrigation and drainage work. Unlike the North Meadow, with its perfectly flat turf expanses, the East Meadow has retained its pleasing, rolling-landscape character.

▲ *The East Meadow's Fifth Avenue side is fringed mostly with pin oaks and elms. The meadow itself is a bowl, with its southern side sloping down from the 97th Street transverse and its northern side sloping up to the 102nd Street entrance road—a topography that sledders use to their advantage after snowfalls. The single dark conifer in the distance is a Douglas-fir, a West Coast native.*

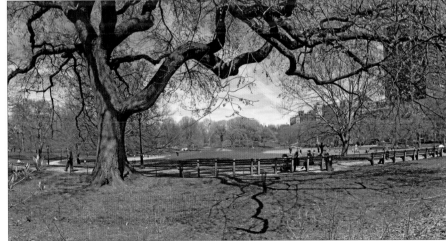

▶ *Perhaps 150 years old, this American elm towering over the path at the East Meadow's southern end is an official Great Tree of New York City. Arborists have fenced off the ground beneath it to help reduce soil compaction.*

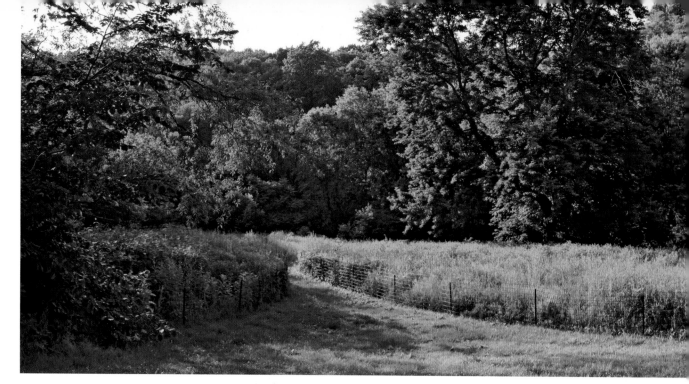

Wildflower Meadow

Wildflower Meadow is at the southern border of the North Woods at the edge of the 102nd Street cutoff near the East Drive. Closely cropped turf surrounds a small fenced, semicircular meadow that is mowed once a year in March. It is planted with native wildflowers donated by the Garden Club of America in the spring of 1994. It appears to be a lovely bit of wild meadow, a plot of turf that has gone to seed, a place that ecologists would call an oldfield. However, like most landscapes in Central Park that seem "natural," Wildflower Meadow is carefully main-

tained in a kind of ecological stasis. Left alone, most land in the Northeast will revert to forest as woody plants slowly crowd out grasses and herbaceous plants.

A woodland volunteer crew works in Wildflower Meadow on a weekly basis, pulling up noxious weeds, such as mugwort, and woody plants—often exotic invasive species, such as Norway maple. Native wildflowers are sometimes weeded out as well, so that one species, such as goldenrod,

does not outcompete other native species, such as cup plant and milkweed. Plants are moved around, too. Bee balm or dogbane, for example, might be transplanted to bare spaces where undesirable species have been removed. So while Wildflower Meadow appears natural and is a fine place to see native wildflowers that commonly grow in oldfields, it is hardly a wild meadow.

The edge of the North Woods provides a changing backdrop for Wildflower Meadow.

▶ *Wildflower Meadow offers a parade of blossoms from spring to fall. Milkweed blooms in June (left); Joe-Pye weed's dusty-purple flower clusters stand 3 feet tall in August (center); goldenrod dominates by October (right).*

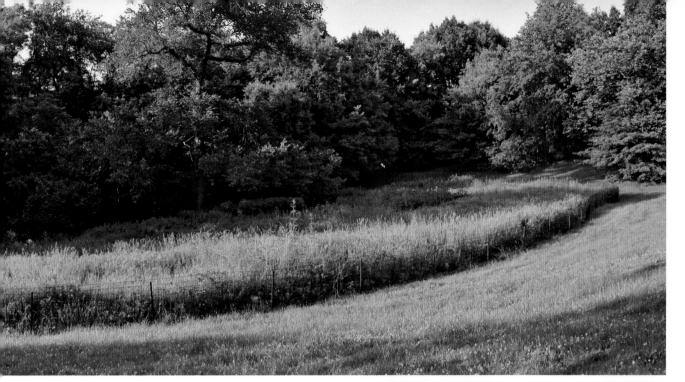

Dense foliage in summer hides the wooded hillside above the Loch, but in other seasons the hill is visible behind trunks and branches of trees bordering the meadow. These trees include black cherries, of course, but also an old red maple, black locusts, pin oaks, red oaks, a wych elm, and an American beech. Three species of sumac—staghorn, smooth, and shining sumac—cluster at the northwestern corner of Wildflower Meadow beside a path leading north to the Loch.

A few feet west of Wildflower Meadow, almost hidden in the forest-edge underbrush lining the 102nd Street cutoff, is a very curious, strangely twisted American hornbeam with spidery branches.

▶ *On a wintery day in January, the view across Wildflower Meadow to the wooded hillside above the Loch looks more like upstate New York or New England than Manhattan. We can imagine that Olmsted would appreciate this view and approve of the meadow.*

▲ *By June, the meadow's wild grasses are already waist high. Song sparrows, blue grosbeaks, American goldfinches, indigo buntings, purple finches, and other granivorous birds will feed on seeds produced by these grasses in fall.*

▶ *By early November, the American hornbeam growing next to the 102nd Street cutoff just west of Wildflower Meadow has lost its leaves, and its contorted limbs are easy to see.*

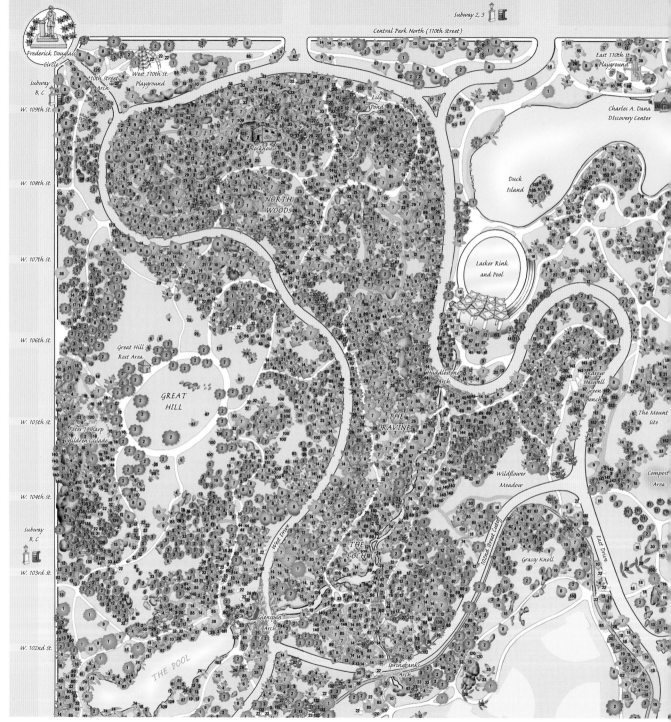

Frederick Douglass
Circle

Subway
B, C

W. 109th St.

110th Street
Arch

West 110th St.
Playground

W. 108th St.

W. 107th St.

W. 106th St.

Great Hill
Rest Area

W. 105th St.

GREAT
HILL

Peter J. Sharp
Children's Glade

W. 104th St.

Subway
B, C

W. 103rd St.

W. 102nd St.

THE POOL

Glenspan
Arch

Springbanks
Arch

THE
LOCH

West Drive

102nd Street Cutoff

Central Park North (110th Street)

Subway 2, 3

East 110th St.
Playground

Lily
Pond

Charles A. Dana
Discovery Center

Blockhouse

NORTH
WOODS

Duck
Island

Lasker Rink
and Pool

Huddlestone
Arch

THE
RAVINE

Wildflower
Meadow

Andrew
Haswell
Green
Bench

The Mount
Site

Compost
Area

Grassy Knoll

East Drive

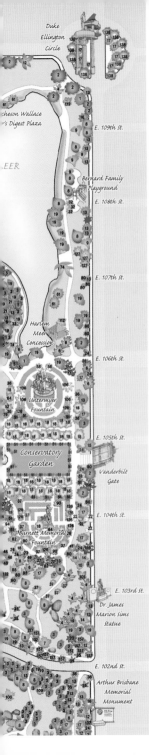

The northern end of the park is far less frequented by tourists than are other sections, but it contains several of the park's most beautiful landscapes. Nearby residents treasure these special places and the opportunities they offer for quiet contemplation and recreation. On pleasant sunny afternoons, the Great Hill's lawn is dotted with strollers and sunning New Yorkers. A storm in August 2009 downed many stately trees but many remain, and the openings created by felled trees have restored vistas that visitors in horse-drawn carriages once enjoyed. To the south of the Great Hill is the Pool, a lovely pond surrounded by tree-shaded parkland and winding paths. The Pool was created when the park was constructed and a stream known as Montayne's Rivulet was dammed. Water from the Reservoir arrives through a pipe hidden by boulders along the south shore. It supplies the Pool and spills over a dam at the Pools's eastern end. There it forms a winding stream known as the Loch, which flows under Glen Span Arch and tumbles down a ravine through the 37-acre North Woods. On its way, it cascades over waterfalls created with large boulders, rushes through Huddlestone Arch, passes under Lasker Rink, and finally empties into the Harlem Meer. A tranquil 11-acre lake, the meer lies at the foot of a hill where fortifications built during the War of 1812 were located. Just south of the meer is the 6-acre Conservatory Garden.

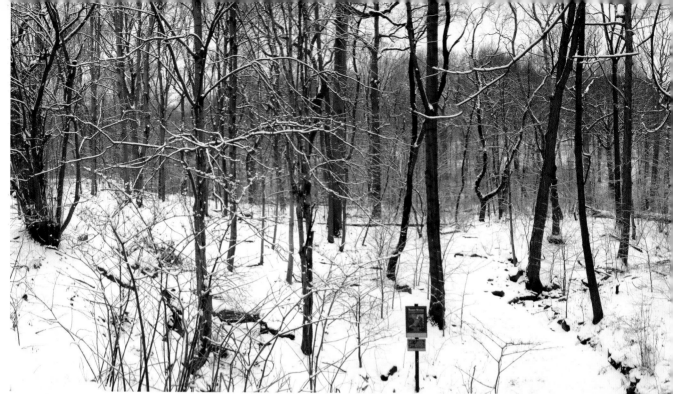

North Woods

In *A Description of the New York Central Park,* Clarence Cook wrote about the old Blockhouse located at the upper edge of the North Woods and what it offered visitors: "On a rocky summit near the northern boundary still stands a stone Block-House....It had become a receptacle for rubbish, but the Commissioners caused it to be cleared out, and a simple stairs put up on the inside in order to enable the visitor to mount to a platform at the top from whence a beautiful view is obtained, east, west, and north and south."

The Blockhouse is not presently open to visitors, but even if it were, the panoramic view would be gone. After the park was established, firewood could no longer be harvested. Trees grew up around the Blockhouse. Partially forested before Hessian and British soldiers cut down nearly every tree during the Revolution, this rocky hilltop has become a forest once more. However, it is not the fire-sculptured forest the Lenape created here before Europeans arrived. The there would have been large chestnut tree as well as black, white, and scarlet oaks o the hilltop. On the midslopes, there woul have been more oaks and chestnuts as we as white ashes, hickories, sassafrases, tulip trees, hornbeams, and black tupelos. In we ter places near streams, there probably woul have been hemlocks and beeches.

▶ *A pair of photographs taken from 110th Street in the late 1850s or early 1860s show the park's northern end, now the rugged upper edge of the North Woods. The Blockhouse stands on a hilltop fringed with a few conifers.*

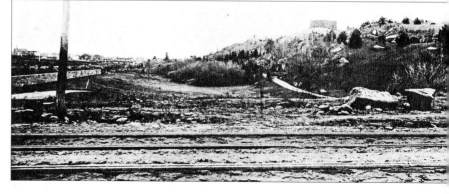

The 37-acre North Woods now has no chestnuts. They vanished from the eastern United States in the early years of the 20th century, eradicated by an Asian fungal disease. As of 2013, oaks were a large component of the forest population, which included some 172 red oaks, 111 pin oaks, and 22 white oaks. Among other native trees were 184 ashes, 64 elms, 53 hickories, 42 sassafrases, 40 sweet-gums, 30 tuliptrees, 27 red maples, and 23 hackberries. However, the most numerous species present now were not mentioned in an 1857 survey: 498 black cherries, 133 Norway maples, 91 sycamore maples, 29 ailanthuses, and 17 white mulberries. The North Woods is a unique mixture of native and exotic trees, a reflection of New York City's varied human population.

▲ *On a snowy January afternoon at the edge of the 102nd Street cutoff, one can look north over the Ravine and glimpse, behind trunks in the foreground, the hilltop where the Blockhouse stands hidden by trees. It is a second-growth forest with many trees about the same age and size.*

▼ *This engraving of a drawing by the Hudson River painter A. F. Bellows pictures the Blockhouse on the North Woods' hilltop as it appeared in the late 1860s. The oldest structure in the park, it was built in 1812 on the foundations of a Revolutionary War fortification.*

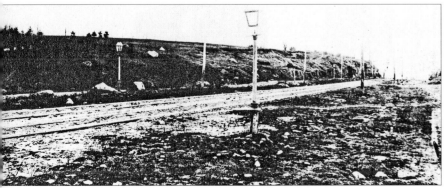

Great Hill

In a report written in 1856, J. B. Bacon, the engineer in charge of surveying the park's northern section, noted, "The northwesterly corner…consists of a succession of slopes and table lands, rising one above the other, until they finally terminate in a plane, one hundred and thirty feet above tide; distant two hundred and fifty feet from the Eighth avenue, and one hundred feet south of One hundred and sixth street. As this plane is entirely devoid of trees, it affords a magnificent view of the surrounding country."

A dozen years later, after the construction and initial planting of the park was largely completed, Clarence Cook described the area as still lacking trees: "In time this pretty picturesque spot will be second in its attractions only to the Ramble; at present. the vines and shrubs have not made a sufficient

growth, and the place is too far off for those who live south of the Park, but the views from it are finer now than they will be in ten years, for by that time we may look for the rising flood of the city to have swallowed up whatever there is left of grass and trees and garden ground between this and Harlem, and there will be nothing left for us to see from this height but the bricks and mortar of the city." Cook's words were prophetic, for in 1903 Louis Harman Peet would write: "This Section embraces the larger portion of the most beautifully wooded portion of the Park." Trees were clearly taking over, but they were not entirely blocking the view.

▶ *After the storm in August 2009, a log pile beside the Great Hill's oval path included several logs from downed trees over 100 years old and one log with more than 130 annual rings.*

Commenting on the Great Hill, which wa then known as the Concourse because of it oval carriage drive, Peet noted: "[T]he high ground gives open and broad vistas at ever step. The view here, out over the north western corner of the Park, is impressive with the broad sweeps of lawn, the rolling masses of trees and the roofs of the cit fading away in the farther distance."

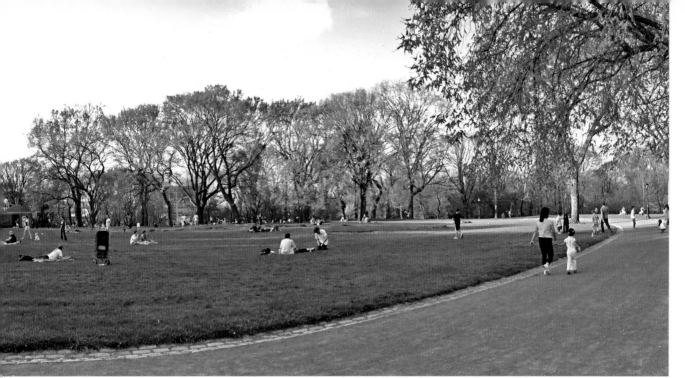

The Great Hill has gone through a succession of changes over the past 225 years. Once known as Mount Prospect because of its commanding views, the hill was occupied by British and Hessian military encampments during the Revolutionary War. Originally, Olmsted and Vaux had planned to put a tower atop the 135-foot Great Hill, but they later made it a destination for carriage riders and built an oval turnaround. In the 1940s, Robert Moses converted the Great Hill's open meadow into a recreation area with tennis and volleyball courts and horseshoe pits, but by the 1980s these facilities were run-down. In 1993, the conservancy razed and replaced them with a central lawn again surrounded by an oval track.

Over the years, shade trees planted by Olmsted, Samuel Parsons, Jr., Moses, and others have grown up on the Great Hill's flanks. By the late 20th century, these trees completely blocked the views that early park visitors in horse-drawn carriages had enjoyed. Then on August 18, 2009, a fierce thunderstorm with wind bursts probably well exceeding 80 miles per hour felled over 160 trees on the Great Hill and in the adjacent North Woods. Left open by the conservancy, blowdown meadows on the Great Hill's southern and eastern sides have restored some views. Despite the storm's toll, the Great Hill's sylvan population as of 2013 remained substantial, at a total of 1058 trees, including 301 black cherries, 119 elms, 91 oaks, 49 black locusts, 49 sycamore maples, 34 hickories, 30 Norway maples, 19 ashes, 13 Eastern white pines, and seven tuliptrees.

▶ *Ken Chaya marked in red on his map the trees damaged by hurricane-strength winds that slammed into the Great Hill on the evening of August 18, 2009. More than 160 trees were uprooted, splintered, or otherwise maimed.*

▲ *Near sunset on a tranquil afternoon in late April 2009, American elms fringing the Great Hill's oval catch the golden light. Some of these trees were downed later in the year by the raging winds of an evening thunderstorm.*

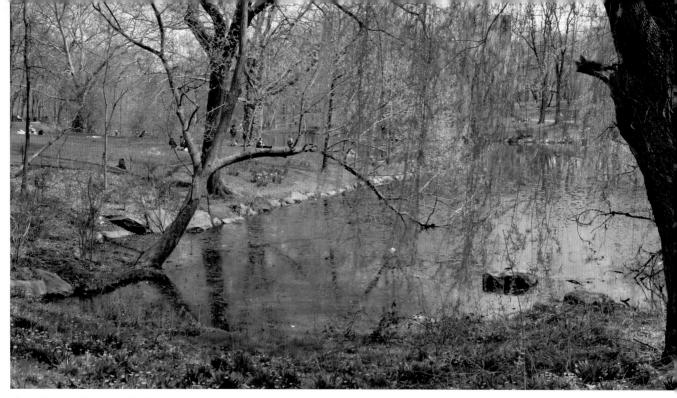

Pool and Loch

Dr. Johannes Mousnier Montagne (1595–1670), a Huguenot educated in Holland, arrived in New Amsterdam in 1637. Quickly establishing himself as a physician and chandler, he obtained a grant to a 200-acre parcel located just north of land that was to become Central Park. This area, known as the Harlem Flats, was a particularly appealing location for a farm. It was flat, fertile, and treeless because it had been frequently burned by Native Americans. An account in Carl Horton Pierce's *New Harlem Past and Present* describes how Montagne "furnished himself with a dugout, and demonstrated

▶ *A portion of Egbert Viele's Sanitary Topographical Map of 1865 shows north Central Park (yellow outline) with waterways as they were before the park was established.*
76 *Montayne's Creek was later known as Harlem Creek.*

his daring temper by forthwith paddling up the East River far beyond the limits of the colony, past Blackwell's Island [Roosevelt Island], and landed with his family and farm hands at the turn in the shore…ascended a

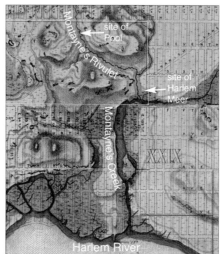

creek which then formed a tributary of the Harlem [River], subsequently known as Montagne's Creek."

We can imagine that Montagne and his farmhands may have cut down trees for lumber and firewood, growing in the forest along the stream later to be known as Montayne's Rivulet, one of the four streams originally crossing Central Park. All four began on Manhattan's west side and ran east across the park. Only Montayne's Rivulet remains. It now begins at the Pool, where a dam has created a pond. Water flowing over the dam runs downhill along an ancient streambed, now called the Loch, to the Harlem Meer. The stream used to be fed by a nearby spring and a watershed to the west of the park. Now its water comes from a concealed pipe near the Pool connected to New York City's water system.

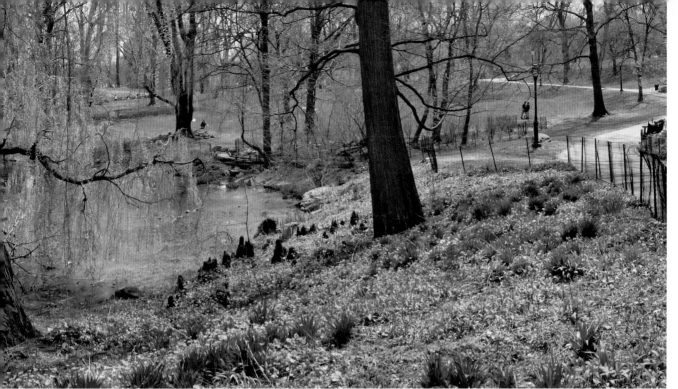

Long before Native Americans arrived in Manhattan, glacial meltwater rushed down Montayne's Rivulet through a barren, boulder-strewn landscape. Eventually, vegetation took hold—lichens, reindeer moss, and stunted birches. In time, conifers arrived—larches, furs, and spruces—followed by deciduous trees, such as American chestnuts, oaks, hickories, and tuliptrees. People came with the trees, too: first Native Americans, who periodically burned away forest underbrush and maintained grassy clearings by setting frequent fires; then Europeans, who vigorously attacked the forest with metal axes and saws, stripping away nearly every standing trunk so that by 1856 the land-scape was "entirely devoid of trees."

Now pleasant parkland surrounds the Pool, and as of 2013, some 250 trees shaded the turf, including 25 London planes, 15 pin oaks, 10 tuliptrees, nine red maples, eight bald cypresses, and six willows. The Loch's waters flow through a forest again, though not the fire-sculptured forest of old-growth hemlocks, chestnuts,

▲ At the western end of the Pool in spring, a weeping willow's branches are strung with catkins, and lesser celandine blooms around the stubby "knees" of an old bald cypress that is just beginning to sprout new needles.

and tuliptrees that Montagne saw when he paddled up a brackish creek over 350 years ago. It is just a second-growth, regenerating forest, but it reminds us, nevertheless, of a Manhattan long gone.

▶ The Loch, once known as Montayne's Rivulet, flows from the Pool under Glen Span Arch, then down the Ravine over several waterfalls, through Huddlestone Arch, and under Lasker Rink to the Harlem Meer.

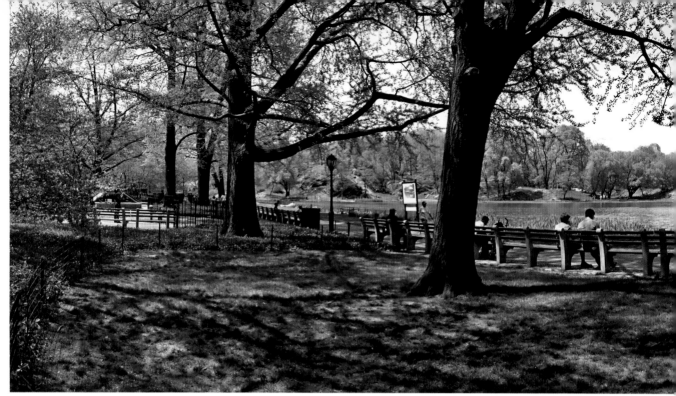

Harlem Meer

J. B. Bacon, who surveyed the park's northern section in 1856, reported that the northwestern corner was "entirely devoid of trees," but he found the northeastern corner less forbidding: "There are but few trees of any size on this division.…A great portion of the surface, however, is thickly covered with undergrowth, where…many valuable shrubs and young trees are struggling for life."

Bacon's report did not cover the portion of the park between 106th and 110th Streets, which was added in 1863. This addition included the North Woods' northern half (then thinly covered with shrubs), sites of Revolutionary War and War of 1812 fortifications, and a low, wet area where Montayne's Rivulet met Harlem Creek.

No other section of the park has as many

historical associations. Prior to European settlement, a Native American trail running from Manhattan's southern tip to Spuyten Duyvil Creek (known as the Kingsbridge Road in colonial times) entered the park at 92nd Street and went north along the route of the present East Drive. At the top of the hill now overlooking the Harlem Meer, the path veered slightly right rather than left, as

the drive does; descended the hill; and crossed Montayne's Rivulet slightly west of where the stream emptied into Harlem Creek.

Around 1750, a tavern was built on the hill top. First owned by Jacob Dyckman, Jr., it was bought 10 years later by Catharine Mc Gown, a sea captain's widow. From then on this site and the road, which passed through a narrow break in a rocky outcropping on its

▶ *Several young cypresses stand along the Harlem Meer's northeastern shore at the Lila Acheson Wallace Reader's Digest Plaza near the Charles A. Dana Discovery Center (on the right almost hidden by trees). Harlem Creek was once located at this spot on the Meer's shore.*

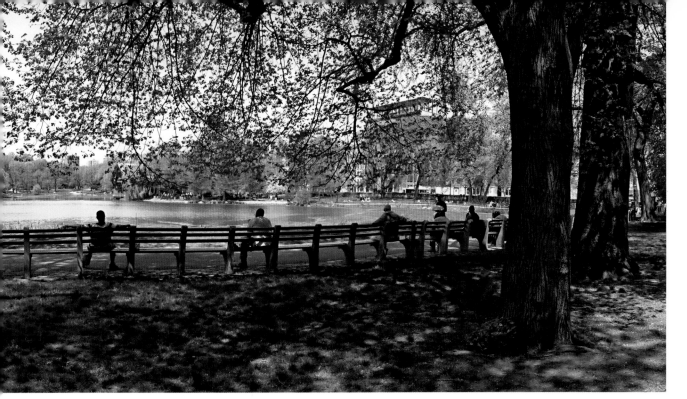

...way down to the stream, were known as Mc-Gown's Pass (now spelled McGowan's Pass). In *McGown's Pass and Vicinity,* Edward Hagaman Hall wrote: "It cannot fail to add to the interest of the visitor to the Park to recall that the Royal Governor, Council, and Colonial Assembly once met at McGown's Pass; that it was fortified and occupied during the Revolution; that Washington himself was here; that it was fortified in the War of 1812–15; that for many years it was the seat of a celebrated charitable and educational institution—the Academy and Convent of Mt. St. Vincent; that wounded soldiers were nursed there during the Civil War."

The marshy ground where Montayne's Rivulet met Harlem Creek was excavated and dammed in 1864 and 1865 to create the 14-acre Harlem Meer, later reduced to 11 acres when Lasker Rink and Pool was built in the mid-1960s. The pleasant parkland overlooking and surrounding the Harlem Meer is shaded by nearly 500 trees, including, as of 2013, some 82 black cherries, 43 black locusts, 36 elms, 27 lindens, 19 Turkey oaks, 17 ashes, 12 bald cypresses, and 12 ginkgos.

▲ *Large ginkgos and a linden shade benches along the Harlem Meer's eastern side on a sunny May morning. Across the Meer to the left is the base of a hill on which fortifications were built during the War of 1812.*

Like the Great Hill, the Harlem Meer is much loved by nearby residents, who enjoy sauntering along its paths, relaxing on its many benches, and fishing in its waters on a catch-and-release basis.

► *For years, black locusts have clustered at the Harlem Meer's northwestern corner, providing dappled shade in summer. Storms, however, have diminished their number.*

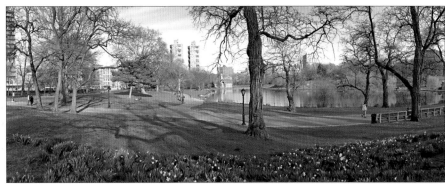

Conservatory Garden

Two places in Central Park have "Conservatory" in their names: the Conservatory Water and the Conservatory Garden. Neither has a conservatory. A conservatory was planned for and actually started on the site of the Conservatory Water but was never completed. A 250-foot-long complex of interconnected conservatories, however, did stand on the site of the 6-acre Conservatory Garden. It was opened to the public in 1899 on ground once occupied by plant nurseries and refuse dumps. The impressive, heated,

glass-and-iron structures housed flower shows and displays of tropical plants that were immediately very popular. A chrysanthemum show in November 1900 drew 330,000 people, and over the course of the year more than 1.4 million visitors walked through the buildings. As time passed, though, budget constraints and resulting maintenance problems took a toll. In 1934, the buildings, by then abandoned hulks with hundreds of broken glass panes, were torn

down by the newly appointed parks commissioner, Robert Moses.

On September 18, 1937, a formal garden designed by Gilmore D. Clarke and his wife M. Betty Sprout, opened on the conservatories' site. It consisted of a central Italianate turf rectangle edged by yew hedges, dominated on its western end by a fountain spraying a plume of water 12 feet high in front of three semicircular, yew-lined terraces topped by an iron wisteria pergola.

▶ The peak of the glass-and-iron roof of the central building of the park's conservatory complex was 48 feet above the ground, making this 60- by 100-foot structure tall enough to accommodate tree ferns and tropical palms.

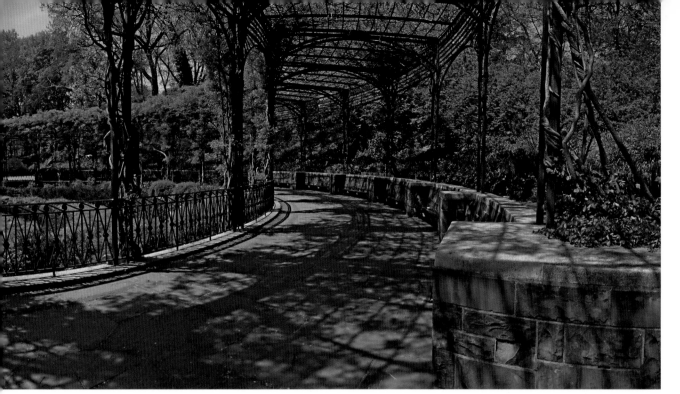

North and south of the central lawn, here were two splendid crab apple allées planted with large trees brought down the Hudson on barges from an upstate nursery. Beyond the allées, two flower gardens were planted in contrasting styles. The northern "French" garden, organized in concentric circles around a central fountain with rose arbor gates, featured massed seasonal displays: thousands of multicolored tulips in spring and Korean chrysanthemums in fall. The southern "English" garden, with its parallel and straight and concentric paths, was planted with perennials shaded here and there by such shrubs and trees as saucer magnolias, lilacs, and cornelian cherries.

The Conservatory Garden's crab apple allées contain 37 trees assiduously trained over the years to achieve remarkable gnarled habits. Snowy days in December and January offer ideal conditions for viewing their twisting limbs.

Like the conservatories, which it replaced, the Conservatory Garden has experienced ups and downs. In the 1970s, it reached a nadir of neglect. When Elizabeth Barlow Rogers took over management of the park's restoration in 1979, she appointed garden designer Lyndon Miller to restore a derelict garden. Miller emphasized plants that offer

▲ *The view from the Conservatory Garden's wisteria pergola in late April 2000 was breathtaking, as the crab apple allées were in full bloom. Borders of the lawn between the allées had just been replanted with hybrid English yews.*

beauty in every season, not just in spring and summer. Now under the direction of curator Diane Schaub, the Conservatory Garden is a joy to visit throughout the year.

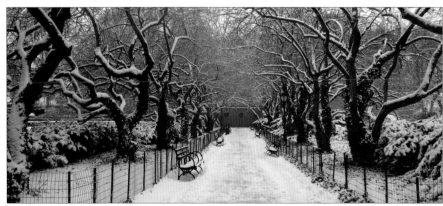

THE TREE GUIDE

The great tupelo in Tupelo Meadow

Using the Tree Guide

SCALES

SINGLE FLAT NEEDLES

SINGLE NEEDLES IN TUFTS

NEEDLES IN TUFTS

SINGLE, STIFF,
FOUR-SIDED NEEDLES

The tree genera and species described in the entries on the following pages are divided into two categories: conifers and broadleaf trees. Within these two categories, genera and species are broken down into 15 groups based on the shape and arrangement of their scales, needles, or leaves. Within each of the 15 groups, species are usually listed in alphabetical order by scientific name. A tree's group is indicated on the left side of the green tab at the top of every left-hand page. The 15 groups appear in numerical order with one exception. All oak species covered, except for the willow oak, are in group 13—trees with leaves alternately arranged, simple, and lobed. The willow oak has been grouped with the other oaks, although it is technically in group 15—trees with leaves that are alternate and smooth.

To narrow down the identity of a tree with the Tree Group Key, turn to the inside front cover. Compare the scales, needles, or leaves of a tree you want to identify with the illustrations in the Tree Group Key.

If the tree has scales or needles, it is a conifer (a tree bearing uncovered or naked seeds in cones) and belongs to one of the first five groups. If the tree has scales, it belongs to group 1. If it has needles, it belongs to group 2, 3, 4, or 5. Look at the needles on your tree. Are they flat and soft or stiff and four-sided? Are they arranged

singly on twigs, in tufts of 12 or more, or bundles of two, three, or five? The answe to these questions place a conifer in i proper group.

If a tree has leaves, it is a broadleaf tre If its leaves are fan-shaped, the tree belong to group 6 and is a ginkgo. (Group 6 co sists of only one species.) If the leaves a not fan-shaped, the tree belongs to grou 7, 8, 9, 10, 11, 12, 13, 14, or 15. Look at th form of the leaves. Are they simple, co sisting of just one undivided leaf blade? so, the tree belongs to group 6, 7, 8, 9, 1 14, or 15. Or are the leaves pinnately con pound or palmately compound, consistir of two or more leaflets attached to a cent leaf stalk? If so, the tree belongs to grou 10, 11, or 12.

How are the leaves on your tree arrange on their twigs? Do the leaf stems occur opposite pairs on their twigs or branche If so, the tree belongs to group 7, 8, 9, 1 or 11. Or are the leaves alternately arrange with only one leaf at any one position on twig or branch? If so, the tree belongs t group 12, 13, 14, or 15.

Once you have determined whether you tree's leaves are simple or compound an whether they are in opposite pairs or alte nately arranged, you may be able to narro the tree to one group. More often, howeve you must also look at the shape of the lea

FAN-SHAPED

SIMPLE

nd its edges. Is it lobed, with large projec-
ons and notches in between? Or is it un-
obed and toothed, with small sharp or
ounded projections? Or does it have
mooth edges, with no lobes or teeth? The
nswers to these questions place your
roadleaf tree in its proper group.

Scales, needles, and leaves are generally
he best indicators of a tree's species, but
he leaf shapes of some species can vary a
reat deal even on one tree. So in addition
o examining a tree's leaves, you should con-
ider its bark, flowers, and fruit if they are
vailable and compare them with the pho-
ographs in the Tree Guide entries.

Another problem with using leaves to
lentify trees is that some conifers and most
roadleaf trees described in this book are
leciduous, which means that they shed their
needles or leaves in the fall. Of course, you
vill have trouble identifying a deciduous
ree by its needles or leaves in the winter un-
ess you can find a few still on the tree or
on the ground beneath the tree. Buds are
perhaps the best clues to a deciduous tree's
dentification in winter, but there is not
pace enough in this book to cover them
horoughly.

Every genus and species page in the Tree
Guide is introduced by the tree's common
name in large green type. Most tree species
nave more than one common name, but

only one is listed. Others may be men-
tioned in the text. Genus entries precede
some groups of species entries, such as
oaks and maples.

After the common name, there is a two-
word scientific name in italics. The binomial
system of Latin scientific names has fol-
lowed this format since the mid-18th cen-
tury, when the Swedish botanist Carolus
Linnaeus (1707–1778) published his monu-
mental treatise *Species Plantarum.*

The first word of a scientific name de-
notes the genus and the second word, the
species. For example, the scientific name of
the American elm is *Ulmus americana.* The
first word, *Ulmus,* is the genus name and is
the Latin word for "elm," indicating that
botanists place this tree in the elm genus.
The second word, *americana,* the Latinized
word for "American," is the species name.
This particular two-word scientific name is
exclusive to the American elm and is used
by botanists around the world.

Sometimes an entry in the Tree Guide
covers several species in a genus. For exam-
ple, the entry "European Elms" covers four
species. In this case, there is not room to list
four separate scientific names, so the scien-
tific name listed is *Ulmus* spp. The abbrevi-
ation "spp." stands for "species" in the
plural, indicating that more than one species
of elm are being described.

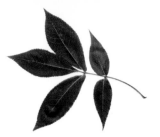

PINATELY COMPOUND

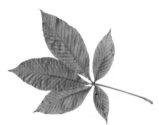

PALMATELY COMPOUND

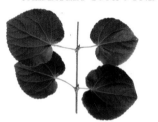

OPPOSITE PAIRS

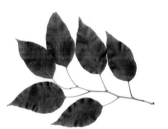

ALTERNATELY ARRANGED

SMOOTH EDGES

UNLOBED, TOOTHED EDGES

LOBED

Eastern Red Cedar

Juniperis virginiana

Not really a true cedar but a juniper, the Eastern red cedar has been highly valued since colonial times for its fine-grained, decay-resistant wood, used to panel closets and make fence posts, pails, lead pencils, and chests. The volatile cedrine camphor oil in the wood has been proved to kill the larvae of some moths that feed on wool. This hardy, medium-size tree is often among the first to spring up in abandoned pastures, where its seeds are spread by cedar waxwings and other birds that feed on its fleshy, bluish seed cones.

In the 19th century, lead pencils were made almost exclusively from red cedar wood, which is strong enough not to break when it is cut into pencil-size strips but is also soft enough to sharpen easily. Henry David Thoreau worked for a time in his father's pencil factory, trying to improve the process of making graphite and enclosing it in red cedar casings. Apparently he succeeded because the pencils produced by Thoreau &

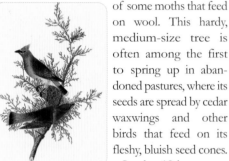

A hand-colored engraving from the Royal Octavo edition of John James Audubon's *Birds of America* (1840–1844) shows a male cedar waxwing (*top*) and a female (*bottom*) perched on an Eastern red cedar branch bearing female cones.

Company were considered among the best made in the United States and sold well, though they were more expensive than those of many rival manufacturers. Red cedar lumber used in pencil making during the 19th century came mostly from Tennessee, but as supplies dwindled there, manufacturers switched to incense cedar, a western conifer.

Seven stalwart Eastern red cedars planted in the early 1990s stand in a bushy phalanx near Cedar Hill's summit. Five are roughly conical; two are scraggly, with separate branches more apparent. Three or four bear blue seed cones part of the year; the others never bear seed cones. Eastern red cedars carry their male and female cones on separate trees. Female trees produce blue cones; males produce cones, too, but they are tiny brownish-yellow structures, easily overlooked. Wild red cedars are narrow and conical when young and more spreading, irregular, and pendulous when mature. Red cedar cultivars are numerous, varying in habit from small shrubs to tall, columnar spires with needle colors ranging from dark green to silver blue.

Several other juniper species are spread around the park, mostly low-growing shrubs. The Eastern red cedar and other juniper species have been continuously present in the park since the early 1860s.

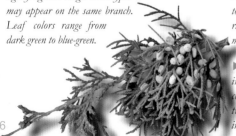

▼ *The Eastern red cedar's evergreen leaves may be either needle-like juvenile leaves up to ¼ inch long radiating from twigs or scale-like mature leaves about ¹⁄₁₆ inch long pressed tightly against twigs. Both types may appear on the same branch. Leaf colors range from dark green to blue-green.*

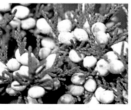

▶ *Waxy, berry-like, ¼-inch Eastern red cedar cones on female trees turn from green to blue as they slowly ripen over the summer months.*

▶ *Tiny ¹⁄₁₆- to ⅛-inch Eastern red cedar cones on male trees release pollen in early spring.*

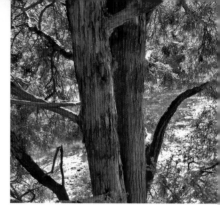

▲ *Eastern red cedar bark is reddish-brown but becom[es] ashy gray and fibrous with age. The wood is very hard.*

▼ ▶ *The row of seven Eastern red cedars on Ced[ar] Hill exhibit a variety of habits, suggesting that sever[al] cultivars of different ages are grouped here. Only t[he] three or four female trees bear waxy, pea-size blue cone[s.]*

▼ *One November, two male trees among the Eastern r[ed] cedars on Cedar Hill had a ½-inch* Gymnosporangiu[m] juniperi-virginianae *gall growing on a leaf twig. If not re[-]moved, the galls would have produced gelatinous protrusion[s] in spring, releasing spores that could travel to nearby apple [or] crab apple trees and infect them with leaf-rust disease.*

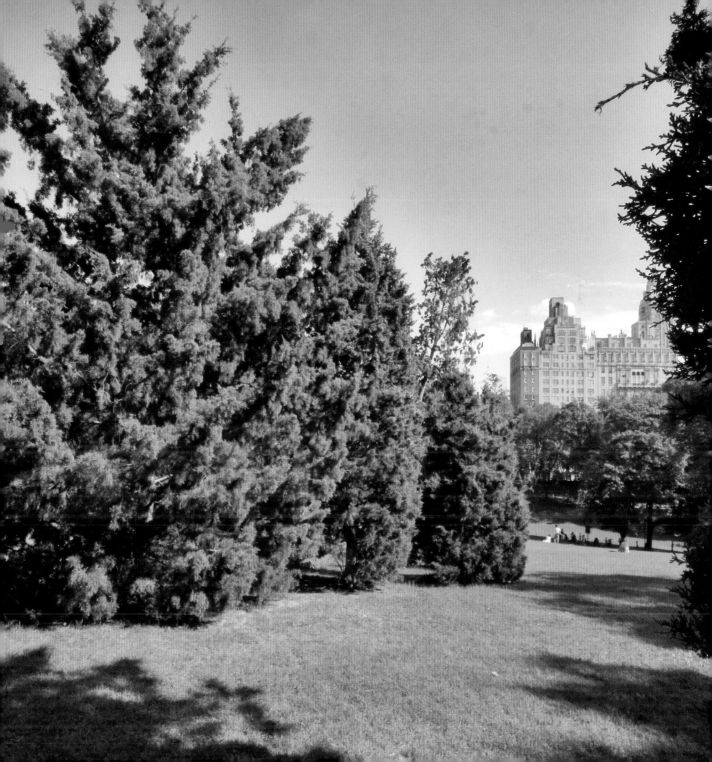

Dawn Redwood *Metasequoia glyptostroboides*

In the summer of 1943, Zhan Wang, a Chinese forester and naturalist, made one of the greatest botanical discoveries of the 20th century. He was recuperating from an attack of malaria near Wanxian, a city in central China, when he was visited by a college friend who was the principal of the local agricultural high school. Wang's friend described a huge tree of an unknown species located around 60 miles away in a remote small town called Moudao.

Zhan Wang (1911–2000) is best known in the West for his discovery of the dawn redwood. A beloved botany professor, mentor, and field biologist, he was passionately interested in preserving China's wild places.

Wang decided to see the tree for himself. He travelled for three days along rutted dirt roads through narrow river valleys walled by steep mountains. When he finally reached Moudao, he found a scraggly old conifer nearly 100 feet tall, with a trunk over 5 feet in diameter at its base, standing alone in a completely deforested valley surrounded by rice paddies. Frustrated that seed cones hung only on upper limbs out of reach, Wang managed to snip off some branches and gather a few fallen cones from the roof of a temple beneath the tree.

Eventually, Wang's samples reached two distinguished Chinese biologists, W. C. Cheng and H. H. Hu, who together named the tree *Metasequoia glyptostroboides* and confirmed that it was the same tree that had been described from a fossil by Shigeru Miki, a Japanese biology professor. (Such redwood fossils ranging in age from 2 million to 60 million years have been found as far north as the Canadian Arctic and Greenland.) Seeds were also sent to Harvard's Arnold Arboretum, which distributed them to other botanical institutions around the world.

This ancient relative of the giant sequoia and the California redwood is a deciduous conifer that looks much like the bald cypress but grows faster and tolerates a broad range of soil conditions. Planted widely in Europe, Asia, and North America since 1947, some of these trees are already nearly 100 feet tall.

Three dawn redwoods planted in 1985 are clustered at the northern tip of Strawberry Fields. This trio of dawn redwoods provides a perfect northern terminus to an intimate landscape dedicated to the memory of John Lennon. Other dawn redwoods have recently been planted throughout the park, including a group of seven southwest of the Conservatory Garden.

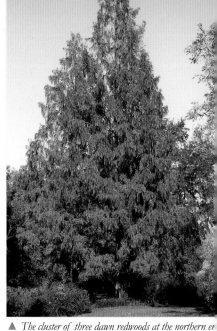

▲ *The cluster of three dawn redwoods at the northern end of Strawberry Fields turn to beautiful shades of rusty red fall, rivalling the colors of the park's maples and tupelos.*

▶ *Reddish, peeling bark and gangly upswept branches give the park's three dawn redwoods a primitive aura appropriate for a species little changed in 60 million years.*

▶ *Male pollen cones are less than ¼ inch long. They hang on spikes in early spring only on trees growing in places with hot summers.*

▼ *Arranged in opposite ranks, dawn redwood needles assume a unique and distinctive reddish-bronze color in late fall before entire twigs with needles drop from the tree.*

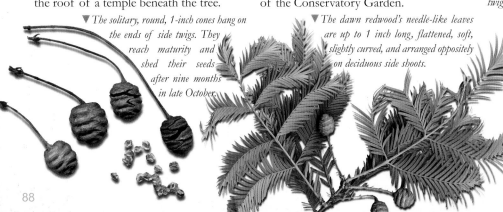

▼ *The solitary, round, 1-inch cones hang on the ends of side twigs. They reach maturity and shed their seeds after nine months in late October.*

▼ *The dawn redwood's needle-like leaves are up to 1 inch long, flattened, soft, slightly curved, and arranged oppositely on deciduous side shoots.*

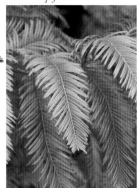

Douglas-fir and Fir *Pseudotsuga menziesii* and *Abies* spp.

The world's tallest trees grow along the coasts of Washington, Oregon, and California. A California coast redwood named Hyperion now holds the world record at 379 feet. It is likely, however, that the tallest tree on Earth may once have been a coast Douglas-fir. One Douglas-fir known as the Mineral Tree, located southwest of Mount Rainier, was measured in 1930 at 393 feet.

David Douglas (1799–1834), a Scottish botanist, was sent to North America's West Coast in 1824 by the Royal Horticultural Society. There he discovered about 240 plant species new to European botanists, including the Douglas-fir, Sitka spruce, and ponderosa pine.

Archibald Menzies, a Scottish naturalist and surgeon, was the first European to record an encounter with the Douglas-fir. He collected specimens but without cones in 1792 on Vancouver Island. The tree did not yet have a name when another Scotsman, David Douglas, collected more specimens, including cones, in 1824 and sent them back to Scotland, where seeds were immediately planted at Scone Palace. At the time, the tree was thought to be a pine—some called it the Oregon pine—although its spirally arranged needles do not grow in clusters, as do the needles of all true pines, and its pendant cone is different from a typical pine's. John Muir, the renowned Scottish-American naturalist of the Sierra Nevada, referred to the tree as the Douglas spruce. Nineteenth-century botanists kept assigning it to different genera—pine, fir, spruce, hemlock. Finally in 1867, new botanical discoveries in China and Japan resulted in the Douglas-fir's being placed in a new genus, *Pseudotsuga*, meaning "false hemlock." However, its species name changed several times even after its genus was established. In 1950, botanists settled on *Pseudotsuga menziesii*. The accepted common name, however, has remained Douglas-fir, with the hyphen inserted to signal subordinate status for the word "fir."

In addition to several Douglas-firs, the park contains one or two specimens each of four true fir species: white fir (*Abies concolor*), Nordmann fir (*A. nordmanniana*), Fraser fir (*A. fraseri*), and balsam fir (*A. balsamea*). Like all of the world's 48 to 55 fir species, they bear upright cones on upper branches. The Douglas-fir and the true firs all make good Christmas trees. Indeed, the balsam and Fraser firs in the park's southwestern corner may have been Christmas trees before they were planted, perhaps without official permission, some 20 or more years ago.

▼ *Just over ½ inch to slightly less than 1 inch long, with notched or rounded tips, balsam fir needles are flat and flexible and have a pleasant, distinctive odor when crushed. All fir needles lack stalks. They narrow toward their base (inset) and then flare.*

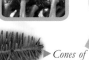

▼ *The 7-inch Nordmann fir cones are green in late summer but turn brown in fall and gradually disintegrate. A cone consists of 150 to 200 scales, each bearing two winged seeds. All firs bear upright cones, not pendant cones.*

▶ *Cones of the Douglas-fir have three-pointed bracts that stick out above each of their cone scales.*

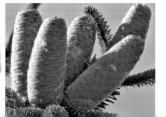

▲ *A 28-foot balsam fir is overshadowed by 59th Street skyscrapers. The most widespread North American fir, the balsam fir has a natural range stretching from eastern Canada south to West Virginia and west to Alberta.*

▶ *A towering trio of Douglas-firs borders the East Drive opposite a pair of white firs at the North Meadow's eastern edge. Actually blue-green, the white fir is native to the Rockies, Sierras, and Cascades.*

▼ *A 30-foot Nordmann fir stands north of Sheep Meadow and Mineral Springs Pavilion. Native to the Caucasus Mountains, this fir can exceed 200 feet in height, making it one of the tallest Eurasian tree species.*

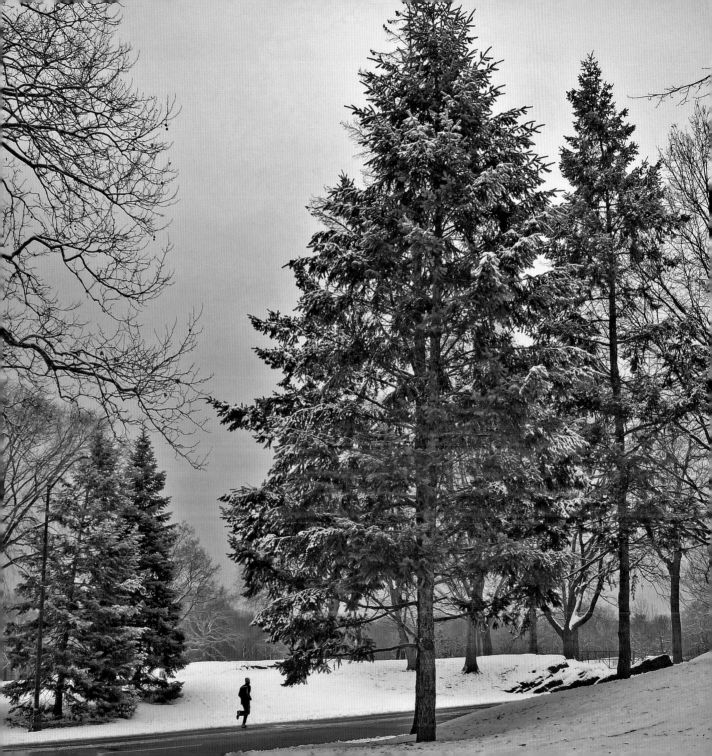

Bald Cypress *Taxodium distichum*

The bald cypress is native to bayous of the Gulf of Mexico and to swampy areas of the East Coast from Delaware to Florida, where it is often festooned with Spanish moss. However, it is tolerant of cold and has been planted as far north as Ontario and Maine. Its ability to thrive in water-saturated, low-oxygen environments also makes it successful as a park and street tree in urban settings, where compacted soils lacking oxygen are common.

Water towers on roofs of many New York City apartment buildings are made of bald cypress planks.

The bald cypress is a conifer, but it is also deciduous, shedding shoots with needle-like leaves every fall—hence the adjective "bald" in its common name. A relative of the giant sequoia and the California redwood, it is the largest tree in terms of bulk growing in the eastern United States. The wood of old-growth bald cypresses is amazingly decay resistant and has been widely used for pilings, docks, boats, outdoor furniture, and the water towers atop many New York City buildings.

Bald cypresses standing in water are usually surrounded by curious, knobby protuberances known as knees. The precise function these woody structures has been debated by botanists. One explanation is that the knees are intended to store starch like the roots of vegetables such as potatoes and beets. Another explanation for the knees is that they absorb air for the roots, which may spread through water and soil with little dissolved oxygen. A third theory suggests that the roots act like stabilizers, and indeed bald cypresses do manage to remain upright even during severe hurricanes.

Some bald cypresses in Central Park, such as the pair of large trees at the southeastern corner of the Harlem Meer, do not have any knees. But when a bald cypress is located in or very close to water, like the large specimen at the western end of the Pool, it will very likely exhibit a few small knees, usually less than 1 foot tall.

Bald cypresses are now planted more frequently in the park than they were in past years. The plant survey of 1873 mentioned only four trees. Louis Harman Peet's *Trees and Shrubs of Central Park* lists nine. The survey of 1982 counted 15. The survey of 2008 included 28, some of them recently planted on the island in the Lake and at the Harlem Meer's Dana Discovery Center. As of 2013, there were 64 bald cypresses in the park.

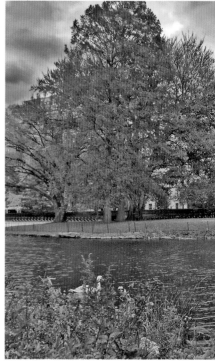

▲ *Fall is a fine time to enjoy the Harlem Meer's magnificent bald cypresses. Then their needles turn from green to rich rust-red, crimson, and gold.*

▶ *Slanting rays of late-afternoon sun in October burnish the needles of the Harlem Meer's bald cypress twins.*

▼ *The large bald cypress growing at the western end of the Pool has a few small knees less than 6 or 7 inches tall, protruding from the ground between its trunk and the water. In southern swamps, bald cypresses are sometimes surrounded by knees 4 or 5 feet tall.*

▶ *Needle-like bald cypress leaves are less than 1 inch long. Flattened, soft, bluntly pointed at the tip, with a yellowish-green upper side and a whitened underside, the needles grow on alternate deciduous shoots.*

▼ *Spherical, woody cones about 1 inch in diameter begin developing in spring after fertilization and ripen by late fall. Each cone contains two to more than 30 irregularly shaped seeds.*

92

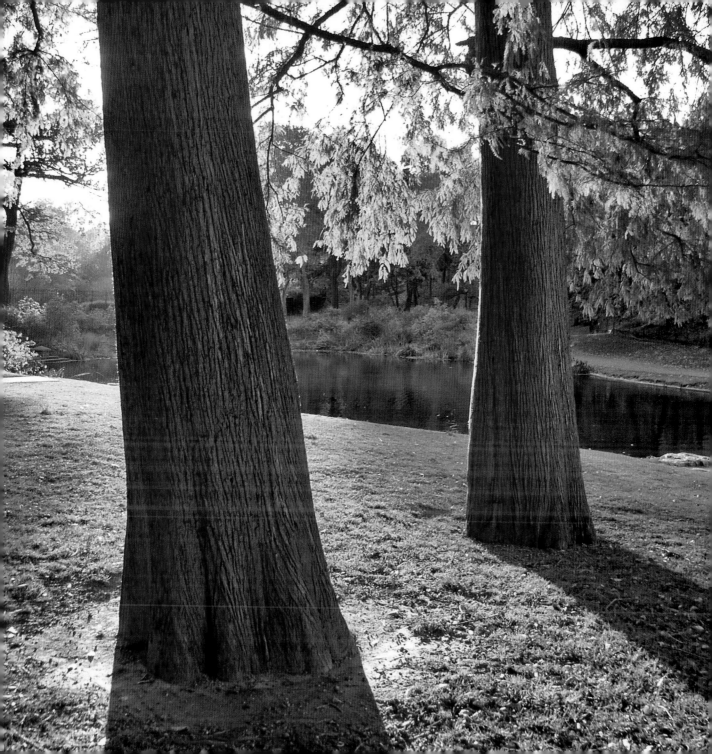

Yew *Taxus* spp.

Once used to make longbows in England, the English yew (*Taxus baccata*) is steeped in lore. The English yew is known both as the "tree of death" for its toxic foliage and ubiquity in churchyard cemeteries and as a symbol of eternal life due to its longevity. Magnificent specimens found in England can be 2000 or more years old and up to 50 feet tall.

All *Taxus* species are quite toxic to people and livestock alike; ingestion of a few leaves or seeds or a small amount of bark can be fatal to horses and cattle. It has been proposed that churchyard planting was simply a way to grow yews in an enclosed area while protecting livestock from their toxic shoots. Alternatively, yews may have deterred farmers from letting livestock graze on sacred ground.

The many cultivars planted today are mostly derived from the English yew or the Japanese yew (*T. cuspidata*) or are a hybrid of the two (*Taxus × media*). They range from small shrubs to columnar trees. The chemical taxol—used to treat breast, ovarian, and lung cancer—is derived from the Pacific yew (*T. brevifolia*) and the Canadian yew (*T. canadensis*).

Over 100 yews are spread around the park. Many are multi-trunked shrubs or small trees, like those that once lined the steps leading to the western side of Cleopatra's Needle. Others, such as those surrounding the central lawn of the Conservatory Garden, have been clipped into hedges.

A striking cultivar of the English yew is the Irish yew (*T. baccata* 'Fastigiata'), with its imposing mass of sharply upright branches. A fine large Irish yew stands next to a pier on the southern side of Olmsted & Vaux Way opposite the stairways to Bethesda Terrace.

Every Irish yew is a clone of a yew found in County Fermanagh, Northern Ireland, in 1767 by a farmer named George Willis. As the story goes, Willis was hunting hares when he noticed two odd little upright yew saplings. He pulled them up; planted one, which survived until 1865, in his garden; and gave the other to his landlord, who had it planted on his estate, Florence Court. The tree survives to this day, and cuttings from it have produced all the world's Irish yews.

A plate from Otto Wilhelm Thomé's four-volume *Flora of Germany, Austria, and Switzerland* (1885) pictures female and male twigs of the English yew, along with details of arils, seeds, and pollen cones. Thomé (1840–1925) was a German botanical artist.

▲ *English yew bark is reddish-brown, often peeling in th*[e] *layers. The wood is very hard and resilient. A yew spe*[ar]*head 400,000 years old is the oldest known wooden too*[l]

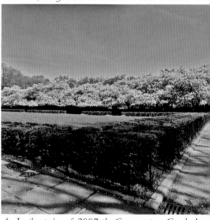

▲ *In the spring of 2007, the Conservatory Garden's ce*[n]*tral lawn's border was planted with* T. media *'Hatfieldi*[i]*,] a compact upright yew cultivar ideal for hedges.*

▶ *The somber 14-foot Irish yew at the Mall's nort*[h]*ern end brushes a pier embellished with Jacob Wr*[ey] *Mould's botanical carvings.*

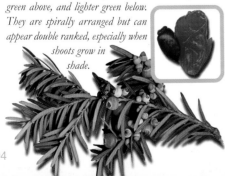

▼ *The English yew's evergreen-needle-like leaves are* ½ *inch to 1¼ inches long, up to ¼ inch wide, shiny, dark green above, and lighter green below. They are spirally arranged but can appear double ranked, especially when shoots grow in shade.*

▶ *Freighted with snow, branches of the Irish yew at the Mall's northern end bend to the ground but will spring back up when the snow melts.*

▼ *Female yews bear red cones, or arils (left), each containing one seed (inset). Male yews bear yellow pollen cones in spring (right).*

Eastern Hemlock *Tsuga canadensis*

Before Europeans arrived in Manhattan, there were surely sheltered stream valleys and north-facing slopes deeply shaded by stands of towering old-growth Eastern hemlocks. Until just a few years ago, such

An engraving in *The North American Sylva* by François Michaux (1770–1855) pictures a hemlock branch with cones and a single seed. In the text, Michaux notes: "In the beginning of summer the delicate green branches, surmounted with a tuft of yellowish-green recent leaves, have an effect of peculiar beauty."

hemlock stands existed in forests along the top of the Palisades, at places such as the Greenbrook Sanctuary across from Riverdale, and in Westchester County, at locales such as the Mianus River Gorge.

The Eastern hemlock reproduces naturally only after more shade-intolerant trees—such as birches, poplars, maples, and beeches—have created a shady environment. Hemlock stands have their own distinctive microclimate. Beneath the hemlock canopy, the air is cooler and more moist than it is in the surrounding hardwood forests, and the ground, bare of other vegetation, is covered with a carpet of needles. Tragically, these serene groves are being destroyed in the eastern United States by the hemlock woolly adelgid, a minute aphid-like

insect originally from Japan that infests the tender bark of hemlock twigs, sucking their sap, withering their needles, and slowly but surely killing the trees.

If hemlock stands existed in the area that is now Central Park, they were long gone by the time Olmsted and Vaux were preparing the Greensward Plan. Swampy areas abounded with alders, silver maples, bay berry, and mountainbush cranberry, but there were no hemlocks—indeed, no conifers at all except for a few red cedars.

In a report dated October 1857, Olmsted described the trees he intended to plant: "[T]he stiffer forms of evergreens trees will best accord with, and set off, the picturesque rocks which are the marked feature of the landscape. The Hemlock and Black Spruce will probably be preferred as the predominating trees, wherever it is practicable to supply and retain the deep, loose, rich, black soil which they require; and on steeper slopes and higher ground the Norway Spruce." Now just a few Norway spruces remain, no black spruces at all, and only around 60 hemlocks, mostly recently planted, spread thinly around the park. There will never be many more hemlocks because they do poorly in summer heat and periodic dry spells, and they must be sprayed to combat the woolly adelgid.

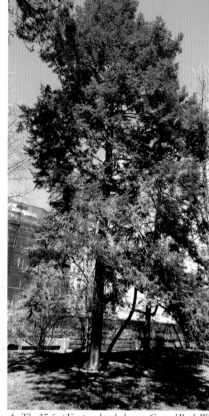

▲ *The 35-foot Eastern hemlock near Central Park West and 88th Street is one of the taller specimens in the park.*

▶ *Planted during the Wagner Cove restoration, a line of young hemlocks borders the road to Cherry Hill Fountain.*

▼ *Hemlock male cones reach full size in late summer and may persist for a year or more. Yellow pollen cones (inset) with globular pollen packets are about ⅛ inch across.*

▼ *Hemlock needles are lightly tapered, flat, and ⅓ to ⅔ inch long with a rounded tip. Arranged in opposite rows along twigs, they have a grooved, shiny green upper side and an underside lightened by lines of white stomata. Fine teeth are visible with a pocket magnifier.*

▼ *Hemlock seed cones (right) are only ½ to ¾ inch long. Hemlock twigs (inset) infected by tiny aphid-like woolly adelgid insects may become lined with white, cottony egg masses most noticeable in early spring.*

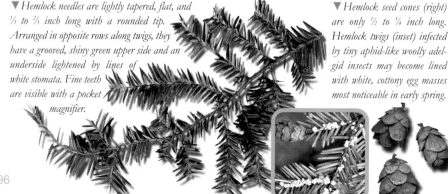

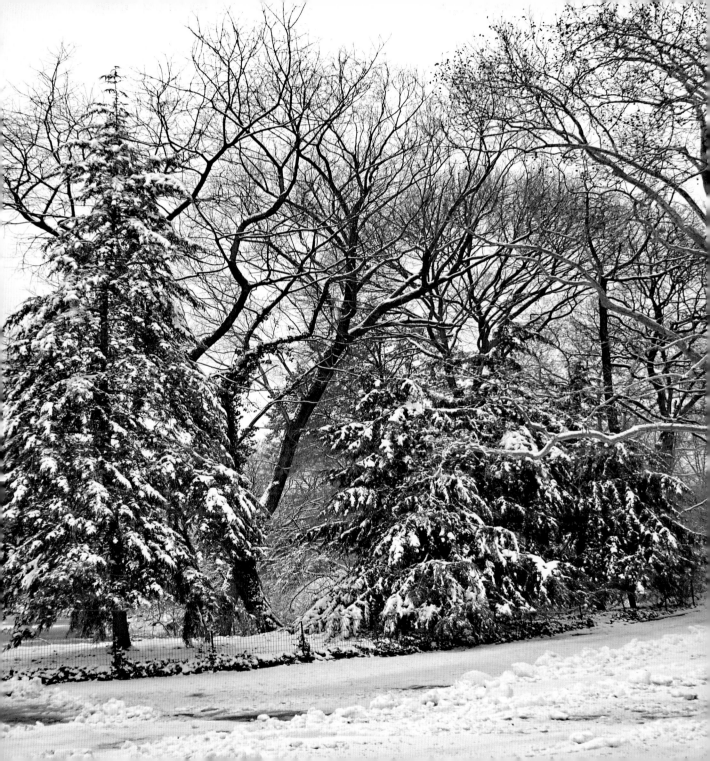

C E D A R S

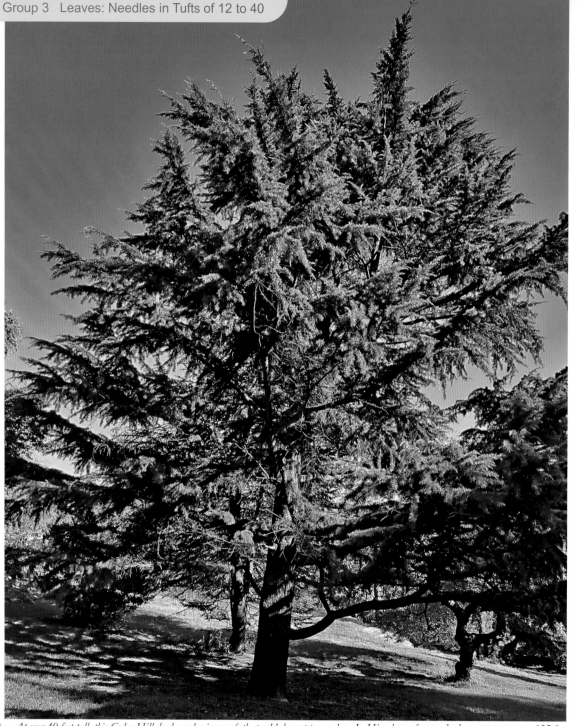

At over 40 feet tall, this Cedar Hill deodar cedar is one of the park's largest true cedars. In Himalayan forests, deodars may tower over 125 feet.

*He built also the ho
of the forest of Leb
the length thereof w
hundred cubits, and
breadth thereof fifty
cubits, and the heigh
thereof thirty cubits
upon four rows of
cedar pillars, with ce
beams upon the pilla*
1 Kings 7:1–3

*The green cedar
of Lebanon
on the flag of
Lebanon is
the symbol of
the country's
Maronite
Christian
community.*

The genus *Cedrus* in the plant family Pinaceae consists of four true cedar species or subspecies. Three, including the cedar of Lebanon and the Atlas cedar, are native to the Mediterranean; one, the deodar cedar, is native to the western Himalayas. Once a ring of cedar forests rimmed the Mediterranean from Lebanon to Spain and across northeastern Africa from Morocco to Tunisia, but only tiny patches of these great montane forests exist today.

The leaves of true cedars are evergreen and needle-like, as are those of other members of the Pinaceae—firs, hemlocks, larches, pines, and spruces. Vase-shaped female seed cones stand upright on higher branches. Smaller upright male pollen cones grow on lower branches in fall.

The cedar of Lebanon was the tree of Solomon's Temple, a symbol of strength and fruitfulness for biblical peoples. A trio of young cedars of Lebanon shades the top of the hill south of the Conservatory Water by the path leading from the 72nd Street transverse.

Two elegant deodar cedars stand on the southeastern side of Cedar Hill, easily identifiable by their soft, light-green needles and gracefully drooping branch tips.

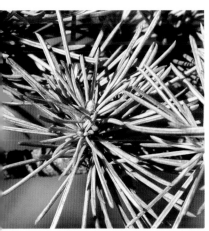

Needles of true cedars are arranged in spiral clusters of 15 to 45. Colors of cedar needles may range from dark green to light green or pale blue-gray green.

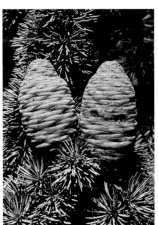

The 2¼- to over 4-inch cedar seed cones stand upright, usually on higher limbs, as they mature from green to brown.

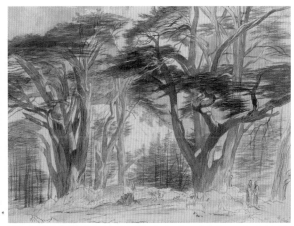

Edward Lear's 1862 watercolor of ancient cedars of Lebanon probably pictures the Arz El Rab, or Cedars of the Lord, at Bsherre, Lebanon. Though much diminished, this grove still contains four great cedars over 100 feet tall.

Atlas Cedar *Cedrus atlantica*

The Atlas cedar is the only tree species native to Africa in Central Park. One of four true cedars, it grows up to 125 feet tall in national parks situated in the Atlas and Rif Mountains of Algeria and Morocco, where the last wild troops of Barbary macaques forage in the cedar crowns, often stripping bark off trunks to reach moist cambium. (One other small introduced population of Barbary macaques lives on handouts in Gibraltar; these are the only free monkeys in Europe.)

The Barbary macaques of Gibraltar eat food supplied by humans. Wild macaques in Morocco and Algeria feed on young cones, leaves, and cambium of the Atlas cedar. Populations of these primates are dwindling as human incursion and global warming shrink their mountain habitats.

The Atlas cedar is planted throughout the world's temperate regions as both a timber tree and an ornamental. The silver-blue 'Glauca' variety is particularly popular. The blue tint of its needles is caused by a wax coating that reduces desiccation. Some botanists consider the Atlas cedar to be a subspecies of the cedar of Lebanon, and, aside from their differing growth habits and needle lengths, the two are similar.

Chinese botanists have traced all four existing cedar species or subspecies—the Atlas cedar, cedar of Lebanon, Cyprus cedar, and deodar cedar—to a common ancestor that grew in northern Eurasia more than 50 million years ago. As the climate of the Northern Hemisphere cooled during the Tertiary period, this ancient cedar population slowly migrated south and split in two, one branch moving toward the Himalayan region and the other toward the Mediterranean. Genetic analysis indicates that the Himalayan branch is the older, with just one cedar species: the deodar. The Mediterranean branch split into two sub-branches about 19 million years ago, when the Atlas cedar emerged from the ancestral line, and then split again around 5 million years ago as the cedar of Lebanon and the Cyprus cedar evolved. All these new species developed in response to a rapidly changing climate in Eurasia. Glaciers waxed and waned, and conditions became drier, isolating tree populations from one another as forests contracted.

Twenty-one Atlas cedars were counted in the tree census of 2008, a large increase over the five noted in 1982. Louis Harman Peet listed three in *Trees and Shrubs of Central Park*. In 1872, only two Atlas cedars along with three cedars of Lebanon were recorded.

▲ *An Atlas cedar displays the blue-green coloring of t popular 'Glauca' cultivar. The 25-foot specimen stands ne the East Drive south of the Chess & Checkers House.*

▶ *The pair of Atlas cedars located between the Reserv and the West Drive were frosted by an early-spring sno fall in 2003. Later, one tree fell during a wind storm.*

▼ *Upright, green, 1¼-inch male cones appear on lo branches of the Atlas cedar in summer. After sheddi their pollen in autumn, the male cones turn brown an drop off the tree. The barrel-shaped 3- to 4-inch fema cones growing on upper branches take a year to matur Then they disintegrate as they shed their seeds.*

▶ *The needles of the Atlas cedar are clustered in spiral rosettes. A rosette consists of 30 to 40 needles, each about ¼ inch long. The deodar has fewer needles in rosettes but longer needles. The needles shown here are those of the blue Atlas cedar (Cedrus atlantica 'Glauca').*

▼ *A female cedar cone cross section reveals that the sharp-pointed winged seeds are arranged in circular layers. As a cone matures, seeds drop off one by one.*

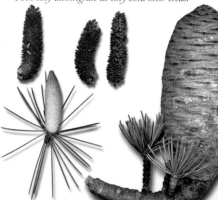

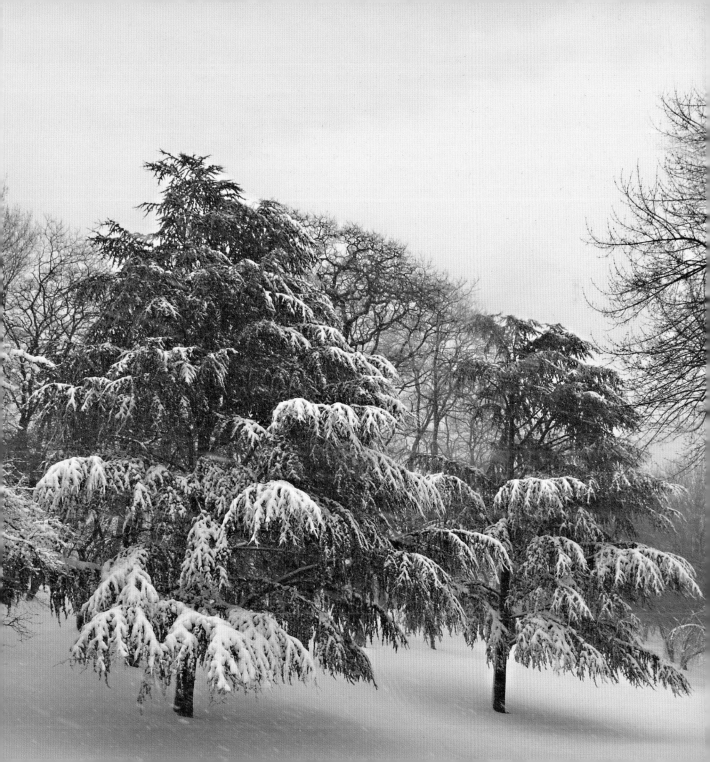

European Larch *Larix decidua*

The genus *Larix*, larch, includes around 10 to 15 deciduous conifer species spread across North America and Eurasia. Most larch species are native to boreal forests of the north temperate zone, although one grows as far south as Burma. The European larch is the only larch species that has been continuously present in the park since the 1860s. It withstands hot New York City summers somewhat better than the tamarck (*L. laricina*), a native of the Great North Woods of New England and Canada, which has been planted in the park from time to time but has done poorly.

A color plate from Aylmer Bourke Lambert's *A Description of the Genus Pinus* (1803) shows two European larch branches: one (*left*) with young male and female cones; the other (*right*) with mature female cones. At far right are details of cones, seeds, and needles.

The European larch in the park tends to be just a medium-size tree, but in the Alps, the Sudetes, and the Carpathian Mountains of central and eastern Europe it can grow over 100 feet tall. Pliny the Elder (23–79) described a mighty beam of larch wood 120 feet long and at least 2 feet in diameter through its entire length. It was harvested in the alpine province of Raetia and brought to Rome as "the largest tree ever seen at Rome down to the present time."

The European larch is a light-loving, fast-growing, early pioneer tree that colonizes freshly disturbed sites. It occurs naturally on mountainsides between 5000 and 6000 feet, where it is less likely to be shaded out by broadleaf trees and other European conifers than it would be at lower elevations. Valued for its resin and lumber—which is unusually tough for a conifer, not easily split, and relatively free of knots—it has been cultivated extensively in tree plantations throughout Europe and was introduced to Britain around 1620. In southern England, a larch can reach 25 feet in just 10 years. One felled in Dunkeld, Scotland, after 60 years was 110 feet tall; another at Glenarbuck, near the River Clyde, was 140 feet tall, with a circumference of 13 feet.

Highly resistant to rot, European larch wood has been used for ship planking, bridge timbers, fence posts, pilings—such as those supporting many Venetian buildings—roof beams, and shingles since ancient times.

More than a dozen European larches are in the park, including five in Strawberry Fields and three to the west and southwest of the Chess & Checkers House.

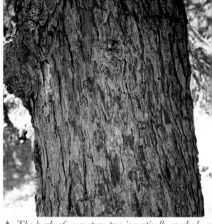

▲ *The bark of a mature tree is vertically cracked and scaly. Flakes dropping off reveal reddish underbark. In the Swiss Alps, an old tree may have foot-thick bark at its base.*

▶ *The 50-foot European larch next to the Chess & Checkers House is spindly compared with fuller alpine specimens.*

▲ *Caught in the slanting sunlight of an afternoon in late October, European larches high in the Trenta Valley of Slovenia's Julian Alps turn to spires of flaming gold.*

▼ *European larch cones often persist on their branches for several years. The deciduous needles turn from green to gold in November and may hang on into mid-December.*

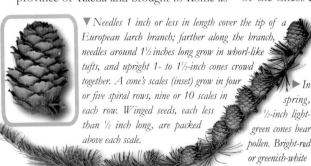

▼ *Needles 1 inch or less in length cover the tip of a European larch branch; farther along the branch, needles around 1½ inches long grow in whorl-like tufts, and upright 1- to 1½-inch cones crowd together. A cone's scales (inset) grow in four or five spiral rows, nine or 10 scales in each row. Winged seeds, each less than ½ inch long, are packed above each scale.*

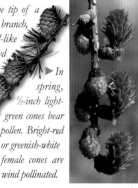

▶ *In spring, ½-inch light-green cones bear pollen. Bright-red or greenish-white female cones are wind pollinated.*

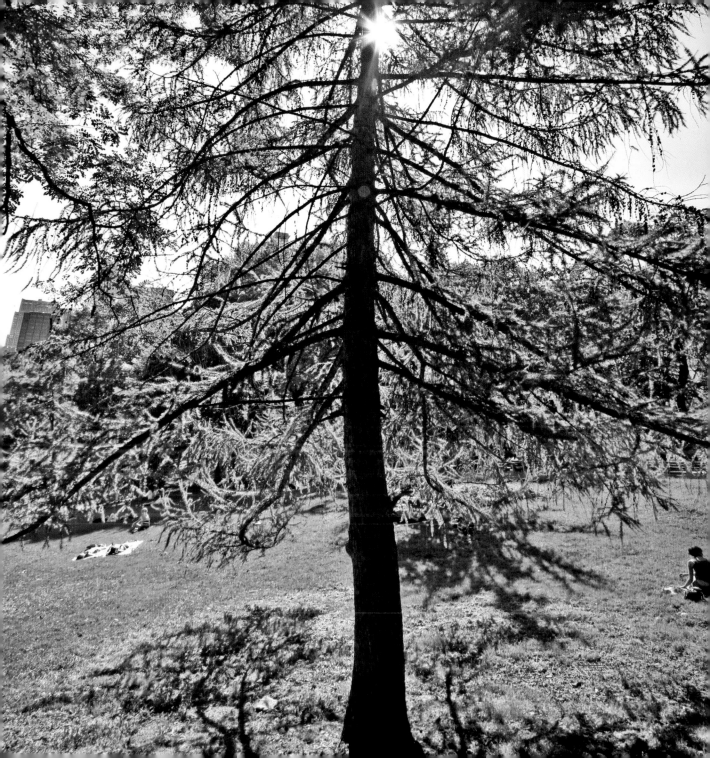

Golden Larch *Pseudolarix amabilis*

The golden larch presently is native to only the mountains of southeastern China, but 50 million years ago it grew in temperate rain forests across both Eurasia and North America, and its direct line may stretch back over 150 million years, making it nearly as ancient as the ginkgo. Not actually a larch, as its genus name *Pseudolarix* (false larch) suggests, it is in a genus of its own, with just one species. Although closely related to the larch, it is also near kin to the fir and the cedar.

The Wardian case, the terrarium's forerunner, was the invention of London physician Nathaniel Ward (1791–1868). The case allowed young plants on a ship's deck to get sunlight and condensed moisture without being exposed to salt spray.

On his first trip to China in 1842, Robert Fortune, a Scottish plant explorer, found only potted golden larches and dwarf specimens in gardens. On a subsequent trip in 1854, he described one of his early encounters in the mountains with big golden larches: "We had left the highest point of the mountain ridge, and were gradually descending, when on rounding a point I observed at a distance a sloping hill covered with the beautiful object of our search....One tree in particular seemed the queen of the forest, from its great size and beauty, and to that we bent our steps. It was standing all alone, measured 8 feet in circumference, was fully 130 feet high, and its lower branches were nearly touching the ground. The lower branches had assumed a flat horizontal form, and came out almost at right angles with the stem, but the upper part of the tree was of a conical shape, resembling more a larch than a cedar of Lebanon. But there were no cones even on this or any of the others, although the natives informed us that they had been loaded with them on the previous year. I had, therefore, to content myself with digging up a few self-sown young plants which grew near it; these were afterwards planted in Ward's cases and sent to England, where they arrived in good condition." This shipment of seedlings followed Fortune's earlier delivery of seeds, most of which failed to germinate when they arrived in England.

Two or three trees from Fortune's shipment were imported to Flushing, Queens, by the nurseryman Samuel Parsons in 1859 and successfully raised to maturity. Probably all of Central Park's golden larches—the three near the Delacorte Theater and the one west of the Conservatory Water—are descended from Parsons's trees.

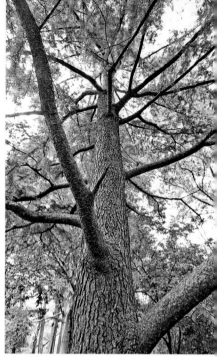

▲ *The golden larch typically has a gradually tapering trunk with widely spaced horizontal or slightly ascending branches.*

▶ *Over 60 feet tall, with a trunk 2¼ feet in diameter at breast height, the golden larch west of the Conservatory Water assumes a glowing, golden mantle in early October.*

▼ *Resembling 10,000 yellow-ocher starbursts, the golden larch's fall foliage display lasts only about two weeks.*

▼ *The 1- to 2-inch leaves arranged in whorls on short shoots and in spirals on long shoots (insert) change from green to gold in fall.*

▶ *Looking somewhat like globe artichokes, female cones 1½ to 2½ inches wide with pointed scales mature in seven months, release winged seeds, and fall apart.*

◀ *Yellow male cones in clusters of 10 to 25 shed pollen in April.*

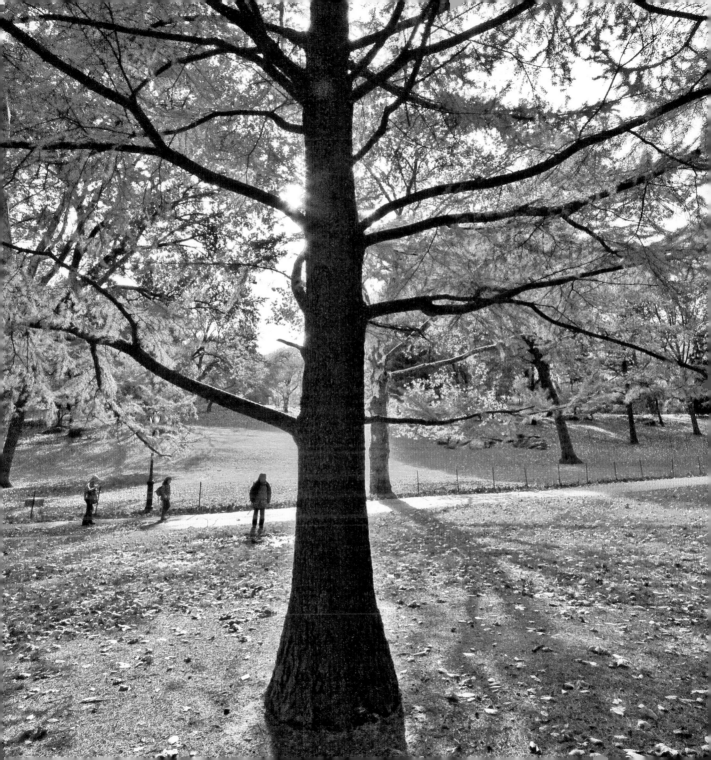

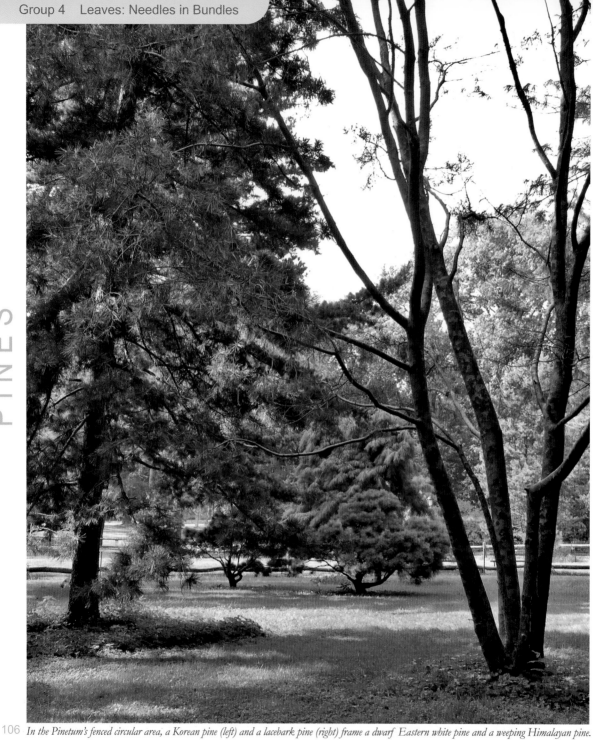

P I N E S

In the Pinetum's fenced circular area, a Korean pine (left) and a lacebark pine (right) frame a dwarf Eastern white pine and a weeping Himalayan pine.

Pinus *is the oldest gen of the conifers and the most important and in teresting, whether cons ered from the botanica economic or agriculture standpoint. Occurring it does in many species throughout the whole northern hemisphere, from it are derived m of the most valuable timbers and extractibl products of commerce.*

Irving W. Bailey,
"Anatomical
Characters in
the Evolution
of *Pinus*"

*Scotch
pine twig
with cone*

The genus *Pinus,* pine, includes around 100 species of trees with thin needle-like leaves and woody cones native to North America, Europe, and Asia. Divided by botanists into two subgenera, the hard pines and the soft pines, *Pinus* evolved largely in the Northern Hemisphere, but pines have been planted widely in the Southern Hemisphere in recent times.

Hard pines—such as the Austrian pine, Scotch pine, and lacebark pine—have two or three needles in a cluster. Soft pines—such as the Eastern white pine, Himalayan pine, and Swiss stone pine—have five needles in a cluster.

All the pine species named here can be found in Central Park, which contains more than 15 members of *Pinus.* Three of these—the Eastern white pine, Austrian pine, and Himalayan pine—are by far the most common pines in Central Park.

A good place in the park to look carefully at pines is the Arthur Ross Pinetum's western end. Here three young Japanese red 'Tanyosho' pines grow close to the West Drive. In and around the circular area nearby are other interesting exotics, including a multi-trunked lacebark pine.

When a lacebark pine is five to eight years old, its inelastic bark begins flaking off as its trunk expands, exposing patches of varying green, gray, and reddish-brown.

In 30 years, the trio of young 'Tanyosho' pines at the western edge of the pinetum with handsome exfoliating red bark may be among the park's most striking conifer groupings.

The Japanese white pine's 1- to 4-inch cones grow in clusters at the branch tip, causing boughs to bend gracefully. Eventually, they turn brown and persist for up to six years.

Austrian Pine *Pinus nigra*

Introduced to America in 1759, the Austrian pine is widely planted as an ornamental in the Northeast. This handsome European native has been favored for its dense pyramidal outline and long, lustrous needles, which may persist for four and, occasionally, eight years. The paired needles of the Austrian pine are stiff and stout and do not snap when bent.

Terra-cotta storage jars, or amphorae, were used extensively by the ancient Greeks, Romans, and Egyptians to transport wine, nuts, grains, fish oil, and other commodities. Data obtained from mass spectrometers indicate that amphorae were frequently coated with pine pitch to prevent leakage.

The Austrian pine, also known as the European black pine, is native to most countries of the northern Mediterranean region, including Spain, Corsica, Italy, the Balkan nations, and Turkey. The largest stands of Austrian pine are in the mountains of the Balkans. Today in Mediterranean countries, its wood is used both for construction and for paper pulp.

In ancient times, Austrian pine wood played a crucial role in the rise of Athens as a major maritime power. Themistocles, a great Athenian soldier and politician, persuaded the Athenian Assembly in 482 B.C.E. to build 200 triremes, light, highly maneuverable ships with formidable rams on their bows and three tiers of oars on both sides manned by 170 oarsmen. The wood for the hulls of these triremes was probably mostly Austrian pine that Athens imported from the mountains of southern Italy and the island of Euboea, northeast of Athens. With its hastily built armada of triremes, Athens was able to defeat the Persians at Salamis in 480 B.C.E. and establish naval supremacy in the Aegean for more than 60 years.

Due to its lightness and relative abundance, pine lumber was undoubtedly widely used for both warships and merchant ships in the ancient Mediterranean. Analysis of a Punic warship sunk off northern Sicily revealed that most of its hull planks were pine.

The Austrian pine is the second most common pine in Central Park; about 200 individual trees were present in 2013. In the 1982 tree inventory, however, the Austrian pine population stood at 380, making it the park's most numerous pine at the time. Due to Diplodia tip blight, a disease that affects all pines but the Austrian pine the most severely, the species is no longer planted in the park and is being replaced by Himalayan pines, white pines, and other species such as the Korean pine.

▲ *A squirrel pauses before scurrying up an Austrian pine. This tree is one of several Austrian pines planted over 5? years ago just east of the Conservatory Water. Older tree? develop bark with plates up to 1 foot long and 4 inches wide.*

▶ *A cluster of 40-foot Austrian pines flanks a path leading from the crest of Cedar Hill to the West Drive. The Austrian pine and the Corsican pine, another sub? species of the European black pine, were among the first trees planted by Olmsted's gardeners in Central Park.*

▼ *Austrian pine cones mature two years after fertiliza? tion by pollen from male cones. Maturing 2- to 3-inch cones change from yellow-green to brown in the fall of their second year and release seeds in winter and spring.*

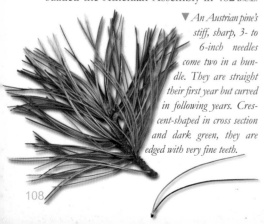

▼ *An Austrian pine's stiff, sharp, 3- to 6-inch needles come two in a bundle. They are straight their first year but curved in following years. Crescent-shaped in cross section and dark green, they are edged with very fine teeth.*

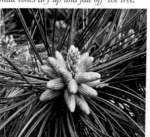

▼ *Clusters of male Austrian pine cones develop in spring. Pollen is wind carried to female conelets, which are receptive for only two or three days. After pollen distribution, male cones dry up and fall off the tree.*

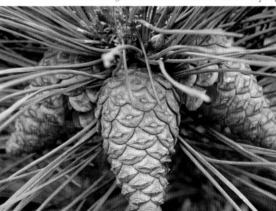

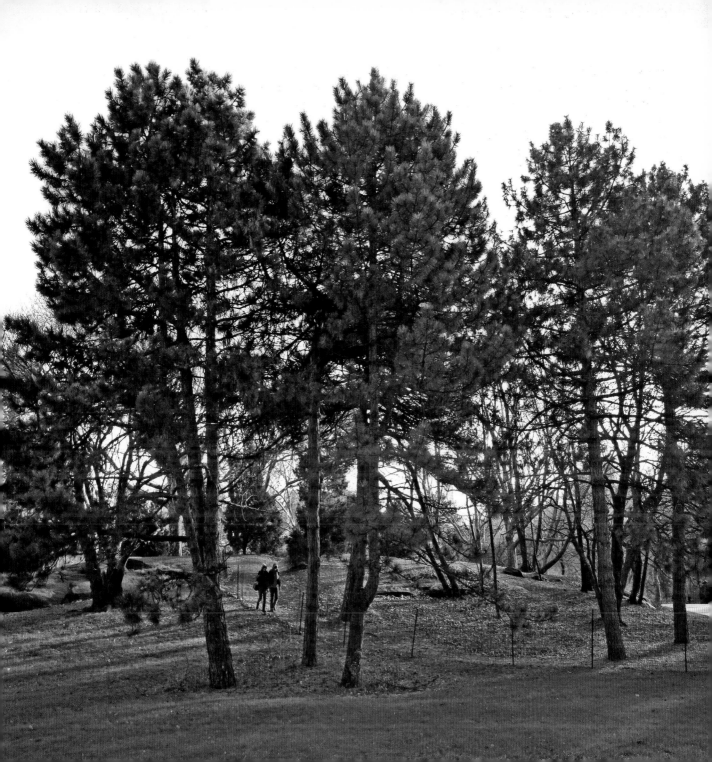

Eastern White Pine

Pinus strobus

The Eastern white pine was the monarch of the vast aboriginal forests of the Northeast. When Europeans first arrived in North America, pure stands of white pine covered large portions of Pennsylvania, New York, and New England. Trees 150 feet tall with trunks free of branches for the first 80 feet were common, and giants towering 240 feet are on record. Topping out at 183.6 feet, the current champion white pine is the Longfellow Pine in Cook Forest State Park, Pennsylvania.

Launched in 1637, the *Sovereign of the Seas* was the greatest British ship of the 17th century. Covered with gilded carvings, its three-deck hull was 215 feet long and armed with 102 brass guns firing broadsides with two tons of canonballs. Each mast was made of a single white pine trunk. The 99-foot main mast was 35 inches in diameter at its base.

Many great old-growth white pines of colonial times fell before the woodsman's ax and were shipped to England to become masts of British naval vessels. A good mast tree was worth £100—a small fortune in those days. The Charter of Massachusetts Bay (1691) contained a clause reading: "For better providing and furnishing of Masts for our Royal Navy wee do hereby reserve to us Our Heires and Successors ALL trees of the diameter of 24 inches and upward of 12 inches from the ground, growing upon any soils or tracts of land within our said Province." After 1722, colonists were forbidden to fell white pines over 8 inches in diameter unless a contract and license were obtained from the Royal Navy. The largest trees were branded with three ax cuts like a crow's footprint known as the King's Broad Arrow, signifying that the trees were the property of the British monarch.

White pine wood shrinks less than other softwoods and is used for window sashes, doors, molding, furniture, and siding. Mature white pines tend to be tall and straight, but when a tree is attacked by the white pine weevil, which kills the lead shoot, side branches take over, creating a forked trunk. Fire fosters pure white pine stands. Older trees protected by their thick bark survive the flames and reseed the forest floor, where competitors have been eliminated.

Well over 400 mature white pines are now growing in Central Park. The white pine was probably present in the pre-colonial forests of Manhattan, but it was not noted on the park's site in 1857. However, it was among the first conifers planted in the 1860s.

▲ *Named* Pinus strobus *'Pendula,' this weeping white pine cultivar, with its drooping limbs and leader looping back toward the ground, will probably not grow much taller than 15 feet. It is one of several planted in the eastern and western sections of the Arthur Ross Pinetum.*

▶ *Snow over ice has produced a beautiful but potentially limb-breaking frosting on two white pines bordering a path leading from the East Drive to the Great Lawn.*

▼ *The pyramidal growth habit and whirled branch structure of these white pines are dramatically silhouetted against the Metropolitan Museum's stark western facade.*

▼ *The slender, blue-green, 3- to 5-inch needles of the Eastern white pine drop off after two to three years. Triangular in cross section with the inner side marked by three to five lines of tiny stomata, they are edged with very fine teeth.*

▼ *Mature 3- to 7-inch, slender Eastern white pine cones are reddish-brown. The scales are thin, rounded, without prickles, and often whitened at the tip by resin. Cone production begins when trees are five to 10 years old.*

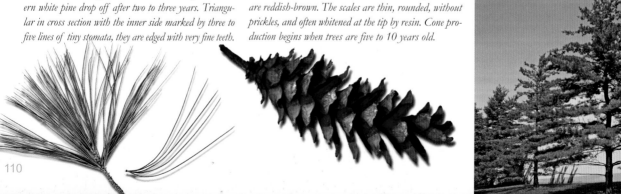

Himalayan Pine *Pinus wallichiana*

Also known as the Bhutan pine and blue pine, the Himalayan pine is considered by many to be the world's most beautiful pine. This Asian species is similar to the Eastern white pine, but its features are exaggerated a bit. For example, like the Eastern white pine, the Himalayan pine has five slender needles in a bundle, but they are up to 3 inches longer than its North American relative's. Its cone, too, looks very much like that of the Eastern white pine, but it is much larger.

Nathaniel Wallich (1786–1854), born in Copenhagen and trained as a surgeon there, travelled in 1807 to India, where he became botanist for the British East India Company and director of its botanical garden in Calcutta. He sent many plants back to England, including the Himalayan pine.

The Himalayan pine and the Eastern white pine share an ancestor that was likely widespread 150 million years ago. Since then, however, Earth's surface has undergone a series of upheavals. The supercontinent Laurasia broke up. The Indian subcontinent collided with Eurasia as North America and Eurasia were drifting apart. New mountain ranges, such as the Himalayas, soared skyward. Massive ice sheets advanced and retreated. Sea levels fell, only to rise once more, exposing and submerging land bridges between continents. Populations of plant species such as the common ancestor of the Himalayan pine and the Eastern white pine, which ranged across the north temperate zone, shrank and fragmented into isolated pockets, cut off from one another by mountains, glaciers, oceans, and changing climates. Once separated, these pocket populations proceeded to go their own ways, evolving into different species.

The first Western scientist to write about the trees of Nepal, Scottish doctor and naturalist Francis Buchanan-Hamilton, in his book *An Account of the Kingdom of Nepal* (1802), mistook the Himalayan pine for the "Weymouth pine"—the British name for the Eastern white pine. The first botanist to recognize the Himalayan pine as a new species was Nathaniel Wallich, a Danish doctor and botanist employed by the British East India Company. Wallich named the tree *Pinus excelsa*. Later it was renamed *Pinus wallichiana* in Wallich's honor.

The Himalayan pine was not mentioned in the plant survey of 1875, but Louis Harman Peet located five "Bhotan pines" in *Trees and Shrubs of Central Park*. Thirty-five Himalayan pines were in the park as of 2013, and more are being planted. The species is very adaptable to urban conditions and far outperforms the park's Eastern white pines.

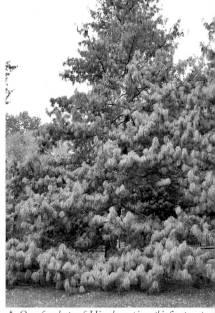

▲ *One of a cluster of Himalayan pines, this fine tree stands next to the entrance to the Arthur Ross Pinetum on the northwestern section of the path circling the Great Lawn.*

▶ *A panoply of blue-green epaulets, the wide-spreading, gracefully curving needles of the Himalayan pine are among the most beautiful leaves produced by any conifer and give the species an elegant weeping habit.*

▼ *The snow-covered face of Nanga Parbat, the ninth highest mountain in the world, hovers above a mixed forest of tall Himalayan pines and firs in northern Pakistan at the western end of the Himalayas. In Bhutan, at the eastern end of the Himalayas, dense secondary stands of Himalayan pine (inset) have replaced more diverse forest.*

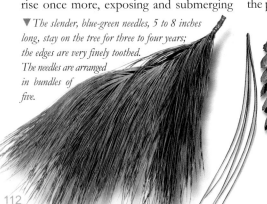

▼ *The slender, blue-green needles, 5 to 8 inches long, stay on the tree for three to four years; the edges are very finely toothed. The needles are arranged in bundles of five.*

▼ *The slender cones of the Himalayan pine are 7 to 12 inches long and hang high on the tree, upright at first but later pendant. The scales are bluish-green when young but mature to brown.*

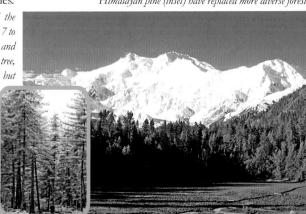

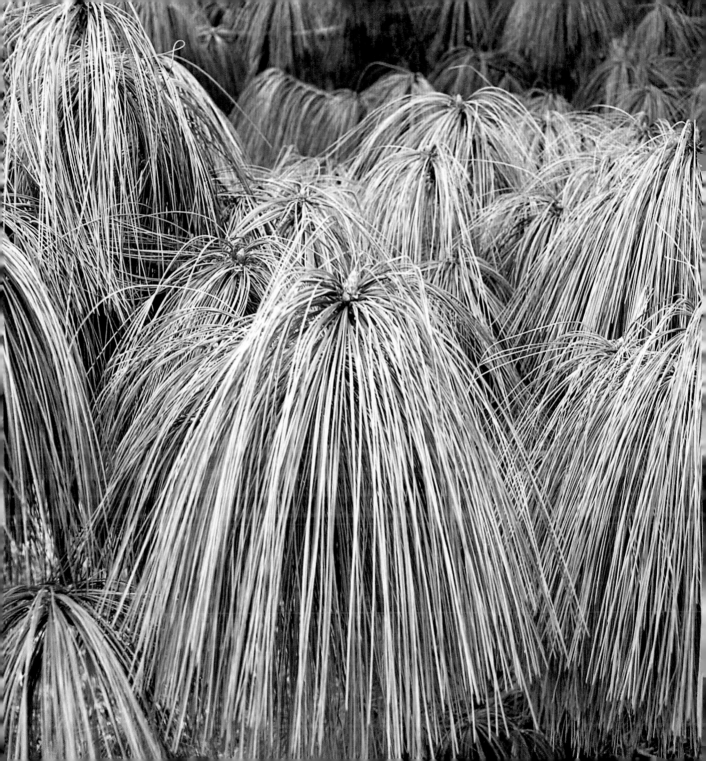

Spruce *Picea* spp.

Spruces are a boreal tribe, native to cooler temperate regions of the Northern Hemisphere and to mountain slopes farther south. There are about 40 species in the genus *Picea*. Seven species are North American and the rest, European and Asian. Central Park contains spruces from all three continents: the Norway spruce (*Picea abies*) from Europe, the Oriental spruce (*P. orientalis*) from Asia, and the Colorado blue spruce (*P. pungens*) and white spruce (*P. glauca*), both from North America.

At first glance, spruces and firs look quite similar. Both have conical habits suited to shedding snow and branches in more or less regular whorls. Spruce needles are stiffer and sharper at their outer end than are fir needles, and each spruce needle is attached to its twig by a peg-like structure. Fir needles, though, are attached directly to their twigs. Another distinguishing feature is that spruce seed cones are upright as they develop but hang pendulously once they are fertilized by pollen from male cones. Fir cones are always upright and do not drop whole from the tree; instead, they disintegrate on the tree, dropping individual seed scales.

The most common spruce in Europe, the Norway spruce, was introduced to North America in colonial times and has been widely planted in the East as an ornamental and a windbreak. In its native habitat, the tree may grow more than 100 feet tall with a trunk over 3 feet wide. The Norway spruce exhibits great natural variation, and there are hundreds of cultivars, including several weeping types.

In the Fulu Mountains of Sweden, a clump of Norway spruce roots periodically sprouts stems that sometimes live as long as 600 years, and portions of the root system itself have been proved by carbon dating to be over 9500 years old.

For centuries, older Norway spruce trees growing on the slopes of Italy's Dolomite Mountains have supplied wood with narrow growth rings, ideal for making violins and other stringed instruments.

Several spruce species were planted early in the park's history, including the Norway spruce and the Oriental spruce. As of 2013, there were about 36 Norway spruces in the park, two Oriental spruces, two white spruces, and one Colorado blue spruce.

Made in 1703 by the legendary Cremonan luthier Antonio Stradivari (1644–1737), this violin has a top of Norway spruce wood harvested from an old-growth mountain tree with very narrow annual rings.

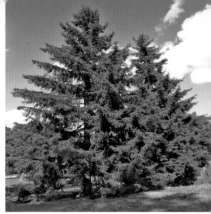

▲ *The Oriental spruce pair just northeast of the Mineral Springs Pavilion at the northern edge of Sheep Meadow exhibit broad pyramidal habits with nearly horizontal branches fringed by pendulous twigs. Often, however, these natives of Asia Minor and the Caucasus are narrower.*

▶ *With tier after tier of gracefully curving branches, Norway spruces planted on Cedar Hill in 1973 have reached their prime. As they age, they will become less symmetrical.*

▼ *The lone example of its species in the park, a white spruce stands northwest of the Conservatory Water. Somehow it manages in a climate far too warm. It is native to Alaska and Canada, where it grows right up to the tree line.*

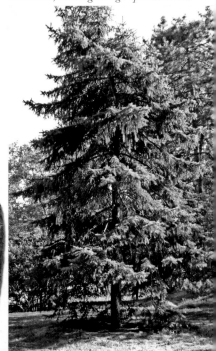

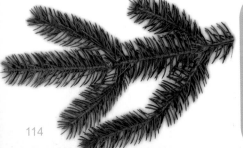

▼ *Norway spruce needles are stiff, sharp, four-sided, and ½ to ¼ inch long. Each dark-green needle has tiny dotted lines of white stomata visible with a hand lens. Attached by pegs (inset), needles remain on a tree for six or seven years.*

▶ *Upright until pollinated, then pendulous, spruce seed cones develop in spring on higher branch tips. Seeds scatter in fall; old cones drop whole in spring. A Norway spruce cone (right) may be over 7 inches long; an Oriental spruce cone (left) is seldom more than 3 or 4 inches long.*

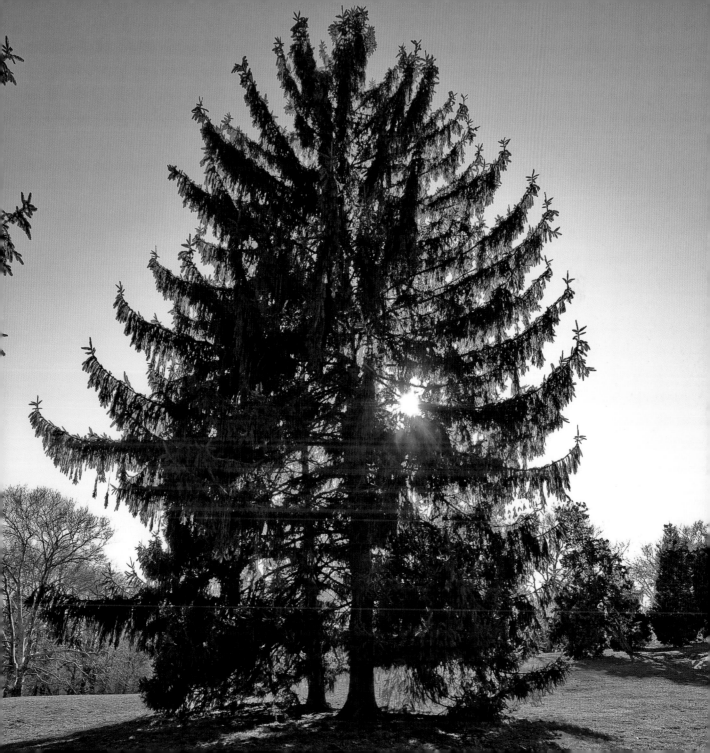

Colorado Blue Spruce *Picea pungens*

In the summer of 1862, Charles Christopher Parry, a British-American doctor, botanist, and mountaineer, encountered a stately, conical spruce tree with stiff, blue-green to dark-green needles while he was exploring and botanizing in the Colorado Rocky Mountains near Pikes Peak. It was the tree that we now call the Colorado blue spruce.

Charles Christopher Parry (1823–1890) studied medicine at Columbia University and botany under Asa Gray, John Torrey, and George Englemann, three of America's most distinguished botanists.

During the same summer of 1862, Parry also discovered another spruce very similar to the Colorado blue spruce, a tree now known as the Englemann spruce. Close cousins, these two trees are sometimes intermingled on alpine slopes, but the Colorado blue spruce tends to grow low on mountainsides near streams, while the Englemann spruce usually grows higher in drier terrain all the way to the tree line. The only significant visual differences between the two species are their cone size and twig growth. The Colorado blue spruce has cones around 3 to 4 inches long and small twigs growing from the main trunk between large branches, whereas the Englemann spruce has cones less than 3 inches long and few, if any, twigs growing between branches.

Dubbed the "king of Colorado botany" by Sir Joseph Hooker, director of the Royal Botanic Gardens at Kew, Parry discovered more than 100 Colorado plant species, including the Colorado blue spruce, during 20 years of collecting in the state.

Although its natural range is limited primarily to the central and southern Rocky Mountains, the Colorado blue spruce is one of the best-known western conifers. A number of Colorado blue spruce cultivars such as 'Glauca,' 'Koster,' and 'Thomsen' with striking blue colors are propagated by grafting and planted as ornamentals throughout North America and Europe. The silvery-blue color is caused by a powdery, waxy substance on the needles. The species name *pungens* is from a Latin word meaning "to prick"—a reference to the stiff, sharp needles. A slow grower, the tree may live for 500 or more years in the wild and attain heights of over 120 feet.

There have never been many Colorado blue spruce trees in the park. Louis Harman Peet mentioned two in *Trees and Shrubs of Central Park*. The tree census of 2008 also included just two. Now the tree northwest of the Conservatory Water is the only one.

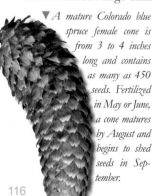

▼ *A mature Colorado blue spruce female cone is from 3 to 4 inches long and contains as many as 450 seeds. Fertilized in May or June, a cone matures by August and begins to shed seeds in September.*

▼ *Bark on a mature tree is gray, rough, and scaly with an orangish under layer.*

◄ *At pollination time in May or June, immature male and female cones may be rose-red or yellowish-green.*

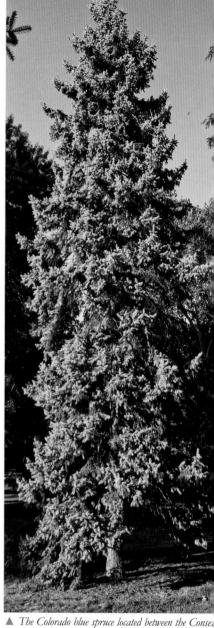

▲ *The Colorado blue spruce located between the Conservatory Water and the East Drive exhibits the narrow profile of a tree adapted to mountain snowfalls and high wind.*

▶ *The stiff, sharp, four-sided, ½- to 1¼-inch needles of the Colorado blue spruce range in color from dull gray-green to blue-green to silver-blue. New foliage is bluer than old. Needles remain on a tree for eight or nine years.*

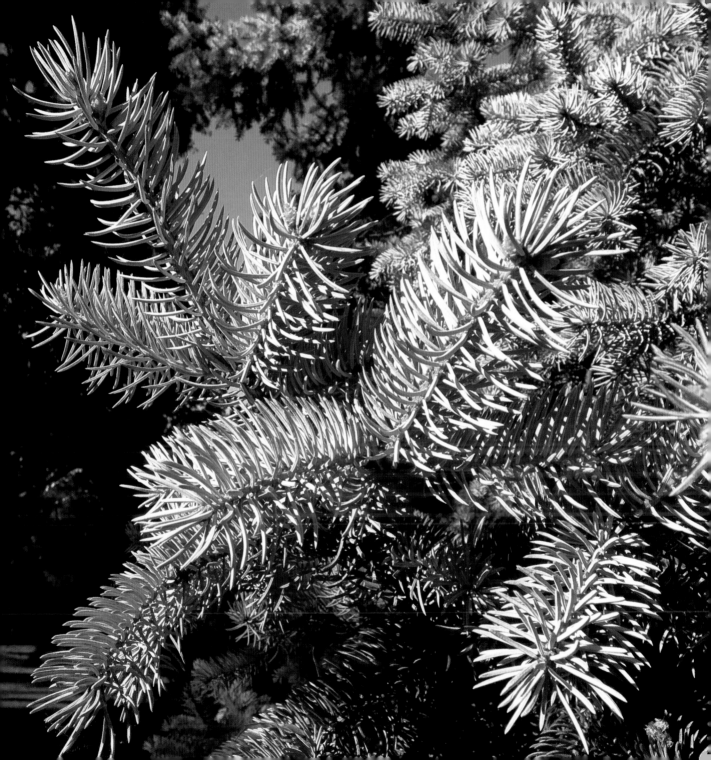

Ginkgo *Ginkgo biloba*

The ginkgo is the sole remaining member of an ancient arboreal order. Its closest living relatives are the palm-like cycads, the only other seed plants to have motile sperm cells. The ginkgo's lineage can be traced back nearly 250 million years. Although only a single ginkgo species is known today, several species once coexisted with the dinosaurs and were widespread in both hemispheres. By the conclusion of the last ice age, however, just a few wild ginkgos were left in mountain valleys of eastern China. Fortunately, Buddhist monks planted the trees around their monasteries and temples, and today some of these compounds are shaded by ginkgos over 1500 years old. In the early 18th century, European visitors brought cuttings and seeds home. The ginkgo proved to be tolerant of difficult urban growing conditions, and it is now found in cities the world over.

Ginkgo seeds are deemed by some to be delicacies. After collecting the smelly, fruit-like seeds when they drop to the ground in fall, Asian people peel and either roast or boil them. Herbalists say that ginkgo leaf extracts improve circulation and memory.

In spring, the ginkgo bears inconspicuous male cones and female ovules on separate trees. Male trees are preferred because of the malodorous fruits that females drop.

The first printed description of the ginkgo appeared in Engelbert Kaempfer's *Amoenitatum exoticarum* (1712). In 1771, the great Swedish taxonomist Carolus Linnaeus named the species *Ginkgo biloba,* which refers to its two-lobed leaves. By 1785, William Hamilton, a wealthy Philadelphia horticulturalist, had imported several ginkgo trees, one of which still stands in John Bartram's garden by the Schuylkill River.

Over the years, both male and female ginkgos have been planted in Central Park. As of 2013, there were about 350 trees in the park. The females do sometimes create unpleasant odors as their seeds mature and drop to the ground. However, the ginkgo tree more than makes up for its occasional olfactory infractions. It is free from insect pests and diseases. Its yellow foliage is spectacular in fall. And with its stiff, spiky branches and corky gray bark, it is a distinctive presence in the winter landscape.

A near-perfect impression of a ginkgo leaf is preserved in this 50-million-year-old rock from the Tranquille Shale deposits of Cache Creek, British Columbia. Some ginkgo fossils are much older, dating back over 200 million years to the late Paleozoic era.

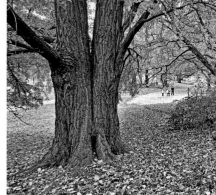

▲ *The largest ginkgo in the park, the great twin-trunked tree next to the wall at Central Park West and 88th Street is nearly 5 feet in diameter and about 150 years old.*

▶ *The ginkgo at the western entrance to Sheep Meadow flaunts its autumn finery in mid-October. In four or five days, the leathery leaves will rapidly fall to the ground.*

▼ *Two tiny ginkgo seedlings are sprouting at the foot of their mother tree from seeds that dropped the previous fall.*

▶ *The ginkgo does not flower; instead, a female tree develops stalked ovules in spring. Each ovule is tipped with a pore that exudes a droplet to catch wind-blown pollen from a male tree.*

▶ *The ginkgo's fan-shaped, parallel-veined, deciduous leaves are 1½ to 3 inches wide and may have one or more notches, with or without shallow, irregular teeth. They are yellow in fall.*

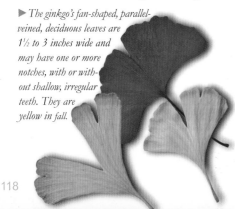

▼ *As ginkgo seeds ripen, they turn from green to yellow and fall off the tree. Then they produce an unpleasant odor as their fleshy coatings rot, exposing the hard inner seeds (inset).*

▼ *In April and May, a male ginkgo tree produces cone-like clusters of pollen sacs that release thousands of four-celled pollen grains. After a pollen grain reaches a droplet on an ovule of a female tree, it is drawn into the pollen chamber. There sperm cells develop and fertilize egg cells in fall.*

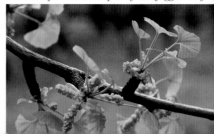

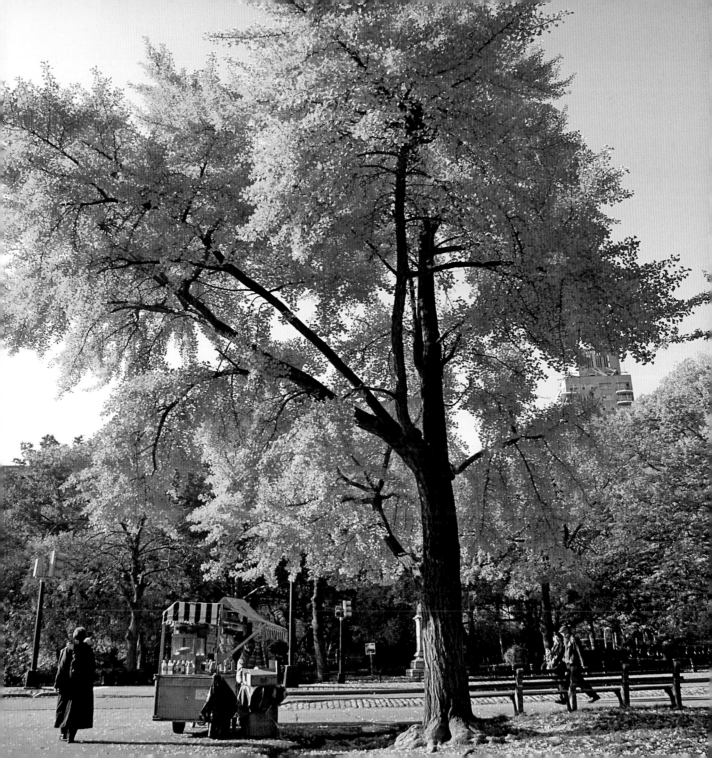

MAPLES

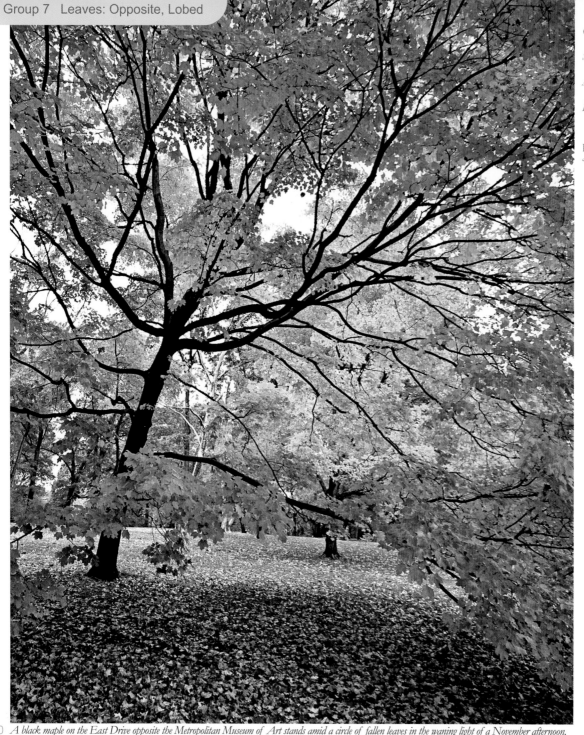

Once they came on a
maple in a glade,
Standing alone with
smooth arms lifted up,
And every leaf of
foliage she'd worn
Laid scarlet and pale
pink about her feet.

Robert Frost,
"Maple"

The national flag
of Canada,
adopted in 1965,
features a stylized
sugar maple leaf.

120 *A black maple on the East Drive opposite the Metropolitan Museum of Art stands amid a circle of fallen leaves in the waning light of a November afternoon.*

The genus *Acer*, maple, consists of about 125 species of trees and shrubs, most of which are native to the Northern Hemisphere. Some reach heights of 125 feet; others never grow more than a few feet from the ground. Often components of climax forests, maples are shade-tolerant trees with dense root systems that inhibit the growth of other trees.

Some maple leaves, such as those of the boxelder, are compound, but most maple leaves, such as those of the sugar maple, are simple, opposite, and palmately veined. Maple flowers are borne in clusters of male and female flowers, usually in early spring when they are important sources of pollen for bees. The fruits are called samaras, or "maple keys," and have wing-like structures attached to the seeds. Shaped to spin as they fall, samaras are released in pairs and may travel like tiny helicopters a good distance from their trees.

Central Park has always had maples, but the maple population has changed greatly over the years. The 1857 survey of the area that was to become the park listed only one species—the silver maple, with 9000 individual trees. The 2008 census listed nine maple species, but they totalled only 1641 trees.

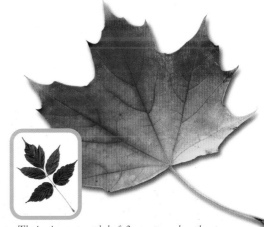

Norway maple flowers erupt from buds in April. These male flowers display pollen-tipped anthers. Female flowers, perhaps on the same tree, will produce mature keys by fall.

Sycamore maple double samaras from 1½ to 2 inches long have paddle-shaped wings that turn from green to brown in late summer. Clusters of samaras hang on trees into late fall.

The iconic sugar maple leaf fires autumnal northeastern forests with golds, oranges, and reds. The boxelder, with its compound leaf (inset), is often mistaken for an ash.

Hedge Maple *Acer campestre*

The hedge maple, also called the field maple, is widely planted in Britain and on the Continent along roads and in hedgerows. Its natural range extends from southern Britain and Sweden east to the Caucasus Mountains and south as far as the Pyrenees, Sicily, and northern Turkey with isolated populations in Spain and North Africa.

The hedge maple can grow over 50 feet tall and live for 250 to 350 years but in most circumstances rarely exceeds 45 feet. Large specimen trees are unusual because most hedge maples are either closely planted and pruned into hedges or crowded among other species in woodlands. Alhough it seldom grows large enough to produce timber for construction, its hard, fine-grained wood is used for cabinetry, carvings, and musical instruments.

British hedgerows can be dated by the tree species found in them. Hedgerows established within the past 200 years often consist of just one or two species, typically hawthorns. Older hedgerows frequently contain hedge maples along with several other species, indicating that they may be very old—possibly remnants of wildwoods that existed before the land was first cleared.

Given a little space, this small European native tree makes a fine ornamental with a round, dense habit. Its usually compact stature and tolerance of pollution make the hedge maple, and its cousin the Amur maple, well suited for urban-street planting.

Hedge maple twigs often, but not always, have corky wings. The sap exuded from a broken leaf stem is white. The neat three- to five-lobed leaves of the hedge maple turn to various shades of yellow in fall.

The hedge maple's Latin scientific name, *Acer campestre* (rural maple), probably originated in Italy. Common in the Italian countryside, particularly in Tuscany, the tree is planted with elms in vineyards to support grapevines.

The hedge maple was introduced to North America in 1822 by the Prince Nursery in Flushing, Queens. It has never been common in the park. Just three specimens were included in the plant list of 1873, two were pinpointed by Louis Harman Peet on maps in *Trees and Shrubs of Central Park*, and eight were counted in the park as of 2013.

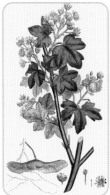

This hand-colored engraving by the British botanical artist James Sowerby (1757–1852) is from Sir James Edward Smith's *English Botany* (1813). It shows a flowering hedge maple branch, winged samaras, and flower parts.

▲ *The trunk bark of a mature hedge maple is brown wi. orange fissures. Bark on twigs and young trunks smoother and gray, but some twigs may be winged (inse.*

▶ *This fork-trunked hedge maple is located by the E. Drive on the western side of Cedar Hill. It is probably least 60 or 70 years old but is only about 30 feet tall.*

▼ *Clusters of yellow-green, ¼-inch hedge maple flowe hang on long stems among newly unfolded leaves in la April or early May. Fragrant, the flowers attra insects that carry pollen from the anthers of one flow to the protruding, twin-lobed ovaries of another flowe*

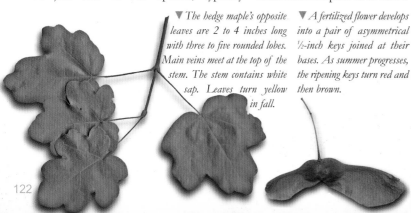

▼ *The hedge maple's opposite leaves are 2 to 4 inches long with three to five rounded lobes. Main veins meet at the top of the stem. The stem contains white sap. Leaves turn yellow in fall.*

▼ *A fertilized flower develops into a pair of asymmetrical ½-inch keys joined at their bases. As summer progresses, the ripening keys turn red and then brown.*

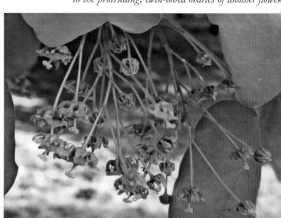

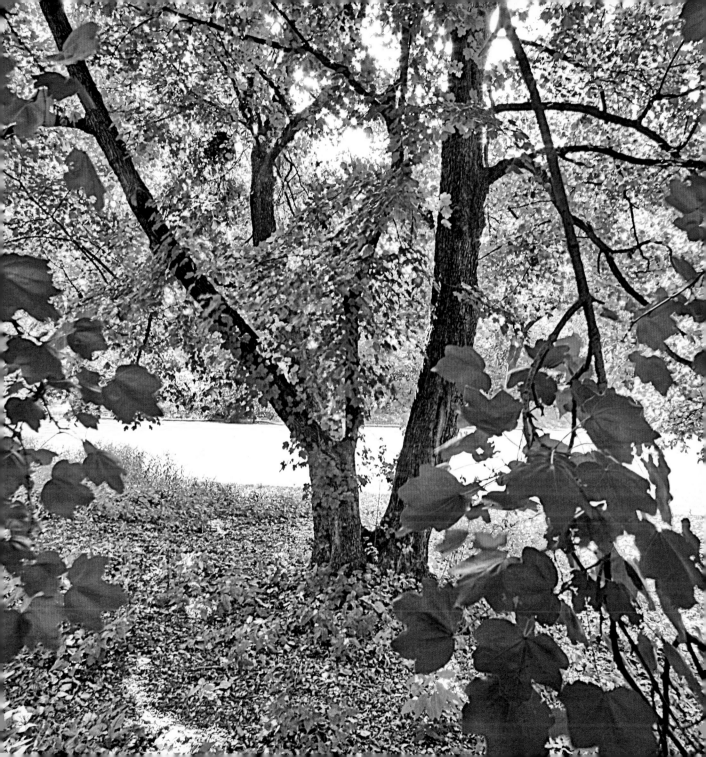

Japanese Maple *Acer palmatum*

The Japanese maple is an aristocrat. Everything about this tree is refined and exquisite—from its slender, sinuous limbs to its delicate, finely cut leaves, which turn to brilliant shades of scarlet, yellow, and orange in autumn. Like all patricians, the Japanese maple has a long and illustrious pedigree. It is native to China, Japan, and Korea, but centuries of selective breeding, first by Japanese gardeners and more recently by Japanese and Western horticulturists, have created the tree we know today, with its hundreds of cultivars.

A pochoir (stencil) print of a Japanese maple bearing the leaves of five cultivars appeared in the 1898 catalog of the Yokohama Nursery. This grafted specimen dramatically illustrates the amazing variability of this beautiful small maple species.

The Japanese maple was first described by an 18th-century Swedish botanist, Carl Peter Thunberg, in his book *Flora Japonica* (1784). However, the tree did not reach the United States until 1862 when a young American physician, George Rogers Hall, delivered Wardian cases containing *Acer palmatum* saplings as well as saplings and seeds of a number of other Asian exotic trees, including the star magnolia and the Japanese zelkova, to Samuel Parsons's nursery in Flushing, Queens. This nursery was located on the site of present-day Kissena Park.

Many Japanese maples now growing in America are descended from the small collection of seeds and seedlings brought to Queens by Hall and cultivated by Parsons & Company. Once established in the United States, however, this small but beautiful and most variable of all maples became increasingly popular, and demand for its multitude of colorful cultivars outstripped the capacity of any single source. By the 1890s, a few Japanese firms were selling seeds and plants directly to American customers. The most successful of these was the Yokohama Nursery, which had offices in New York. Its beautifully illustrated catalogs, written in flawless English and often featuring Japanese maples, continued to be published into the 1920s.

The Japanese maple was not among the trees planted in the park in the 1860s and 1870s. Louis Harman Peet noted only two specimens in *Trees and Shrubs of Central Park*, and neither M. M. Graff in *Tree Trails in Central Park* nor Dennis Burton in *Nature Walks of Central Park* mentioned the Japanese maple. The census of 2008, however, included 14, so this lovely little maple has gained a foothold in the park.

▲ *Known as dissected Japanese maples, a large group of Japanese maple cultivars have lacy leaves varying in color from green (inset) to various shades of red and purple.*

▶ *This lovely full-moon maple is located in the Olmsted Flower Bed at the foot of the Mall. The full-moon maple Latin species name is* Acer japonicum. *A close cousin of* Acer palmatum, *this small winter-hardy maple native to Japan is also commonly called a Japanese maple.*

▼ *Five Japanese maples west of the bust of Thomas Moore edge the eastern side of the Pond. In the foreground to the left and right, respectively, are two low, dissected-leaf varieties, 'Garnet' (red) and 'Viridus' (green). Nearer the water are three taller, nondissected trees, all 'Bloodgood.'*

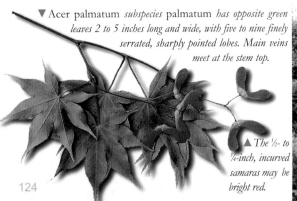

▼ Acer palmatum *subspecies* palmatum *has opposite green leaves 2 to 5 inches long and wide, with five to nine finely serrated, sharply pointed lobes. Main veins meet at the stem top.*

▲ *The ½- to ¼-inch, incurved samaras may be bright red.*

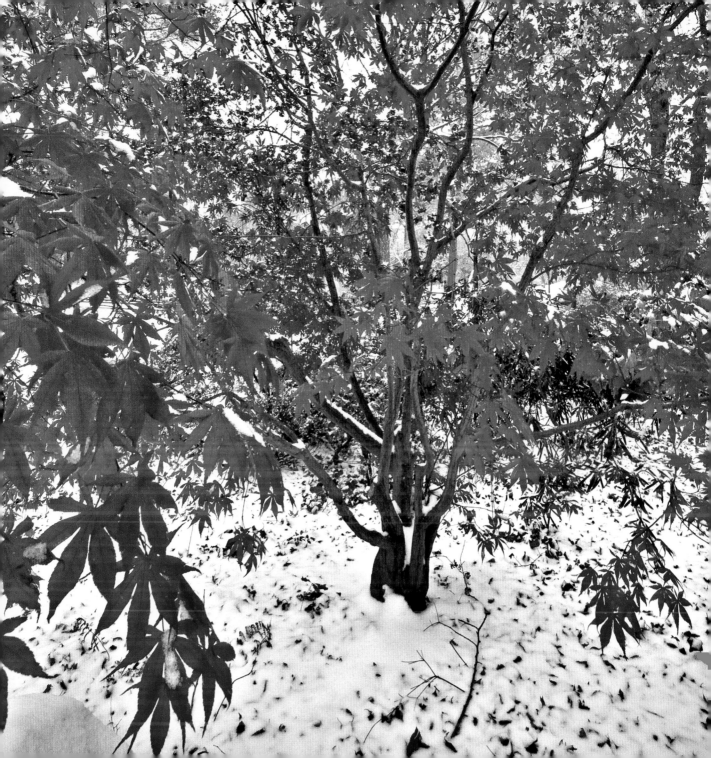

Norway Maple *Acer platanoides*

The Norway maple was introduced to North America by John Bartram, a Quaker botanist who established the first plant nursery in the United States near Philadelphia in 1728. In a letter dated June 20, 1757, Bartram thanked Philip Miller, a British botanist and author of the *Gardners Dictionary* (1731), for sending to Philadelphia a basket of roses and some Norway maple seedlings. "The roses all died," Bartram noted, "but two or three of the maples are alive…and one or two is enough for me, of a sort." His Norway maples must have done well, for in the 1760s Bartram probably sent trees to the Prince Nursery in Flushing, Queens. In 1792, William Bartram, John Bartram's son, sold Norway maple seeds or seedlings to George Washington.

Tolerant of shade, soil compaction, and air pollution, this hardy, fast-growing native of Europe was firmly established as an ornamental by the late 19th century and was planted by the thousands in the 1930s throughout the Northeast to replace trees killed by Dutch elm disease.

The Norway maple's common name is somewhat misleading. Its natural range reaches to only a portion of southeastern Norway but extends east across most of Europe into Russia and south to the northern sections of Spain, Italy, Greece, Turkey, and Iran. In fact, it is the most widespread maple in Europe.

Today this European immigrant is also one of the most widespread—and problematic—urban trees in the eastern United States, and it is no longer planted along streets and in parks. It invades woodlands and disrupts native forest regeneration. It is highly susceptible to a fungal disease called verticillium wilt. And it is a host to a recently arrived, very destructive forest pest, the Asian longhorn beetle, which also attacks other species of maple as well as elm, birch, willow, and poplar.

Not one Norway maple has been intentionally planted in Central Park in more than a decade, but it is still one of the park's most common trees, with a population of more than 500 individuals recorded as of 2013. The park's gardeners pull up every Norway maple seedling they encounter, but more are always springing up.

One of the earliest illustrations of a Norway maple, this engraving by the Dutch botanist Abraham Munting appeared in the third edition of his book *Accurate Description of Terrestrial Plants* (1696).

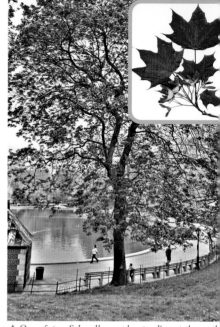

▲ One of two Schwedler maples standing at the southern end of the Conservatory Water, this Norway maple cultivar begins the season with dark-crimson leaves (inset) that slowly turn green as the season progresses.

▶ A Norway maple once at the foot of Cedar Hill displayed thousands of flower clusters on a sunny day in April. If you walk around Central Park at this time of year, you will seldom be out of sight of a flowering Norway maple.

▼ The ground beneath this large Norway maple in the Dene is littered with spent flowers. Norway maple trees in the park flower in mid- or late April just before their leaves unfold. Around ⅓ inch wide, the greenish-yellow flowers (inset) are borne in clusters of 10 to 30 flowers.

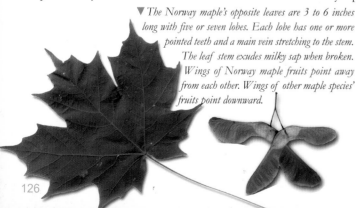

▼ The Norway maple's opposite leaves are 3 to 6 inches long with five or seven lobes. Each lobe has one or more pointed teeth and a main vein stretching to the stem. The leaf stem exudes milky sap when broken. Wings of Norway maple fruits point away from each other. Wings of other maple species' fruits point downward.

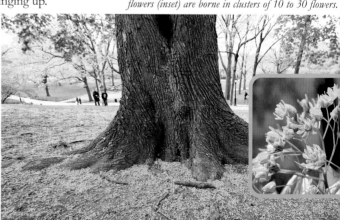

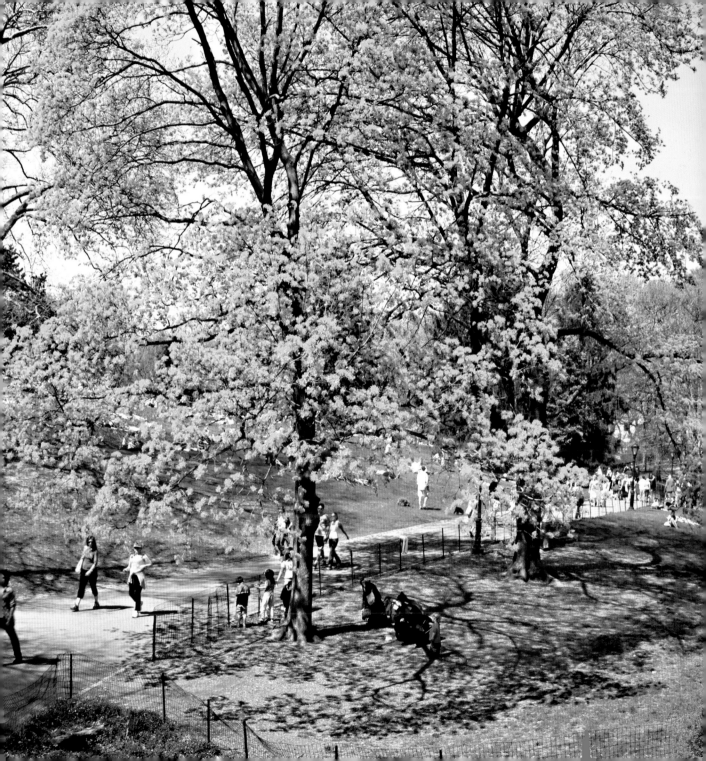

Sycamore Maple *Acer pseudoplantanus*

Introduced to North America from Europe, the sycamore maple has been grown as an ornamental in the Northeast for many years. Its Latin name means "false planetree," and indeed its leaves are similar in shape to those of the American sycamore and the London plane. The word "sycamore" originally referred to the fig species *Ficus sycomorus*, which has been cultivated in the Middle East since biblical times and was often confused with the common fig (*F. carica*), which has a three-lobed leaf somewhat similar to a maple leaf.

Like the Norway maple, which it resembles in size and habit, the sycamore maple is regarded by urban foresters as a weed tree and is no longer recommended for planting in New York City. It reproduces quickly, and its deep-rooted saplings often crowd out native species, so it has become widely naturalized in Great Britain and North America.

A rapid grower, the sycamore maple tolerates sandy or clay-based soils and high salt lev-

Violins made by the Cremonan luthier Antonio Stradivari (1644–1737) have backs made of two pieces of matching figured sycamore maple glued together so expertly that the seam is almost invisible.

els well, but it is subject to disease and boring insects. There are several cultivars of the sycamore maple, such as 'Brilliantissimum' with pinkish new leaves that turn to a creamy yellow, 'Leopoldii' with speckled dark- and light-green leaves, and 'Atropurpureum' with leaves that have a purple underside.

The fine-grained wood of the sycamore maple is nearly white and polishes to a high luster. In Europe, it is used for furniture, flooring, and musical instruments. It is the traditional wood for the backs and scrolls of violins. The particular form of maple preferred by luthiers is so-called figured wood, with beautifully rippled grains known as curly maple, tiger maple, flame maple, and rippled sycamore.

The great violin makers of Cremona, Italy, such as Antonio Stradivari and Andrea Amati, often used figured sycamore maple wood from the mountains of Bosnia that had been submerged for a time in lake water to keep it from cracking. Bacteria in the water stained the wood, giving it a darker, richer color.

The Central Park plant survey of 1873 listed three sycamore maples; Louis Harman Peet located 15 in *Trees and Shrubs of Central Park*; as of 2013, there were over 350 in the park, many no doubt self-seeded.

▲ *Sycamore maple leaves very often turn dingy brown or muted yellow in autumn before they drop. Occasionally however, they assume an arresting bright-gold hue like the leaves of this sycamore maple near Turtle Pond.*

▶ *A mature sycamore maple shades the East Drive near the Reservoir. It was probably planted by gardeners 60 or more years ago. Most younger sycamore maples in wilder areas such as the Ramble and North Woods, are self-seeded.*

▼ *Sycamore maple seed clusters hang quite conspicuously on their trees in late summer and early fall. Every twin samara consists of two seeds fused together, each with a downcurved tail 1 inch or more long capable of catching the wind and whirling the seed a very good distance from its tree.*

▼ *The palmately veined leaves of the sycamore maple are up to 7 inches long and wide. Each leaf is dark green above and whitish- or purplish-green below, with three large coarsely toothed central lobes and two smaller peripheral lobes.*

▶ *Quarter-inch sycamore maple flowers are usually pollinated by insects.*

▶ *Pendulous sycamore maple flower clusters appear in mid-April. The 4- to 6-inch yellow-green racemes consist of 50 or more separate flowers.*

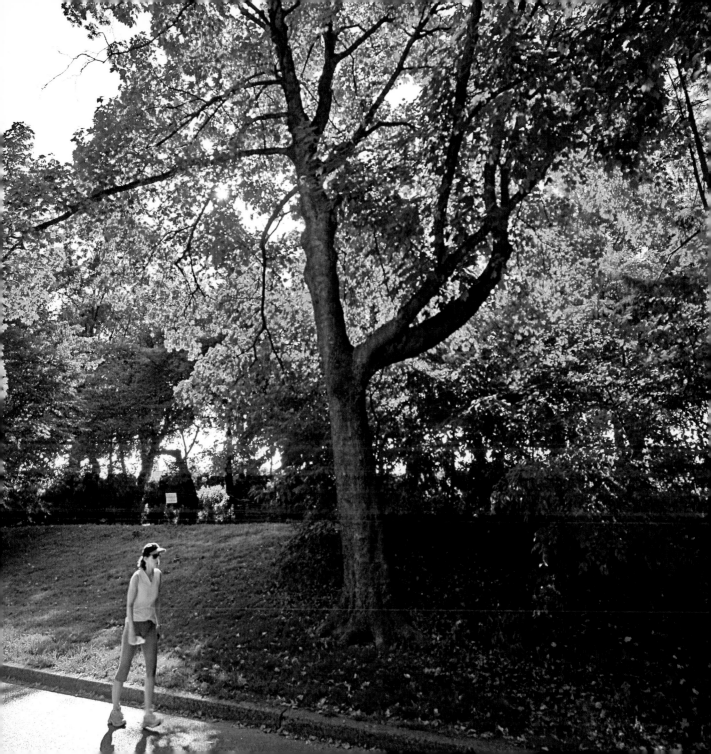

Red Maple *Acer rubrum*

The red maple displays some red in every season. In winter, its red buds give its rounded or irregular crown a dusty-pinkish tinge. In spring, its small, bright-scarlet flowers bloom before the leaves unfold and clothe the tree in a feathery, scarlet mantle. Its unfurling leaves are also tinged red; as they grow larger, they turn green but retain reddish stems. In fall, the red maple's foliage ranges from flaming scarlet to orange-gold to pure yellow. Only the sugar maple equals or surpasses the red maple's extravagant autumn hues.

A hand-colored engraving by Joseph Prestele depicts red maple leaves, keys, and female and male flowers. It is a reproduction of a painting by Isaac Sprague, once an assistant to John James Audubon. Asa Gray, America's foremost 19th-century botanist, commissioned it for his unfinished book project *Forest Trees of North America*.

Few North American trees have a greater north–south range than the red maple. It grows from Canada to the tip of Florida, where it flowers in February. It thrives in a variety of habitats—swamps, lowland forests, and rocky mountainsides up to 3000 feet. It is tolerant of urban conditions and is widely planted in parks.

It grows fast and typically lives around 150 years, but trees over 300 years old grow on the slopes of Mount Wachusett near Worcester, Massachusetts.

The red maple is much more common in the forests of the eastern United States than it once was. It is vulnerable to fire, and North American forests were frequently swept by fires before European settlers arrived. Lightning started fires naturally, and Native Americans regularly burned off forest undergrowth around their villages to make way for agriculture and to improve hunting. Large oaks and chestnuts with their thick bark tended to be less affected by frequent burns, but maples with their thinner bark were easily killed by fire. As a result, red maples in colonial times were largely confined to swampy lowland areas and probably amounted to only about 5 percent of forest cover. Now natural fires are suppressed, and red maples not only are more common but also are among the dominant forest species in many areas.

Central Park's red maple population has increased over the years. The 1875 survey listed just five; Louis Harman Peet located 15 in *Tress and Shrubs of Central Park*; and by 2013, the count had reached more than 200.

▲ *Red maple keys are double samaras, each containing o seed. About 1 inch to 1½ inches wide, the keys develop ju three or four weeks after female flowers are wind pollinate*

▶ *In mid-November, young red maples punctuate the ea of the Great Lawn with brilliant crimson spires. The trees are cultivars bred to produce especially intense reds.*

▼ *Female flowers exhibit forked stigmas for catchi pollen. Red maples are polygamodioecious, meani that some bear male flowers, some bear female flov ers, and others bear both male and female flowers.*

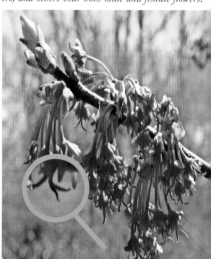

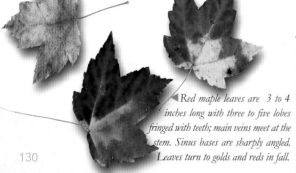

▶ *Red maple leaves are 3 to 4 inches long with three to five lobes fringed with teeth; main veins meet at the stem. Sinus bases are sharply angled. Leaves turn to golds and reds in fall.*

▼ *In late March and early April, the park's red maples are still leafless but covered with tiny red flowers. Some trees bear only male flowers, each with four to 12 stamens.*

Silver Maple *Acer saccharinum*

The silver maple is named for its deeply notched five-lobed leaves, which are green above and silvery white beneath.

A hand-colored engraving by the New York lithographer George Endicott depicts silver maple leaves, keys, and female and male flowers. It is a reproduction of a painting probably by Agnes Mitchell, one of three artists commissioned by John Torrey to illustrate *A Flora of the State of New-York* (1843).

When breezes twist its doubly saw-toothed leaves, a silver maple is riffled with waves of green and silver. Handsome and fast growing, it was once widely planted along streets, especially in the Midwest. As the tree ages, though, it often proves to be weak-wooded and susceptible to limb breakage. For this reason, it is no longer considered appropriate for curb-side planting, and fewer than 5 percent of New York City's street trees are silver maples.

In the wild, the silver maple is most often found along streams, creeks, and rivers, frequently growing beside sycamore, river birch, red maple, and other tree species adapted to riparian habitats. The silver maple flowers in early spring. Its oblong samaras with papery veins mature in May as leaves are unfurling

and twirl down on mud banks, where they germinate almost immediately. A seedling develops rapidly, adding as much as ½ inch annually to its circumference.

The silver maple can withstand temporary flooding but not fire. Its root system spreads wide but is usually shallow. Its brittle branches are likely to snap off when subjected to high winds and ice storms, leaving openings for fungal spores to invade, rot the trunk, and create holes ideal for nesting animals. As a consequence, a silver maple seldom lives for more than 100 years or so.

The silver maple's nearly white sapwood surrounds light-brown heartwood. Softer than red maple or sugar maple wood, it is used for shipping crates, pulp for paper, and inexpensive furniture. Like other maples, the silver maple has sweet sap that can be made into syrup, but its sap is less sugary than sugar maple sap.

In his 1857 report on preparations for the construction of Central Park, Egbert Viele, the park's engineer-in-chief, noted that "drainage of the entire area must precede any attempt at improvement." It was, in his words, a "pestilential spot, where rank vegetation and miasmatic odors taint every breath of air." One of the most common trees then was the water-loving silver maple; 9000 were counted. As of 2013, only seven mature trees were in the park.

▲ *Silver maple saplings sprouted from seeds carried in wind or birds sometimes appear along the stone banks [of] the Reservoir. Silver maple leaves usually turn pale yel[low] in fall, but occasionally they take on scarlet or crimson h[ues].*

▶ *A silver maple with typical gray bark broken into lo[ng] narrow scales formerly stood at the southern edge of Ce[ntral] Hill's lawn. Low branches made its leaves easy to exam[ine].*

▼ *Female (left) and male (right) flowers flank unopen[ed] flowers on a twig tip. Some silver maple trees bear flo[w]ers of only one sex; others bear male and female flowe[rs].*

▼ *Opposite leaves 4 to 6 inches long have five lobes with coarse, irregular teeth; lobes are separated by deep notches. Veins meet at the base of the stem. Leaves are green above and silvery white beneath. Young leaves have very thin lobes; older leaves have thicker lobes.*

▼ *By early May, a silver maple bears clusters of paired fruits, or samaras, among its newly unfurled leaves. The wings of the 1½- to 2½-inch fruits diverge at around 30 to over 40 degrees.*

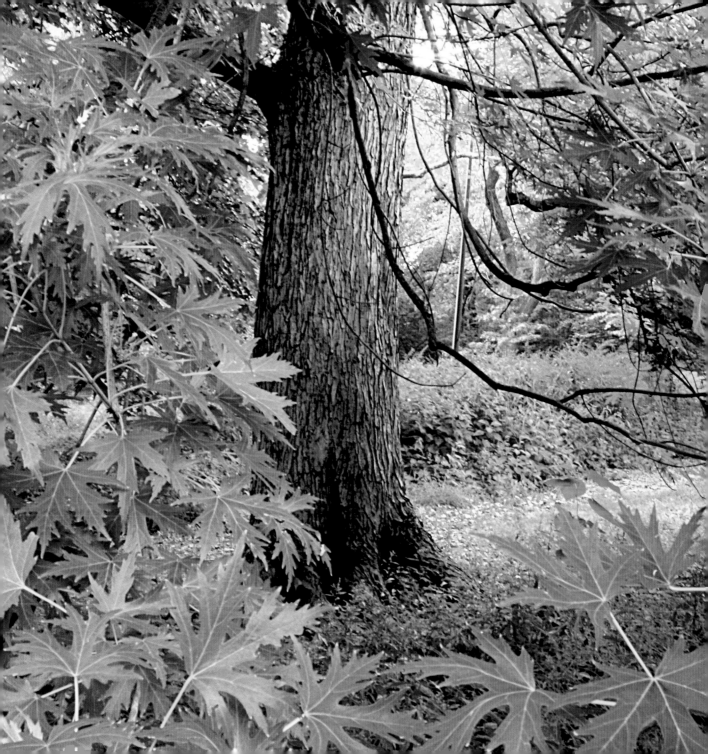

Sugar Maple *Acer saccharum*

Although its range extends as far south as the Carolinas, Georgia, and Texas, the sugar maple is thought of as a northern tree. It is the source of Vermont maple syrup. Its leaf is on Canada's flag. Its fall foliage emblazons New England's villages and mountain slopes with flamboyant displays of color. In New York City's forests and parks, it is often found alongside elms, pin oaks, and Norway maples, but it is not planted as a street tree. Intense heat radiating from pavements causes leaf scorch, and pollution and salt runoff weaken its resistance to fungal infections and insect pests.

A plate from *The North American Sylva* by François Michaux (1770–1855) depicts a sugar maple bough with three leaves, three paired samaras, and male flowers. Michaux remarked of the samaras: "Externally, they appear equally perfect, but I have constantly found one of them empty."

Although all maples have sugary sap, sugar maple sap is the sweetest and is used to make most of the maple syrup and maple sugar sold in stores. Sugar maple sap is typically about 2½ percent sugar, but some trees have been bred to yield sap with more sugar. Around 200 to 250 gallons of sap may rise through a mature tree on a spring day. A grove of producing sugar maples, or a sugar bush, as such groves are called in New England, is usually tapped at the first flow of sap in early spring when the sugar content is highest. Freezing nights alternating with warmer, thawing days help to convert carbohydrates stored in the stem wood into sugar, which dissolves in flowing sap. The sap is boiled until it thickens into maple syrup. It takes about 32 gallons of sap to make a gallon of syrup. Some of the syrup may then be evaporated further to make maple sugar candy. A gallon of syrup produces up to eight pounds of maple sugar.

The black maple is another maple with sap almost as sweet as the sugar maple's, and it is also frequently tapped for maple syrup, particularly in Canada. Some taxonomists classify the black maple as just a subspecies of the sugar maple. Abundant in the Midwest, the black maple grows in drier, warmer places than the sugar maple. West of the Mississippi in Minnesota, Iowa, and Missouri, it is more common than the sugar maple.

There were over 50 mature sugar maples in the park as of 2013. Hundreds of seedlings have also been planted recently in the Ramble and North Woods. When a canopy opening occurs due to a storm or a fallen tree, a young sugar maple may be there to close the gap.

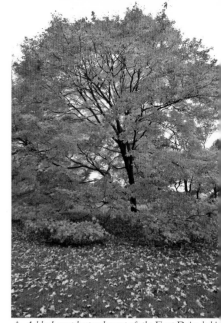

▲ *A black maple stands west of the East Drive behind the Metropolitan Museum of Art. This maple species resembles the sugar maple in its form and autumn colors.*

▶ *A sugar maple nearly 60 feet tall displays its vivid autumn colors in mid-October. It stands next to a flagpole west of the Naumburg Bandshell. Only the sweetgum, red maple, and black tupelo among the park's large native trees can rival the fall colors of the sugar maple and black maple.*

▼ *Female sugar maple and black maple flowers produce ripened fruits in the form of paired samaras by September. The ripe samaras quickly fall from their trees by the thousands and twirl away on their ½- to 1-inch wings.*

▼ *Both sugar maple and black maple leaves are opposite. Sugar maple leaves (right) are 3½ to 5½ inches long with three wide and two narrow lobes; black maple leaves (left) are a bit smaller with three wide lobes and few teeth.*

▼ *Sugar maples and black maples start flowering in their early twenties. Flowers appear in April as leaves are unfolding. The pendant yellowish-green flowers are either male with brown anthers or female with forked pairs of stigmas.*

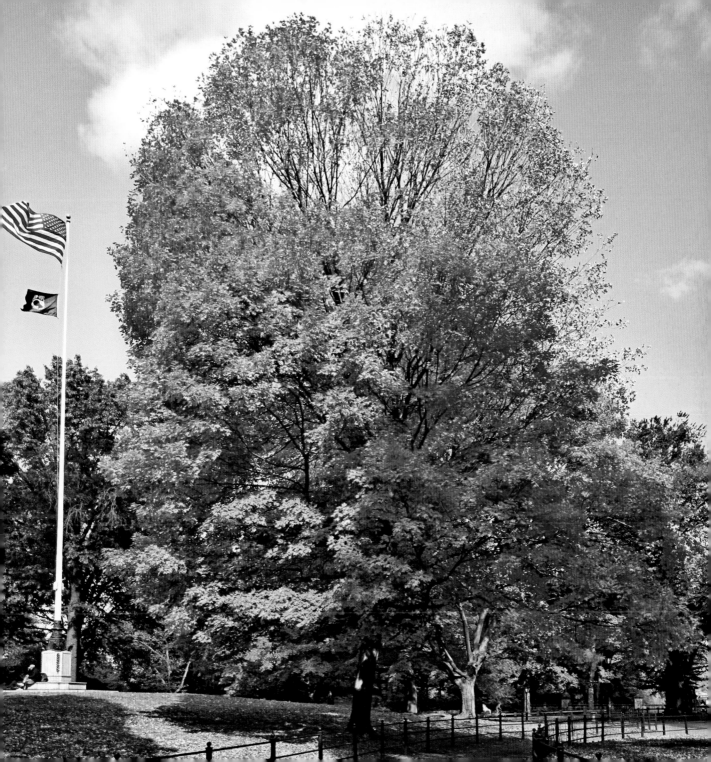

Amur Maple *Acer tataricum* ssp. *ginnala*

Named for the Amur River, which forms the border between the Russian Far East and northeastern China, the Amur maple is a hardy, small tree native to eastern Siberia, Manchuria, and northern Japan. Botanists classify it as a subspecies of the Tatarian maple, a similar maple native to southwestern Russia. The chief difference between the two trees is that the Amur maple usually has a three-lobed leaf with an extended central lobe, whereas the Tatarian maple has an oval leaf with smaller lobes or no lobes at all.

Stepan Petrovich Krasheninnikov spent 10 years exploring Siberia and studying its natural history on Vitus Bering's Second Kamchatka Expedition (1731–1742). Later he headed the St. Petersburg Academy of Science's botanical garden and taught botany at the university.

A Russian explorer and scientist, Stepan Petrovich Krasheninnikov (1711–1755), was the first European to describe the Tatarian maple. Proud of his paper on the tree, published in 1749 in the St. Petersburg Academy of Science's journal, Krasheninnikov sent a copy to the great Swedish botanist Carolus Linnaeus, who responded enthusiastically, remarking that "more unknown plants have been found in ten years in the Russian Empire than in the whole world in half a century." In addition, Linnaeus paid Krasheninnikov a high compliment by including the Tatarian maple as *Acer tataricum* in his monumental treatise *Species Plantarum* (1753), giving full credit to the Russian botanist's paper. The drawing of the leaves and flowers accompanying the article was so detailed that Linnaeus apparently deemed a dried sample mounted on a sheet of paper unnecessary and referred to only the drawing.

A hundred years passed before another Russian explorer and botanist, Carl Johann Maximowicz (1827–1891), discovered the Amur maple on a trip to the Russian Far East and described it as *Acer ginnala* in an 1856 paper. For a time, the Tatarian maple and the Amur maple were considered separate species. A few years later, a Belgian taxonomist, Alfred Westmael (1832–1905), postulated that the Amur maple is not a separate species but a subspecies of the Tatarian maple and dubbed it *Acer tataricum* ssp. *ginnala*.

Only a few Amur maples have been recorded in the park. At present, there is only one. Louis Harman Peet noted one individual in the Ramble in *Trees and Shrubs of Central Park*. The plant list of 1873 included two Amur maples, both in the northeastern section of the park.

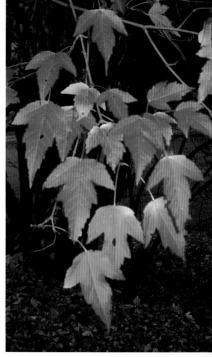

▲ *Amur maple leaves turn to vivid yellows, orange, and reds in fall, with the brightest colors displayed whe days are crisp and sunny. In spring, the Amur map. is among the first of the park's maples to leaf out.*

▶ *Located along the East Drive near the Loe Boathouse, this multi-trunked Amur maple develope from a stump. Amur maples tend to be multi-trunke and seldom grow much taller than 20 feet.*

▼ *Clusters of yellow-white Amur maple flowers unfu in late April or early May. They are fragrant and attra insects, though the tree is usually wind pollinated.*

▶ *The Amur maple's leaves are 1½ to 3 inches long, usually with a prominent central lobe and two smaller side lobes but occasionally unlobed. The edges are serrated with irregular, jagged teeth. The wings of the 1-inch fruits are translucent (left).*

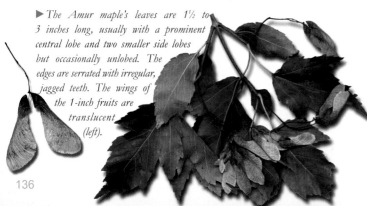

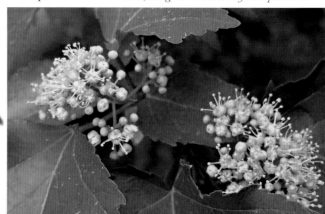

Oakleaf Hydrangea

Hydrangea quercifolia

On a pleasant evening in June 1776, William Bartram (1739–1823), the son of John Bartram, a self-taught Philadelphia botanist, was camping in Georgia next to a large brook not too far from present-day Macon. There he observed "a very singular and beautiful shrub…a species of Hydrangia.…[T]he stems grow five or six feet high…and these again divide, forming others which terminate with large heavy pannicles…of flowers, but these flowers are of two kinds…a multitude of very small fruitful flowers…[and] very large expansive neutral or mock flowers.…[T]hese neutral flowers, with the whole pannicle, are truly permanent, remaining on the plant…until they dry and decay; the leaves which clothe the plants are very large…very much resembling the leaves of some of our Oaks."

This first printed mention of the oakleaf hydrangea appeared in William Bartram's *Travels*, the account of his five-year journey through Florida, Georgia, and the Carolinas in the mid-1770s. Bartram's book contains not only very accurate written descriptions of the plants and animals he encountered but also meticulously rendered illustrations.

The genus *Hydrangea* consists of about 75 species of flowering plants. The majority of *Hydrangea* species are native to China, Korea, and Japan, but the genus also has members in North and South America, the Himalayas, and Indonesia. Most hydrangeas have rounded clusters of small fertile flowers with very small petals, surrounded by sterile florets with much larger petals or sepals. The oakleaf hydrangea, however, bears its flowers in cone-shaped panicles covered with large, white sterile florets that nearly hide the inconspicuous fertile flowers beneath them.

The oakleaf hydrangea has been in the park since the early 1860s. Several large bushes along Rhododendron Mile, the straight stretch of the East Drive between 86th and 94th Streets, provide dazzling displays in June. Oakleaf hydrangeas are scattered elsewhere around the park as well, often close to entrances or playgrounds. For example, there is a fine bush by the statue *Group of Bears* in the playground off Fifth Avenue and 79th Street. As of 2013, there were about 50 oakleaf hydrangias in the park.

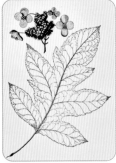

This engraving is one of 13 that William Bartram prepared for *Travels* (1791), the account of his five-year journey through Florida, Georgia, and the Carolinas. A portion of a flower panicle in the upper-left corner shows four sterile florets and a clump of smaller fertile flowers; the large leaf details every major vein.

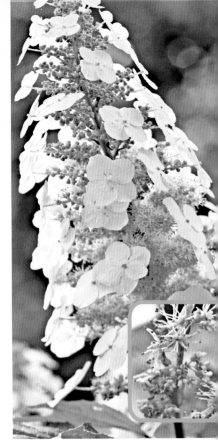

▲ *A 10-inch panicle of a blossoming oakleaf hydranga is dotted with sterile white flowers that attract pollinato to the inconspicuous underlying fertile flowers (inset).*

▶ *A handsome oakleaf hydrangea bush blossoms ne to the East Drive southeast of the Carousel in mid-Jun Oakleaf hydrangeas prefer shaded locations like this on*

◀ *The 4- to 12-inch leathery leaves of the oakleaf hydrangea have from three to seven lobes with irregularly serrated edges. Green on top, they are lighter green and downy underneath.*

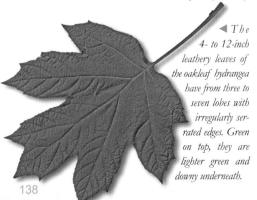

▼ *In fall, oakleaf hydrangea leaves turn to various shades of yellow, orange, purple, and crimson and persist well into the winter months.*

▼ *The sterile flowers on a cone-shaped flower cluster, or panic of the oakleaf hydrangea are usually white when they open in Jur As summer progresses, however, they turn pinkish. early fall, they dry to a rusty brown, but the seed capsules produced by the small underlying fertile flowers are still green.*

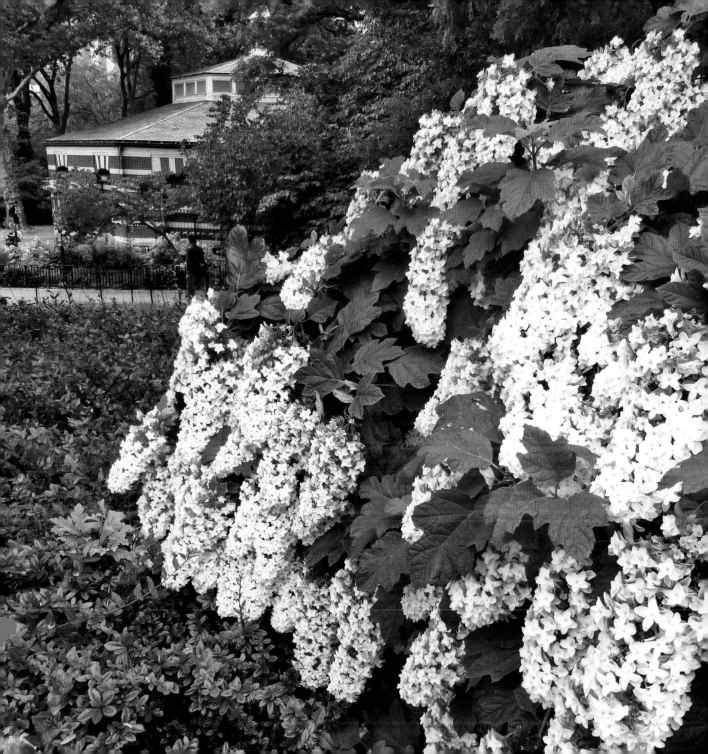

Royal Paulownia *Paulownia tomentosa*

The royal paulownia has an extravagant, tropical look about it not unlike the catalpa's, although the two are not closely related. Its leaves are very large, sometimes reaching over 1 foot in length. It produces a prodigious quantity of seeds. A large tree, for example, may scatter over 20 million tiny winged seeds in a season. It grows extremely fast, too, producing shoots 10 feet long in a single season and aggressively colonizing empty lots and highway edges. It can survive fires because its roots quickly sprout new stems. In its native Japan and China, it is widely cultivated for lumber, fuel, animal fodder, and soil conservation.

Anna Pavlovna Romanov (1795–1865), queen of the Netherlands, was the eighth child of Czar Paul I of Russia. She had a hard time adjusting to social norms in Holland, where there was less distance between members of the royal family and their subjects than in Russia.

The first European to describe the tree was Englebert Kaempfer (1651–1716), a German doctor, who included a very accurate drawing of the royal paulownia's leaves, flowers, and seed pods in his book *Amoenitatum exoticarum* (1712). In 1775, some 83 years after Kaempfer served in a Dutch trading house on an island off Nagasaki, Japan, Carl Peter Thunberg, a Swedish doctor, arrived at the same trading house. Thunberg was a disciple of Carolus Linnaeus, the Swedish botanist who established the binomial system for naming plants and animals. During his two-year stint as head surgeon of the trading house, Thunberg was able to collect many Japanese plants, including the royal paulownia, which he named *Bignonia tomentosa*.

Another doctor, a German named Philipp Franz von Siebold, went to the Dutch trading house in 1823, bringing with him a copy of Thunberg's book *Flora Japonica* (1784). Siebold determined that the royal paulownia and several closely related trees and shrubs are not members of the genus *Bignonia*, as Thunberg had thought, but belong in a genus of their own, which Siebold named in honor of his Dutch employers' queen, Anna Pavlovna Romanov, wife of King William II of the Netherlands and daughter of Czar Paul I of Russia.

The royal paulownia is not mentioned in the 1873 tree survey, but Louis Harman Peet located seven on maps in *Trees and Shrubs of Central Park*. As of 2013, there were 13 in the park, including two or three in the Ramble, two or three near the Seventh Avenue entrance on 59th Street, and a large and handsome specimen south of Cherry Hill.

▲ *The earliest depiction of the royal paulownia, a drawing by Englebert Kaempfer from 1712, shows a flower panicle with blossoms (upper left), portions of three leaves, and a detached blossom and several seed pods (lower right).*

▶ *The royal paulownia south of Cherry Hill near the 72nd Street transverse blooms and leafs out after most other Central Park tree species have produced leaves.*

▼ *Resembling foxglove blossoms, showy, 2-inch, trumpet-shaped royal paulownia flowers bloom in late April or early May just as the tree's leaves start to unfold.*

▼ *The opposite leaves of the royal paulownia are 6 to 14 inches long and sometimes heart-shaped at their base, with small teeth on their edges and sometimes short lobes. They are medium green above and sparsely hairy but paler green beneath and hairy.*

▼ *Initially green, the 1- to 1½-inch seed pods mature in late summer and fall, turn brown, and crack open in winter and spring, releasing tiny winged seeds by the thousands (inset).*

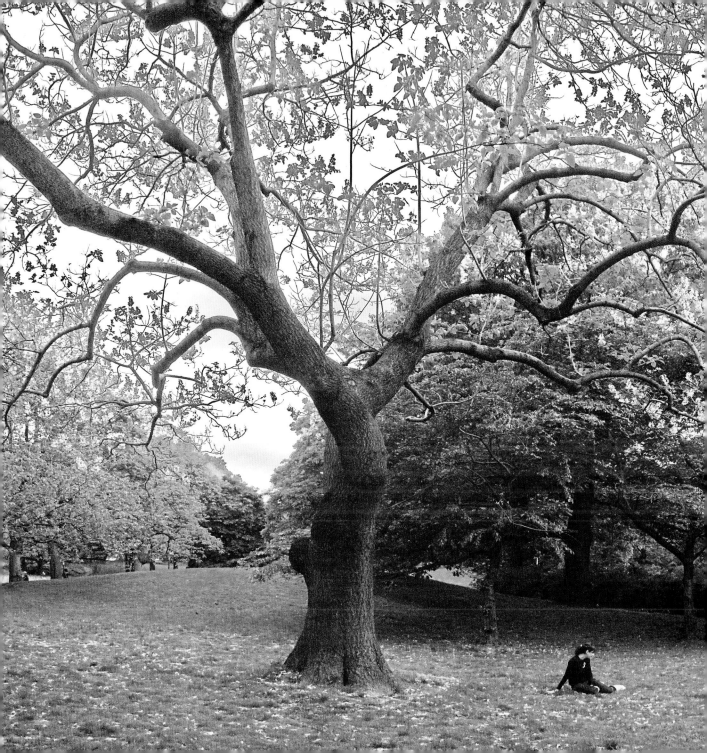

Catalpa *Catalpa* spp.

The catalpa looks like a tree you might see in a tropical rain forest. Its cascading, heart-shaped leaves are big—up to 1 foot long, not including their stem. Its pyramidal flower clusters are large, lush, and showy, with their tiers of trumpet-shaped, frilly, white blossoms sporting purple stripes, dots, and bright-yellow blotches. The catalpa's fruits are outsized and tropical looking, too, like string beans stretched to many times their normal length.

Mark Catesby's hand-colored engraving from the first volume of *Natural History of Carolina, Florida, and the Bahama Islands* shows a Baltimore oriole pair against catalpa leaves, flowers, and fruits.

Despite its exotic aspect, the catalpa is a native tree, occurring naturally in the south-central United States but widely planted in northern cities because of its rapid growth and tolerance of urban conditions. In the 19th century, it was popular as a lumber source and as an ornamental and was widely planted throughout the Midwest. Two catalpa species are present in the Northeast: the northern catalpa (*Catalpa speciosa*) and the smaller southern catalpa (*C. bignonioides*). The differences between them include bark color and texture and their flower spots, which are less conspicuous on the northern tree.

The catalpa was first described in print by English naturalist Mark Catesby (1682–1749) in his beautifully illustrated two-volume *Natural History of Carolina, Florida, and the Bahama Islands* (1731–1743). Catesby wrote of the catalpa: "[T]he Leaves [are] shaped like those of the *Lilax* [*sic*], but much larger, some being ten inches over. In May it produces spreading Bunches of tubulous Flowers...succeeded by round Pods, about the thickness of one Finger, fourteen Inches in Length....This Tree was unknown to the inhabited Parts of the *Carolina* till I brought the Seeds from the remoter Parts of the Country. And tho' the Inhabitants are little curious in Gard'ning, yet the uncommon Beauty of the Tree has induc'd them to propogate it; and 'tis become an Ornament to many of their Gardens, and probably will be the Same to ours in *England*." And, indeed, the catalpa is now widely planted in England.

Both catalpa species are present in Cental Park and have been since its completion. The 1875 survey noted six trees; as of 2013, there were more than 35 catalpas in the park. One drawback to catalpas in a park is that they are subject to aphid infestations, which can cause leaves to get sticky and moldy and benches beneath the trees to be covered with sap.

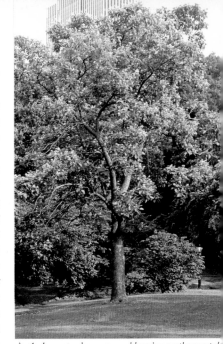

▲ *A skyscraper looms over a blooming southern catalp at the edge of the lawn west of Wollman Rink. T southern catalpa's flower clusters are denser and showr than those of the northern catalpa.*

▶ *The three blooming northern catalpas bordering t 72nd Street Cross Drive west of Bethesda Founta are among the park's finest specimens.*

▼ *The northern catalpa's gray bark is ridged. The sout ern catalpa's reddish-brown bark (inset) is scaly.*

▼ *A catalpa seed pod may be 7 to 20 inches long and persist on the tree through winter.*

◀ *A catalpa leaf may be 7 to 12 inches long and 5 to 8 inches wide with a 4- to 6-inch stem.*

▼ *Purple and gold markings on 2-inch-wide catalpa flowers, which bloom in June, lure insects to a nectar reward.*

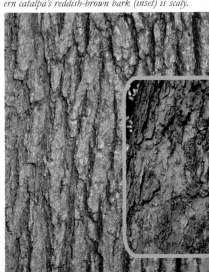

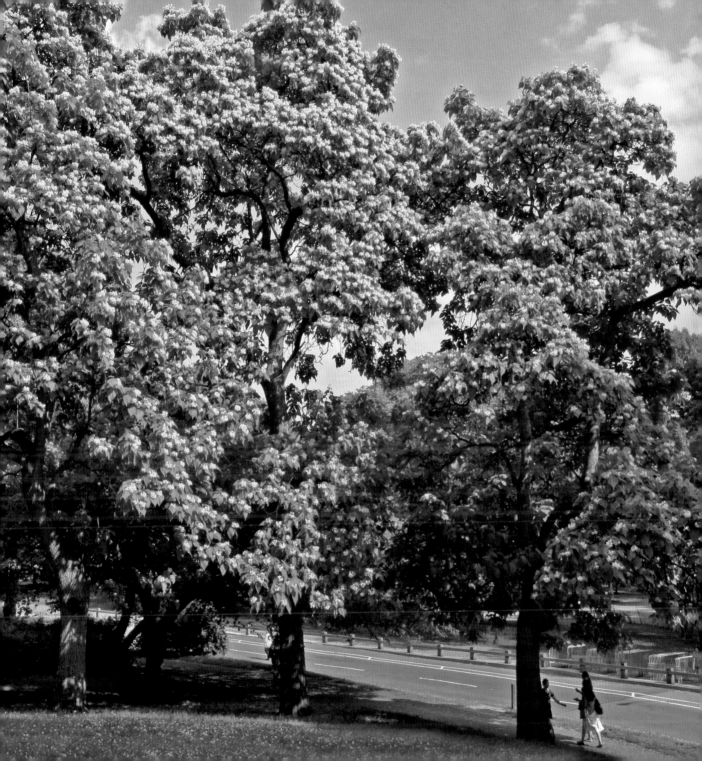

Chinese Fringetree *Chionanthus retusus*

There are two Chinese fringetrees in the park. The larger one is only about 30 feet high. It once had two trunks but lost one in a storm. It makes up for its unimposing size and loss of a trunk with an extravagant spring floral

Robert Fortune (1812–1880), a Scottish gardener and plantsman, braved pirates, xenophobic mobs, and typhoons to bring back to Britain from China, Formosa, and Japan hundreds of plants previously unknown to Western botanists.

display. In mid-May, every branch of this remarkable little tree is freighted with hundreds of fragrant, pure-white flowers, each with four thin petals that riffle and flutter in spring breezes. At night in moonlight, it glows with a luminescent radiance. Quite appropriately, its genus name, *Chionanthus*, means "snow flower" in Greek. Another Chinese fringetree has been planted just south of this beautiful tree; in time, it may rival the beauty of its older companion.

The Chinese fringetree has been cultivated for centuries in China, Korea, and Japan. Western gardeners were introduced to the tree in 1845, when a gruff, eccentric Scotchman named Robert Fortune brought seeds back from China. Fortune had only a primary education and was apprenticed as a boy to a

nurseryman. Intelligent and hard working, he quickly advanced through a series of jobs to become a gardener at the Horticultural Society of London. Recognizing his energy and knowledge of botany, the society chose him to collect plants in China. His mandate was not to seek specimens in the field but to purchase or acquire hardy plants any way he could from growers, gardeners, and graveyard custodians, even if they were not eager to part with them. Equipped with pistols, spades, trowels, and a Mandarin dictionary, Fortune made his way on foot and by boat, carriage, and sedan chair through the countryside shortly after the Opium Wars, at a time when the Chinese were hostile to foreigners. After he learned to speak rudimentary Mandarin, he sometimes would pose as a visitor from another province, assuming Chinese garb and a shaved head except for a pigtail. Imagine Fortune's excitement when he first gazed upon a blooming Chinese fringetree in a private garden in Fuzhou, capital of Fujian Province.

Fortune made four trips to the Far East and brought back 120 plant species from China, Formosa, and Japan, including the fringetree. But he is probably best known for bringing tea plants from China to the Darjeeling area of India for the British East India Company.

The 2- to 4-inch opposite oval leaves of the Chinese fringetree are shiny green above with a downy underside. In fall, they turn yellow.

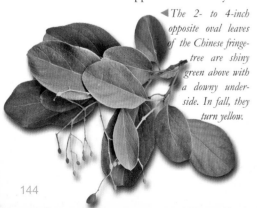

The ⅛- to ½-inch oval fruits of the Dene's fringetree are drupes, or stoned fruits, like olives. They ripen from green to purplish blue-black. The tree is a female; males don't bear fruit.

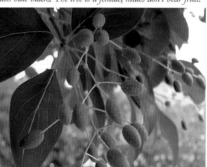

▲ *The raised, rounded ridges and deep twisting furrows the Chinese fringetree's thick bark are gray, but cracks a abrasions reveal a bright reddish-orange underlayer.*

▶ *The profuse blossoms of the Dene's Chinese fringet reflect the zone gardeners' constant care and its shelte but sunny location next to a large rock outcropping.*

▼ *Each spicy-scented Chinese fringetree flower l four pure-white, 1-inch, narrow strap-like petals.*

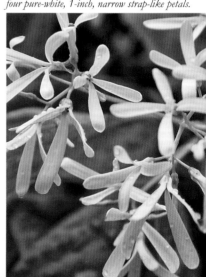

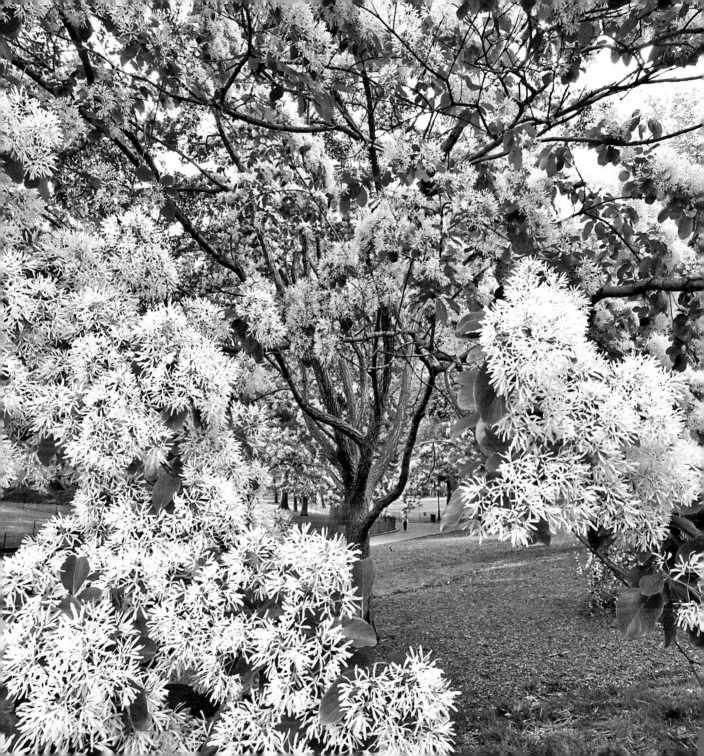

Flowering Dogwood *Cornus florida*

If the giant sequoia is the king of North American forests, the flowering dogwood—with its graceful branches, delicate early-spring blossoms, and crimson fall foliage—is the queen. As the author Donald Culross Peattie wrote, "Stepping delicately out of the dark woods, the startling loveliness of a Dogwood in bloom makes each tree seem a presence, calling for an exclamation of praise, a moment of worship with our eyes." Sadly, the flowering dogwood is no longer blooming so profusely in the understories of eastern forests.

A hand-colored engraving from Mark Catesby's *Natural History of Carolina, Florida, and the Bahama Islands* (1743) depicts a mocking-bird perched on a pink dogwood limb. Catesby was the first botanist to encounter the pink dogwood.

A virulent fungal disease that first appeared in the early 1970s called dogwood anthracnose (*Discula destructive*) has killed many trees throughout the species' natural range. However, some cultivars, such as 'Appalachian Spring' and 'Cherokee Brave,' are less susceptible, especially when they are grown in bright, breezy locations.

The "dog" in "dogwood" may be a corruption of the Middle English *dagge*, which means "pointed end" and is the word from which the term "dagger" is derived. The wood of the dogwood is indeed very hard and was likely often whittled into sharp points. Once a valuable source of lumber, the flowering dogwood produces a shock-resistant, fine-grained wood that wears smooth with use and does not easily crack. It was made into loom shuttles, golf-club heads, tool handles, pulleys, and spindles before synthetic substitutes were developed.

Philadelphia naturalist William Bartram (1739–1823), son of John Bartram, is credited with first bringing the dogwood to the attention of botanists. In his book *Travels*, Bartram described an amazing forest of dogwoods in Alabama: "We now enter a very remarkable grove of dog wood trees...which continued nine or ten miles unalterable, except here and there a towering Magnolia grandiflora; the land on which they stand is an exact level....[T]hese trees were about twelve feet high, spreading horizontally; their limbs meeting and interlocking with each other, formed one vast, shady, cool grove."

Flowering dogwoods have always been present in the park and always will be despite their disease susceptibility. The 2008 census listed 37 trees. A fine pink specimen next to the Swedish Cottage puts on an especially beautiful show every spring.

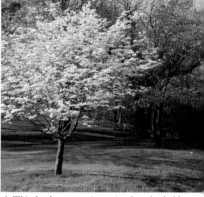

▲ *This lovely, contrasting pair of profusely blossom young flowering dogwoods greets runners on the East Dr as they pass the northeastern corner of the North Meade*

▶ *This splendid pink flowering dogwood adorns lawn in front of the Swedish Cottage.*

▼ *Creamy-white flowers edged with touches of pink displayed by a dogwood variety called 'Karen's Appalach Blush' growing at the East Meadow's northeastern corn*

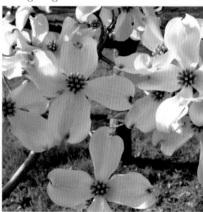

▼ *The opposite, pointed, elliptical 2- to 4-inch leaves of the flowering dogwood turn from dark green to bright crimson in fall. They have smooth edges, a straight central vein, and curving secondary veins, which follow the edge contours.*

▶ *A flowering dogwood blossom consists of four 1¼-inch white or pink bracts (modified leaves) notched at their outer ends, surrounding a ½-inch central cluster of up to 20 tiny four-petalled, greenish-yellow flowers (inset).*

▼ *The bright-red fruits, or drupes, of the flowering dogwood ripen in clusters of two to 10 in late summer. Birds spread the seeds.*

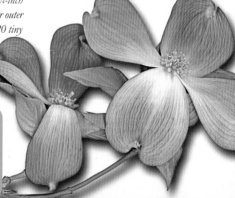

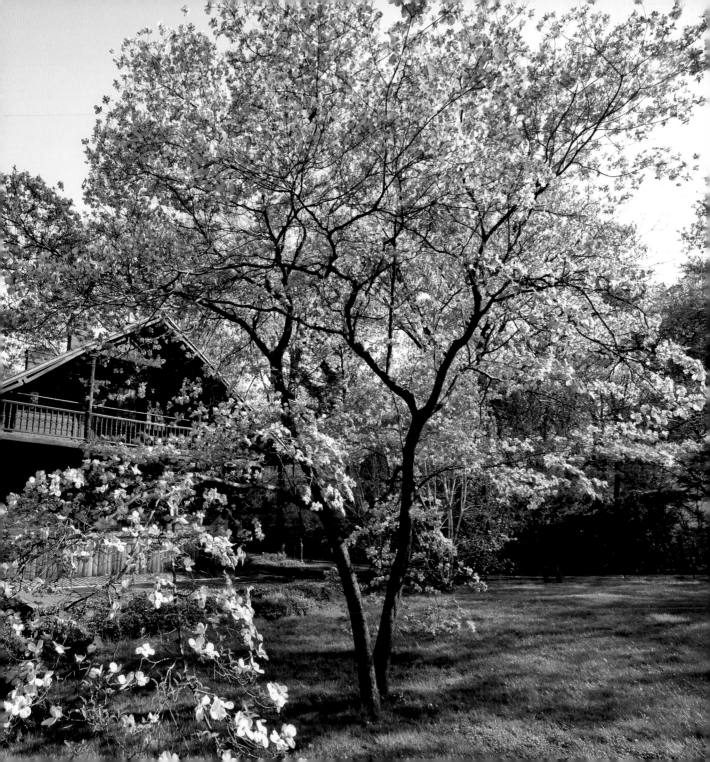

Kousa Dogwood *Cornus kousa*

Until the 1850s, Japanese plants were virtually unknown in the United States. Japan had been closed for centuries to all but a few Dutch and Chinese traders. Commodore Matthew Perry opened Japan for trade with the United States by sailing his sinister black-hulled ships into Uraga Harbor and intimidating shogun Tokugawa Ieyoshi into signing a treaty in 1854. Enterprising American businessmen soon followed. In 1861, George Rogers Hall, a Yankee doctor turned trader who had established himself in Yokohama, sent the first shipment of living Japanese plants, including the kousa dogwood, from Japan to Boston.

The kousa dogwood is an elegant Asian cousin of the North American flowering dogwood. Botanists theorize that the two species have a common ancestor that thrived in an epoch when northern temperate flora stretched in a continuous band across North America and Eurasia. Over

A hand-colored engraving from Philipp Franz von Siebold and Joseph Gerhard Zuccarini's *Flora Japonica* (1875) shows a flowering kousa dogwood branch and details of the central flower cluster, including tiny petals, stamens, stigmas, seeds, and a red berry-like fruit.

the millennia, shifting landmasses and climate changes isolated plant populations, and separate dogwood groups evolved. The kousa dogwood developed fleshy fruits appealing to monkeys that lived in China and Japan. The monkeys helped to disperse the tree's seeds, which passed through their digestive systems unharmed. The flowering dogwood, though, had no monkeys in its range and developed smaller, hard, red fruits attractive to birds.

Like the flowering dogwood, the kousa dogwood has blossoms with showy, petal-like bracts that begin as bud scales protecting the tiny central green flowers. But the kousa dogwood's bracts have pointed tips instead of the broad, notched tips of the flowering dogwood.

The kousa dogwood was not among the park's earliest plantings and is not mentioned in Louis Harman Peet's *Trees and Shrubs of Central Park*. It may have been first planted in the park in the 1970s when dogwood anthracnose, the fungal disease that has killed many thousands of flowering dogwoods, became a major problem. The kousa dogwood, which is resistant but not entirely immune to anthracnose, has gained in popularity as a handsome substitute for its North American cousin.

▲ *The blooming kousa dogwood at the junction of the East Drive and the path to Fifth Avenue near 85th Street greets park strollers in late May and early June.*

▲ *The kousa dogwood's continually peeling bark produce ever-changing mosaic patterns of brown, gray, and yellow.*

▶ *A cluster of kousa dogwoods at the North Meadow southeastern edge is spangled with star-like blossoms late May, a month after flowering dogwoods have bloomed.*

▼ *Kousa dogwood leaves are opposite, pointed, elliptical and 2 to 4 inches long, with smooth edges, a straight central vein, and curving secondary veins following edge contours.*

▶ *Resembling raspberries, the ⅞- to 1½-inch fruits turn from green to pink or red in late summer.*

▶ *The pointed, petal-like bracts of the kousa dogwood flower surround a globular cluster of flowers that becomes a plump berry (inset).*

▼ *Used to make wine, kousa dogwood fruits can be sweet when ripe, but older fruits that persist on a tree may become unpleasantly pulpy.*

Cornelian Cherry *Cornus mas*

The cornelian cherry is named for its bright-red, cherry-like berries. The word "cornelian" is derived from the Latin *cornus*, the Romans' name for this attractive shrub or small tree, native to Europe and Asia. Actually not a cherry but a member of the dogwood family, the cornelian cherry is valued primarily as an ornamental in America. It flowers in early spring, produces lush green leaves and red fruits in summer, and adds subtle foliage color to a garden in fall. Very hardy, it grows in shade to full-sun and in the poorest drought-compacted soils.

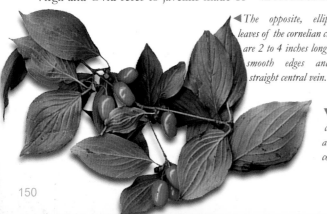

The olive-shaped, astringent red fruits of the cornelian cherry are between ½ and 1 inch long. They change from green to red in midsummer and are ready to eat when they darken to maroon.

In parts of Europe and Asia, where it grows wild, the cornelian cherry, or cornel, as it is known in Europe, is regarded as far more than just an attractive landscape plant. People of the Balkans and Asia Minor have cultivated the cornel for millennia as a source of wood and sustenance. Homer alludes to cornel fruit as food in the *Odyssey*. Virgil and Ovid refer to javelins made of cornel wood. Legend has it that Romulus hurled a spear to mark the spot where Rome was to be built. It landed on the Palatine Hill, and from its shank of cornel wood grew almost immediately a beautiful tree, an omen of the strength and durability of the Roman state.

Serbs of the Drvar Valley have a traditional expression, "Zdrav kao dren," meaning "Healthy as cornel." They believe that the astringent cornel fruit promotes good health. And, indeed, the fruits contain vitamins C and E, antioxidants such as carotenoids and flavanoids, and several essential minerals. Throughout the Balkans, Turkey, Georgia, and adjacent countries, people use the fruits to make jams, syrups, wines, and liqueurs. Long cultivation has yielded fruits larger than those present on many ornamental cornelian cherry varieties. These cultivated fruits, much like domestic apples, vary in color from several shades of red to a range of oranges and yellows.

Spring is the time to enjoy cornelian cherries in Central Park. Suddenly about the third week in March, these bushy shrubs seem to be everywhere, spangled with thousands of delicate mustard-yellow flower clusters. Less showy than the forsythias that blossom at about the same time, they are no less appealing.

▲ *The flamboyant golden-yellow petals of a blooming forsythia bush in the foreground contrast with the muted mustard-yellow flowers of a large cornelian cherry.*

▶ *A splendid line of blooming cornelian cherries border the path to Fifth Avenue at the northern end of the Glade.*

▼ *In early spring, the cells of the complete flowers within each cornelian cherry flower bud begin to expand, and the bud's four protective outer scales are pushed aside.*

◀ *The opposite, elliptical leaves of the cornelian cherry are 2 to 4 inches long with smooth edges and a straight central vein.*

▶ *Less than ⅓ inch across, yellow-petalled cornelian cherry flowers appear in clusters of 10 to 25 in late March, well before the leaves unfurl.*

▼ *The rotund flower buds of the cornelian cherry form in late summer and contain fully developed flowers complete with pollen grains.*

Crape Myrtle *Lagerstroemia indica*

"Ask any resident of the South to name the most beautiful flowers of that favored region and he will at once mention the crepe myrtle, the azalea, the dogwood, and perhaps the Cape jessamine. No matter what other plants he names, he is pretty certain to put the crepe myrtle first." So wrote Willard Nelson Clute in the November 1922 issue of the *American Botanist*. Now nearly nine decades later, the crape myrtle remains near the top of any list of best-loved and most widely planted flowering shrubs in the South. The reasons for its ubiquity in southern landscapes are many. It flowers prolifically for two months or more in summer, when most other shrubs and trees have finished blooming. Flowers are borne at the ends of branches in 6- to 8-inch clusters, or panicles, of fragrant 1- to 1½-inch scarlet, purple, pink, and white blossoms with beautiful crinkled petals and bright-yellow stamens. Most crape myrtles have multiple, gracefully bending trunks, and each trunk is covered with smooth, peeling bark that constantly produces changing shades of tan and gray. Crape myrtles may also exhibit striking fall color.

The genus *Lagerstroemia*, crape myrtle, consists of some 50 species of trees and shrubs native to China, Japan, India, Southeast Asia, parts of Oceania, and Australia. The genus was named in 1759 in honor of Swedish merchant Magnus von Lagerström, who procured the common crape myrtle (*L. indica*) from India for his countryman and renowned botanist Carolus Linnaeus.

The common crape myrtle was brought to the United States about 1790 by French botanist André Michaux, who planted it in his 111-acre garden in Charleston, South Carolina. Both Jefferson and Washington established the crape myrtle on their estates in the 1790s. Hundreds of crepe myrtle cultivars are now available, and with the warming trend in the Northeast cold-hardy crepe myrtles are being cultivated as far north as southern New England. As of 2013, there were five crape myrtles in Central Park, all planted in the 1990s. Two others from that planting died after an unusually cold winter.

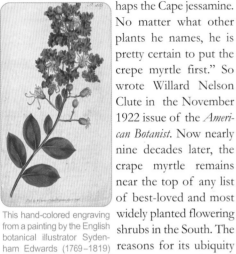

This hand-colored engraving from a painting by the English botanical illustrator Sydenham Edwards (1769–1819) appeared in *Curtis's Botanical Magazine* in 1798. It shows a crape myrtle branch with flower panicle and leaves. Up to 30 people were employed to color each issue, sent to some 3000 subscribers.

▲ *A December snowfall outlines the arching trunks of common crape myrtles north of the Conservatory Water.*

▲ *The base of a common crape myrtle usually consists of several diverging trunks clad in thin, smooth, peeling bark.*

▶ *Crape myrtles opposite the Alice in Wonderland sculpture on the path leading north from the Conservatory Water to the Glade are in full bloom in late August.*

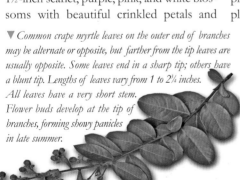

▼ *Common crape myrtle leaves on the outer end of branches may be alternate or opposite, but farther from the tip leaves are usually opposite. Some leaves end in a sharp tip; others have a blunt tip. Lengths of leaves vary from 1 to 2¼ inches. All leaves have a very short stem. Flower buds develop at the tip of branches, forming showy panicles in late summer.*

▼ *Crape myrtle fruits appear in late summer after flowers have been pollinated. At first, they are succulent, green, pea-size capsules, but as fall progresses they dry out and become brown and hard. Each dried fruit (inset) contains 20 or more winged seeds.*

▼ *Central Park's common crape myrtles produce vivid pink flower panicles. Each blossom has crinkled petals and five long stamens bearing green pollen and 20 or more short stamens bearing yellow pollen.*

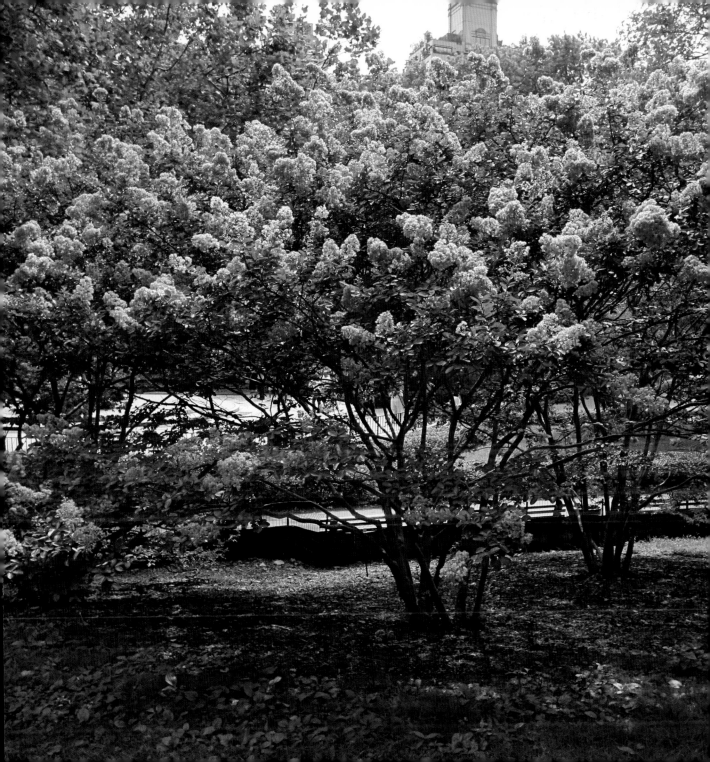

Lilac *Syringa* spp.

"You have forgotten your Eastern origin, / The veiled women with eyes like panthers, / The swollen, aggressive turbans of jeweled pashas. / Now you are a very decent flower," wrote Amy Lowell in her poem "Lilacs" (1925). A native of the mountains of the Balkans, the common lilac (*Syringa vulgaris*) was sent to Vienna from Constantinople about 1560. By 1597, both purple and white varieties were growing in London.

This portrait of New Hampshire colonial governor Benning Wentworth was painted by Joseph Blackburn in 1760, just 10 years after the common lilac was planted on the grounds of the governor's mansion in Portsmouth.

In 1753, Carolus Linnaeus, the great Swedish botanist, placed the lilac in the genus *Syringa*, the Greek word for "pipe," because the piths of some lilac shoots can be easily removed to make hollow pipes suitable for musical instruments. According to Ovid, the water nymph Syrinx, when pursued by the amorous god Pan, was transformed by her sister nymphs into hollow reeds from which Pan fashioned his panpipe.

The oldest living common lilac bushes in the United States may be those at the Wentworth-Coolidge Mansion in Portsmouth, New Hampshire. Colonial governor Benning Wentworth is reputed to have planted several lilac bushes on the mansion's grounds around 1750. In 1767, Thomas Jefferson recorded a method of planting lilacs in his Garden Book, and on March 3, 1785, George Washington wrote about transplanting already existing lilacs in his garden. By 1865, when Walt Whitman wrote his beautiful elegiac poem "When Lilacs Last in the Dooryard Bloom'd" to commemorate Abraham Lincoln's death, the lilac had become a familiar and beloved shrub throughout the rural Northeast and Midwest.

The common lilac and its hundreds of cultivars are by far the most widely planted lilacs in America, but there are about 23 species and over 2000 cultivars altogether, with seven flower colors: lilac, violet, blue, purple, red, pink, and white. Only two species are European natives; all the rest are Asian, and many of these were discovered by famous 19th- and early-20th-century plant explorers such as Robert Fortune and Ernest Henry Wilson.

Central Park has always had lilacs. The best way to enjoy the park's many blooming lilac cultivars in spring is by strolling along Lilac Walk at the northeastern edge of Sheep Meadow or by visiting the Conservatory Garden at Fifth Avenue and 105th Street.

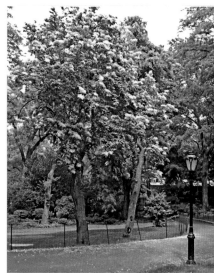

▲ *Three Japanese tree lilacs once stood south of the Conservatory Garden. They were probably almost 100 years old. One was cut; two remained in 2014. Their trunks were hollowing, but they still produced a profusion of white flowers.*

▶ *A fine selection of more than a dozen different lilac cultivars borders the northeastern edge of Sheep Meadow along Lilac Walk. Here two strollers pass a showy white variety and a more subdued lavender bush.*

▼ *The classic color of the common lilac's flowers is, of course, lilac, which is a pale violet or light purplish-blue. The delicate color of these flowers, combined with their sweet lingering fragrance, evokes for many people powerful feelings of nostalgia for Mom, old farmhouses, and breezy days in May.*

▼ *The common lilac's 2- to 5-inch leaves are opposite, smooth-edged, and heart-shaped. The ⅝-inch seed capsules develop over the summer.*

▼ *The four-petalled flowers of common lilac cultivars range in color from pure white to purplish-red.*

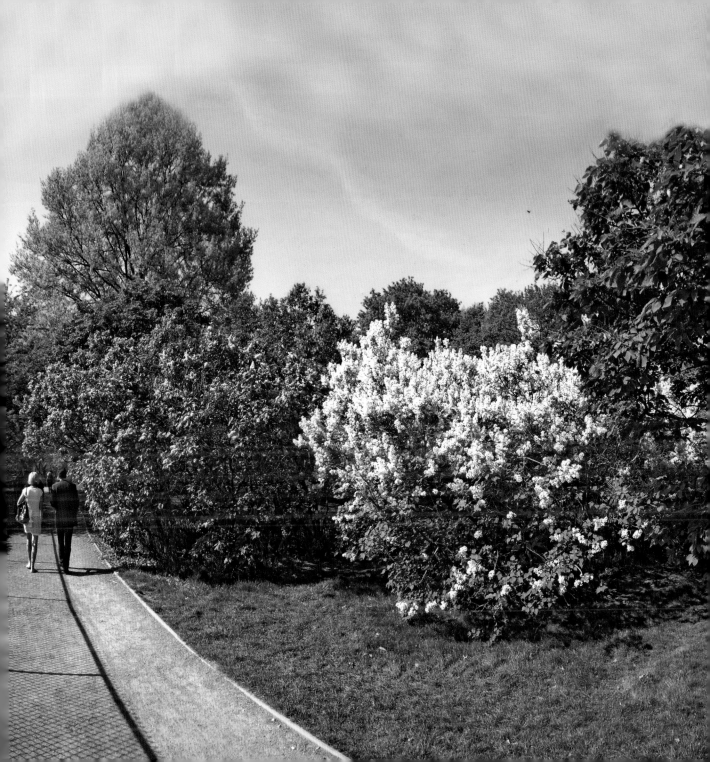

Katsuratree *Cercidiphyllum japonicum*

In Japan and China, the katsuratree achieves a girth and height greater than those of any other Asian deciduous tree. In Japan, the tree usually has several trunks sprouting from its roots. In China, it often has a single trunk. In North America, the katsuratree is commonly a medium-size tree, seldom topping 60 feet. But what it sometimes lacks in size, it makes up for in understated arboreal elegance. Its multi-trunked habit; the rich golds, yellows, and crimsons of its spicy-smelling fall foliage; its handsome, shaggy bark; and its dense rounded crown in maturity make it an excellent ornamental for lawns and streets.

A painting by Mary Eaton (1873–1961) from the New York Botanical Garden's bulletin *Addisonia* shows a katsuratree's green seed pods, a single leaf, and twigs with red, petalless male and female flowers.

The word "katsura" is the Japanese name of the tree. The Latin genus name, *Cercidiphyllum,* refers to the resemblance of *Cercidiphyllum* leaves to those of the genus *Cercis,* redbuds. The two genera are easy to tell apart, though, because *Cercidiphyllum* leaves are opposite on their twigs, whereas *Cercis* leaves are alternate.

Like the ginkgo, the katsuratree belongs to a genus of Asian trees once native to the forests of North America before repeated Pleistocene glaciations decimated the flora. The genus *Cercidiphyllum* returned to North America in 1865 when a U.S. marshal assigned to Japan, Thomas Hogg, who was the son of a horticulturist and brother of a Manhattan nurseryman, sent seeds of the katsuratree from Japan to his brother James's nursery on East 84th Street and to Parsons & Company in Flushing. Trees raised from these very seeds or from their descendants may still be seen growing in a row, but now with trunks fused together, in the Historic Grove in Kissena Park, Queens.

The eight katsuratrees in Central Park as of 2013 were most probably also direct descendants of Hogg's seeds. One katsuratree is on the slope at the southern side of the Metropolitan Museum; another is at the southern end of Strawberry Fields near the path leading past the Imagine mosaic to Central Park West. Both trees are growing in shaded areas and will probably never reach their full potential. In sunny, well-watered locations, however, a katsuratree can attain truly monumental proportions, towering 90 feet or more with a crown spread of over 100 feet.

▲ The five-trunked katsuratree in Strawberry Fields stands in November twilight amid a golden circle of leaves.

▶ The katsuratree at the southern end of the Metropolitan Museum exhibits the typical multi-trunked habit.

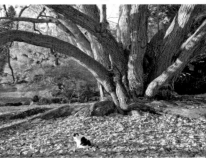

▲ The great male katsuratree at the Morris Arboretum, in Philadelphia, is 7 feet wide at its base and 86 feet tall.

▼ The katsuratree's red, petalless flowers bloom in March or April before the leaves unfold. The male flowers grow in clusters, each with several pointed stamens.

▼ The katsuratree's opposite, heart-shaped leaves are 2 to 4 inches long. They turn from green to shades of yellow, apricot, crimson, and purple in fall. As they change color, they smell quite spicy, like brown sugar or caramel.

▼ Katsuratree leaves have a main vein radiating from the stem. Their edges have rounded teeth. Seed pods cluster close to twigs.

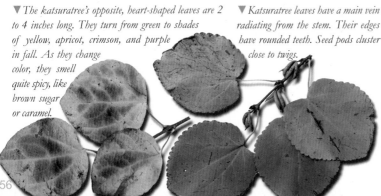

▶ The katsuratree's ½- to ¼-inch seed pods form over the summer on female trees and split open in late October to release their thin, winged seeds.

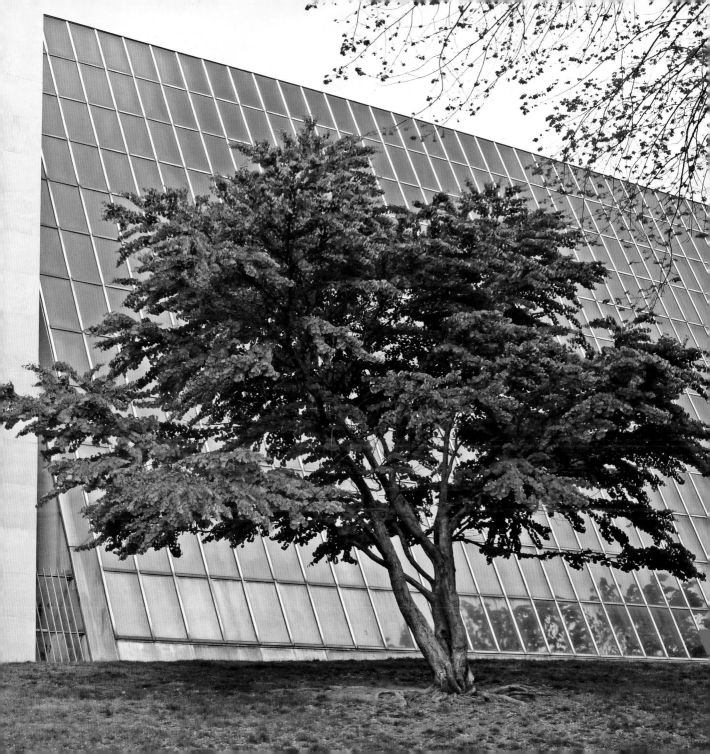

Euonymus *Euonymus* spp.

The genus *Euonymus* includes some 170 species of deciduous and evergreen small trees, shrubs, vines, and ground covers. The term is derived from two ancient Greek words meaning "good name"—a somewhat curious label for a genus notorious for its poisonous plants.

An engraving of the leaves, flowers, and fruit of the European spindle tree by C. Mathews from William Baxter's *British Phaenogamous Botany* was one of a number of plates hand-colored by Baxter's daughters and daughter-in-law.

In his illustrated guide *British Phaenogamous Botany*, William Baxter wrote of the little European spindle tree (*E. europaeus*), a species present in Central Park since the 1860s: "The whole plant is foetid and poisonous. The berries operate violently on the bowels.…According to Linnaeus, cows, goats, and sheep eat the leaves, but horses refuse them."

If the European spindle tree was well known by 19th-century botanists for its poisonous foliage and fruits, it was also highly regarded for its tough, close-grained wood, which has been harvested from coppiced trees in Britain since Anglo-Saxon times, when it was first whittled and later turned on primitive lathes to make spindles and bobbins for homespun wool and flax. The wood was also prized for the superior slow-burning, unusually dense charcoal it produced, charcoal good both for drawing and for making gunpowder.

Another euonymus planted early in the park's history is the very showy burning bush (*E. alatus*), a multi-stemmed shrub, often with corky, winged (*alatus* means "winged") stems that may grow 10 or 20 feet tall and wide. Michael Dirr, in his authoritative *Manual of Woody Landscape Plants,* calls it "one of the finest landscape plants." In autumn, its leaves turn to flamboyant shades of red and are interspersed with reddish-purple fruits.

Perhaps the most widespread but often overlooked euonymus in the park is the evergreen shrub *Euonymus kiautschovicus* 'Manhattan.' Its cultivar name 'Manhattan' refers not to Manhattan Island but to Manhattan, Kansas, where this euonymus variety was discovered. Clipped into hedges bearing glossy, evergreen foliage and red berries, it is most noticeable in fall and winter.

Among the various euonymus cultivars and varieties growing in the park are climbing and creeping plants, some with variegated leaves.

▲ *In July and August,* Euonymus kiautschovicu *'Manhattan' bushes produce inconspicuous ⅓-inch flower (inset). By fall, their shiny leaves are accompanied by pinkish fruit capsules, each containing four orange-red seeds.*

▲ *A hedge of* Euonymus kiautschovicus *'Manhattan' forms an evergreen frame around the flower beds o the Conservatory Garden's "English" Garden.*

▶ *In mid-November, leaves on a European spindle tre at the park's edge near Central Park West and 88t Street are just beginning to turn.*

▼ *The 1- to 2½-inch elliptical, finely toothed or almost smooth-edge, leaves of the European spindle tree, with stems varying from ⅛ to 1½ inches long, are oppositely arranged on their twigs. In fall, they turn from green to yellow or red before dropping.*

▶ *A burning bush along the East Drive by the Reservoir displays its fall finery in mid-November. Introduced from Asia in 1860, this euonymus species has escaped cultivation in areas of the Northeast. Its twigs may have wings (inset).*

▼ *This four-valved fruit of a European spindle tree has lost three of its four bright-red, toxic seeds.*

▼ *Around ½ inch wide, fruits of the European spindle tree are poisonous to humans but are eaten by birds.*

Forsythia *Forsythia* spp.

April may be the "cruelest month," as T. S. Eliot wrote, but it is also the month when spring erupts in Central Park with intense cannonades of the forsythia's bright canary yellow and scattered fusillades of the cornelian cherry's lemon yellow. Snow may cover blossoms at times, but these hardy shrubs go about their blooming campaigns nevertheless. Forsythias, indeed, are so well established in gardens and parks throughout the East that it is hard to imagine spring without them. Yet forsythias are not native to North America and became firmly established here only about a century ago.

William Forsyth (1737–1804), a Scottish gardener trained at the Chelsea Physic Garden, was a founding member of the Royal Horticultural Society.

There are some 11 species of forsythia. One is indigenous to eastern Europe; the rest are natives of Asia. Carl Peter Thunberg, a Swedish doctor and naturalist who brought a number of plants from China and Japan to Europe, was the first to describe a forsythia species. He called it *Syringa suspensa* in his book *Flora Japonica* (1784), thinking that it was a lilac relative. In 1804, Martin Vahl, a professor of botany in Copenhagen, realized that Thunberg's plant was not a lilac and established a new genus, *Forsythia*, named to honor William Forsyth, then director of the royal gardens at Kensington Palace. Thereafter, *Forsythia suspensa* was cultivated in Holland and England and eventually reached Harvard's Arnold Arboretum in 1876. Several varieties of *Forsythia suspensa* are now widely planted. Some have gracefully arching and trailing branches that look particularly dramatic on walls and steep banks.

Another Asian species of forsythia, *Forsythia viridissima,* was sent to the Horticultural Society of London from China by the Scottish plantsman Robert Fortune in 1845. This species, when crossed with *Forsythia suspensa,* produced a form called *Forsythia × intermedia,* also known as border forsythia, which is hardier than either parent. An unruly shrub, it can form impenetrable thickets of tangled branches, but its masses of four-petalled yellow flowers on naked branches in early spring are spectacular. Today there are hundreds of varieties of *Forsythia × intermedia* growing in temperate zones worldwide.

Forsythia is scattered about the park, but when the *Forsythia suspensa* spilling over the walls of the 86th Street transverse is in bloom, it is perhaps the most impressive of all the park's forsythia plantings.

▲ *Forsythias flower in April when warm spells may force buds to open and then cold spells frost fresh petals with snow.*

▶ *An early April snowstorm outlines the bending stems of a blossoming border forsythia near the Pool.*

▼ *Cars crossing the 86th Street transverse during the second half of April pass beneath a golden, blossoming fringe of trailing* Forsythia suspensa *branches.*

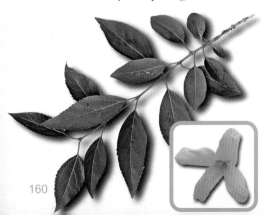

◀ *Lance-shaped, 3- to 5-inch border forsythia leaves are opposite and toothed from their tip halfway down each side. The four-petalled flowers (inset) are up to 1½ inches wide.*

▶ *Edward Kenny's bronze panther,* Still Hunt, *crouches by a cascading* Forsythia suspensa.

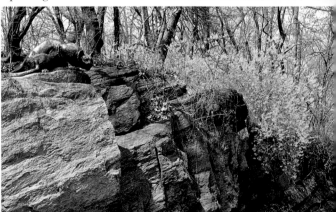

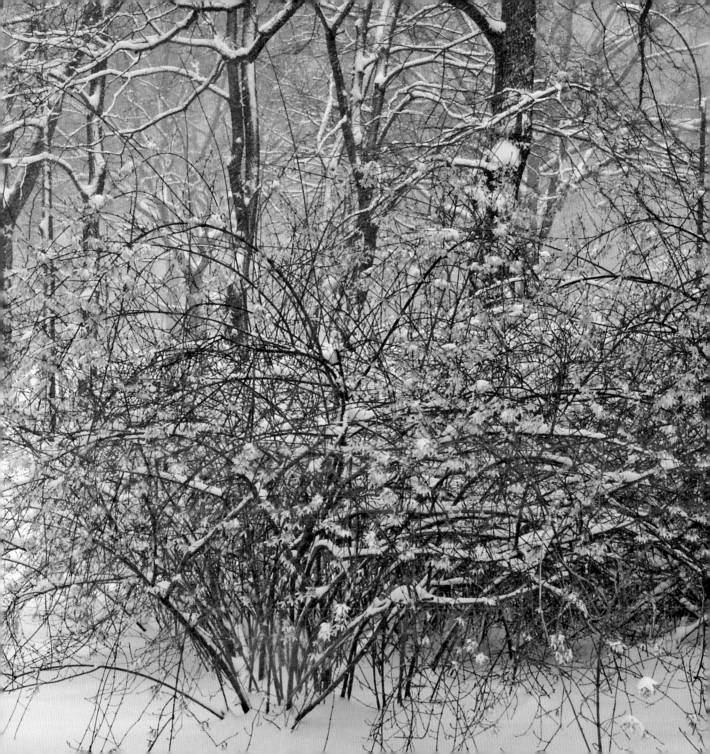

Viburnum *Viburnum* spp.

"A garden without a viburnum is akin to life without music and art." So wrote Michael Dirr in his authoritative *Manual of Woody Landscape Plants*. Central Park's gardeners seem to agree with him, for close to 100 plants of more than a dozen species, cultivars, hybrids, and varieties of the genus *Viburnum* are spread around the park.

A hand-colored engraving from Philipp Franz von Siebold and Joseph Gerhard Zuccarini's *Flora Japonica* (1875) shows a branch from a flowering doublefile viburnum with two pairs of flower clusters. At the bottom are details of individual infertile flowers and fertile flowers with anthers.

The genus *Viburnum* contains about 200 species of evergreen and deciduous shrubs and small trees, mainly from wooded areas of the north temperate zone, but also from tropical Malaysia and South America. Most viburnum flowers are white; a few are pink. Some are very fragrant; some have very little fragrance or an unpleasant smell. Viburnum fruits are usually small, spherical, and black, blue, red, or yellow, each with a hard seed at the center and not much meat. Birds and other animals eat the seeds. Leaves of many deciduous viburnums are shiny with prominent veins and turn various shades of bright red or purplish-red in autumn.

Among the most striking of the park's viburnums is the doublefile (*V. plicatum* var. *tomentosum*). Several large doublefile viburnums near the Reservoir close to the West Drive opposite the 90th Street entrance are especially arresting in mid-May when their branches are topped with double lines of showy, stalked corymbs—round, flat-topped, 5-inch flower clusters composed of central bunches of tiny yellow-white fertile flowers ringed by larger sterile blossoms.

Another white-flowering viburnum species much in evidence around the park is the arrowwood viburnum (*V. dentatum*), which can be a large shrub 8 or more feet high, usually with many small straight stems at its base. As its name suggests, Native Americans harvested these stems for arrow shafts.

Other common park viburnum species are the linden viburnum (*V. dilitatum*), with bright-red fruits in fall; leatherleaf viburnum (*V. rhytidophyllum*), with thick, lustrous, evergreen leaves; and Korean spice viburnum (*V. carlesii*), with corymbs of pink flower buds opening to very fragrant white flowers.

▲ *In mid-May, the spreading branches of the park doublefile viburnums are topped with spectacular tw rows of circular flower clusters raised above pleated, dar green leaves on 2-inch stalks, or peduncles (inset).*

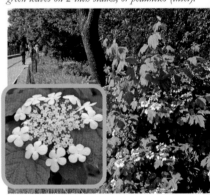

▲ *A European cranberrybush viburnum (V. opulu near the Reservoir bears blossomss in May with tiny fe tile flowers circled by larger infertile flowers (inset).*

▶ *In mid-October, a linden viburnum that once grew the foot of Cedar Hill was often laden with cherry-r fruits, some of which persisted until spring.*

▼ *The linden viburnum's 2- to 5-inch roughly toothed leaves (left) have five to eight veins on either side of a central vein. Leaf shapes vary from nearly round to oval to tear-shaped and have pointed tips or no tips. The smooth-edged leatherleaf viburnum's 4- to 8-inch lance-shaped leaves (right) are thick, and shiny.*

▶ *A row of 8-foot-tall leatherleaf viburnums at the northern edge of Cedar Hill helps screen the 79th Street transverse. Slightly fragrant flowers with yellow anthers (inset) bloom in late April.*

▼ *The pink-budded, white-flowering, incredibly sweet-smelling blossoms of the Korean spice viburnum perfume the park's breezes in mid- to late April.*

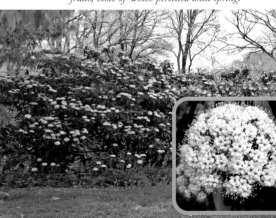

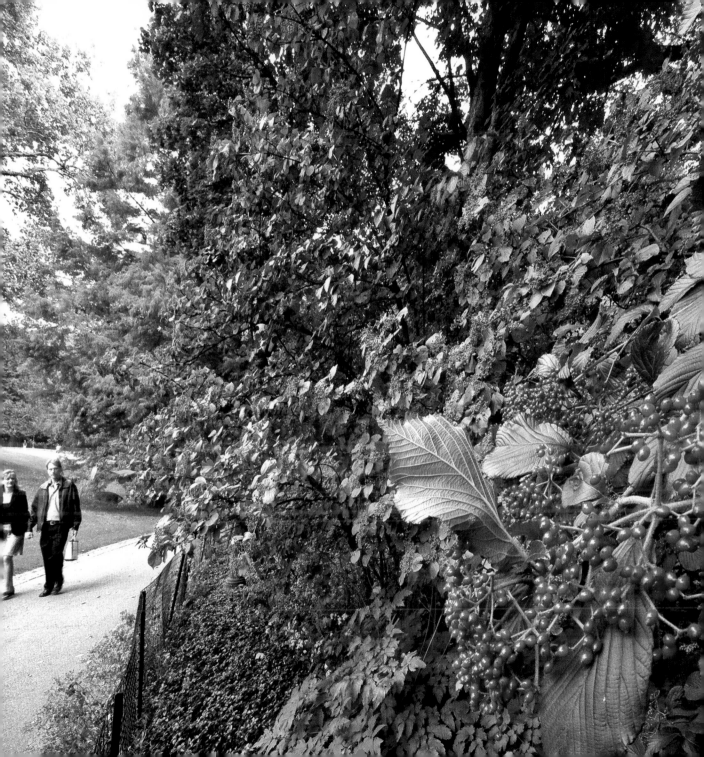

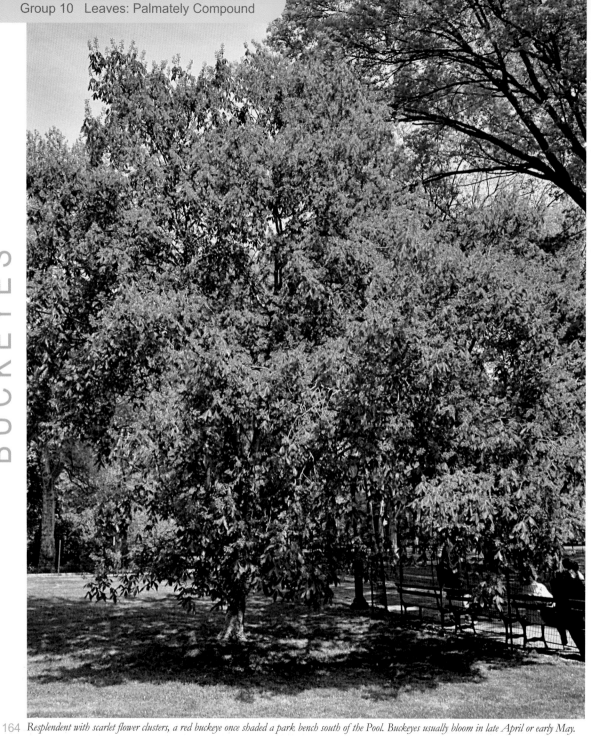

BUCKEYES

*Red
buckeye
fruit*

If a census of opinion
were taken as to which
the most handsome ex
flowering tree in the ea
ern part of the United
States there is little do
in my mind that it wo
be overwhelmingly in
favour of the Horsech
nut. In England the
same would be true.
For no other tree is a
day especially set apar
in England as is Ches
nut Sunday for this
famous exotic.

Ernest Henry
Wilson,
*The Romance of
Our Trees*

164 *Resplendent with scarlet flower clusters, a red buckeye once shaded a park bench south of the Pool. Buckeyes usually bloom in late April or early May.*

The genus *Aesculus,* buckeye, includes 17 species of trees and shrubs native to Europe, North America, and Asia. North America has 10 species; Asia, only six; and Europe, just one, *Aesculus hippocastanum.*

All species in the genus *Aesculus* have opposite palmately compound leaves with five or seven leaflets; erect clusters of white, red, or yellow flowers; and spiny or smooth capsules containing large, shiny seeds.

Mostly smaller trees or shrubs, the North American species of the genus *Aesculus* are called buckeyes. The single European species, known as the horsechestnut, is a large tree native to Greece, Macedonia, Albania, and Bulgaria but now is widely planted across Europe and other temperate areas of the world.

Central Park contains over 40 mature horsechestnuts but only about half as many buckeyes. During damp summers, a fungus disease known as leaf blotch may affect park horsechestnuts. At first, their leaves look scorched along their edges. Eventually, they turn entirely brown and fall off in late summer, long before most other trees have shed their leaves.

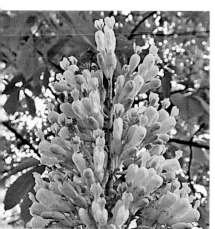

The aureolin-hued flowers of a yellow buckeye inflorescence appear after leaves emerge, anywhere from late April to June. The upper flowers are fertile; the lower, infertile.

The scarlet blossoms of the red buckeye are attractive to both hummingbirds and bees. The showy yellow-splotched upper petals advertise nectar and pollen rewards.

The horsechestnut's white flowers with spots of red or yellow and long anthers attract bees. Spots change from yellow to red when a flower is no longer producing nectar.

Buckeye *Aesculus* spp.

The name buckeye was given to North American members of the genus *Aesculus* because their characteristic shiny, dark-brown nuts, each with a pale spot, reminded early settlers of deer's eyes. Although the nuts look like the familiar chestnuts sold by street vendors, they are toxic and not fit to eat.

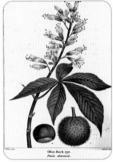

This engraving of the Ohio buckeye's flowers, leaf, and fruits accompanied François Michaux's account of the tree in *The North American Sylva*. Michaux remarked that its fruit "is prickly like that of the Asiatic species [horsechestnut], instead of being smooth like that of the *Paviae*."

Four buckeye species out of 10 native to North America grow in Central Park: the yellow buckeye (*A. octandra*), Ohio buckeye (*A. glabra*), red buckeye (*A. pavia*), and bottlebrush buckeye (*A. parviflora*).

The yellow buckeye is the largest of Central Park's four *Aesculus* species, sometimes towering up to 90 feet tall in its native Ohio Valley. A large, old yellow buckeye over 70 feet tall once stood in Central Park south of the Pool, but it was blown down in the violent storm on August 18, 2009. A 40-foot young yellow buckeye is located just inside the 72nd Street entrance on Fifth Avenue. It produces clusters of bright-yellow flowers in mid-April or early May.

The Ohio buckeye, a cousin of the yellow buckeye and also a Midwest native, tends to be a somewhat smaller tree. Sometimes called the fetid buckeye, the tree's leaves and yellow flowers have a disagreeable odor. Two Ohio buckeyes once grow east of Memorial Grove.

In mid-April or early May, the red buckeye stands out briefly as one of the park's showiest trees, with its striking upright clusters of bright-scarlet blossoms amid lustrous, dark-green, palmately compound leaves. This small tree once grew only sparsely along the Atlantic coastal lowlands from Virginia to the Florida Panhandle and west to Louisiana. Now, because of its increasing popularity as an ornamental and because of the steadily warming climate, it is cultivated well north of its original range. Several red buckeyes recently have been planted near the West 100th Street playground and on the Great Hill's southern slope.

The park's smallest member of the genus *Aesculus* is the bottlebrush buckeye. Its distinctive, palmately compound leaves with five to seven leaflets immediately identify it as a buckeye. The erect white flower clusters of this bushy shrub are evident in the Ramble near Bow Bridge, in the Conservatory Garden, and along the path skirting the western side of the Pond in June.

▲ *This fine young yellow buckeye stands just inside th park entrance at 72nd Street and Fifth Avenue. Becau it is only 15 or 20 years old, it has smooth bark like beech. As the tree ages, its bark will become rougher.*

▶ *Near the playground at the park entrance at We. 100th Street, a little red buckeye's graceful descending branches cast a welcoming circle of shad*

▼ *A bottlebrush buckeye in the Conservatory Garde blooming in June—later than other buckeye species—di plays the erect, tubular flower clusters for which the speci is named. Filamentous stamens (inset) bearing coral-co ored anthers project from around 40 individual flowers*

▼ *The palmately compound leaf of the Ohio buckeye consists of five, or occasionally seven, leaflets from 4 to almost 10 inches long. Leaflets turn yellow-green or orange in fall.*

▼ *Yellow buckeye fruits (left) are 2 to 3 inches across and smooth. Ohio buckeye fruits (right) are 1 to 2 inches across and slightly spiny. Both contain glossy brown seeds that are poisonous.*

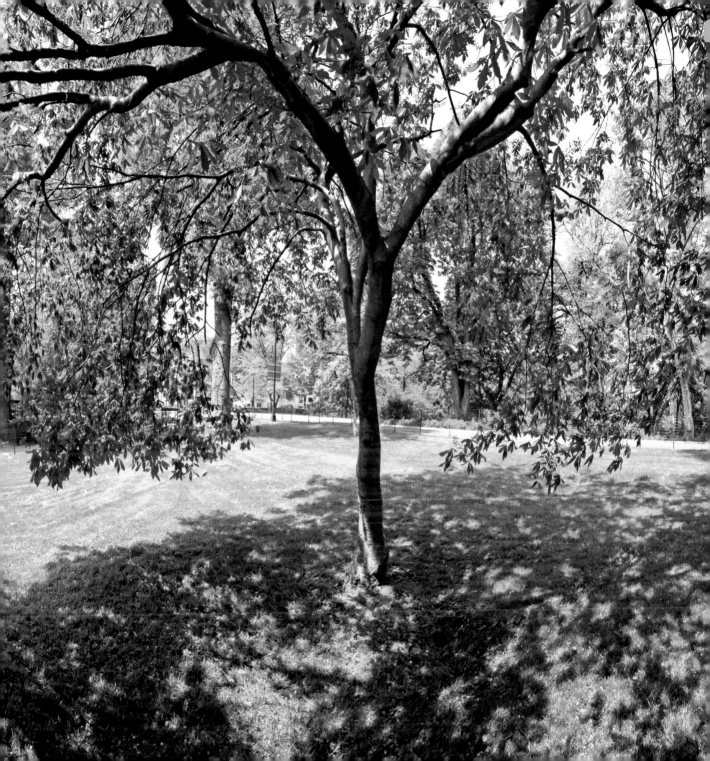

Horsechestnut *Aesculus hippocastanum*

Not really a chestnut at all, the horsechestnut is the European relative of the American buckeyes and is native to the Balkans. Among the closely related North American species are the yellow buckeye, bottlebrush buckeye, Ohio buckeye, and red buckeye.

The earliest illustration of a horsechestnut, this woodcut appeared in an herbal by Pietro Andrea Mattioli published in 1565. It clearly shows the horsechestnut's palmately compound leaves and spiky fruits (*upper right*).

The polished nuts in the horsechestnut and buckeye fruits, which drop to the ground beneath the trees in fall, look good enough to eat, but they are extremely bitter. They are also mildly poisonous, particularly when fresh. They can sicken horses, but deer eat them without ill effect. In the British Isles, children play a game called conkers with horsechestnut nuts.

The first written mention of the horsechestnut was in a letter that Willem Quackelbeen, a Flemish physician living in Istanbul, sent in 1557 to Pietro Andrea Mattioli, an Italian physician and author working in Prague. Quackelbeen described a tree that he had seen in Istanbul: "A species of chestnut is frequently found here, which has 'horse' as common second name, because devoured three or four at a time they [the nuts] give relief to horses sick with chest complaints, in particular coughs and worm diseases."

It seems likely that Quackelbeen not only wrote to Mattioli about the horsechestnut but also sent him a bough with leaves and fruit. In *Commentarii in libros sex Pedacii Dioscoridis De medica materia* (1565), Mattioli described the tree in some detail, calling it "Castaneae Equinae," and included a woodcut showing the leaves and fruit.

In a short time, horsechestnuts were planted in Vienna and in Italian botanical gardens. By 1615, seeds had reached France, and by 1633 the horsechestnut was growing in John Tradescant's garden in London. More than a century would pass, however, before the horsechestnut joined its buckeye cousins in North America. Peter Collinson, a London woolen draper and plant enthusiast, sent seeds in 1746 to John Bartram in Philadelphia. Seventeen years later, in 1763, Collinson was pleased to learn that one of Bartram's horsechestnuts had flowered.

For nearly 350 years after Quackelbeen wrote his letter, botanists assumed that the horsechestnut came from Asia—probably India. Only in 1897 was it definitively established that the tree is a Balkan native.

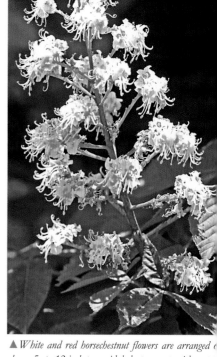

▲ *White and red horsechestnut flowers are arranged [in] showy 5- to 12-inch pyramidal clusters, or panicles, at [the] branch tip. Each panicle carries around 20 flowers.*

▶ *Bedecked with flower clusters in May, a lovely horsechestn[ut] stands along the East Drive opposite the Mall's southern en[d.]*

▼ *A horsechestnut flower is composed of five white, wa[xy] petals. Yellow spots turn to red once nectar production ceas[es.] Reddish-brown anthers tip each of the seven stamens.*

▼ *The horsechestnut's opposite, palmately compound leaves with five to seven leaflets are 4 to 10 inches long, with serrated edges and a pointed tip. Dark green, they turn weak yellow or brown in fall.*

▼ *After a flower is fertilized in May, it produces a 2-inch spiky fruit in late June. The fruit, here cut open to show the nut, ripens by mid-September.*

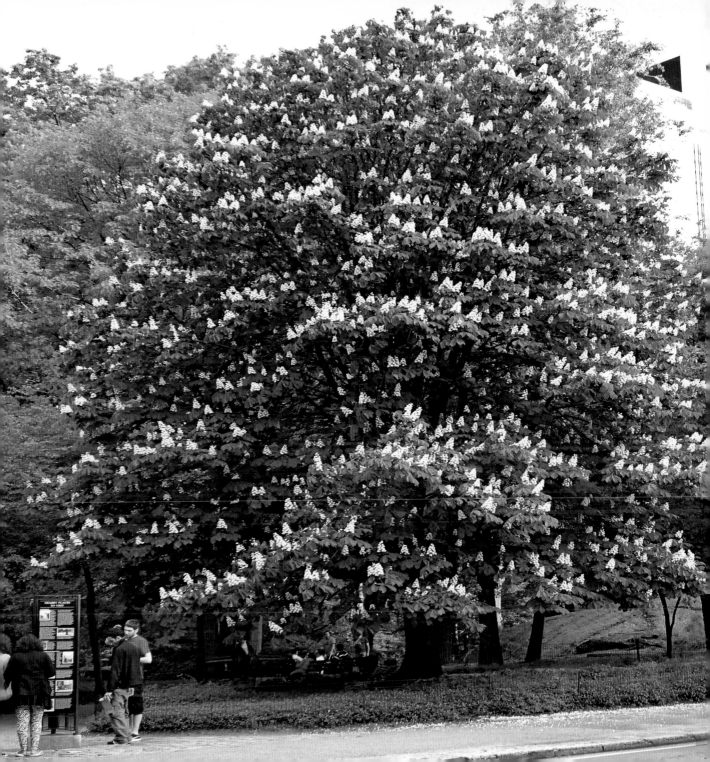

Ash *Fraxinus* spp.

Since the 1890s, when the Louisville Slugger was invented, the sweetest sound in all of American sports has been the supremely satisfying smack of an ash bat hitting the hand-stitched cowhide of a baseball for a homer. Babe Ruth swatted his way through 714 lifetime homers with an ash Louisville Slugger. Lou Gehrig whacked 23 career grand slams with a Slugger. Hank Aaron belted his 755th home run with one. Other Slugger club charter members include Pete Rose, Ty Cobb, Ted Williams, and Jackie Robinson. For generations, ash has also been used for other sports paraphernalia, such as hockey sticks, tennis racquets, and skis.

The Sultan of Swat posing with his Louisville Slugger.

Unfortunately, however, the future for ash baseball bats and other ash products may be dim. All over the Midwest and Northeast, ashes are declining. As the trees lose vigor, their leaves become paler green and turn yellow. Their crowns become thinner and thinner until the trees eventually die. Ash yellows is among the diseases that appear to be responsible. Ash yellows is caused by a virus-like organism spread by insects. One of these insects, the emerald ash borer, is also a serious threat to ashes. It carries pathogens, feeds on inner bark, and disrupts the flow of water and nutrients. Fortunately, though, the emerald ash borer has not been found in the park yet.

The ash trees of Central Park once numbered in the hundreds, but in the 2008 tree census only 45 green ashes (*Fraxinus pennsylvanica*) and just 10 white ashes (*F. americana*) over 6 inches in diameter were counted. During the past 25 years, several hundred ashes have died, most of them located in the North Woods. Many individuals declined over several years as an increasing number of twigs died back in their canopies every year. In some cases, though, a tree would die in one season. Several healthy, large white and green ashes still stand in the Ramble. But there is no telling how long they will survive.

The green ash, a smaller tree in maturity than the white ash, is the most widespread ash in America, with a range extending all the way from the East Coast to Montana. The white ash, which can top 120 feet and attain a girth of 6 feet, grows from Nova Scotia to Texas.

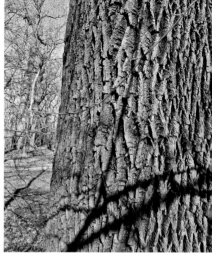

▲ *The bark of a mature white ash is deeply furrowed into sharp interlacing ridges that create a repeated diamond pattern that is very distinctive and easy to identify.*

▶ *This large white ash stands on Pilgrim Hill near the Conservatory Water. A male, this tree produces no fruit but bears purplish or yellowish pollen flowers in April as its leaves are just beginning to unfold.*

▲ *Inconspicuous female ash flowers bloom on female trees in late April or early May before or while leaves unfold.*

▼ *Pollen flowers appear on male trees when female flowers develop on female trees. Pollen is shed for three or four days and is carried by wind to the female flowers.*

▶ *The 8- to 12-inch compound leaves of the white ash consist of five to nine short-stalked, lance-shaped, smooth-edged or round-toothed, 2- to 5-inch leaflets. They are dark green above and pale green and hairless below.*

▼ *Clusters of yellowish-green fruits, or samaras, 1 to 2 inches long ripen from flowers on female green and white ash trees in July. White ash samaras are usually a bit longer than green ash samaras.*

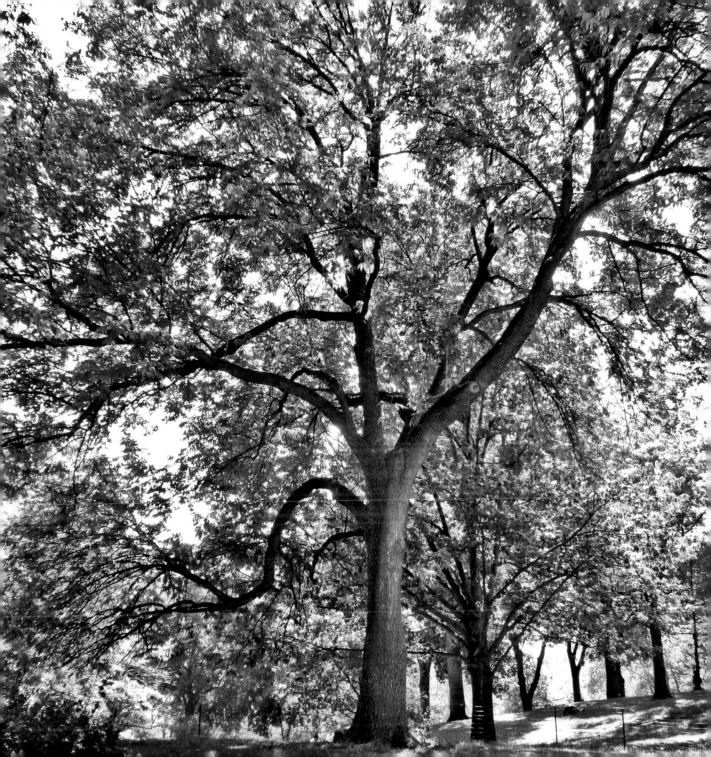

Amur Corktree

Phellodendron amurense

The genus name *Phellodendron* is derived from the Greek words for "cork" (*phellos*) and "tree" (*dendron*). The species name *amurense* refers to the Amur River Valley, where Russian botanists first encountered this tree species growing along the banks of the Amur River, which for a portion of its length serves as the border between northeastern China and the Russian Far East.

Born in Austria but educated in Prague, Franz Josef Ruprecht became a physician in 1836 and shortly thereafter moved to St. Petersburg to pursue a career in botany. He described and named many plants from the Russian Far East, including the Amur corktree.

The Amur corktree's bark is cork-like but not thick enough to be harvested for wine corks. The tree has a bold, open habit with large sinuous branches that, along with its grayish-brown, deeply furrowed bark, give it a striking appearance in winter. It is appealing in fall, too, when its dark-green composite leaves turn to brilliant shades of yellow. Clusters of yellowish-green flowers appear in May and June. By midsummer, female trees produce numerous bunches of fruits the size of small grapes on branch ends. These aromatic fruits turn from yellow-green in summer to shiny black in fall and may persist into winter long after leaves have fallen.

Largely free from diseases and serious insect pests, the Amur corktree withstands drought and air pollution and tends to thrive and naturalize in urban landscapes. Its shade-tolerant seedlings reach reproductive maturity in just three to five years and then begin to produce thousands of seeds. In the Northeast, it has aggressively colonized city parks and invaded hardwood forests, forming dense stands that shade out seedlings of native trees such as oaks and hickories.

The Amur corktree was not among Central Park's original plantings. The plant list of 1873 does not include it, but it is in Louis Harman Peet's *Trees and Shrubs of Central Park*, in which Peet refers to a "tall thin tree about thirty feet high, somewhat Y-form in shape" near the greenhouses located where the Conservatory Garden is now situated. Amur corktrees grow relatively fast, but a 30-foot-high specimen would likely be at least 15 to 20 years old. Therefore, the species must have arrived in Central Park in the 1870s or early 1880s. Amur corktree seeds from the Imperial Garden of St. Petersburg had reached Harvard's Arnold Arboretum by 1874, so it is probable that seeds also arrived in Central Park around the same time.

▲ *Amur corktree roots grow close to the surface and spread wide, stabilizing the trunk in high winds and excreting substances that suppress competing vegetation.*

▲ *The weathered bark of some of the Ramble's older Amur corktrees is intricately convoluted with numerous twisting, interlacing, and overlapping ridges and fissures.*

▶ *This handsome pair of Amur corktrees arching over the path on the southern side of the Ramble's Azalea Pond were probably planted more than 100 years ago.*

▼ *Amur corktree opposite, compound leaves are 10 to 15 inches long with five to 11 short-stalked, ovate, smooth-edged, sharply pointed, 2½- to 4½-inch leaflets, which have a citrus odor when crushed. Lustrous dark green above, the hairy-stemmed leaves turn golden yellow to bronze-yellow in early fall.*

▶ *Amur corktrees at Winterdale Arch, on the West Drive opposite West 82nd Street, turn gold in early October ahead of most other deciduous trees.*

▼ *Amur corktree ¼- to ½-inch fruits, each containing five seeds, turn from green to black as they mature in the late summer.*

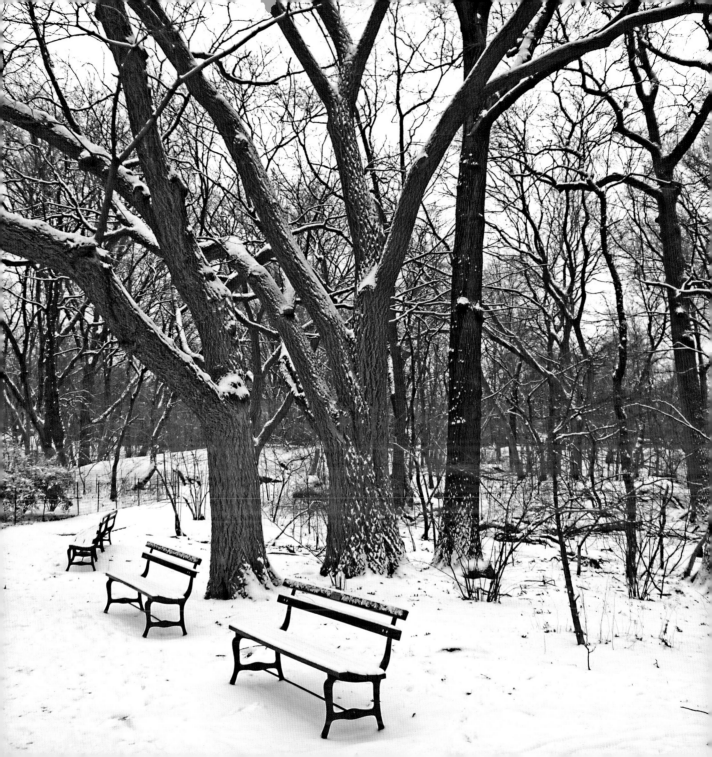

Ailanthus *Ailanthus altissima*

The dust jacket of the first edition of Betty Smith's novel *A Tree Grows in Brooklyn* pictures an ailanthus on a Williamsburg, Brooklyn, street, where Francie Nolan, the heroine, grew up in the early 20th century.

A great ailanthus tree 3½ feet in diameter once shaded the ramp at the Yard near West 79th Street. When it was cut down in the early 1990s, it was 130 years old. Perhaps the park's oldest ailanthus, it could have been planted by Olmsted's gardeners. To the east of the Yard in the Ramble, Olmsted definitely did direct his gardeners to plant ailanthus trees to achieve a wild, tropical effect. Most ailanthus trees growing in the park in recent years, however, have sprouted from wind-scattered seeds.

The ailanthus tree's proliferation during the past century was symbolic of Central Park's decline. In a 1982 survey, 503 ailanthus trees were counted in the park. As of 2013, there were fewer than 200. Park gardeners pull up all saplings. The tree is an invasive pest that competes with more desirable species.

The ailanthus is, above all, a survivor. A single specimen can produce up to 325,000 seeds every year. It grows in cracks in rocks, pavements, and building foundations. Its roots secrete toxins that inhibit the growth of other plants and spread wide and deep, sometimes clogging drains and sewer pipes. In Betty Smith's novel *A Tree Grows in Brooklyn* (1943), an ailanthus is the central metaphor, symbolizing the working-class heroine's struggle for a better life against grinding urban poverty.

While the ailanthus possesses a formidable array of adaptations enabling it to grow in parched vacant city lots, in toxic soils of abandoned mining sites, and in polluted dust-laden air, it is not invincible. Lately, many ailanthus trees have been infected by root rot or Verticillium wilt, a fungus disease causing leaves to prematurely turn yellow and branches to die back, a process that eventually kills a tree. It does not tolerate disturbance well either, perhaps because it develops an extensive root system before it produces much of a canopy. Once established, though, its growth rate is phenomenal—over 3 feet a year in its first four years.

The ailanthus was sent overland in the 1740s via Siberia from its native China to Europe by the French Jesuit Pierre Nicolas Le Chéron d'Incarville. In 1784, William Hamilton, a Philadelphia gardener, sent seeds to the United States from Britain. By 1840, it was growing in nurseries in Queens.

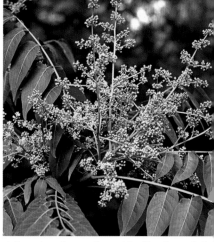

▲ *In spring, clusters of greenish-yellow flowers bedeck ailanthus trees. Male and female flowers usually grow on separate trees. All parts of an ailanthus, and especially the male flowers, have a pungent unpleasant smell.*

▶ *A old ailanthus grows from a crevice in a Manhattan Schist outcropping southeast of the Dairy. It vividly exemplifies the tree's ability to grow where there would not appear to be enough soil for its roots. An older ailanthus can be a beautiful specimen tree, and despite its drawbacks the species will always have a place in the park.*

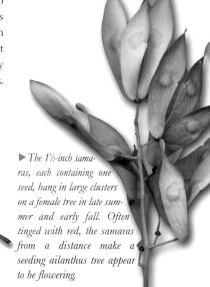

▶ *The 1½-inch samaras, each containing one seed, hang in large clusters on a female tree in late summer and early fall. Often tinged with red, the samaras from a distance make a seeding ailanthus tree appear to be flowering.*

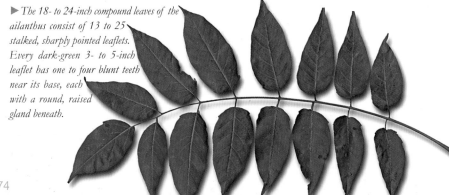

▶ *The 18- to 24-inch compound leaves of the ailanthus consist of 13 to 25 stalked, sharply pointed leaflets. Every dark-green 3- to 5-inch leaflet has one to four blunt teeth near its base, each with a round, raised gland beneath.*

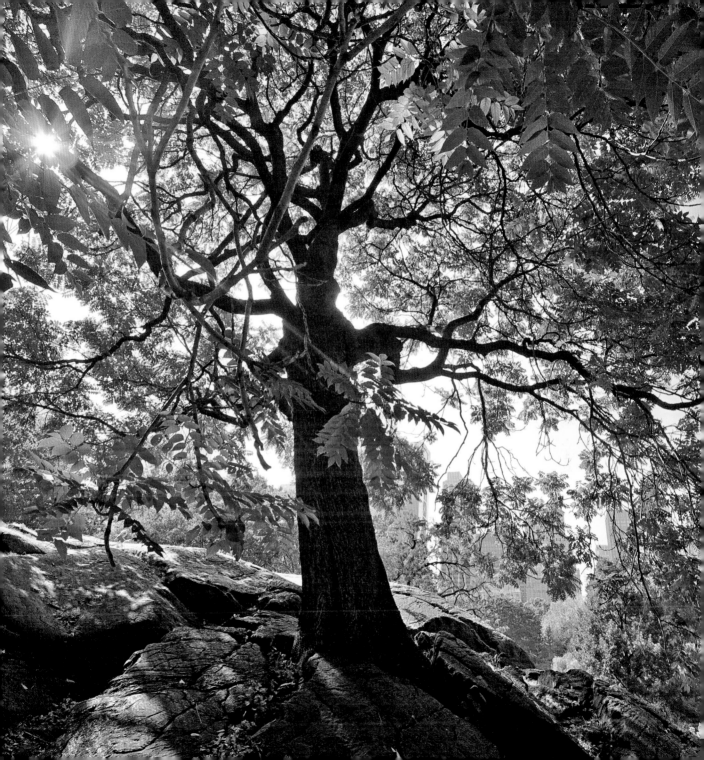

Hickory *Carya* spp.

Hickory trees are native to the Northeast and were present in the lush forests that blanketed Manhattan Island when Henry Hudson sailed up the Hudson River on September 12, 1609. Those trees are long gone, of course, but there are still more than 100 hickory trees in Central Park, nearly all of which have seeded on their own. These remaining hickories are most likely descended from trees that grew in the pre-Columbian forests of Manna-hata, a Lenape word meaning "island of many hills."

The shagbark hickory (*Carya ovata*) bears nuts that are good to eat. It is the most easily recognized of the park's four hickories species, with its gray bark broken into flat plates that continually peel off in long strips. A prodigious nut producer, a mature shagbark may drop two or three bushels of fruits in a good year—a bonanza for squirrels and people. Both Native Americans and early European settlers included the shagbark's sweet nuts in many of their recipes. Settlers

About 3 feet across, this tree "cookie," or trunk cross section, was cut from a 148-year-old bitternut hickory that once stood on the northern side of Cherry Hill overlooking the Lake.

also made tool handles, furniture, and wagon wheels from its tough, resilient wood.

Another park hickory species with edible nuts is the mockernut (*C. tomentosa*). It is present in the North Woods. Native Americans pounded mockernut hickory nuts and then boiled them to make an oily, milky liquor.

The most widely distributed throughout the East as well as the most common hickory in the park, the bitternut (*C. cordiformis*) also has the least edible nut. These two facts may be connected. Many of the tree's nuts survive to germinate because squirrels appear to dislike them as much as people do.

The bitternut grows fast for a hickory, but it seldom lives longer than 200 years. Bright-yellow, ¾-inch buds on branch ends make the bitternut easy to identify in winter.

A hickory barely present in the park is the pignut (*C. glabra*). Farmers once let their hogs root under the pignut hickory for its fallen nuts, which are too sour for people. The pignut is able to thrive in poor soils and dry locations, but it can look dead in spring as it is late to leaf out. It matures in 200 years and can live for 400. Its wood, heaviest of the hickories, was once much in demand. Only one mature pignut hickory remains in the park. It is situated on the Pool's northern side.

▶ *Alternate and compound, the hickory leaf is 6 to 10 inches long with five to nine stalkless, lance-shaped, finely toothed leaflets. Widths of leaflets vary (inset).*

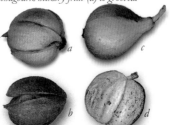

▼ *The ¼- to 1¼-inch bitternut hickory fruit (a) is seamed. The 2-inch mockernut hickory fruit (b) has a dark-brown husk. The 1- to 1½-inch pignut hickory fruit (c) may be pear-shaped. The 1¼- to 2½-inch shagbark hickory fruit (d) is grooved.*

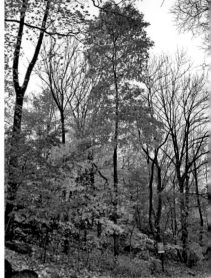

▲ *This 40-foot bitternut hickory is situated at th[e] North Woods' steep northern edge close to the Driv[e.] Several other bitternut hickories grow nearby on the hi[ll.]*

▶ *A bitternut hickory high on the eastern side of th[e] North Woods displays the spectacular deep-golden fa[ll] foliage that is the hallmark of the hickory tribe.*

▼ *A 70-foot shagbark hickory specimen towers over [a] path in the Dene. The tallest hickory in the park, it [is] easily identifiable by its long, loose bark plates (inset).*

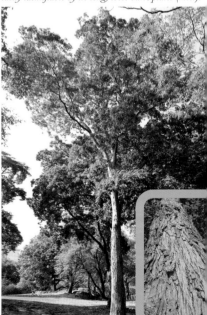

Yellowwood *Cladrastris kentukea*

As the yellowwood's name hints, its heartwood is bright yellow and the bark of the roots produces a yellow dye with which pioneers colored homespun. Extremely hard, heavy, and fine grained, the wood was also fashioned into gun stocks by early settlers.

A hand-colored engraving from François Michaux's *The North American Sylva* pictures a yellowwood fruit, a seed, a leaf with nine leaflets, and a flower raceme. Michaux wrote in his book *Travels* (1805): "Several of the inhabitants have remarked that there is not in the country a single species of tree that produces so great an abundance of sap."

Rare in the wild, the yellowwood is a small, graceful tree with spreading branches, a forking trunk, and a rounded crown. When not crowded by other trees, it can attain a height of 60 feet, but most mature specimens are less than 50 feet tall. Very limited in range, this member of the pea family grows naturally only in the southern Appalachian Mountains of Tennessee and adjacent states. Highly regarded as an ornamental, the yellowwood has been planted throughout the Northeast and in Europe.

In mid- to late May, the yellowwood is bedecked with white flowers that hang in loose clusters 12 to 14 inches long. By mid-August, the bean-like seed pods are fully developed and beginning to ripen. Each pod contains a few flat, hard seeds.

André Michaux, a renowned French botanist, was the first European to collect the yellowwood. He wrote in his journal in March 1796, when he was exploring by the Cumberland River at Fort Blount near Gainesboro, Tennessee: "Snow covered the ground and I was unable to get any young shoots but Captain Williams, the young [officer] stationed in the Fort, cut down some trees and I found some good seeds." In 1802, the year of his father's death from tropical fever in Madagascar, François Michaux also encountered the yellowwood in Tennessee, and a decade later he, too, collected seeds as he recounted in his book *The North American Sylva*: "[I]n the year 1812, I collected a quantity and afterwards distributed them in France to nurserymen and amateurs of foreign plants. From these [seeds have] sprung plants which we see growing with so much vigor in Europe."

Yellowwood trees have never been plentiful in Central Park, but they were among the earliest plantings, and two were described by Louis Harman Peet in *Trees and Shrubs of Central Park*. Only about eight yellowwood trees are now spread around the park.

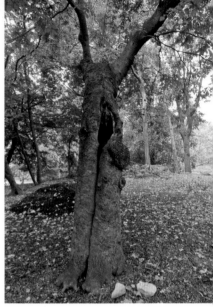

▲ *A 25-foot yellowwood stood for about a century west of the Conservatory Water near the East Drive. In the tree's later years, the center of its trunk rotted out, a common development in older yellowwoods. It was cut down in 2012.*

▶ *A yellowwood tree standing across the East Drive from the Metropolitan Museum of Art exhibits the typical habit of a short trunk topped by ascending branches.*

▼ *Fragrant yellowwood flowers open in June on 12- to 14-inch pendulous racemes, resembling those of wisteria. Flower petals are mostly white with central, pale-yellow blotches (inset). Most trees flower only in alternate years.*

▼ *Yellowwood alternate, compound leaves are 8 to 12 inches long with seven to 11 oval 2- to 4-inch leaflets. Leaflets have smooth edges and a pointed tip. They are bright green above, lighter green below, and clear yellow in fall.*

▼ *Yellowwood flowers produce 2- to 4-inch, flattened, papery seed pods, or legumes, that drop in fall. Each pod contains four to six brown ¼-inch seeds (inset).*

▼ *The smooth bark is silvery gray or brown and somewhat resembles beech bark or saucer magnolia bark.*

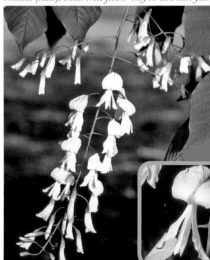

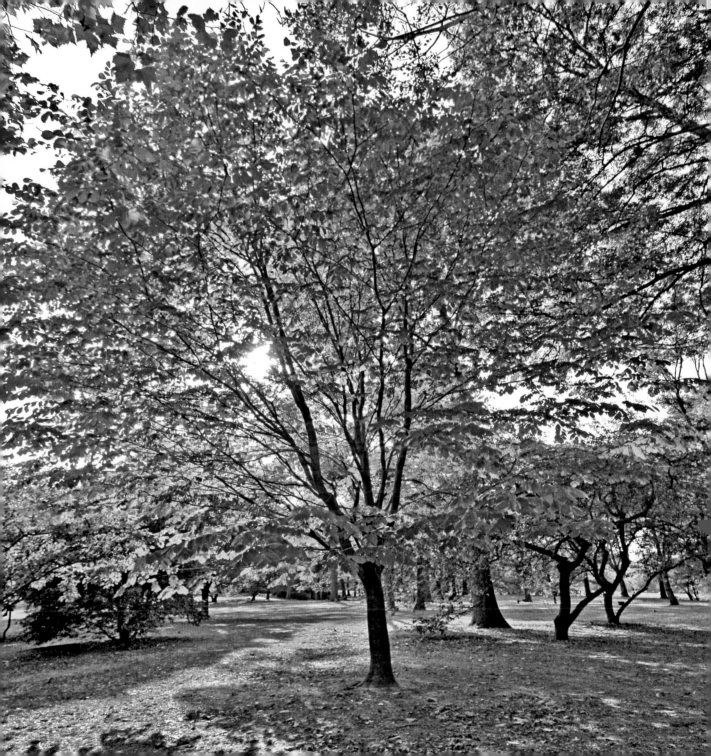

Honeylocust *Gleditsia triacanthos*

The honeylocust is the only American tree with large, sharp spines growing in irregular clumps from its trunk and branches. A medium-size tree with delicate foliage and slender, sometimes twisting, branches, it is native to states close to the Mississippi River, from the Great Lakes to the Gulf of Mexico. It has been planted beyond its range, as an urban ornamental, as far north as Canada. Because it tolerates the harshest urban conditions—such as salt runoff, pollution, compacted soil, and drought—the thornless variety (*Gleditsia triacanthos* var. *inermis*) is widely planted in northeastern cities, and it is the most common street tree in Manhattan.

An engraving from François Michaux's *The North American Sylva* illustrates a doubly compound honeylocust leaf and a seed pod. Michaux noted that the honeylocust's "foliage is elegant and of an agreeable tint; but it is thin, and scarcely obstructs the passage of the sunbeams."

The honeylocust's inconspicuous, yellowish-green pollen and seed flowers appear on the same trees in May as the leaves unfold. Seed pods mature by autumn, often reaching 1 foot or more in length. The bean-like seeds inside the seed pods are enclosed in a sweet, succulent pulp from which the tree derives its name. This pulp is a favorite food of cattle and deer, which swallow the seeds unharmed, partially breaking down their hard outer coatings with digestive juices, and then spread them far and wide.

Paleoecologists speculate that during the Pleistocene period, between 1.8 million and 10,000 years ago, giant sloths, mammoths, mastodons, and other large extinct herbivores fed on honeylocust seed pods and scattered the enclosed seeds. Pleistocene mammoths and mastodons, like modern elephants, also probably stripped bark from some trees. If so, then honeylocust thorns may have developed as an adaptation for discouraging bark snacking—an adaptation that protected these trees from being destroyed by the very animals that spread their seeds.

The honeylocust has been in Central Park from its founding. Olmsted favored it for its tropical appearance. Louis Harman Peet, in *Trees and Shrubs of Central Park,* called it "a tower of strength, with its fine, soft, light green leaves flutering in exquisite grace at every breath of stirring air." Some 300 honeylocusts were counted in the 1982 tree inventory; as of 2013 there were around 225 honeylocusts in the park.

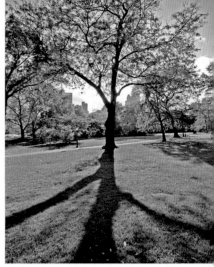

▲ Once the park's largest honeylocust until it was felle in 2012, this Great Tree of New York City stoo across the East Drive from the Mall's southern entranc

▲ Thorns 1 to 4 inches long may partially or completely cov the reddish-brown or dark-gray trunk of a honeylocust.

▶ Two honeylocusts cast dappled shade along a path lead ing from the East Drive past the King Jagiello Monumen.

▼ Greenish-yellow, 2- to 5-inch honeylocust flower clu ters hang from branches in late May or early June.

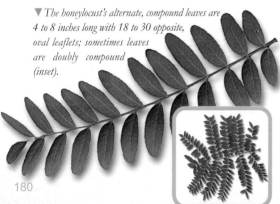

▼ The honeylocust's alternate, compound leaves are 4 to 8 inches long with 18 to 30 opposite, oval leaflets; sometimes leaves are doubly compound (inset).

◀ Honeylocust seed pods are typically 6 to 8 inches in length but can be over 1 foot long. The pulp inside a ripening, green pod is sweet and edible. Each pod contains around 24 flattened, oval seeds that turn from green to brown as the pod dries to a dark reddish-brown.

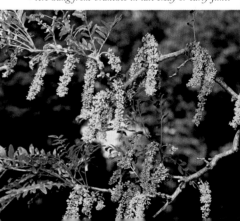

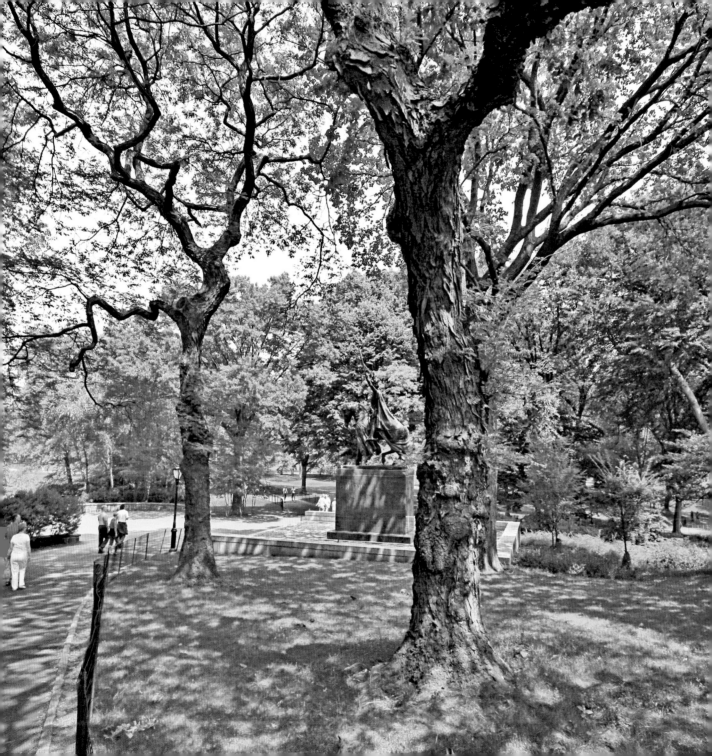

Kentucky Coffeetree *Gymnocladus dioicus*

The Kentucky coffeetree is a loner and a bit of an oddball. A midwestern tree with a natural range that extends from Ontario to Louisiana and from Kentucky to eastern Nebraska, it is often planted singly in the East as an ornamental, but even within its natural range it usually grows as a solitary tree or in small clonal groups.

The British painter Robert Edge Pine painted this portrait of George Washington at Mount Vernon in May 1785, probably just a month or two after Washington had planted his "Eight Nuts" of the Kentucky coffeetree.

The Kentucky coffeetree's genus name, *Gymnocladus,* meaning "naked branch," alludes to the relatively brief annual appearance of its thin deciduous foliage, which casts a light shade. The tree unfurls its large compound leaves in late spring after most other deciduous trees have leafed out and drops its leaves in late summer before most broadleaf trees have begun to turn color.

The Kentucky coffeetree's species name, *dioicus,* refers to the fact that male and female flowers bloom on separate trees. A legume, the tree bears large, pea-like pods containing hard seeds that are said to be toxic when raw but were roasted by Native Americans and early European settlers to make a coffee substitute.

The Founding Fathers were fond of the Kentucky coffeetree. George Washington, who kept records of his Mount Vernon gardening, noted on April 13, 1785, that he had planted "Eight Nuts from a tree called the Kentucke Coffee tree." In a letter to James Madison dated "Philadelphia, June 2, 1793," Thomas Jefferson wrote, "Bartram [John Bartram, Jr., son of the self-taught Philadelphia botanist John Bartram] is extremely anxious to get a large supply of seeds of the Kentucky Coffee tree. I told him I would use all my interest with you to obtain it, as I think I heard you say that some neighbors of yours had a large number of trees. Be so good [as] to take measures for bringing a good quantity, if possible, to Bartram when you come to Congress." Apparently, Jefferson got the seeds for Bartram from Madison and kept some for himself because on March 17, 1794, he wrote in his Garden Book: "Planted 200 paccan nuts and seeds of Kentucky coffee."

The Kentucky coffeetree has been in the park since its founding. Olmsted liked the tree's exotic, tropical look and planted it in the Ramble and elsewhere. As of 2013, there were about two dozen Kentucky coffeetrees in the park.

▲ *The five fused trunks of the Kentucky coffeetree o the slope at the northern side of the East Meado. sprouted from a tree that was cut down in the late 1980.*

▶ *The largest Kentucky coffeetree in Central Park, graceful, five-trunked specimen, shades the gentle slope a the northern side of the East Meadow. It is early Sep tember, and the tree will shortly begin to drop its leaves*

▼ *This pair of Kentucky coffeetrees on the North Meadow southeastern edge were just beginning to leaf out in ear June, weeks after other trees had sprouted leaves. They wer cut down in 2014, but another pair of large Kentucky coffeetrees stand near Ladies Pavilion at Hernshead.*

▼ *Alternate, doubly compound leaves of the Kentucky coffeetree are up to 34 inches long, with 50 to 70 short-stalked, oval, smooth-edged leaflets on three to seven pairs of small stalks branching off a central stalk. Leaflets are dark green above and pale below.*

▼ *The dark purplish-brown, thick-walled, woody 6- to 10-inch pod of the Kentucky coffeetree contains five or more ¼-inch dark-brown, rock-hard seeds surrounded by a gooey, sticky, sweet pulp.*

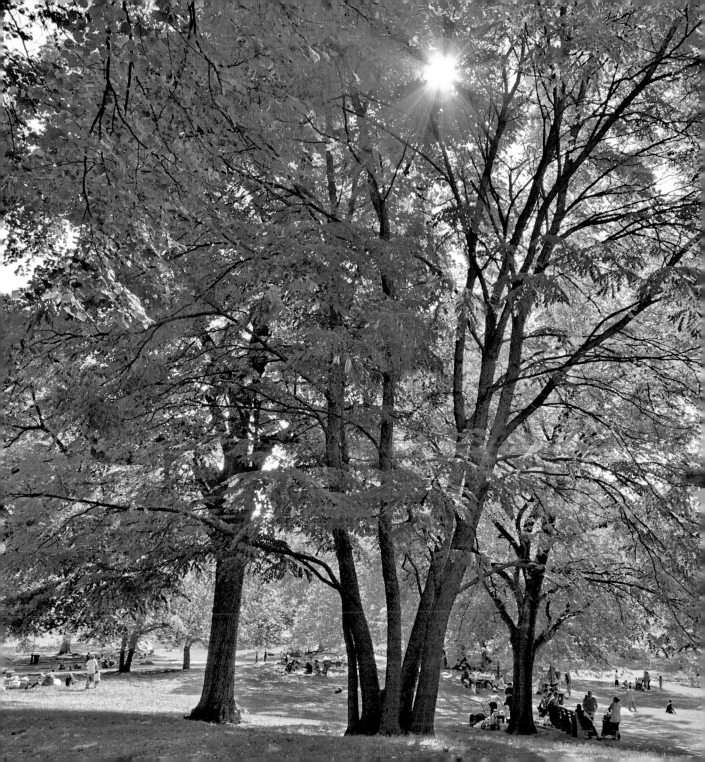

Black Walnut *Juglans nigra*

Intolerant of shade, the black walnut secures its ecological niche by producing a substance called juglone, which retards the growth of other trees around it. Juglone is secreted by black walnut leaves, roots, and fruit husks.

An engraving in François Michaux's *The North American Sylva* shows male flowers, a leaf, a nut, and the fruit of the black walnut. Michaux remarked that the nut "is of a sweet and agreeable taste, though inferior to that of the European [English] walnut."

The fruits are edible, but their tough husks must be rolled underfoot to crush them and release their rock-hard nuts, and the nuts then must be cracked open with a heavy hammer to expose their oily, bittersweet meat. Good crops of nuts develop in alternate years. The somewhat larger but milder-tasting nut of the black walnut's Old World cousin, the English walnut, is the one offered in markets. Orchards of English walnuts in California produce most walnuts sold in America.

Indigenous to eastern North America, the black walnut ranges from Ontario to Florida and as far west as Nebraska and Texas. It was once plentiful in the eastern United States, but most of the great old-growth forest trees are gone, felled by lumberman seeking America's finest cabinetry wood. For generations, walnut has been the preferred wood for chairs, tables, desks, bedsteads, and gun stocks. Today many medium-size trees are cut to make veneer. J. Jay Smith, a Philadelphia horticultural editor, foresaw the fate of the black walnut over 150 years ago when in a footnote in François Michaux's *The North American Silva* (1859), he noted: "This resource must fail in time, and the wood may not improbably become nearly as costly as Mahogany."

If it is not cut down for its valuable wood, a black walnut tree can grow very large indeed. John Claudius Loudon, in *Arboretum et fruticetum britannicum*, described the trunk of a black walnut from "the south side of Lake Erie" exhibited in London in 1827: "It was 12 ft. in diameter, hollowed out, and furnished as a sitting room. The tree was said to have been 150 ft. high, with branches from 2 ft. to 4 ft. in diameter. The bark was 1 ft. thick." The largest living black walnut in America is located on the grounds of a private residence on Sauvie Island, Oregon. It is 8 feet, 2 inches in diameter and 112 feet tall.

The black walnut was among the first trees planted in the park. Early in the park's history, there were English walnuts, too, but none of them have survived. As of 2013, there were about 25 black walnuts in the park.

▲ *Black walnut bark is dark brown or dark gray and deeply furrowed on older trees. Trunks of forest-grown trees may extend unbranched for 40 feet or more.*

▶ *A trio of black walnuts with leaning trunks and curving branches stands next to the East Drive near the composting area on the hillside descending to the Harlem Mee*

▼ *Green male flowers of the black walnut dangle on 3 to 5-inch catkins from branches in spring. Female flowers (inset) on branch ends have V-shaped stigmas attached pear-shaped ovaries, which develop into fruits.*

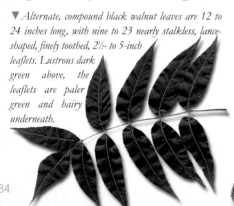

▼ *Alternate, compound black walnut leaves are 12 to 24 inches long, with nine to 23 nearly stalkless, lance-shaped, finely toothed, 2½- to 5-inch leaflets. Lustrous dark green above, the leaflets are paler green and hairy underneath.*

▼ *The 1½- to 3-inch black walnut fruit looks like a green tennis ball. The very hard, corrugated shell of the nut inside the green, lemon-scented husk contains soft, edible meat with a strong, sweet, musky taste.*

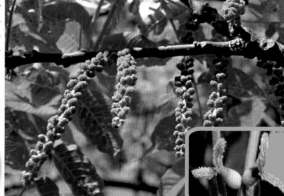

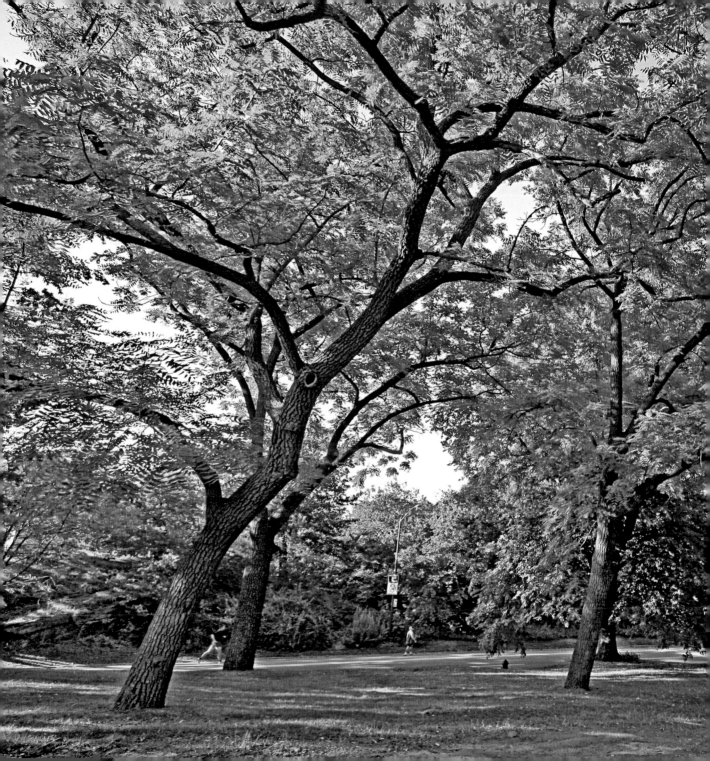

Goldenraintree *Koelreuteria paniculata*

In 1771, a 34-year-old Finnish naturalist named Erik Laxmann, a professor at the St. Petersburg Academy of Sciences, sent a short note with a leaf to the great Swedish botanist Carolus Linnaeus describing a little tree that had flowered for the first time after 20 years in the academy greenhouse. The following year, Laxmann wrote a scientific paper about this tree, "whose nuptials our botanist had so many years eagerly awaited." He named it *Koelreuteria* in honor of "a man outstandingly and deservedly most distinguished"—Joseph Gottlieb Kölreuter, a German botanist.

The little greenhouse tree had grown from seed sent overland from China to St. Petersburg in 1750 by Pierre Nicolas Le Chéron d'Incarville, a Jesuit priest. During his long residence in China, d'Incarville had shipped seeds of many different plants—including the ailanthus and the Chinese scholartree—to Stepan Krasheninnikov, a naturalist at the Academy of Sciences, and Bernard de Jussieu, a botanist at the Jardin des Plantes in Paris.

In 1809, Thomas Jefferson received goldenraintree seeds from France sent by the comtesse de Tessé, aunt of General Lafayette. They were from trees raised from the seeds that d'Incarville had dispatched by plodding camel caravan to Jussieu. Jefferson commented on the seeds two years later in a letter dated March 27, 1811: "Since I had last the pleasure of writing to you, I have to acknowledge the receipt of the seeds of the Koelreuteria, one of which has germinated, and is now growing." Jefferson's tree was the first goldenraintree in America.

A native of northern China, the goldenraintree is a tough, small tree, able to withstand heat, drought, and poor soil. It is also an exceptionally beautiful tree, especially in mid-June and July when it produces a profusion of yellow blossoms that yield three-valved, bladder-like fruits containing dark, round, ¼-inch seeds. In *Tree Trails in Central Park*, M. M. Graff likened ripening goldenraintree fruits to "strings of miniature Chinese lanterns at a late summer garden party."

The goldenraintree was among the first trees planted in the park. Over 50 specimens were counted in the 2008 census; as of 2013, there were about 40 trees in the park.

Joseph Kölreuter (1733–1806), a German physician and botanist, studied plant sexuality and developed theories about plant fertilization and hybridization. His groundbreaking experimental work inspired both Gregor Mendel and Charles Darwin.

▲ *Cyclists whiz by self-seeded goldenraintrees near the Reservoir's northeastern corner. It is late June, and the upper branches are tipped with clusters of yellow blossoms.*

▶ *In late October, goldenraintrees at the Reservoir's northeastern corner turn shades of fiery gold. The goldenraintree deserves its name not only for the showers of golden flower petals that dust the ground beneath it in July but also for the gentle rain of fluttering golden leaves it drops in fall.*

▼ *Yellow goldenraintree flowers are barely ½ inch long, but hundreds of them may be clustered on each showy, 12- to 18-inch panicle. Male flowers open first, then female.*

▼ *The alternate, compound leaves of the goldenraintree are 6 to 18 inches long, with seven to 15 stalked, lobed, coarsely toothed, 1- to 4-inch green leaflets that turn golden yellow and sometimes vivid orange in fall.*

◀ *After blooming, fertilized goldenraintree female flowers transform into 1½- to 2½-inch seed pods. Lime green at first, they turn yellow flushed with pink and finally dry to a papery brown.*

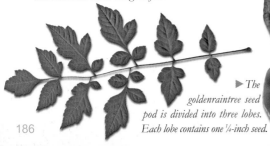

▶ *The goldenraintree seed pod is divided into three lobes. Each lobe contains one ¼-inch seed.*

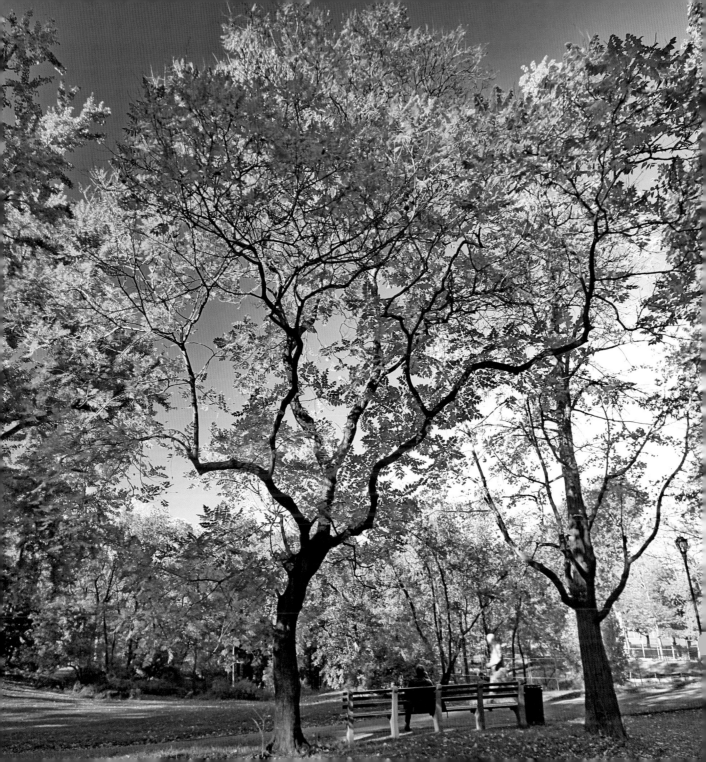

Sumac *Rhus* spp.

Sumacs are wanderers and opportunists. They invade forest clearings, vacant lots, and untended roadside edges. How do they get there?

An engraving from Mark Catesby's *Natural History of Carolina, Florida, and the Bahama Islands* (1743) pictures a fruiting smooth sumac. Catesby noted the "resplendence of its scarlet panicles...[a] scarlet colour nothing can excel, especially when the sun shines upon it."

The sumacs have a compact with birds. They wave their tempting, red fruit clusters above snow and pilfering rodents all winter, beckoning hungry birds to come and eat. Because sumac fruits are small and dry and contain little meat, starlings, robins, crows, and catbirds eat them only in late winter, after more palatable and perishable wild fruits are long gone. The sumac seeds pass through the birds' digestive systems unharmed and are deposited miles away.

There are five species of sumac in Central Park: smooth sumac (*Rhus glabra*), one of the few trees found in all 48 contiguous states, named for its smooth and hairless twigs; shining sumac (*R. copallina*), easily identified by its lustrous leaves and "wings" on its central leaf stalk; staghorn sumac (*R. typhina*), similar to smooth sumac but with

hairy, velvety twigs like deer antlers in their velvet stage; and fragrant sumac (*R. aromatica*), usually a low-growing shrub with leaves composed of three toothed leaflets that are fragrant when bruised and resemble those of the sumacs' close relative, poison ivy, but are not irritating to the skin.

William Bartram, in "Observations on the Creek and Cherokee Indians," described how Native Americans of the Southeast utilized the bright-red pigment of smooth sumac fruits to maintain their hair color: "[T]hey preserved its perfect blackness and splendour by the use of the red farinaceous or fursy covering of the berries of the common sumach (*Rhus glabrum*). Over night they rub this powder in their hair; as much as it will contain, tying it up close with a handkerchief till morning, when they carefully comb it out and dress their hair with bears' oil."

Sumacs were among the park's early plantings. Olmsted liked their tropical look and directed his gardeners to plant them in the Ramble. Over the decades, however, they dwindled, perhaps shaded out by larger maturing trees. By the early 1980s, few were left. In recent years, they have been reestablished in Wildflower Meadow, Strawberry Fields, and other places in the park.

▼ *Alternate, compound staghorn sumac leaves are 12 to 24 inches long, with 11 to 31 sharply pointed leaflets. They turn from green to bright scarlet and yellow in fall.*

▼ *Alternate, compound shining sumac leaves are 6 to 12 inches long with nine to 21 pointed leaflets with a few teeth. They turn from lustrous green to vivid scarlet in fall. Wings on stems extend between leaflets.*

▲ *A stand of shining sumacs display their fall colors at the southern end of Strawberry Fields. The leaves of shining sumac are noticeably more lustrous than those of other sumacs.*

▶ *A thicket of staghorn sumacs at the western end of Gapstow Bridge signal autumn's arrival with what Donald Culross Peattie called their "hellfire flickering."*

▼ *The vivid fruit clusters of smooth sumac, consisting of several hundred bright-red ⅛-inch drupes, each containing an oval nutlet, develop from yellow flower clusters (inset).*

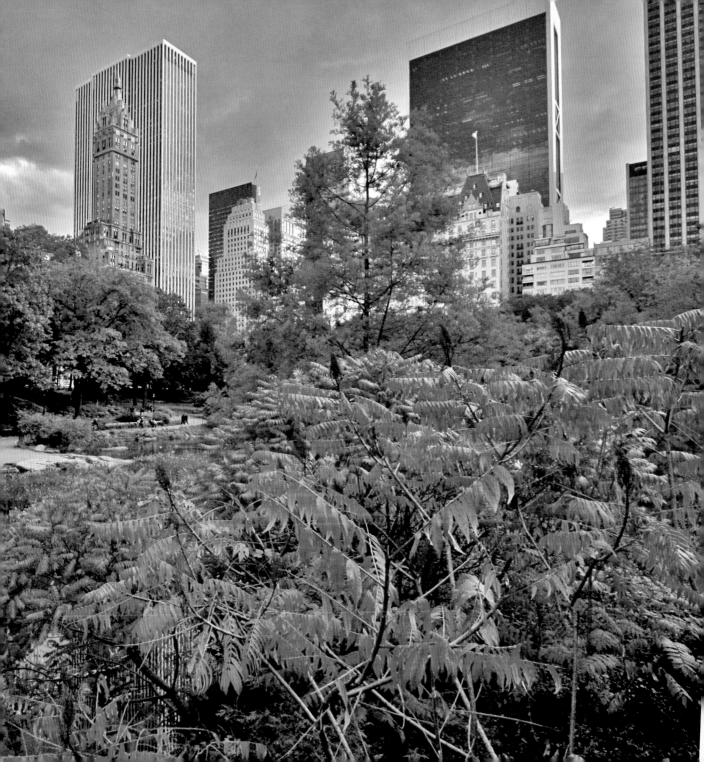

Black Locust *Robinia pseudoacacia*

The black locust's Latin name honors Jean Robin, gardener to Henry IV of France. Robin was among the first to establish the tree in Europe. A black locust located on Paris's Square René Viviani is said to have been planted in the early 17th century by Robin or his son Vespasien.

Supported by cement posts but still bearing blossoms every year, the ancient black locust on Square René Viviani is generally conceded to be the oldest living tree in Paris.

A member of the legume family, the black locust has pea-like flowers and fruits and nodes on its roots inhabited by bacteria that transform atmospheric nitrogen into nitrates usable by plants, enabling it to grow in the most impoverished and barren soils. Native to the Ozarks and the southern Appalachians, it has been established in many northeastern states and is widely planted in Europe and Asia. It is a pioneering tree that springs up on disturbed ground and in forest openings but is later succeeded by more shade-tolerant species.

Black locust wood is very hard, durable, and rot resistant. It was used by pioneers for fence posts and pegs—or treenails, as they were called—in early sailing ships. These pegs often outlasted the hull planks they fixed in place. Later it was cut for cross arms of telephone and power lines. In Central Park, it is used for rustic fencing. The black locust is one of the fastest-growing North American trees, capable of sprouting more than 8 feet in a single growing season. The species probably would be a major commercial source of lumber were it not for the widespread locust borer, a black and yellow native beetle that riddles trunks and branches of mature trees.

The black locust's compound leaves open in April or May and are closely followed by drooping clusters of white blossoms that last for no more than 10 days. Bees that collect the nectar of black locust flowers produce a highly regarded light-amber honey. People fry and eat the flowers and boil them to make tea. The foliage and seeds, however, are said to be toxic, but deer and cattle do browse the leaves, and squirrels, rabbits, doves, ruffed grouse, and other game birds are known to eat the small bean-like seeds.

Most of the more than 750 black locusts in the park have seeded on their own. The trees that once composed a grove on the western end of the Harlem Meer may have been among the few that were purposely planted.

▲ *Blossoming black locust trees scent the air near the Carous in late May and attract hordes of pollinating insects.*

▶ *A black locust grove at the western end of the Harle Meer once provided pleasant dappled shade in summer f those who sat on benches or on the grass and enjoyed the vie*

▼ *Black locusts bloom in the park around mid-Ma Their intensely fragrant, creamy-white to lavender or pu ple flowers form pendulous clusters, each 4 to 5 inches lon*

▼ *The black locust's alternate, compound leaves are 8 to 14 inches long, with seven to 19 opposite, oval, 1½- to 2-inch leaflets with smooth edges and a rounded tip. They turn bright yellow in fall.*

▼ *The 2- to 4-inch, flat seed pods, or legumes, of the black locust contain four to 10 peppercorn-size seeds (inset). Pods ripen in late fall and remain on branches until early spring.*

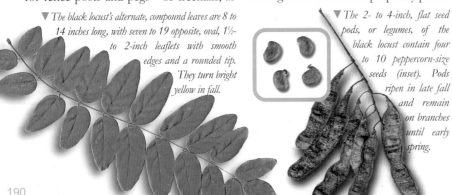

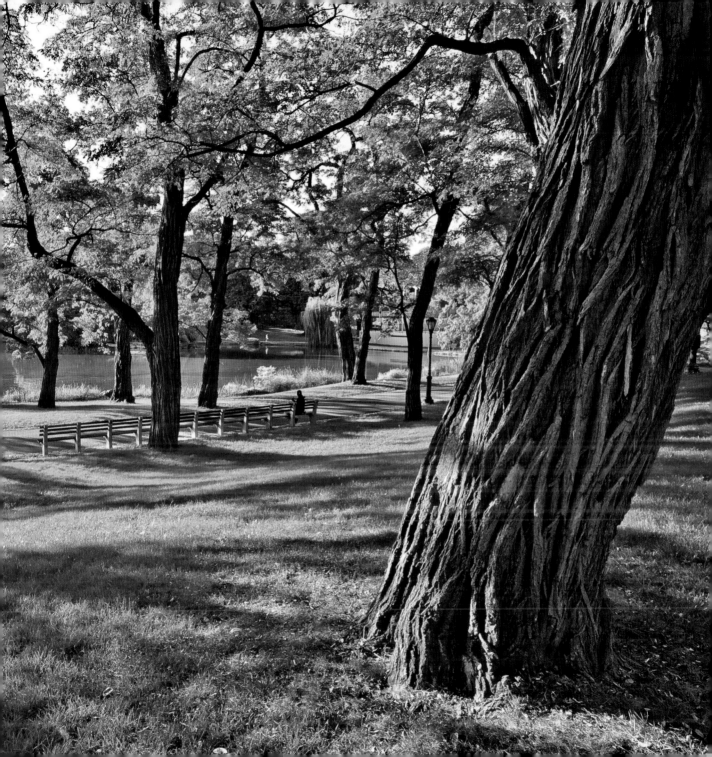

Chinese Scholartree *Styphnolobium japonicum*

The Chinese scholartree reached America by a circuitous route from its native China. A French Jesuit, Pierre Nicolas Le Chéron d'Incarville, sent seeds with a caravan travelling from Beijing to Moscow in 1747. From Russia, the seeds went to the botanic garden at the Schönbrunn Palace in Vienna and to Bernard de Jussieu, professor of botany at the Jardin des Plantes in Paris. In 1753, the tree was taken across the Channel to Kew Gardens in London by James Gordon, a British nurseryman. By 1811, the tree had travelled to New York and was listed in a catalog of the Elgin Botanic Garden, founded

David Hosack (1769–1835) was the physician attending Alexander Hamilton during his fatal duel with Aaron Burr. Besides establishing America's first botanical garden, he was the founder and first president of the New York Horticultural Society.

by Dr. David Hosack on the future site of Rockefeller Center in Manhattan. Like many physicians of his time, Hosack was interested in the medical potential of new plants being discovered in Asia and other remote places. In addition to practicing medicine, he taught botany at Columbia College. Among his students were the distinguished botanists John Torrey and Asa Gray, author of *Gray's Manual.*

The Chinese scholartree was often planted around Buddhist shrines and in graveyards as a memorial to deceased government officials. Today in China, it is still widely used as an ornamental tree in parks and along urban streets.

A legume, like its American cousin the yellowwood, the Chinese scholartree bears showy clusters of fragrant, creamy-white flowers from late July to mid-August, after most trees have finished blooming. Once fertilized, each flower produces a long pod constricted between seeds. Very tolerant of polluted air, heat, and drought, the Chinese scholartree nevertheless lacks the ability of other legumes to fix nitrogen in the soil.

It is very likely that some of the Chinese scholartrees in Central Park are descendants of trees that grew in the Elgin Botanic Garden and are the progeny of the seeds that d'Incarville sent on a plodding journey across Asia over 250 years ago. Chinese scholartrees have always been present in Central Park and are now naturalized in the Ramble. Only three were listed in the 1875 survey, four were noted by Louis Harman Peet in *Trees and Shrubs of Central Park,* but nearly 100 trees were present in 2013.

▲ *A large Chinese scholartree towers 60 feet over a Ramble path. It is an Olmstedian tree, planted in the late 1850s or 1860s by Olmsted gardeners. Its bark (inset) is gray with vertical fissures.*

▶ *In mid-August, a young Chinese scholartree next the West Drive is bedecked with 8- to 12-inch flower clusters. Chinese scholartrees generally have rounded crowns and twisting, horizontal branches.*

▼ *Each faintly scented flower of the Chinese scholartree has two lateral wing-like petals tinged with yellow. Flowers last for two to three weeks and attract bees and flies. A tree is usually 30 or more years old when it first flowers.*

▼ *The alternate, compound leaves of the Chinese scholartree are 6 to 10 inches long, with seven to 17 short-stalked, smooth-edged, 1- to 2-inch lustrous leaflets.*

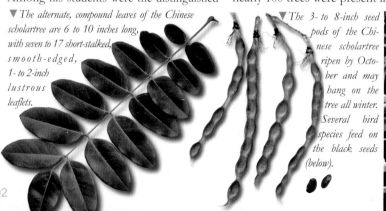

▼ *The 3- to 8-inch seed pods of the Chinese scholartree ripen by October and may hang on the tree all winter. Several bird species feed on the black seeds (below).*

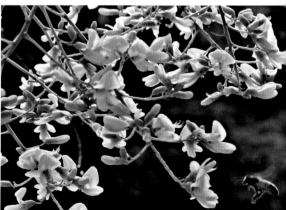

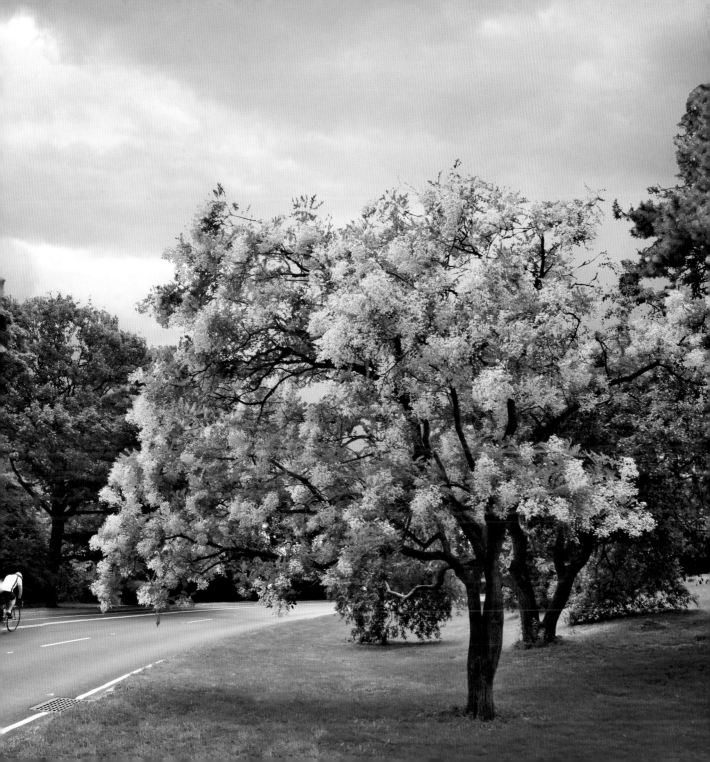

Wisteria *Wisteria* spp.

The Australian botanist and wisteria expert Peter Valder calls the Chinese wisteria (*Wisteria sinensis* 'Consequa') "one of the most appealing plants of all time." Certainly, there are few flowering plants that produce such extravagant clusters of scented flowers; such tactilely tempting, velvety seed pods; and such curious counterclockwise-twining trunks and branches. It is fast growing and invasive, however, and can become difficult to eradicate.

This hand-colored engraving, which appeared in *Curtis's Botanical Magazine* in 1819, shows a flower raceme and leaves of *Wisteria sinensis*. The unknown artist probably had access to the Chinese wisteria plants brought from China to England in 1816. They first bloomed in 1819.

The Chinese wisteria is one of five species in the genus *Wisteria*. Two are North American and three, Asian. The genus *Wisteria* is in the legume family, and like other legumes, such as peas, wisterias bear seed pods with seams.

The English botanist Thomas Nuttall (1786–1859) named the genus *Wisteria* for his friend Caspar Wistar, a professor at the University of Pennsylvania. Nuttall never explained why he ended the genus name with *er* rather than *ar*. He may have made a

spelling mistake, or perhaps he thought the *er* ending better reproduced the way Wistar's name was pronounced. Nuttall named the genus in connection with the North American species *Wisteria frutescens*, brought to Britain in 1724 by the English naturalist Mark Catesby. This species was never widely grown in Britain, perhaps because its leaves are fully developed at flowering time and tend to obscure its blossoms.

The Chinese wisteria was transported to England from the garden of Consequa, a Cantonese merchant, in 1816 aboard the East Indiaman *Cuffnells*. It became immediately popular and was shortly growing in gardens across Britain, the Continent, and the eastern United States. It sets few seeds and is propagated mostly by layering and suckering, so many existing vines, including perhaps the vines growing at the pergola by the Naumburg Bandshell, are clones of the original plant shipped from China.

Another widely cultivated Asian species is the Japanese wisteria (*W. floribunda*), introduced to Europe in the 1850s by the German physician Philipp Franz von Siebold. Unlike its Chinese cousin, the Japanese wisteria reproduces readily from seed and twines clockwise. The vines on the Conservatory Garden pergola are Japanese wisteria.

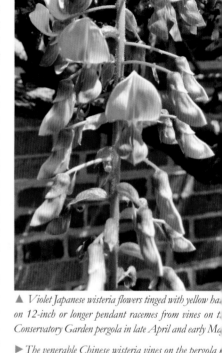

▲ *Violet Japanese wisteria flowers tinged with yellow ha on 12-inch or longer pendant racemes from vines on t. Conservatory Garden pergola in late April and early M*

▶ *The venerable Chinese wisteria vines on the pergola the Naumburg Bandshell were photographed in ear May at their flowering peak by Sara Cedar Miller, t Central Park Conservancy's photographer and historia*

▲ *Japanese wisteria leaves are deciduous, alternate, compound, and 8 to 12 inches long, with 13 to 19 oval ¾- to 2¼-inch leaflets. Japanese wisteria stems twine clockwise; Chinese wisteria stems twine counterclockwise.*

▼ *Chinese wisteria 2- to 4-inch, pendant bean-like seed pods are covered with fine brown hairs that feel soft and velvety to the touch. They ripen in late summer and may persist into winter. Each pod contains one to eight flat, round, brown seeds from ½ to 1 inch in diameter. Seeds seldom germinate.*

▼ *Japanese wisteria vines twine clockwise up the wrought-iron su porting columns of the Conservatory Garden pergola. The wister leaves overhead provide a pleasing dappled shade but obscure blossom*

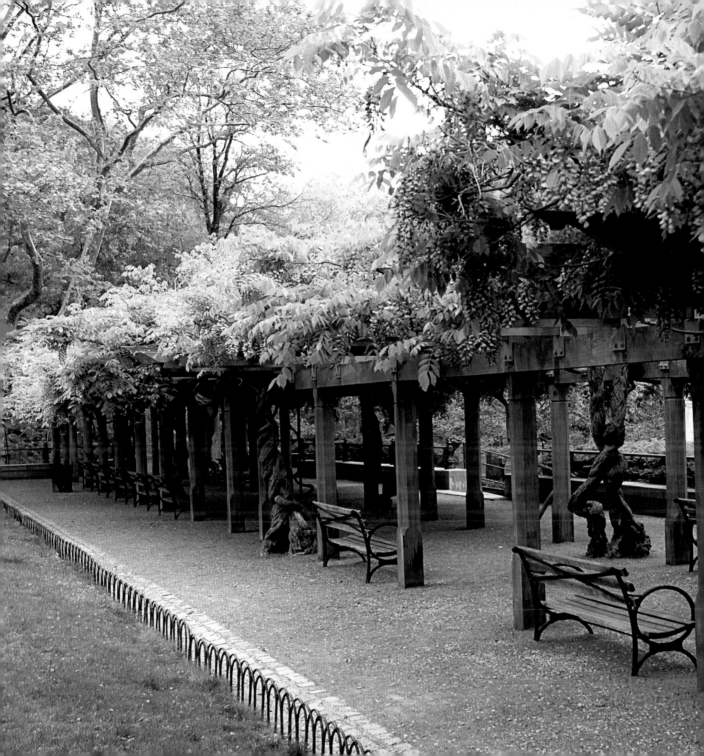

Tuliptree *Liriodendron tulipifera*

North America's tallest hardwood tree, the tuliptree is the monarch of the magnolia family. Also known as the tulip poplar, the tuliptree can attain a height of well over 150 feet, with an absolutely straight trunk 8 to 10 feet in diameter and totally clear of branches for 80 or 100 feet.

An engraving from François Michaux's *The North American Sylva* illustrates a tuliptree leaf, a green cone-like cluster of seeds, a single mature spike-like seed, and a blossom with six orange-tinted yellow petals surrounding an ovule receptacle fringed by stamens.

Tuliptree wood is light and easy to work. The pioneers used it to make dugout canoes and log cabins. Now loggers cut it for crates, siding, door and window frames, and plywood veneer.

A striking ornamental, the tuliptree is widely planted in urban and suburban settings throughout the eastern United States and in Europe. Its handsome orange-tinted greenish-yellow flowers appear in spring just after the leaves unfold. Many of the erect, cone-like spikes of samaras formed from the flowers remain on the tree after the leaves fall, making winter identification easy.

Andrew Jackson Downing (1815–1852), an American landscape designer and editor of the magazine *Horticulturist*, wrote admiringly of the tuliptree: "Whoever has once seen the Tulip tree in a situation where the soil was favorable to its free growth, can never forget it.…[I]t is, in our estimation, decidedly the most stately tree in North America."

An ancient genus in the family Magnoliaceae, *Liriodendron* consists of just two quite similar species: *Liriodendron tulipifera* of eastern North America and *Liriodendron chinensis* of south-central China. Like those of other magnolias, their flowers are primitive, with spirally arranged stamens and pistils. In the Late Cretaceous period, around 130 million years ago, the sun literally never set on tuliptrees; perhaps a dozen or more species of *Liriodendron* were spread across North America, Greenland, Iceland, Europe, and Asia. But after the last of the great ice sheets retreated over 10,000 years ago, only the two remained.

The tuliptree is native to Manhattan and probably was growing for millennia on the land that became Central Park. The census of 2008 listed 21 mature specimens, but the count is increasing (as of 2013, it stands at 122) because dozens of tuliptrees have been planted recently throughout the park.

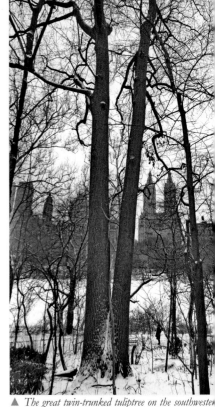

▲ *The great twin-trunked tuliptree on the southwestern side of the Ramble is more than 100 feet tall and probably around 150 years old. It towers over its neighbors.*

▶ *Its regularly fissured bark and soaring, absolutely straight trunk make this Ramble tuliptree easy to identify in winter.*

▼ *Once the central ovule receptacles of tuliptree flowers are pollinated, they develop into cone-like fruits about inches long, from which winged seeds called samaras drop.*

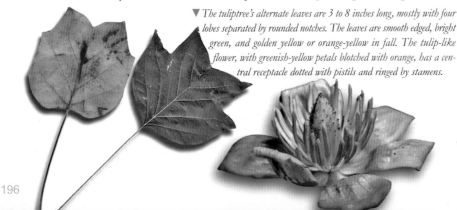

▼ *The tuliptree's alternate leaves are 3 to 8 inches long, mostly with four lobes separated by rounded notches. The leaves are smooth edged, bright green, and golden yellow or orange-yellow in fall. The tulip-like flower, with greenish-yellow petals blotched with orange, has a central receptacle dotted with pistils and ringed by stamens.*

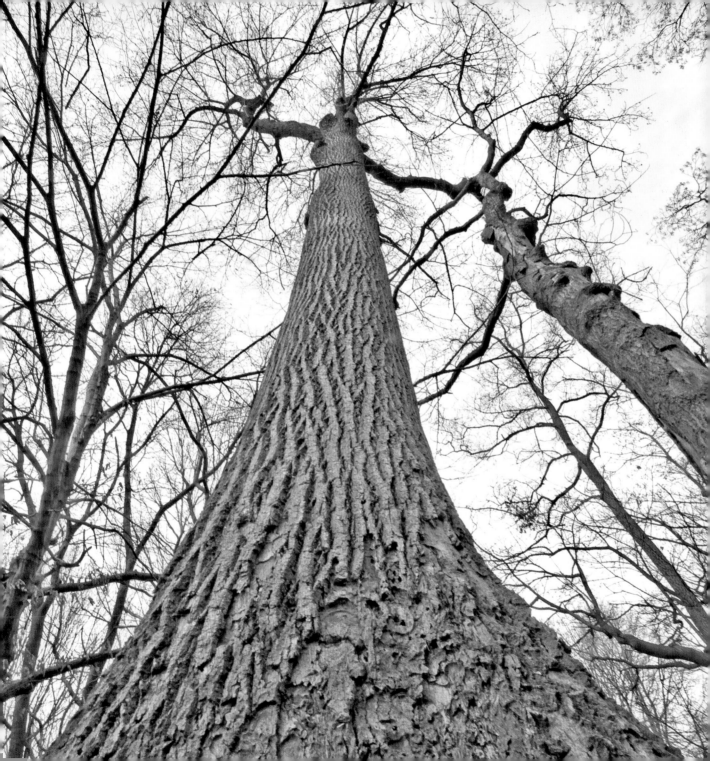

Sweetgum *Liquidambar styraciflua*

The sweetgum is also known as the redgum, a reference perhaps to the color of its heartwood or to its brilliant autumn foliage. The sweetgum attains its most impressive proportions in the moist bottomlands of the Mississippi Valley, where there are specimens more than 130 feet tall and 7 feet in diameter.

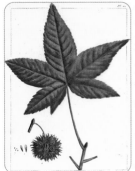

An engraving from François Michaux's *The North American Sylva* pictures a sweetgum leaf, a seed ball, and seeds. In accompanying text, Michaux described how sweetgum wood was used: "At Philadelphia, the Sweet Gum is preferred for small oval or round picture-frames....At New York, it is commonly taken for coffins."

The Latin name of the sweetgum, *Liquidambar styraciflua,* was inspired by the sweet-smelling, balsamic liquid exuded from its bark.

Sweetgum trees are easy to identify in winter. Their brown dried seed balls litter the ground beneath the trees, and some remain on the branches. These spiky spheres are composed of many individual seed capsules, each one ending in two prickly points. The capsules are empty in late winter, all the tiny winged seeds having been shaken out by the wind while the seed ball was still on the tree.

The first European to write about the sweetgum was Francisco Hernández de Toledo, a Spanish physician and botanist. A condensed version of his voluminous description of the plants of New Spain was published in Rome in 1651. Hernández described the sweetgum, which he found in Mexico, as a large tree that exuded a fragrant gum rather like amber in a liquid state, and ever since the word "liquidambar" has been associated with the tree. Another visiting European physician, Count Luigi Castiglioni of Milan, wrote of the sweetgum he encountered as he was travelling in the eastern United States immediately following the Revolutionary War: "From this tree there oozes...a resin of pleasant odor, bitter taste, aromatic and gray-colored known in apothecaries' shops as *Storacis liquidi resina.* The Indians of North America use it for fevers and apply it to wounds, which they thereby heal in a short time."

The sweetgum has always been present in the park and was likely growing wild in the area before the park's construction. As of 2013, there were over 120 sweetgums in the park. Several add fall color to the Ramble. A group of five large sweetgums, all possibly clones, cluster just south of the Blockhouse in the North Woods.

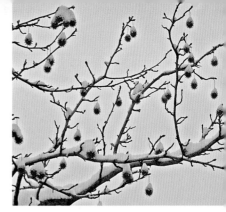

▲ *Many of the sweetgum's empty seed balls persist on the tree through winter. Seeds are quickly shaken out of the balls by wind once they turn from green to brown in late fall.*

▶ *This cluster of stately trunks along the path leading to the Blockhouse in the North Woods is the most impressive gathering of sweetgum trees in Central Park.*

▼ *Pointy sweetgum fruits dangle amid yellowing leaves as if in anticipation of the holiday season. They will darken soon from green to brown and begin to release their seeds.*

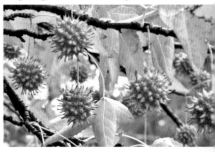

▼ *Male pollen flowers in 3-inch clusters (upper left) and globular female flowers (bottom, center) develop in April.*

▼ *The sweetgum's alternate, star-shaped leaves are 3 to 7½ inches wide, with five to seven finely toothed lobes. Main veins run from stem to lobe tips. In fall, a leaf may turn bright yellow, orange, or crimson.*

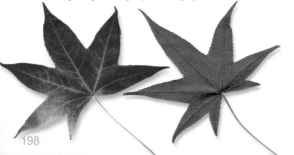

▼ *The easiest way to locate and identify sweetgum trees is to look for their spiky, empty seed balls, inevitably littering the ground beneath them. Every 2-inch seed ball is composed of 40 to 60 seed capsules tipped with beak-like openings that once contained one or two seeds.*

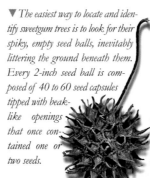

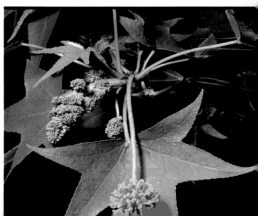

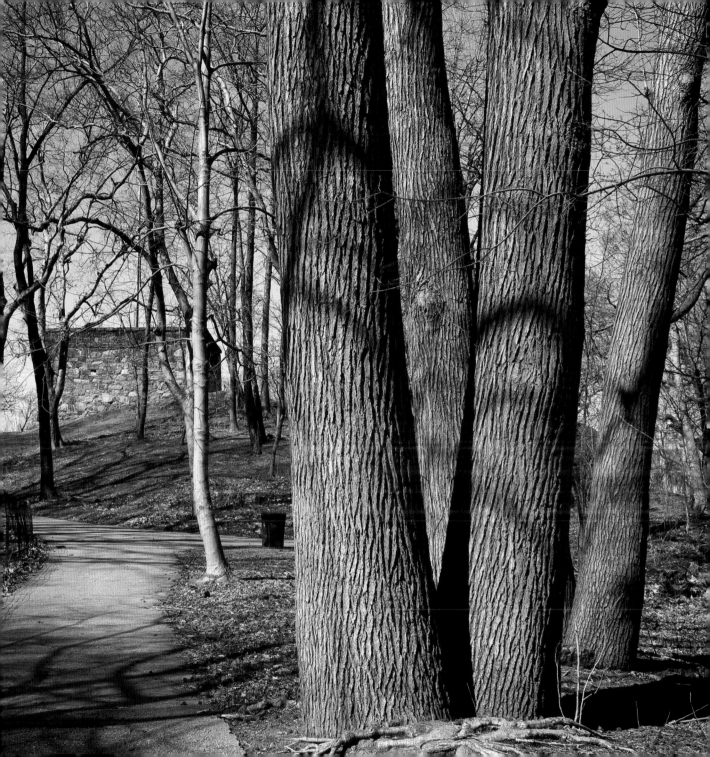

White Mulberry *Morus alba*

There is an old Chinese legend about the origin of sericulture, the farming of silkworms, which feed on only mulberry leaves. One day around 2600 B.C.E., Empress Leizu, wife of the Yellow Emperor (Huangdi), was in her garden drinking tea under a mulberry tree.

A hand-colored engraving from Johann Wilhelm Weimann's *Phytanthoza iconographia* (1742) shows silkworm moths, cocoons, amd silkworms fedding on black mulberry (*Morus nigra*) and white mulberry leaves. This multivolume herbal was the first major botanical work to contain hand-colored engravings.

As a breeze shook the leaves above her head, a silkworm cocoon plopped into her tea cup. When she took the cocoon out of the hot water, she found that a tiny silk strand began unwinding from the cocoon.

The empress supposedly went on to discover that when several strands were wound together and woven on a loom, a marvellous light and smooth fabric resulted. Whether sericulture was first practiced by Empress Leizu or whether it began almost 5000 years ago, as archaeological discoveries suggest, there is no doubt that the Chinese cultivated mulberry trees to feed silkworms and kept sericulture details secret for millennia.

Sericulture spread to Korea around 200 B.C.E., to Japan by 300 C.E., to the Byzantine Empire by about 550, and on to Italy, Spain, and France after 1000. In 1620, King James I tried to foster silk culture in Virginia. He sent mulberry seeds and silkworms, but colonists quickly abandoned sericulture for more immediately profitable tobacco and rice farming. By the mid-18th century, however, silk was being produced in other southern states and in Pennsylvania and Connecticut. William Bartram, in his book *Travels,* describes white mulberries growing near Jacksonburg, South Carolina: "At this plantation I observed a large orchard of European Mulberry tree, '(Morus alba).'…[T]these trees were cultivated for the purpose of feeding silk-worms." In 1774, William Prince, a nurseryman in Flushing, Queens, imported white mulberries with the intention of producing silk. The venture did not prove profitable, but Prince firmly established the white mulberry in New York City.

Much more aggressive than the native red mulberry (*Morus rubra*), which may not be presently growing in Central Park, the white mulberry tolerates heat, compacted soil, high salinity, and air pollution. It also grows faster than the red mulberry, spreading rapidly because birds scatter its seeds far and wide in their feces. It greatly outnumbers red mulberries in the city, and its population in the park may be close to 300.

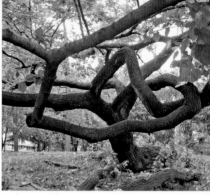

▲ *Helped along by occasional pruning, this white mulberry at the southern end of the park near 59th Street and Seventh Avenue has developed a strange habit of bizarrely knotted, writhing, and twisting limbs.*

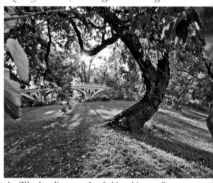

▲ *The bending trunk of this white mulberry seems to echo the graceful curves of Gothic Bridge, spanning the bridle path north of the reservoir near the Tennis Center.*

▶ *Anchored by a tangle of thick roots, the white mulberry south of Cleopatra's Needle across from the Metropolitan Museum of Art demonstrates the tendency of white mulberries to lean one way or another but rarely stand straight.*

▼ *White mulberry leaves are alternate, simple, oval, toothed, 2 to 8 inches long, and unlobed or with two or three lobes. Each leaf has a central main vein extending to the tip. Stems exude a milky juice. Fruits (inset) can be less than ½ inch to well over 1 inch long. Fruit colors may be greenish-white, pink, red, dark purple, or black.*

▶ *Two branches of a white mulberry north of Eaglevale Arch near West 77th Street slither dozens of feet along the ground.*

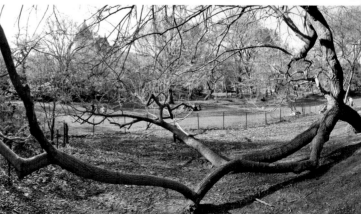

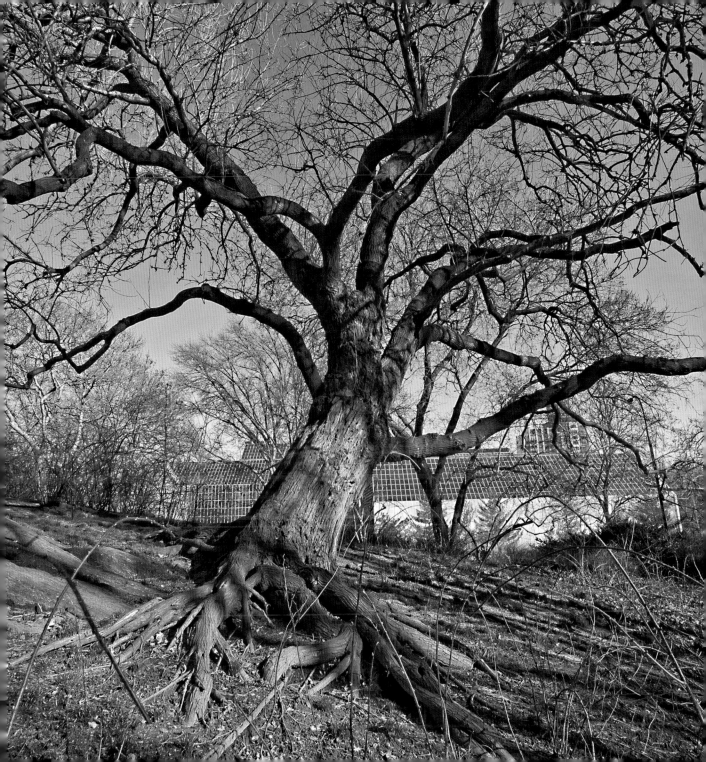

PLANES

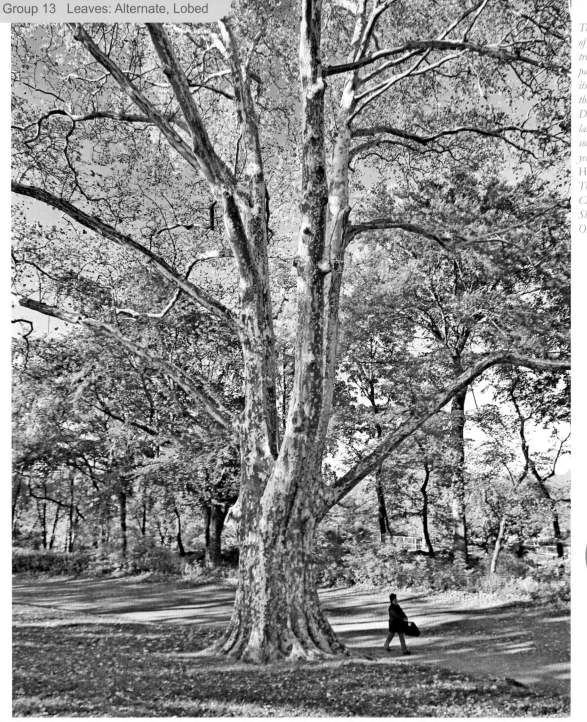

The great London plane growing at the northeastern corner of the Reservoir along the bridle path is Central Park's largest tree and perhaps its oldest.

The family history of Plantanus *is truly majestic, for paleobotanists trace its ancestry back to the Age of the Dinosaurs in the late Cretaceous, some 100,000,000 years ago.*
Hui-Lin Li,
The Origin and Cultivation of Shade and Ornamental Trees

The logo of the New York City Department of Parks & Recreation is a London plane leaf.

The genus *Plantanus,* plane, includes eight species: three native to the United States, three native to Mexico, and two native to Europe and Asia.

The London plane is the most common plane tree in Central Park. Over 1100 mature London planes were present in the park in 2013 but fewer than 30 American sycamores. The American sycamore is the only native plane tree found east of the Mississippi.

Among the most characteristic features of plane trees are their 1-inch-wide seed balls, which may persist on a tree through winter, hanging singly or strung two or three together on a stalk. Another identifying feature is their often-peeling, thin, mottled bark, varying in color from olive to light gray or tan to nearly bone white.

Well-watered plane trees can live as long as 400 years and grow to truly monumental proportions, with enormous trunks and huge ascending branches. Not surprisingly, the largest and perhaps the tallest tree in the park is a London plane growing at the northeastern corner of the Reservoir, where the water table is close to the surface throughout the year.

The leaf of the oriental plane, one parent of the London plane, has more and larger teeth than those of the London plane and five longer, narrowly separated lobes.

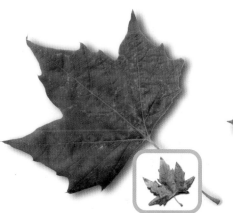

The leaf of the London plane tends to have fewer teeth than those of its parent species' and just three lobes, but occasionally it may resemble a parent's leaf (inset).

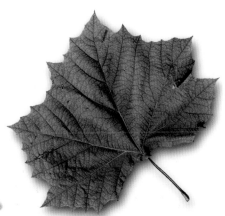

The leaf of the American sycamore may have five or six short, toothed lobes with very shallow notches, but it may also have larger lobes like a London plane's.

London Plane *Plantanus × acerifolia*

The quintessential urban tree, the London plane lines streets throughout the temperate world. Robert Moses, New York City's parks commissioner from 1934 to 1960, chose its leaf as the logo of the Department of Parks & Recreation. Gilmore D. Clarke and Michael Rapuano, landscape designers working for Moses, included the tree in plans for many of the city's parks and playgrounds and may have been responsible for London planes planted in the park during the 1930s.

A British botanist and gardener, John Tradescant the Younger (1608–1662) travelled to Virginia at least once and perhaps as many as three times. He brought back to England seeds of several North American trees, including the bald cypress, red maple, tuliptree, hackberry, black walnut, and American sycamore.

A hardy hybrid of the American sycamore and the oriental plane of southeastern Europe, the London plane tolerates air pollution, salt, and compacted soil. In spring, when other trees are leafing out, however, London planes may be attacked by anthracnose, a fungal disease that destroys leaves shortly after they unfurl from their buds. Within a month, a second crop of leaves will replace the blighted first generation, but repeated attacks of anthracnose weaken trees. Several anthracnose-resistant cultivars are now available.

The London plane may be one of the first hybrid trees of garden origin. In 1637, John Tradescant the Younger, gardener to Charles I of England, established an American sycamore in his garden from seeds he had collected in Virginia. Some botanists speculate that Tradescant's American sycamore may have crossed with an oriental plane already growing in his garden to produce the first London plane. Other botanists believe that the American sycamore crossed with the oriental plane in the Oxford Botanic Garden, and still others argue that the cross occurred in southern Europe, perhaps in Spain.

Although the place where the London plane was created is in question, there is no doubt that it was cultivated in England by the mid-18th century. By the 1880s, the tree was in Central Park. Louis Harman Peet noted eight specimens on maps in *Trees and Shrubs of Central Park*. One London plane downed in the storm of August 18, 2009, was more than 130 years old.

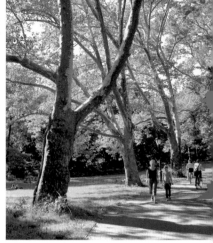

▲ *The northern edge of the Ramble's Tupelo Meadow lined with London plane trees probably planted during the tenure of Parks Commissioner Robert Moses.*

▶ *One of the finest London planes in the park, the magnificent specimen stands north of the Harlem Meer near 110th Street. Unlike older sycamores, which develop dark scales on their lower trunks, mature London planes continue to shed bark in patches down to their roots.*

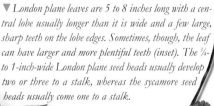

▼ *London plane leaves are 5 to 8 inches long with a central lobe usually longer than it is wide and a few large, sharp teeth on the lobe edges. Sometimes, though, the leaf can have larger and more plentiful teeth (inset). The ¼- to 1-inch-wide London plane seed heads usually develop two or three to a stalk, whereas the sycamore seed heads usually come one to a stalk.*

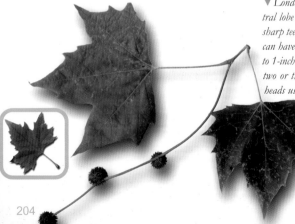

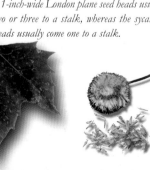

▲ *The trunks of some London plane trees in the Ramble are covered with burls, strange protuberances of cambium tissue formed around insect or fungal infestations.*

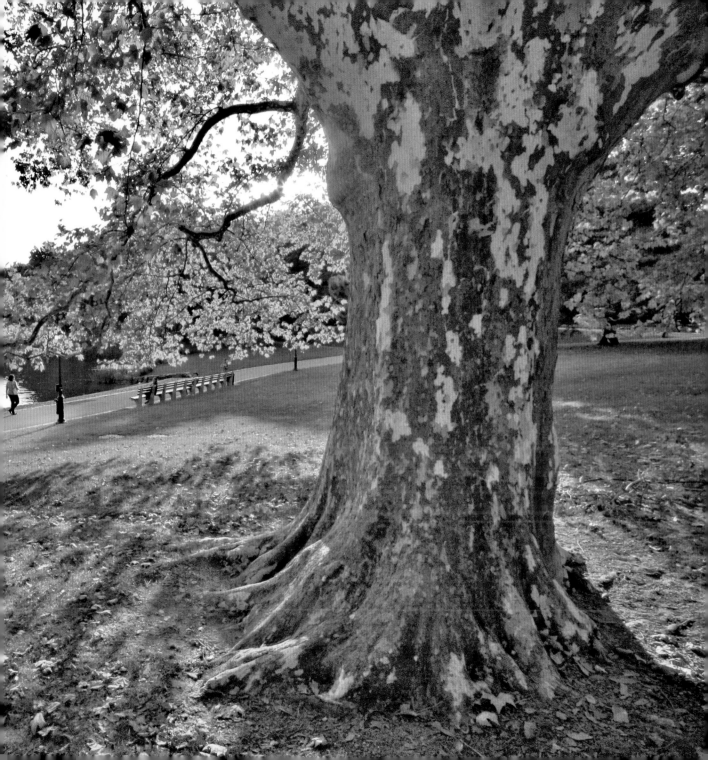

American Sycamore *Plantanus occidentalis*

In winter, the upper branches of a mature American sycamore look as white as bleached bones when they catch the rays of the low-hanging sun. Several sycamores have been planted in the Hallett Nature Sanctuary along the shore of the Pond specifically because their white limbs provide a pleasing contrast with the drabber boughs of the surrounding black cherries, oaks, and black locusts.

A hand-colored engraving from the Royal Octavo edition of John James Audubon's *Birds of America* (1840–1844) shows two males, a female, and an immature Carolina parakeet on a cocklebur branch. Once the only native parrots in eastern North America, they lived in flocks of 200 to 300.

The sycamore is less hardy than its hybrid offspring, the London plane, and is even more subject to defoliation by anthracnose. Thus despite its beauty, it will remain substantially outnumbered by London plane trees in the park and largely confined to the shores of natural areas, such as the Ramble and the Hallett Nature Sanctuary. There were 106 sycamores reported in the park in 1982, but only 28 mature specimens were present in 2013.

In the wild, too, the American sycamore is most often found along streams, rivers, lakes, and other places with plentiful groundwater. In such habitats, it can grow larger than any other North American broadleaf tree. The national champion sycamore, located in Ashland, Ohio, measures 11 feet in diameter at its base and is 129 feet tall.

The massive trunks of the great old sycamores that the early settlers encountered in primeval alluvial forests along the Ohio River were frequently hollow. The cavities could house farm animals or even entire pioneer families while permanent homes were being built. These cavities were also nighttime roosting places for the chimney swift and the extinct Carolina parakeet. Edwin James, a member of S. H. Long's expedition to the Rockies (1819–1820), wrote that "the fruit of the sycamore is [a]favorite food of the paroquet, and large flocks of these gaily-plumed birds constantly enliven the gloomy forests of Ohio." Another contemporary observer recalled seeing a flock of parakeets flying into "a huge sycamore tree, having a large cavity on one side, about 60 feet from the ground."

▲ As a sycamore tree ages, the bark on its lower trunk develops dark-brown scales that do not defoliate in patches, as does the piebald tan, brown, cream, and nearly white bark of the upper trunk and branches.

▶ One of the best times to savor the special beauty of the sycamore is on a crisp, cloudless fall afternoon when the sun's slanting rays brilliantly illuminate the tree's twisted white upper branches against the sky's deep azure. This lovely specimen stands north of the Conservatory Water.

▼ The sycamore leaf is usually 4 to 8 inches long, with five lobes wider than they are long and shallow notches in between. Sharp teeth line the leaf edges, and diverging veins meet near the stem. Sometimes, however, the lobes can be narrower and longer (inset).

▼ The American sycamore produces single ¼- to 1¼-inch fruit heads on slender stems. Each fruit head, or buttonball as they are often called, consists of hundreds of achenes, tiny seeds with hairy tufts that catch the wind.

▼ A plane tree pair near the East Drive opposite the Loeb Boathouse display telltale contrasting bark, with the relatively light, mottled trunk of a London plane on the left and the dark, scaly trunk of a sycamore on the right.

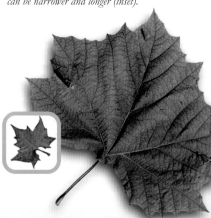

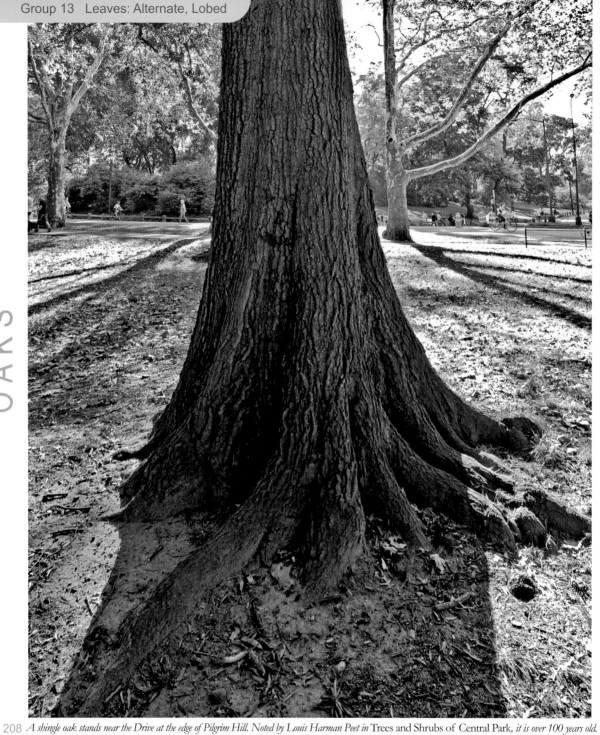

OAKS

A shingle oak stands near the Drive at the edge of Pilgrim Hill. Noted by Louis Harman Peet in Trees and Shrubs of Central Park, *it is over 100 years old.*

In most of the temperate world, oak is the primary, the titular tree of the forest. In Sanskrit the name for the oak and the name for trees in general are the same: dui. No tree has been more useful to human beings than the oak

William Bryant Logan
Oak: The Frame of
Civilization

*Shingle
oak leaf
and acorns*

The genus *Quercus*, oak, consists of approximately 600 species of trees and shrubs. The genus probably originated in Asia, but more species of oaks are native to North America than to any other continent.

Oaks produce separate male and female flowers on the same tree. Male, pollen-bearing flowers dangle in stringy catkins in spring. Inconspicuous female flowers usually grow on short stalks either singly or in pairs. All oaks produce a fruit called an acorn, a nut with a cup-like cap that matures in six to 18 months, depending on the species.

Many oaks have lobed leaves; some have serrated leaves; others have smooth-edged leaves without lobes. Many oaks are deciduous and drop their leaves in fall. Some retain some of their leaves well into winter, and yet others are evergreen. Central Park's 18 species of oaks exhibit nearly all these leaf characteristics.

A good place to observe oaks in Central Park is on the northern side of Pilgrim Hill. Here nine oak species have been planted close together: chestnut oak, pin oak, red oak, shingle oak, Shumard oak, Spanish oak, swamp laurel oak, swamp white oak, and willow oak.

Pin oak leaves, with sharply pointed lobes and deep sinuses, are shaped the way many people expect oak leaves to look, but some oaks, such as the shingle oak, have no lobes.

A open-grown sawtooth oak stands near the northwestern corner of Sheep Meadow. This native of China, Korea, and Japan has unlobed, lance-shaped leaves with serrated edges.

In midwinter, the swamp laurel oak near the path bordering the northern side of Pilgrim Hill still has most of its leaves. They will drop off in spring as they are replaced by new leaves.

Scarlet Oak *Quercus coccinea*

The scarlet oak begins and ends the growing season with a chromatic flourish. When its delicate new leaves, matted with fine hairs, first unfold in spring, they are red. As they develop, they turn to a rich, lustrous green. Once the days begin to shorten in fall, however, the leaves revert to brilliant scarlet hues, and some resolutely cling to their branches into winter. Often planted as an ornamental, the scarlet oak is a fairly fast grower, displaying an attractive pyramidal habit in its youth but developing a more rounded, open crown with age. With a tapering trunk 2, 3, or more feet in diameter, a mature tree may exceed 80 feet in height.

The scarlet oak is frequently found on gravelly or sandy soils near the shore. It seldom forms pure stands but occurs alongside pitch pines, white pines, post oaks, white oaks, and other broadleaf trees. Its roots grow close to the surface and are often exposed.

Stand under this tree and see how finely its leaves are cut against the sky—as it were, only a few sharp points extending from a midrib. They look like double, treble, or quadruple crosses. They are far more ethereal than the less deeply scalloped oak leaves.
Henry David Thoreau
"Autumnal Tints"

François André Michaux, in *The North American Sylva*, wrote of how the scarlet oak is frequently misidentified: "In the Northern States it is confounded with the Red Oak, and in those of the South with the Spanish Oak. The name of Scarlet Oak was given it by my father [André Michaux], and, though not in use by the inhabitants, it will probably be adopted, as the tree is evidently a distinct species....The leaves, which are supported by long petioles, are of a beautiful green, smooth, shining on both sides, and laciniated in a remarkable manner, having usually four deep sinuses very broad at the bottom. They begin to change with the first cold, and, after several successive frosts, turn to a bright red, instead of a dull hue like those of the Red Oak. At this season the singular color of the foliage forms a striking contrast with that of the surrounding trees, and is alone a sufficient inducement to cultivate the tree for ornament."

There have never been many scarlet oaks in Central Park. None were included in the 1872 plant list. Louis Harman Peet located 11 scarlet oaks in *Trees and Shrubs of Central Park*. The 1982 inventory listed 20. Only four were counted during the 2008 census, but in 2013, there were at least 16 scarlet oaks in the park.

▲ *A scarlet oak flaunts its fall finery in the Conservatory Garden. Sometimes confused with the black oak or the red oak, the scarlet oak has leaves more deeply notched than those of these two closely related species.*

▶ *Cyclers and joggers on the hill in the northwestern corner of the park in mid-December pass a scarlet oak that retains many of its leaves, though winter is just a week away.*

▼ *Scarlet oak flowers appear in late April just as the young, red-tinted leaves are unfolding. Dozens of tiny male pollen flowers are strung out on 5-inch dangling catkins. Equally tiny red female flowers (inset) are positioned where the stems of the young leaves join twigs.*

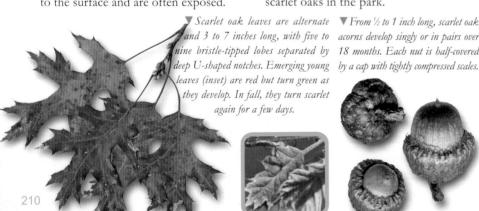

▼ *Scarlet oak leaves are alternate and 3 to 7 inches long, with five to nine bristle-tipped lobes separated by deep U-shaped notches. Emerging young leaves (inset) are red but turn green as they develop. In fall, they turn scarlet again for a few days.*

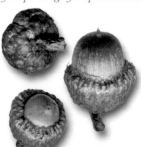

▼ *From ½ to 1 inch long, scarlet oak acorns develop singly or in pairs over 18 months. Each nut is half-covered by a cap with tightly compressed scales.*

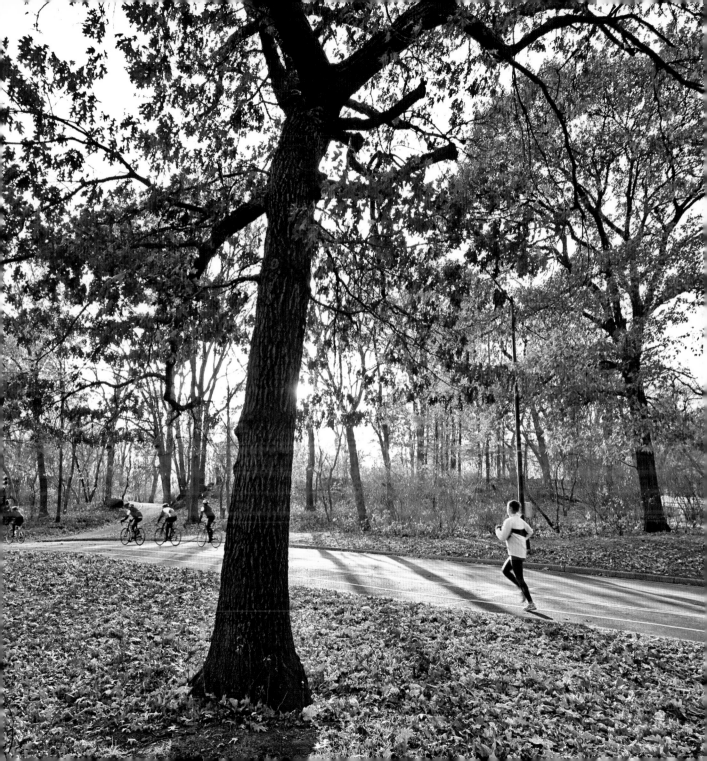

Pin Oak *Quercus palustris*

In an entry on the pin oak in *The Forester's Manual*, Ernest Thompson Seton noted that the tree "is more happily named than most of its kin; first the numerous short straight branches in the lower trunk make it seem stuck full of large pins; next, each point of its leaves has a pin on it; in each armpit of the midrib below is a tiny velvet pin cushion; and finally and chiefly this exceptionally tough wood was the best available for making the pins in frame barns."

As author of the first American edition of the *Boy Scout Handbook* and founder of the Woodcraft League of America, Ernest Thompson Seton (1860–1946) was responsible for instilling a love of nature and a knowledge of trees in several generations of young Americans.

The pin oak usually has a single central trunk extending nearly to the top of its crown and many slender branches instead of a few thicker ones. If they have not been cut off, the lower branches often droop. Typically, the pin oak retains some leaves into early winter.

With a straight trunk and finely divided, glossy leaves, the pin oak is among the most widely planted native oaks in urban landscapes and is the fifth most common street tree in New York City. Adapted to swamp conditions, it is able to withstand occasional flooding and low oxygen levels found in urban soils. It also tolerates drought and is easy to transplant due to its shallow roots.

Pin oak acorns take two years to mature, grow singly or in clusters, and are almost round with distinctive shallow, saucer-shaped cups enclosing one-quarter or less of the nut. In his posthumously published *Wild Fruits,* Henry David Thoreau observed that the nuts are "very prettily marked with meridional lines."

Pin oaks outnumber all other tree species in Central Park, except for black cherries. There were nearly 1500 in the park as of 2013. Most of them, and especially those growing in open areas without shading competition, have had their smaller lower branches pruned off, so that their first branches are substantial and far from the ground atop tall, exceptionally straight trunks. These towering pin oaks are spread throughout the park, but they are particularly impressive near the southwestern corner of the Conservatory Water and along Central Park West south of the 100th Street entrance.

François Michaux remarked in *The North American Sylva* that the pin oak "deserves a conspicuous place in parks and gardens." He would be pleased with the role of pin oaks in the landscapes of Central Park.

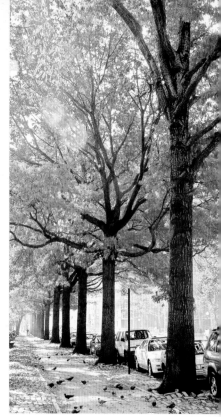

▲ *An impressive stretch of mature pin oaks with beautiful straight trunks borders upper Central Park West. Pidgeons feast on the oaks' fallen acorns in October and November.*

▶ *In early November, this great pin oak just north of the Loeb Boathouse assumes a mantle of lustrous chestnut brown.*

▼ *The pin oak's flowers appear in late April as its leaves are unfolding. The male staminate flower catkins develop from buds formed in the leaf axils of the previous year.*

▼ *Alternate 3- to 5-inch pin oak leaves have five to seven bristle-tipped lobes separating deep U-shaped notches. Shiny dark green above, they are lighter below with tufts of pale hairs at junctions of the main veins (inset).*

▼ *The shallow-cupped acorns of the pin oak range in size from ½ to about ¼ inch long. Trees start producing acorns in their 15th to 20th year.*

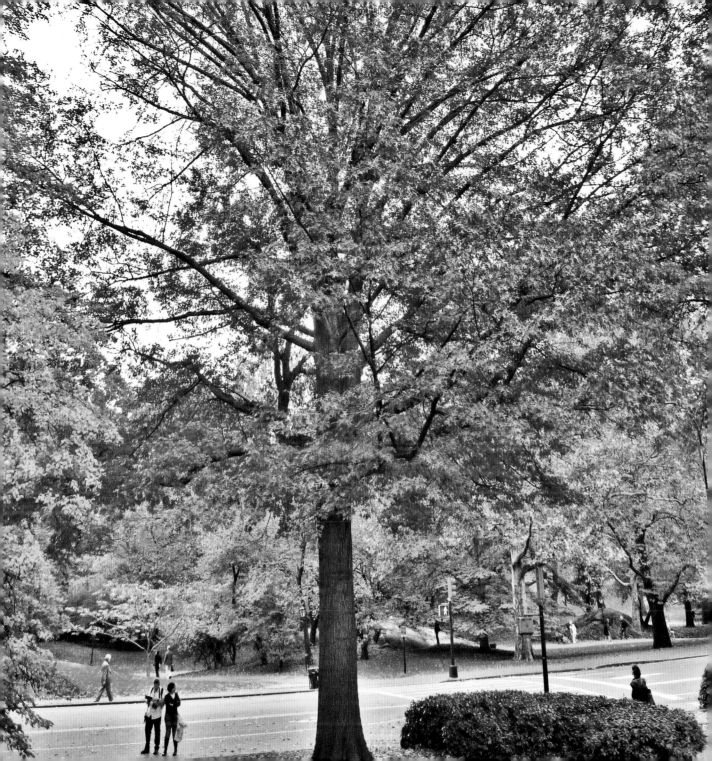

Northern Red Oak *Quercus rubra*

The Northern red oak is the most common oak of the Northeast and ranges farther north than any other oak. During the last ice age, when broadleaf trees were pushed far south, remnant pockets of Northern red oaks may have survived amid spruce and fir forests. When the climate warmed, the red oak advanced rapidly northward, aided by blue jays spreading its acorns.

The red oak's symmetrical form and rapid growth suit it to city streets and parks. Loggers favor it because it develops from a seedling to a timber tree in 40 to 60 years.

The Northern red oak can be confused with the black oak. Its leaves are usually thinner and less glossy and leathery than black oak leaves. Its leaf notches, or sinuses, tend to be shallower than those of black oak leaves. Its acorn cups are shallower, too, enclosing about one-quarter or less of the nut, whereas black oak acorn cups enclose about half of the nut. The bark of a mature red oak is generally reddish-gray with pinkish inner bark. Vertical ridges stretching down a red oak's upper limbs and trunk can look like ski trails on a mountainside.

There are two classes of oaks in the forests of the Northeast: the red oak group and the white oak group. Both groups are well represented in Central Park. Of the members of the red oak group, the Northern red oak is the most numerous and the fastest growing. Other oaks in the red oak group are the scarlet oak, pin oak, and black oak. Each of these oaks has bitter acorns that take two years to mature, leaves with pointed lobes and hairs on their tips, and wood that tends to be reddish-orange. Although bristle-tipped leaf lobes are characteristic of the red oak group, some members of the group, such as the willow oak and the shingle oak, completely lack lobes and bristles. Central Park oaks in the white oak group include the white oak, swamp white oak, English oak, and chestnut oak.

The Northern red oak is the second most common oak in the park, with close to 600 mature trees present as of 2013. In 1857, around the time that work on the park was beginning, the site's red oak population stood at about 2000 trees. The red oak was by far the most plentiful oak species growing on land that was to become Central Park.

Heights of seventy and eighty feet are usual, and diameters of three and four are frequent. The forest grown tree disposes of its lower limbs early in life, and develops a long smooth trunk, with a narrow crown.
Henry H. Gibson
American Forest Trees

▲ *This Northern red oak in the Ramble exhibits the typical habit of a forest-grown tree: a long, straight trunk with a few small branches, topped by a few larger limbs.*

▶ *The great Northern red oak standing to the east of Cedar Hill is buttressed by huge, spreading roots.*

▼ *At the outset of their second season, the nuts of Northern red oak acorns are still entirely enclosed in their caps.*

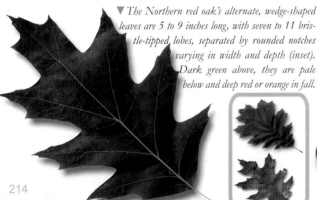

▼ *The Northern red oak's alternate, wedge-shaped leaves are 5 to 9 inches long, with seven to 11 bristle-tipped lobes, separated by rounded notches varying in width and depth (inset). Dark green above, they are pale below and deep red or orange in fall.*

▼ *Mature acorns are sharply pointed, with saucer-like caps, and range from ¾ to 1 inch long. Red oaks do not produce abundant acorn crops until they are about 50 years old.*

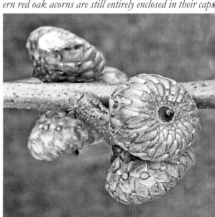

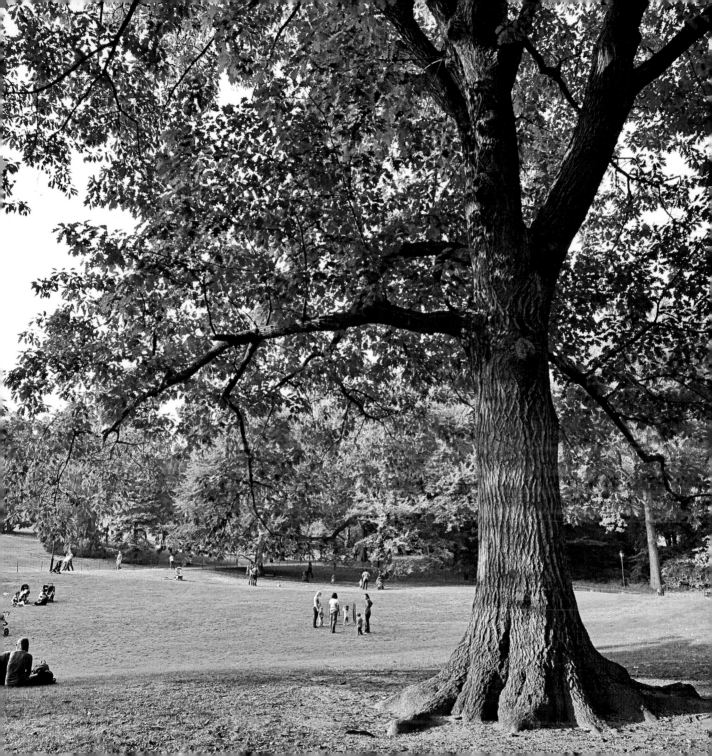

Black Oak *Quercus velutina*

The black oak's Latin species name, *velutina*, is derived from *vellus*, meaning "fleece," and refers to the velvety surfaces of young leaves and winter buds. The common name refers to the furrowed outer bark, which is often dark gray or nearly black but can also be paler gray.

The black oak's leaves vary greatly in shape from tree to tree and even on the same tree, but regardless of their shapes they tend to be glossier and more leathery than red oak leaves and usually have shallower notches, or sinuses, than scarlet oak leaves. Nearly as wide as they are long, the oval acorns have cups edged with shaggy scales.

The black oak occasionally grows in pure stands but is usually found with other trees, such as tuliptrees, hickories, and red, white, post, scarlet, and chestnut oaks.

Early settlers made a yellow dye, called quercitron, from the orange-yellow inner bark of the black oak. In *American Forest Trees,*

This great oak is lovely beyond conception when it is covered with pink-tipped unfolding leaves, no larger than mouse ears, and with yellow-green tassels, in the sunlight of early May. It is a mass of brilliant flashing green in the full sunshine of midsummer noon. It is loud with the wind in its leaves until late autumn.

Cornelius Weygandt
The Wissahickon Hills

Henry H. Gibson observed: "This oak is one of the easiest to identify. The inner layer of the bark is yellow. The point of a knife easily reaches it; cutting through a deep crack in the bark, and no mistake is possible, for no other oak has the yellow layer of bark....The bark of this tree is employed less now than formerly for dyeing purposes. Aniline dyes have taken its place. In pioneer times the bark was one of the best coloring materials the people had, and every family looked after its own supply as carefully as it provided sassafras bark for tea, slippery elm bark for poultices, and witch hazel for gargles."

Species of the genus *Quercus* often hybridize within their groups, making identification sometimes difficult. In Central Park, a fine example of hybridization within the red oak group is the large Lea's oak, a cross between a black oak and a shingle oak, located at the southeastern corner of the Swedish Cottage.

The black oak is less common in the park than the pin oak and the red oak, also members of the red oak group. There were about 100 mature black oaks in the park as of 2013. A survey in 1857 did not include black oaks and neither did one in 1873. There is no doubt, however, that the black oak was present elsewhere in Manhattan at the time.

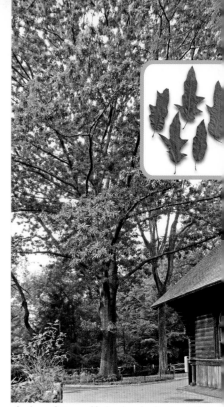

▲ *A cross between a black oak and a shingle oak, the Lea oak next to the Swedish Cottage has leaves of varying shape (inset), some lobeless and others with short, spikey lobes.*

▶ *A pair of black oaks west of the West Drive opposite the Tennis Center exhibit the dark trunks typical of the species.*

▼ *Pollen-bearing male flowers dangle in May on catkins that look like golden epaulets. Tiny female flowers bloom in the axils of new leaves where the leaf stems join their twig.*

▼ *Black oak leaves are alternate and 4 to 10 inches long, with five to nine bristle-tipped lobes separated by U-shaped notches. The shapes of lobes and notches can vary a great deal (inset). Shiny dark green above, leaves are yellow-green and rough below, with hairs at main vein junctions. In fall, they are brown.*

▼ *The black oak's ½- to ¾-inch acorns have bowl-shaped, loosely scaled cups that enclose about half of the nut. The nuts are stained yellow by tannic acid, which gives them a bitter taste and makes them unappealing to animals.*

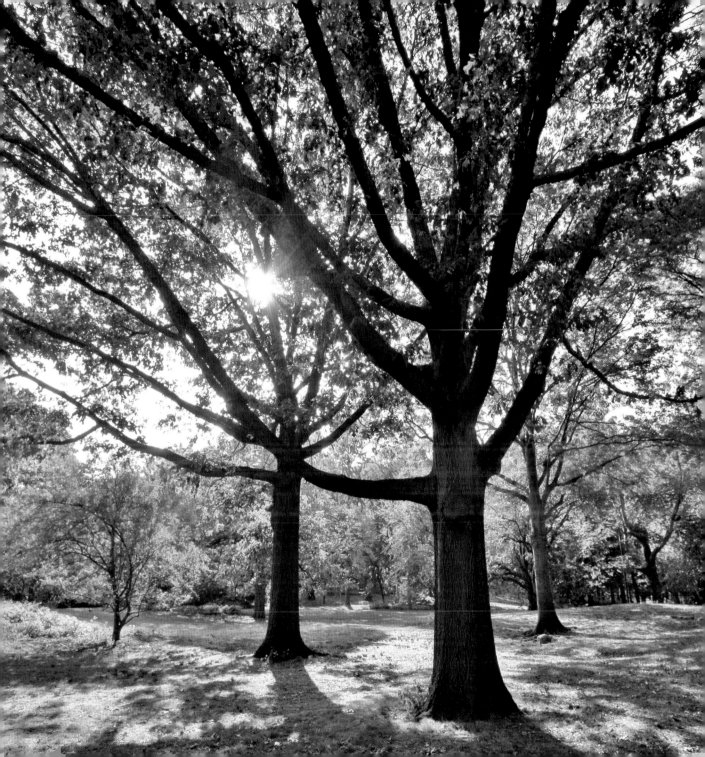

Eastern White Oak

Quercus alba

The Eastern white oak is one of the most majestic North American broadleaf trees. It grows slowly but can live for hundreds of years. An Eastern white oak in Highlands, North Carolina, is known to be over 425 years old. An open-grown tree may exceed 100 feet in height, with massive, gently ascending branches extending from the trunk 60 or more feet.

The Eastern white oak is the most widespread of the eastern oaks. It grows from Maine west to southern Quebec, Ontario, and Minnesota; south to Texas; and east to northern Florida and Georgia.

This 1857 oil painting by Charles De Wolf Brownell depicts the famous Charter Oak of Hartford, Connecticut, shortly before it was blown down in a storm. Legend has it that this great old white oak was once the hiding place for the charter of the Connecticut Colony.

Before Europeans arrived in North America, vast areas of the eastern forests were dominated by the white oak. But settlers cut down millions of Eastern white oak trees. Considered the best all-purpose native hardwood, it was used for barrels, furniture, log cabins, blockhouses, building beams, and sailing ships. Dense and durable, it makes fine flooring and excellent firewood, and resists rot on contact with the ground.

The USS *Constitution*, a three-masted frigate launched by the navy in 1797, was nicknamed "Old Ironsides" because cannon balls bounced off its nearly 2-foot-thick hull, sheathed with white oak planks 4½ to 7 inches thick. It had a 160-foot keel made of four great white oak timbers, each 30 inches deep and 18 inches wide.

The sweet, oblong acorns of the white oak, with bumpy rather than smooth scales on their caps, germinate quickly in early autumn—if they are not eaten first by squirrels and other wildlife. They put down deep central taproots, which anchor even small seedlings firmly in the soil.

A member of the white oak group, the Eastern white oak has leaves with rounded lobes and no hairs at their tips and acorns that reach maturity in a year. Other Central Park oaks in the white oak group include the bur oak, chestnut oak, and swamp white oak.

An 1857 survey of the park site included no white oaks. Nearly all the white oaks in Manhattan had been cut down by British and Hessian soldiers during the Revolution. A few were planted early in the park's history, however, because four were noted in the 1873 survey. Louis Harman Peet located seven in *Trees and Shrubs of Central Park*, and at least 38 were in the park as of 2013.

▲ The massive gray trunk of the Eastern white oak just south of the 86th Street transverse on the eastern side of the Arthur Ross Pinetum is deeply fissured and topped with relatively few massive, rather sharply ascending limbs.

▶ The great Eastern white oak near Central Park West and 96th Street grew with fewer trees around it competing for light and therefore developed more lateral branches than the white oak on the pinetum's eastern side.

▼ In late April or early May, the male pollen-bearing flowers of the Eastern white oak dangle on catkins from twigs. Tiny red female flowers cluster near the leaf stem.

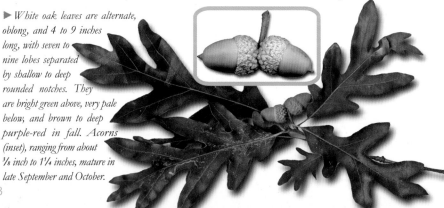

▶ White oak leaves are alternate, oblong, and 4 to 9 inches long, with seven to nine lobes separated by shallow to deep rounded notches. They are bright green above, very pale below, and brown to deep purple-red in fall. Acorns (inset), ranging from about ⅛ inch to 1¼ inches, mature in late September and October.

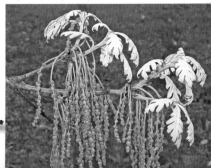

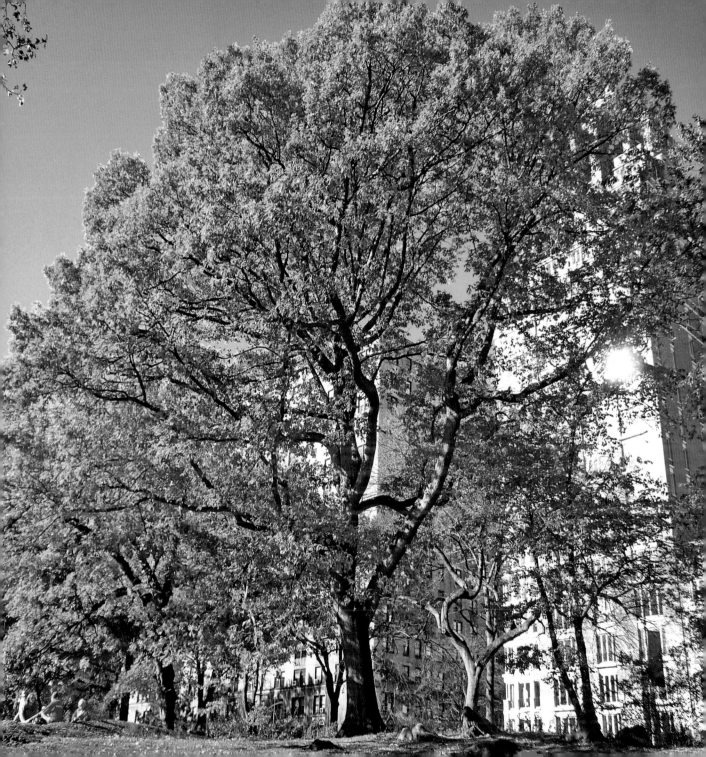

Swamp White Oak *Quercus bicolor*

As its name suggests, the swamp white oak is often found in poorly drained soil along stream banks and swamp edges. Because of its habitat adaptations, it is a successful street tree, surviving the densely compacted soil and low-oxygen environment of city tree pits.

The swamp white oak's Latin species name, *bicolor,* refers to its leaves. They are a shiny dark green on top and pale green with white hairs underneath. It is a member of the white oak group, so there are no hairs on the tips of its rounded leaf lobes.

In the wild under ideal conditions, the swamp white oak may grow over 100 feet tall and live for more than 200 years. The Wadsworth Oak, which stood on the bank of the Genesee River near Rochester, New York, had a trunk 9 feet in diameter and was more than likely well over 200 years old when it fell in 1851 during a flood that undermined the riverbank on which it stood. As Julia Ellen Rogers wrote in *The*

The Swamp White Oak is a beautiful tree, more than 70 feet in height, of which the vegetation is vigorous and the foliage luxuriant....It seems to deserve a place in the forests of Europe, where, in moist grounds, it might be blended or alternated with the Ashes and the Poplars.
François Michaux
The North American Sylva

Tree Book: "The swamp white oak loves the waterside, and many a noble specimen has been swept away by spring floods or by the gradual undermining of the bank on which it grew....Look at a swamp white oak against a winter sky. I mean that old one which has stood there with its feet in the water as long as you can remember. In fact, it seemed to be grown up when first you were told its name. The head is narrow for an oak, the limbs short and tortuous, especially on the lower half of the tree where they have a downward tendency, seeming to sprawl as widely as their grizzled and stubby length permits. Storms have cut gashes in the outline of the top. A weird grey pallor heightens the expression of age. The bark strips off of the branches somewhat after the sycamore's mode of moulting. Nothing contributes more to the picturesqueness of a tree than ragged bark."

The plant count of 1857 included no swamp white oaks, and none were listed in the 1873 survey. However, Louis Harman Peet, in *Trees and Shrubs of Central Park,* located 10 specimens, and the 2008 tree count listed 71 swamp white oaks with an average diameter of 20 inches, so the species has been increasing its presence in the park.

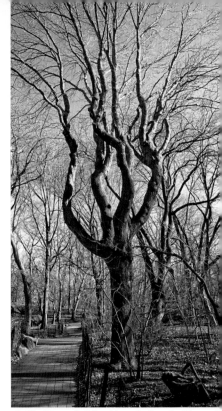

▲ Clutching at the light with curving branches like gnarled fingers, a swamp white oak in the Ramble exhibits a habit resulting from its main leader having been broken or cut off.

▶ A mature swamp white oak on the Lake's shore just west of Bethesda Fountain enjoys an ideal spot close to water.

▼ Swamp white oak pollen-producing male flowers hang on catkins in April and early May as the leaves are developing. Tiny female flowers sprout in the leaf axils.

▼ Swamp white oak leaves are alternate, oval, 4 to 8 inches long with shallow, rounded lobes. The central main vein has angled, secondary veins extending to the edges. Leaves are shiny and dark green above, pale and downy below.

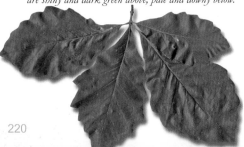

▼ Swamp white oak ½- to 1-inch acorns frequently grow in pairs on a 1- to 3-inch stem, or peduncle. Their roughly scaled caps with fringes around their edges cover one-third of the nut.

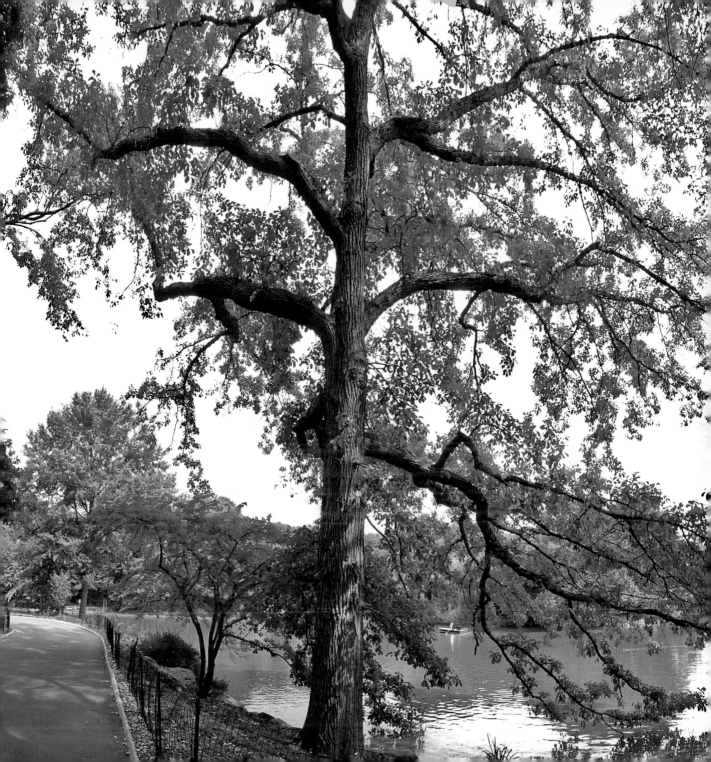

Turkey Oak *Quercus cerris*

The Turkey oak is a native of southern Europe and western Asia. Before the last ice age, about 120,000 years ago, the Turkey oak's range included most of northern Europe and the British Isles.

Reintroduced to Britain by the Exeter gardener John Lucombe in 1735, the Turkey oak is common in British parks and gardens, and it frequently grows wild along roadsides and in hedgerows.

The Turkey oak should not be confused with the American turkey oak (*Quercus laevis*), a small oak indigenous to coastal lowlands of the South. The Turkey oak is named for the country, not the bird. It is common throughout Europe but is rarely found outside parks and botanical gardens in the United States.

The leaves [of the Turkey oak] are of a beautiful bright shining green, somewhat glaucous or hoary beneath; and they vary so exceedingly in size and shape in different trees raised from seed, that almost every individual, if described from the leaves alone, might be constituted a distinct species.
John Claudius Loudon
An Encyclopaedia of Trees and Shrubs

Rugged—with stout, spreading branches and glossy, dark leaves—the Turkey oak is a rapid grower and tolerates cold winters, air pollution, poor soil, and drought. The Roman historian and naturalist Pliny the Elder (23–79) wrote of the Turkey oak's 1-inch acorn set in a hairy cup: "[T]here is no acorn that renders the flesh of the swine more firm, though at the same time it is apt to impart a certain degree of hardness." Pigs feed on the bitter, tannin-loaded Turkey oak acorn, and so do jays and pigeons when other food is scarce. The Turkey oak also produces a tastier substance. When a Turkey oak stem is damaged by insects, it sometimes exudes a sweet sticky fluid that hardens into a kind of manna sold in Middle Eastern markets and that can be boiled in water and used as a sweetening agent.

The wood of the Turkey oak is brittle and prone to split and warp as it dries, so it has been most often used for fencing, firewood, charcoal, and, occasionally, panelling.

The Turkey oak is plentiful in Cental Park. Five trees were listed in the 1873 survey, so the species was planted early in the park's history. Its tendency to self-seed is probably in part responsible for the 356 mature trees in the park as of 2013. The section of the bridle path rimming the Reservoir's southern side is lined with Turkey oaks, and a half dozen fine specimens stand next to the West Drive at the Reservoir's southwestern corner. Also, several large Turkey oaks are located on the eastern side of the Harlem Meer.

▲ *The setting sun casts a warm glow on the fissure trunk of a Turkey oak at the edge of the Harlem Meer*

▶ *A row of Turkey oaks borders the West Drive near the southwestern corner of the Reservoir. It is early November, and their leaves are beginning to turn brown.*

▼ *In May, pollen-bearing male Turkey oak flowers dangle from catkins as the season's new leaves unfold.*

▼ *Turkey oak leaves are alternate, oval, and 4 to 8 inches long, with lobes rounded or pointed and varying in length. From the central main vein, angled secondary veins extend to the leaf edges.*

▼ *Tiny female flowers of the Turkey oak growing where leaves join twigs develop over 18 months into bristly scaled acorns 1 inch or more long that turn from green to brown as they ripen.*

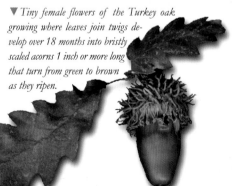

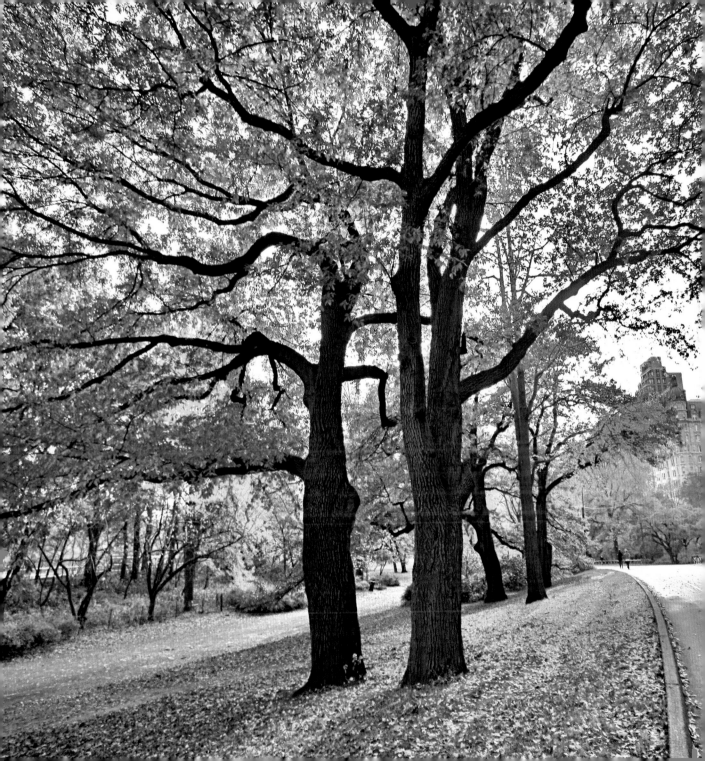

Bur Oak *Quercus macrocarpa*

A tree of midwestern and prairie states, the bur oak rivals the white oak's beauty and majesty and the red oak's northern reach. Its range extends deep into Manitoba, Ontario, and Quebec, and it also grows farther west than any other oak—all the way to the Black Hills in South Dakota and a bit beyond into Wyoming and Montana and south to Texas.

The trees, with very few exceptions, were what is called the "burroak," a small variety of a very extensive genus; and the spaces between them, always irregular, and often of singular beauty, have obtained the name of "openings"; the two terms combined giving their appellation to this particular species of native forest, under the name of "Oak Openings."
James Fenimore Cooper
Oak Openings

When crossing the Midwest in their prairie schooners, westering pioneers would roll into lush park-like forest openings, where bur oaks, in the words of James Fenimore Cooper, "stand in copses, with vacant spaces, that bear no small affinity to artificial lawns, being covered with verdure." Weary travellers often would stop in their tracks and decide to settle these pleasant, grassy places, judging them ideal for raising cattle and crops, and so they were. As Cooper explained, these "grasses are supposed to be owing to the fires lighted periodically by the Indians in order to clear their hunting-grounds."

Bur oaks of oak openings are not usually large trees; rainfall is not as plentiful at prairie edges as it is in the rich bottomlands of southern Illinois and Indiana, where old-growth bur oaks may tower 160 feet or more. In prairie openings, bur oaks seldom grow taller than 50 or 60 feet and wider than 2 or 3 feet. They survive drought by reaching for underground moisture with long taproots. Protected from grass fires by their thick bark, several oak-opening bur oaks in South Dakota are well over 300 years old. Fires actually encourage light-loving bur oaks by killing less fire-resistant but shade-tolerant trees that might otherwise eventually outcompete the oaks and fill in openings.

Central Park has never had many bur oaks. Three were located in the 1873 survey; Louis Harman Peet pinpointed only two in *Trees and Shrubs of Central Park*. In 2013, there were eleven bur oaks in the park including the great old bur oak on the western side of the Oven in the Ramble; three at the southern edge of the East 110th Street playground at the Harlem Meer; one on the southern side of the Great Hill; and two bordering the Great Lawn.

▶ *Bur oak acorns are the largest of any oak's—up to 2 inches wide—with deep cups fringed with hairs. Acorns are abundant every two or three years. Trees start bearing acorns when they are about 35 years old. Acorns mature in a year.*

◀ *The bur oak's alternate 3- to 6-inch leaves are fiddle-shaped—wider near the blunt, wavy-edged tips than at the stems—with seven to nine lobes separated by sinuses deepest near the middle of the leaves. They are dark green above and lighter below.*

▲ *The tall-trunked bur oak at the East 110th Street playground is likely approaching 100 years or more in age.*

▶ *Leaning out from shore, the lovely old bur oak in the Ramble is growing in a well-watered location but has had to compete for light with the trees around it.*

▼ *Pendulous greenish-yellow pollen-bearing catkins appear on bur oaks in late April and May when young leaves are developing. The tiny female flowers grow singly or in small groups near leaf axils.*

English Oak *Quercus robur*

In ancient times, the English oak was a sacred tree associated with Zeus, Thor, and the Druids. It is the legendary tree of Robin Hood's Sherwood Forest and the tree in which King Charles II hid from pursuing Parliamentarians. Its wood was used for centuries in half-timbered buildings and in the hulls of sailing ships. English shipwrights considered the wood of the slow-growing English oak to be the best ship-building wood in the world— more durable and elastic than the wood of the American white oak.

A 17th-century painting shows Charles II after he lost the battle of Worcester in 1651 hiding in a pollarded English oak with a loyal companion, Colonel William Carlos. The king noted in his account of the incident that the tree "had been lopped some three or four years before, and being grown out again very bushy and thick, could not be seen through."

The English oak's native range extends from Africa and western Asia to Britain and northwestern Europe, where it grows best in fertile river valleys. Introduced early to North America, it has been planted from North Dakota to Georgia.

Also known as the pendunculate oak, the English oak bears its acorns at the end of long stalks, or peduncles. A tree begins to produce acorns when it is around 40 years old and attains maximum acorn production only when it is close to a century old. A vigorous mature tree can produce as many as 50,000 acorns in good years, which are known as mast years and generally occur only two or three times a decade.

The English oak can live to a ripe old age and grow very large. Estimated to be 800 to 1000 years old, the Major Oak of Sherwood Forest weighs some 23 tons and measures 35 feet around. Early in its life, this great English oak may have been pollarded. Since medieval times, many English oaks in the British countryside have been pollarded, a process by which upper branches around 9 or 10 feet above the ground—too high to be browsed by livestock and deer—are periodically cut off for timber. Pollarded trees are shorter than unpollarded trees and have very wide trunks with many branches spreading out at the same level. Besides providing regular supplies of lumber, pollarding may help keep trees vigorous and extend their lives.

Three English oaks were listed in the 1873 survey. Eleven were located by Louis Harman Peet in *Trees and Shrubs of Central Park*, and seven were present in 2013, so the English oak is maintaining its small presence in the park.

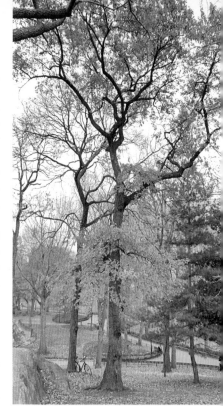

▲ *An English oak in the Dene has a tall trunk with few low branches and just two or three large upper limbs, a habit typical of trees competing with other trees for light.*

▶ *At the Mineral Springs Pavilion, just north of Sheep Meadow, an English oak with ample space around it bristles with substantial limbs on its lower trunk.*

▶ *A large English oak stands close to Fifth Avenue north of the 72nd Street entrance to the park. In summer, it is largely obscured by the foliage of adjacent trees and shrubs, but in winter and early spring its tall trunk, topped by sturdy ascending branches, is clearly visible.*

▼ *Alternate, oblong, 2- to 5-inch English oak leaves have three to seven rounded lobes on each side and very short stalks. They are dark green above and pale blue-green below.*

▼ *English oak ¼- to 1-inch acorns have caps covering about one-third of the nut. Clusters of one to four acorns are borne on 1¼- to 2¾-inch stems, or peduncles. The acorns mature in a single season.*

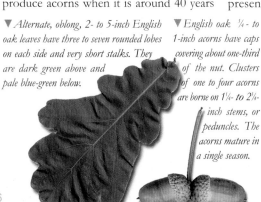

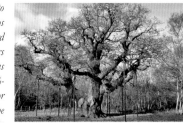

▲ *The Major Oak of Sherwood Forest, reputed to have once hidden Robin Hood from pursuers in its hollow trunk, is among the oldest English oaks, perhaps 500 or more years old.*

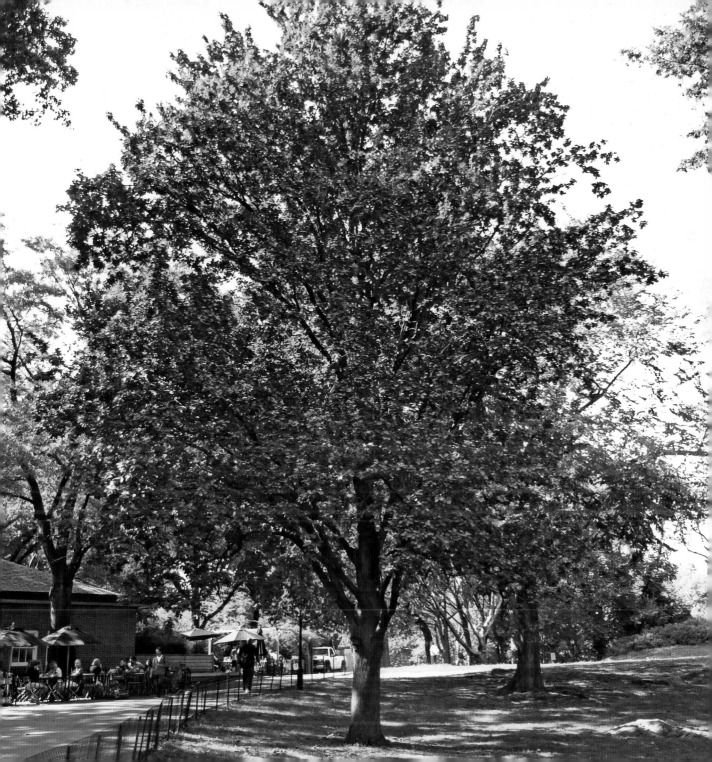

Willow Oak *Quercus phellos*

In a letter to the comtesse de Tessé sent from the White House on October 26, 1805, Thomas Jefferson described a box of seeds that he was sending to Paris. It contained acorns of several oaks, including "Q. Phellos," which, he noted, "combines great irregularity with beauty." Jefferson was perhaps referring to the willow oak's asymmetrical growth habit and the delicacy of its willow-like leaves.

According to B. L. Rayner, Thomas Jefferson once said at a White House dinner: "I wish I possessed despotic power…for by no other means can I preserve the noble forest trees that are still left growing in different parts of the city grounds. It seems to me akin to murder to cut down trees that have been the growth of ages."

It testifies to his high regard for the countess and to his enthusiasm for gardening that Jefferson, who was then serving his second presidential term, took the time to personally collect a considerable number of seeds, describe them in detail, and then carefully pack them in a substantial box "4 feet long, and 1 foot wide and deep" for an uncertain journey past British blockaders.

One of Jefferson's earliest biographers, B. L. Rayner, in *Sketches of the Life…of Thomas Jefferson*, commented on the president's special fondness for the willow oak: "He was rarely seen returning from his daily excursions on horseback, without bringing some branch of tree, or shrub, or bunch of flowers, for the embellishment of the infant capital….The willow-oak was among his favorite trees; and he was often seen standing on his horse to gather the acorns from this tree. He was preparing to raise a nursery of them, which, when large enough to give shade, should be made to adorn the walks of all the avenues in the city." Today, willow oaks shade the Capitol's grounds and line Rhode Island Avenue.

The willow oak is a tree most at home in the Deep South—Alabama, Mississippi, Louisiana, and Arkansas—but its range extends west into Texas and east from Georgia up the Atlantic coast to Staten Island and western Long Island. It is a hardy, fast-growing tree—up to 2 feet a year—and an ideal park shade tree, but in maturity it gets too large for most urban streets.

There were no willow oaks noted in the 1857 survey, but the 1873 survey indicates that at least one willow oak had been planted in the park. Louis Harman Peet, in *Trees and Shrubs of Central Park*, pinpoints only two willow oaks, but as of 2013 the park's willow oak population had increased to 116.

▲ *These towering willow oaks in the Ramble are over 90 feet tall and are more than 100 years old.*

▶ *An open-grown willow oak by the East Drive in the East Meadow has retained most of its leaves into December. Some leaves will hang on until early spring.*

▼ *A carpet of the previous year's leaves beneath a tall tree in the Ramble confirms that it is a willow oak.*

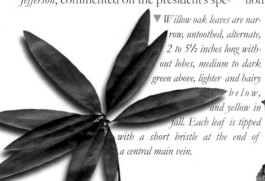

▼ *Willow oak leaves are narrow, untoothed, alternate, 2 to 5½ inches long without lobes, medium to dark green above, lighter and hairy below, and yellow in fall. Each leaf is tipped with a short bristle at the end of a central main vein.*

▼ *The willow oak's ½-inch acorns have shallow cups. A large tree can produce over 30,000 acorns annually. The acorns mature in late summer or early fall of their second year.*

228

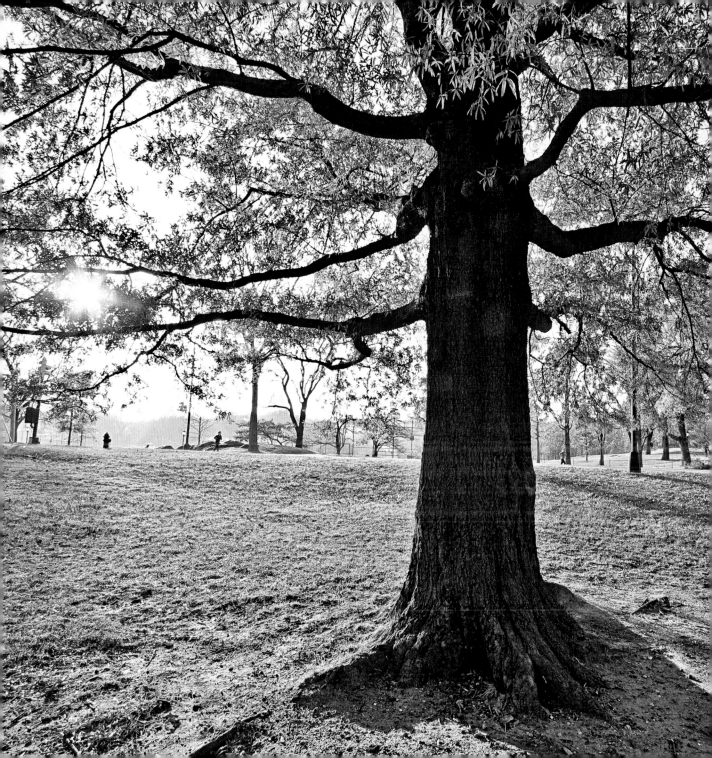

Sassafras *Sassafras albidum*

Word of the sassafras's miraculous curative powers reached the Old World when the first European explorers returned from North America. The earliest account of the sassafras and its supposed healing virtues appeared in a book on New World plants published in 1569 by Nicolás Monardes, a Spanish doctor living in Seville. Monardes did not travel to the New World himself, but he interviewed people who had visited Florida. In an English translation by John Frampton of Monardes's book titled *Joyfull Newes out of the New-found Worlde* (1577), the sassafras was described as a cure-all. Frenchmen in Florida suffering from "greevous and variable diseases" were taught by Indians to use sassafras compounds so that "thei [were] healed of many eviles, which surely it doeth bryng admiration, that one remedy should doe so variable, and so mervilous effectes."

An engraving from François Michaux's *The North American Sylva* illustrates the three different shapes of sassafras leaves, the fully developed bluish-black fruits on their red stems, and the lemony-smelling yellow male and female flowers.

And, as the following passage from François Michaux's *The North American Silva* illustrates, the sassafras's curative reputation lasted for a long time: "The medicinal properties of the Sassafras are so well proved, that during more than two hundred years, since its first introduction into the materia medica, it has maintained the reputation of an excellent sudorific, which may be advantageously employed in cutaneous affections, in chronic rheumatisms, and in syphilitic diseases of long standing." Like so many vaunted panaceas, the sassafras tree has not lived up to its early proponents' extravagant claims. Often little more than a shrub in the Northeast, the sassafras may reach a height of over 80 feet with a trunk more than 4 feet wide in the South. It colonizes untended, disturbed land with other fast-growing species, such as sumac, black cherry, black locust, and ailanthus, preparing the way for such forest-climax species as oaks, hickories, and sweetgums.

The sassafras was present before the park was built. There are still clonal colonies of saplings in the Ramble and the North Woods that likely existed before the park's construction. As of 2013, 170 sassafras trees with trunks of at least 2 or 3 inches in diameter were spread around the park.

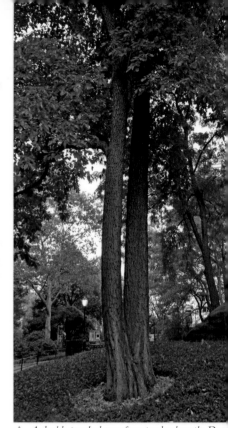

▲ *A double-trunked sassafras stands along the Dene path south of the Billy Johnson Playground. It has probably occupied this spot for 100 or more years.*

▶ *A small sassafras that once stood north of Pilgrim Hill displays the bright-scarlet fall foliage typical of the species.*

▼ *The bark of a mature sassafras is deeply furrowed and reddish-brown or gray with an orangish underbark.*

▼ *Alternate, smooth-edged, wedge-shaped, 3- to 5-inch sassafras leaves have no lobes or two or three lobes. Leaves are green above, hairless or slightly hairy below, and yellow to brilliant scarlet in fall. They smell spicy when bruised.*

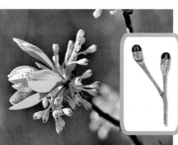

▼ *In spring, sassafras trees bear small pollen flowers and seed flowers, usually on separate trees. The egg-shaped 1/5-inch black seeds (inset) grow on red stalks and mature in late summer.*

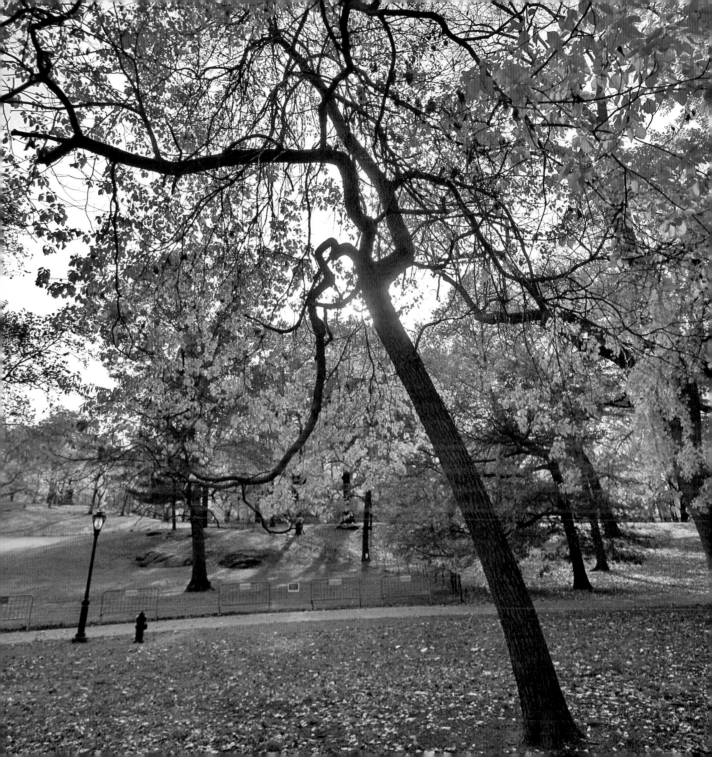

Serviceberry *Amelanchier* spp.

The genus *Amelanchier,* serviceberry, includes some three or four species native to the Northeast. Usually smallish and often multi-stemmed trees or shrubs, serviceberry species readily hybridize and are not always easy to distinguish from one another. All of them have oval, toothed leaves and small white flowers.

Also known as shadbushes, serviceberries are among the first native trees to flower in the Northeast, and their common names reflect this fact. They bloom in early spring, soon after the ground has thawed, when graveside services were once conducted in northern states for people who had died during the winter. The annual appearance of the dazzling white serviceberry blossoms also corresponds with the shad's spawning time in northeastern rivers.

One species of serviceberry found in Central Park, the downy serviceberry (*Amelanchier arborea*), also known as the Juneberry, may be a multi-stemmed shrub or a single-stemmed ornamental tree. Its young leaves are gray-green and very hairy beneath and somewhat greener and less hairy above, but they become smooth and darker green as they mature. The hair insulates the leaves against the frosts of early-spring nights. Another serviceberry species in the park is the shadblow serviceberry (*A. canadensis*). Its leaves are similar to those of the downy serviceberry, though they tend to be slightly narrower and somewhat woolly overall when young, instead of hairy just on the bottom.

Serviceberries are trees for all seasons. In winter, their elegant, smooth gray trunks stand out among the somber boles of many other trees. In mid-April, they become star-spangled beacons of spring, decked with hundreds of delicate white blossoms just as young leaves are emerging. In early summer, they are hung with bunches of sweet-tasting red and purplish-black fruits about ½ inch in diameter. In fall, their leaves turn to extravagant shades of scarlet, pumpkin-orange, and bronze.

Over 110 serviceberries were present in the park as of 2013. A cluster of large specimens, probably dating from the 19th century, stands along the northern edge of the path below Tupelo Meadow in the Ramble.

A painting by Deborah Griscom Passmore (1840–1911), a Department of Agriculture staff artist, depicts the foliage and ripening fruits of the shadblow serviceberry. It was painted in 1909, just two years before the artist died.

▲ *It is mid-April, and a multi-trunked shadblow serviceberry north of the Pool close to Central Park West is in full flower. The shadblow serviceberry's flower petals (inset) are more rounded than the downy serviceberry's flower petals.*

▶ *A downy serviceberry in full autumn regalia stands resplendent in early November near the Ladies Pavilion at Hernshead on the Lake's rocky western shore.*

▼ *A circle of large downy serviceberry trees on the southeastern edge of Tupelo Meadow in the Ramble, some 16 inches in diameter, were likely planted by Olmsted's gardeners not long after the park opened.*

▼ *The downy serviceberry's alternate oval leaves are 1 to 3 inches long, with small teeth, a pointed tip, a central main vein, and curving, secondary veins. Flower petals (inset) are thinner and more elongated than the shadblow serviceberry's flower petals. Birds flock to the blueberry-size fruits as they ripen in June.*

◀ *Young serviceberry trunks are smooth and light gray, almost like young beech trunks, but as trees grow older, they may develop fissures, cracks, and handsome thin, vertical light-gray and darker-gray stripes.*

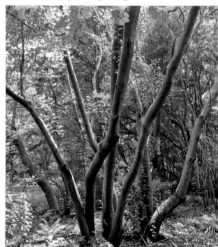

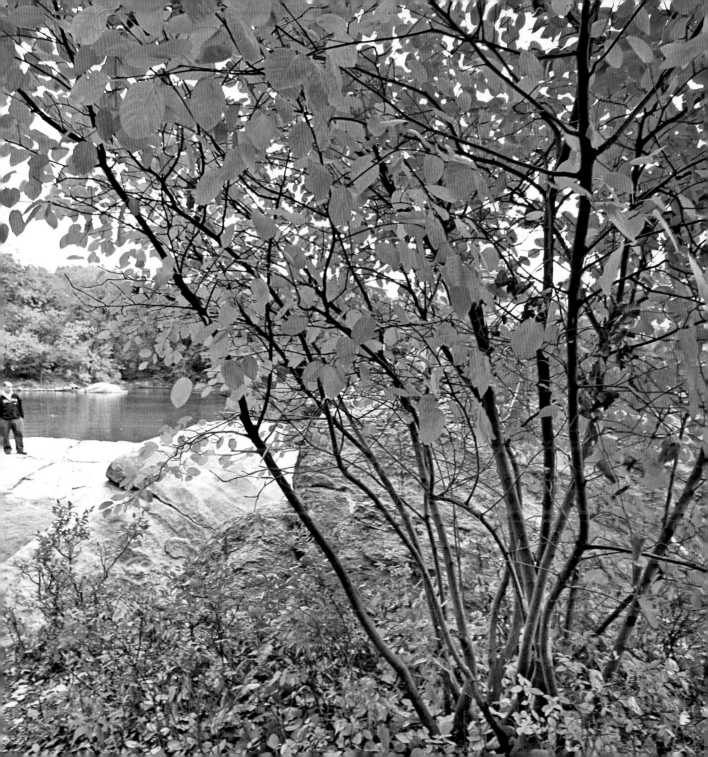

BIRCHES

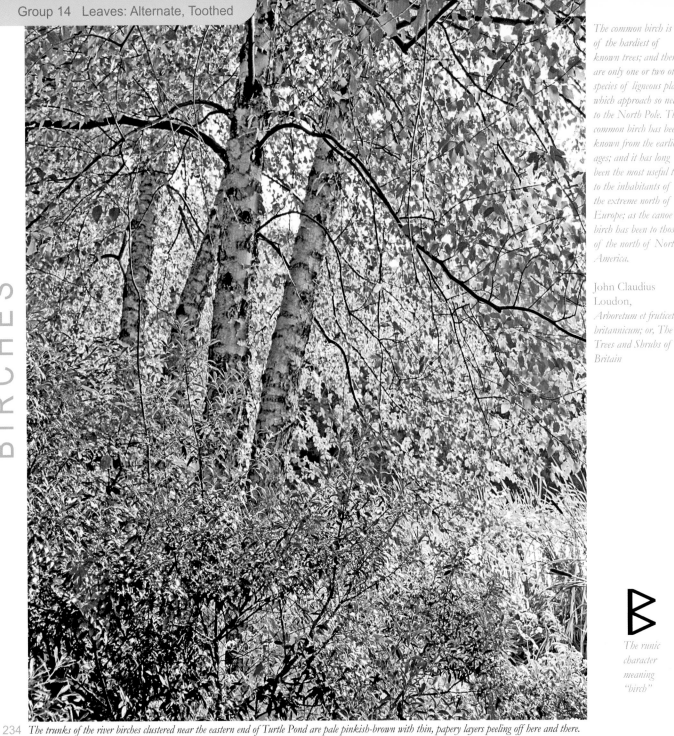

The common birch is one of the hardiest of known trees; and there are only one or two other species of ligneous plants which approach so near to the North Pole. The common birch has been known from the earliest ages; and it has long been the most useful tree to the inhabitants of the extreme north of Europe; as the canoe birch has been to those of the north of North America.

John Claudius Loudon, *Arboretum et fruticetum britannicum; or, The Trees and Shrubs of Britain*

The runic character meaning "birch"

234 *The trunks of the river birches clustered near the eastern end of Turtle Pond are pale pinkish-brown with thin, papery layers peeling off here and there.*

The genus *Betula*, birch, consists of about 50 species of trees and shrubs, most of which are native to the temperate, boreal, and arctic zones of the Northern Hemisphere. Younger birches are easily recognized by their smooth, thin, papery, often peeling bark, marked with thin, horizontal, line-like lenticels.

Birch bark varies in color from bone white, as in species such as the European white birch and Himalayan birch, to dark gray or brown, as in species such as the river birch and cherry birch. Trunks of older trees may develop rough sections or become covered with dark, irregular scales or plates. Leaves are oval or triangular, with pointed tips, toothed edges, and bases around the stems that are straight, wedge-shaped, rounded, or heart-shaped. Drooping, pollen-bearing male catkins are 2 to 4 inches long; erect, cone-like female catkins are shorter.

Central Park contains around 150 birch trees. About 100 of them are native birches—river birches, gray birches, and cherry birches. The others are European white birches and Himalayan birches. In addition, there are at least two or three hard-to-identify birch specimens that may be unusual varieties or hybrids.

The European white birch usually has diamond-shaped toothed leaves (right), but a cultivar called 'Dalecarlica' has leaves with several pointed lobes (left).

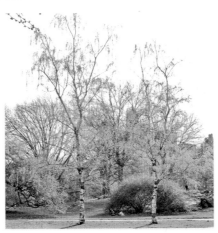

A pair of European white birch cultivars (Betula pendula 'Dalecarlica') next to the West Drive opposite the Arthur Ross Pinetum bear sharply lobed and toothed leaves.

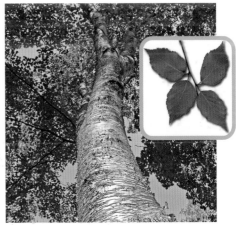

Likely a hybrid, this birch tree south of the Boathouse has leaves like a Himalayan birch's (inset), but its ocher-cream bark does not resemble a Himalayan birch's white bark.

River Birch *Betula nigra*

The most widely distributed birch in the United States, the river birch grows all the way from southern New Hampshire to the Gulf Coast of Texas. In the South, where

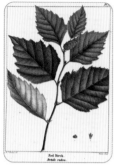

A hand-colored plate in François Michaux's *The North American Sylva* pictures the river birch's alternate leaves, with a wedge-shaped base, and a ripened, dried female catkin that has dropped all its seeds.

this heat-tolerant tree reaches its greatest average size in the rich alluvial soil of the lower Mississippi Valley, it is the only naturally occurring member of its genus. A handsome tree with a vase-shaped habit, it can reach over 100 feet in height under ideal conditions but normally grows 50 to 80 feet tall with a trunk 2 or 3 feet wide.

The river birch is appropriately named, for it is extremely well adapted to a riparian way of life. Most birches shed their seeds in fall, but the river birch produces fully ripened fruits called female catkins in late spring or early summer. Shaken by warm breezes, the seed-laden catkins scatter winged capsules—just in time for many to land in receding rivers and streams and be carried by currents downstream to newly exposed

mud banks, perfect places for quick germination. Not surprisingly, the river birch is tolerant of periodic flooding, a trait that helps it survive in dense, airless urban soils.

Another common name for the river birch is red birch. François Michaux, in *The North American Sylva*, describes the tree's bark and speculates on why it was so named: "On the trunk and on the largest limbs of a lofty Red Birch, the bark is thick, deeply furrowed, and of a greenish color. On trees not exceeding 8 to 10 inches in diameter, the epidermis is reddish or cinnamon-coloured; whence probably is derived the appropriate denomination of Red Birch. The epidermis of this species, like that of the Canoe Birch, divides itself transversally into thin, transparent sheets, which appear to be composed of a mixed substance, instead of presenting a pure, homogeneous texture; hence they have not an uniform transparency, nor a perfectly even surface: compared with the bark of the Canoe Birch, they are like coarse paper compared with fine."

The river birch is the park's most abundant birch. Around 80 specimens are spread around the park, with several of the largest growing along the Great Lawn's perimeter and at Turtle Pond's eastern end.

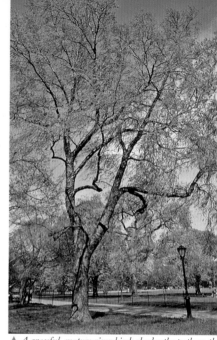

▲ *A graceful, mature river birch shades the path on the southwestern edge of the Great Lawn in Central Park. The river birch grows best in damp soils near lakes and streams. During droughts, it sheds its leaves.*

▶ *All relatively young trees, the river birches at the eastern end of Turtle Pond have reddish, peeling bark.*

▼ *Trunks of young river birches display attractive exfoliating bark varying in color from salmon-pink to orange-brown to cinnamon-brown to very dark reddish-brown. Trunks of mature trees (inset) tend to be dark gray.*

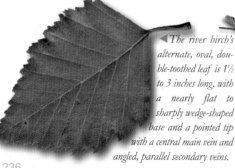

◀ *The river birch's alternate, oval, double-toothed leaf is 1½ to 3 inches long, with a nearly flat to sharply wedge-shaped base and a pointed tip with a central main vein and angled, parallel secondary veins.*

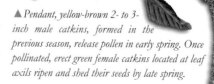

▲ *Pendant, yellow-brown 2- to 3-inch male catkins, formed in the previous season, release pollen in early spring. Once pollinated, erect green female catkins located at leaf axils ripen and shed their seeds by late spring.*

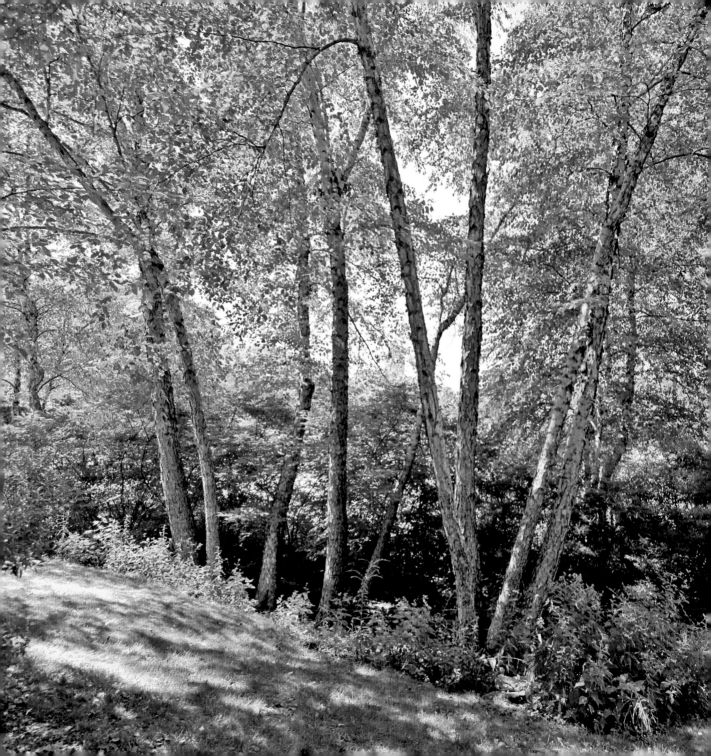

Birches *Betula* spp.

A few birches with white bark are scattered around Central Park. Most people assume that they are paper birches, trees associated with birch-bark canoes and the Great North Woods of Canada and New England. In fact, there isn't a single paper birch in Central Park. All the park's white birches are native gray birches, European white birches, or white-barked Himalayan birches, trees that seem to do a bit better in the hot New York City summers than do paper birches.

This fifth-century Buddhist scroll made of Himalayan birch bark was written with ink made from charcoal boiled in cow urine. Long before the introduction of paper, birch bark was used in northern India for scriptures in Sanskrit and other languages.

Michael Dirr, an American expert on woody plants, once lauded the variety of white-barked Himalayan birch (*Betula utilis* var. *jacquemontii*) now being planted in Central Park, calling it "one of the most beautiful trees on the planet." Dirr was referring specifically to large trees that he had seen in Edinburgh, Scotland. The white-barked Himalayan birches in Central Park are mostly younger, less-imposing trees, but they are handsome enough with their pristine white peeling bark

and butter-yellow fall leaves.

About as numerous as the white-barked Himalayan birches in Central Park are the European white birches (*B. pendula*). However, their trunks tend to blacken with age, so the species may become less numerous as older trees are replaced by more striking white-barked Himalayan birches.

The gray birch (*B. populifolia*), the only native birch with a white trunk in the park, contrasts with the darker-trunked trees along the southern edge of the Hallett Nature Sanctuary. The gray birch seldom grows taller than 30 or 40 feet. Often mistaken for the paper birch, it is easily distinguished from its larger cousin by its triangular leaves.

Besides the river birch, only one other darker-trunked birch species is present in Central Park: the native cherry birch (*B. lenta*). Around the turn of the 20th century, the cherry birch, also known as the sweet or black birch, was a valuable tree. Its hard, strong wood was sold as "mahogany birch" for use in cabinetry and furniture making, and its aromatic sap was distilled to make birch beer. If you chew a cherry birch twig, you will taste the wintergreen flavor. The cherry birch grows best in cooler, mountainous areas from Maine to Georgia. Several are in the northern sections of the park.

▲ *A triple-trunked young cherry birch clings to the hillside the park's edge near 108th Street and Central Park We. Bark on younger trees like this one is smooth with horizont pores. Bark on older trees is cracked into irregular plates.*

▶ *A pair of multi-trunked white-barked Himalaya birch trees border the path leading to the Swedish Co tage. The bark of the Himalayan birch is the white and most striking of that of all the white-barked birche*

▼ *The white bark on Himalayan birch trunks tends peel and curl in sections, revealing orange-brown unde sides. Himalayan birch leaves (inset) look quite a bit li paper birch leaves, making positive identification tricky*

▼ *Alternate, triangular, double-toothed, 2½- to 3-inch gray birch leaves have a long, pointed tip. A central main vein has angled secondary veins extending to the edges. The slender leaf stems produce fluttering. Dark, shiny green above and somewhat rough, they are yellow in fall.*

◄ *Gray birch trees lean over the water along the southern edge of the Hallett Nature Sanctuary and are easily visible from the path skirting the Pond's southern shore.*

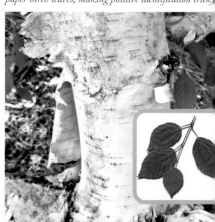

Hornbeam *Carpinus* spp.

The American hornbeam (*Carpinus caroliniana*) was dubbed ironwood by early settlers who fashioned its extremely hard wood into serviceable mallet heads and plow blades in times when iron was often hard to get and expensive. Another common name for the American hornbeam is blue beech. With its thin, smooth, bluish-gray bark, it does resemble a small beech. Usually a bushy tree of the eastern American forest understory from 20 to 30 feet tall, it occasionally reaches 50 or 60 feet.

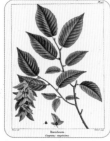

An engraving of an American hornbeam bough in François Michaux's *The North American Sylva* is accompanied by this observation: "The dimensions of the tree are so small as to render it useless even for fuel, but it is employed for hoops in the District of Maine when better species cannot be procured."

The European hornbeam (*C. betulus*), often a larger mature tree than its American cousin, is widely planted in the East. The most telltale difference between the American and the European hornbeam is the superlative fall color of the native variety. Another clue for telling the two species apart is the fruit bract, which is usually untoothed and up to 1½ inches long on *C. betulus* but is usually toothed and not more than 1¼ inches long on *C. caroliniana*. Winter bud

▼ *The hornbeam's alternate, oval, doubly saw-toothed, 2- to 4-inch leaves have a sharply pointed tip and a central main vein, with angled, parallel secondary veins.*

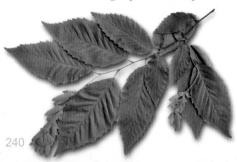

size is also different: buds are about ¼ inch on *C. betulus* but only ⅛ inch on *C. caroliniana*.

The American hornbeam was first named by Humphrey Marshall in 1785 as *Carpinus betulus caroliniana* in his monumental book *Arbustrum Americanum*, the earliest comprehensive treatise on American plants written by an American author. (The tree would be renamed three years later as *Carpinus caroliniana* by Thomas Walter, a South Carolina botanist.) In *Arbustrum Americanum*, Marshall included a short description of the tree: "This grows common by most of our river and creek sides, rising with a strong, woody, somewhat angular stem, to the height of ten or fifteen feet; spreading into many branches, with oval, pointed leaves, sawed on their edges. The flowers are produced at the ends of the young shoots, in loose, leaffy Katkins, and are succeeded by small angular seeds." A cousin of John Bartram and, like him, a self-taught botanist, Marshall in 1772 established the second botanical garden in America in Marshallton, Pennsylvania.

American and European hornbeams were among the first trees planted by Olmsted's gardeners. As of 2013, there were more than 225 hormbeams in the park. The larger, older hornbeams are mostly European; all recently planted hornbeams are American.

▼ *Female catkins develop into leafy bracts. A bract (insert) has a large lobe and two small ones with a nutlet. When a bract drops, it may spin in the wind and travel a distance from a tree.*

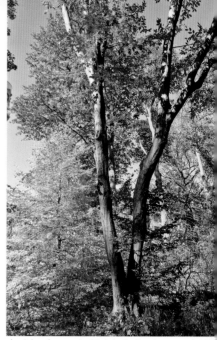

▲ *A hornbeam pair, likely both American, stand side by side at the Pool's western end. The large twin-trunked tree, perhaps 100 or more years old, hovers over a young hornbeam arrayed in gold on a cool November afternoon.*

▶ *Twisted, spreading roots anchor a beautiful European hornbeam standing near the Rustic Shelter in the Ramble. A treasure of the park, this great old tree was likely planted by Olmsted's gardeners around 150 years ago.*

▼ *Borne in early spring, just as leaf buds are beginning to open, hornbeam flowers are pendulous 1- to 1½-inch male pollen catkins that hang from thinner branches and ½-inch female catkins that cluster at twig ends.*

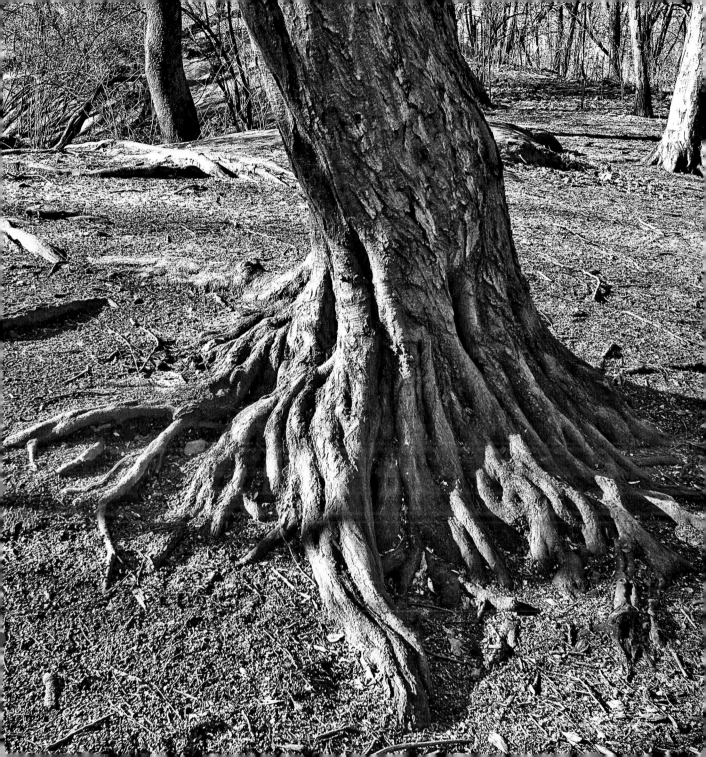

Hackberry *Celtis occidentalis*

The hackberry was called *bois inconnu* (unknown wood) by early French settlers, who deemed it a nondescript tree without much to recommend it. Often displaying a ragged habit, the hackberry's toughness and versatility more than make up for its aesthetic shortcomings. It withstands hurricanes and tornadoes better than many other species. It springs back quickly from repeated cuttings along power lines. It does well in full sunlight and grows in shade. It withstands flooding and is drought tolerant, too, with roots that reach down to moisture up to 20 feet below the surface. It grows in various habitats, from eastern forests to prairie oak openings. Its natural range extends west from the New England coast into the High Plains and south as far as Texas. It grows best in well-watered bottomlands but is present on limestone bluffs, sand barrens, and prairie pothole dunes. It colonizes old-fields and reproduces in old-growth forests. Its fruits are without much meat but are eaten and spread far and wide by many bird, mammal, and reptile species.

A variety of insects are dependent on hackberry trees. Some butterflies, such as the American snout butterfly (*above*) and the hackberry emperor butterfly, lay their eggs exclusively on hackberry leaves so that hatching caterpillars can immediately begin feeding.

Henry. H. Gibson, in *American Forest Trees,* comments on the hackberry's highly variable bark and on a curious phenomenon caused by protuberances on hackberry trunks in Louisiana swamps: "The bark varies as much in appearance as the tree in size. Sometimes it has the smooth surface and pale bluish-green appearance that suggests the bark of a beech; again it is darker and rougher, like the elm. It frequently exhibits the harsh warty bark which is peculiar to the hackberry, and when present is a pretty safe means of identification....The warts are a decided disadvantage to the tree in some of the low swampy districts of Louisiana where Spanish moss is a pest....The hackberry's warts catch and hold every flying strand of moss that touches them, and hundreds, perhaps thousands, of pounds of it may accumulate on a single tree."

Hackberry trees were planted by Olmsted's gardeners in the Ramble in the early 1860s, and one or two original Olmstedian hackberries are still standing at the northwestern end of the Point overlooking the Oven. Many smaller specimens, probably sprung from seeds spread by birds, are also present in the southeastern section of the Ramble west of the Loeb Boathouse. Other specimens are spread throughout the park.

▲ *A group of hackberry trees in the Ramble near the Loeb Boathouse are likely self-seeded descendants of trees originally planted by Olmsted's gardeners in the 1860s.*

▶ *Four gracefully curved hackberries, one with a double trunk, cluster near Pine Bank Arch west of the Heckscher Playground. They were planted in the early 20th century.*

▲ *Hackberry bark can be smooth and gray like beech bark, but more often it is broken into scaly plates, wart-like protuberances, or rough, layered vertical ridges.*

▼ *The hackberry's alternate, oval, toothed, 2- to 5-inch leaves have a pointed tip, a main vein, and two conspicuous ribs branching from an uneven base. Green and smooth or slightly rough above, they are paler green below, and pale yellow in fall.*

▼ *Hackberry flowers appear in spring as male staminate clusters at twig ends or as female flowers (inset) at new leaf axils or as perfect flowers with both stamens and pistils.*

▼ *Hanging on slender stems, berry-like ⅓- to ¼-inch hackberry fruits ripen to a dark red or purple in autumn. A thin, fleshy outer layer surrounds a rock-hard seed.*

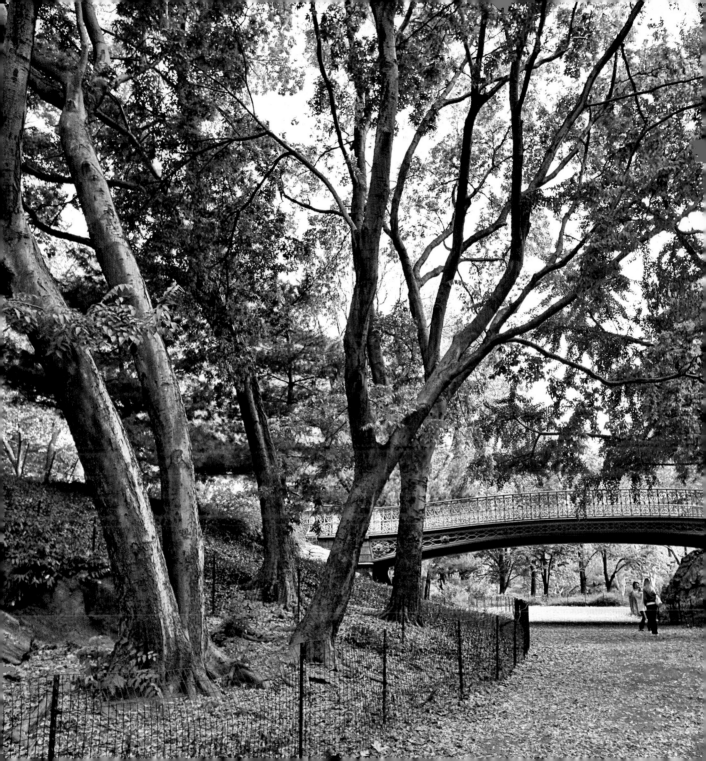

Hazel *Corylus* spp.

There is a curious little tree in the park's Shakespeare Garden just up the hill from the Swedish Cottage. All its branches, even its smallest twigs, are twisted like living corkscrews. From midwinter into early spring, before its leaves unfold, zigzagging branches are hung with hundreds of pale-yellow catkins about 3 to almost 4 inches long. When its leaves begin to unfold in late March or April, they are wrinkled and corrugated. It is a healthy, vigorous small tree, but it looks as if it has struggled to attain its place in the world.

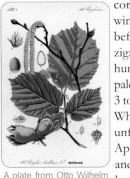

A plate from Otto Wilhelm Thomé's *Flora of Germany, Austria, and Switzerland* (1885) shows catkins, female flowers, fruits, and leaves of the common hazel. Thomé was a German botanical artist best known for this four-volume compendium of 572 illustrations.

This contorted little tree or shrub is a genetic sport, or natural mutation, of the common hazel (*Corylus avellana*), a species native to Europe and the Middle East. Found growing in an English hedgerow in 1863, it has been propagated ever since by grafting or by layering, a process in which portions of branches are buried to form roots and then detached from the parent plant. Its scientific name is *Corylus avellana* 'Contorta,' but it is commonly known as Harry Lauder's walking stick. Harry Lauder (1870–1950) was a renowned Scottish entertainer and singer, who frequently appeared with a crooked walking stick fashioned from a *Corylus avellana* 'Contorta' stem.

The common hazel is well represented in the park with several large bushes growing behind the benches bordering the path north of the Delacorte Theater and along the path to the Locust Grove, which begins behind the benches. Unlike the contorted cultivar, these plants typically consist of clusters of long, straight stems. In Britain, common hazel bushes were cultivated by coppicing for centuries, and their stems were periodically harvested for wattle-and-daub construction, in which a building's walls were made of woven hazel sticks daubed with clay and straw.

The largest member of the genus *Corylus* in the park is a Turkish filbert (*C. colurna*), located in the Glade just north of the Conservatory Water. Like its cousin the common hazel, it bears pale-yellow catkins from midwinter into spring before it leafs out. Also like the common hazel, it bears nuts, but they have thick shells and are not commercially valuable. Common hazel cultivars produce the hazelnuts sold in stores.

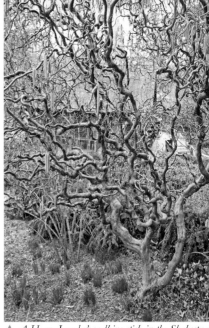

▲ *A Harry Lauder's walking stick in the Shakespeare Garden is decked out with yellow catkins in mid-March.*

▶ *Mid-December snow covers the Turkish filbert at the Glade's southern end. Its partially developed 2- to 3-inch male catkins will continue lengthening into early spring.*

▼ *Fully leafed out in early May, a common hazel bush on the path north of the Delacorte Theater displays the typical multi-stemmed habit of the species.*

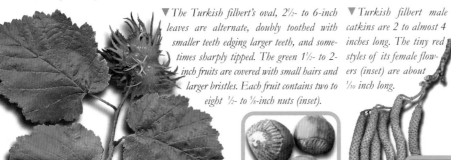

▼ *The Turkish filbert's oval, 2½- to 6-inch leaves are alternate, doubly toothed with smaller teeth edging larger teeth, and sometimes sharply tipped. The green 1½- to 2-inch fruits are covered with small hairs and larger bristles. Each fruit contains two to eight ½- to ⅝-inch nuts (inset).*

▼ *Turkish filbert male catkins are 2 to almost 4 inches long. The tiny red styles of its female flowers (inset) are about ⅒ inch long.*

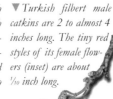

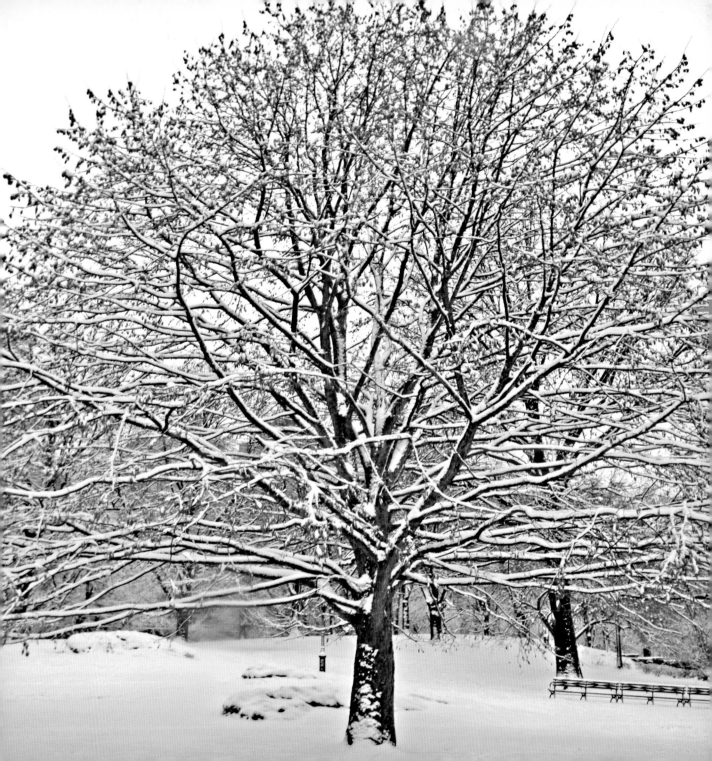

Hawthorn *Crataegus* spp.

There are more than 100 native species of these small trees and shrubs growing in North America along with hundreds of cultivars, varieties, and introduced species from Europe and Asia. Many of them hybridize, so variations abound. Tolerant of drought, salt, pollution, and poor soil, hawthorns accent medians, parks, and other urban spots with colorful displays in spring, fall, and winter.

The ancient hawthorn by the church in Saint-Mars-sur-la-Futaie, France, has a stone plaque at its base reading: "This hawthorn is without doubt the oldest tree in France. Its origin goes back to Saint Julien (3rd century)."

Members of the rose family, all hawthorns have alternate, toothed leaves that are sometimes lobed. All hawthorns bear clusters of white, pink, or sometimes red flowers. Very appealing to birds, the hawthorns' small, crab apple–like fruits, or haws, are often red but can be yellow or even dark blue or black. Many hawthorns have thorns, but some thornless varieties are planted.

Four hawthorn species that were planted early in the park's history and are present throughout the park today are the downy hawthorn (*Crataegus mollis*), Washington hawthorn (*C. phaenopyrum*), English hawthorn (*C. laevigata*), and cockspur hawthorn (*C. crus-galli*).

The English hawthorn grows from Ireland south to northwestern Africa and east to Pakistan. In England, it has been planted in hedgerows since early Saxon times. Indeed, the word "haw" is derived from the Old English word *haga,* meaning "hedge." One English hawthorn growing in a churchyard south of Norwich, England, is reputed to be over 700 years old. Another, in France, is claimed to be 1500 years old, making it perhaps the oldest tree in France. Hawthorns do live for centuries, so it is possible that a hawthorn could be one of the park's oldest trees.

The hawthorn is important in the folklore of many cultures. The Irish associated the tree with fairies; the Greeks used its boughs in fertility rites; many Christians believe that Christ's crown of thorns was made of hawthorn branches; herbalists have used hawthorn fruits and leaves in infusions to treat heart and circulatory problems.

Hawthorns have always been present in Central Park. The 1873 survey cited 11 species. The 1982 tree count included 403 hawthorns with trunks over 6 inches in diameter. As of 2013, there were more than 430 hawthorns in the park.

▲ *The Washington hawthorn's bright-red fruits, or haws, may persist well into winter, providing welcome food for birds.*

▶ *A row of cockspur hawthorns once edged the path on the Great Lawn's eastern side, but it was removed in 2011.*

▲ *A pair of Washington hawthorns spread their fruit-laden branches over a path near the Tennis Center.*

▼ *A cockspur hawthorn's flowers have five petals and 10 anthers, which turn from red to brown in a day or two as they release pollen. Pistils extend from central yellow spots.*

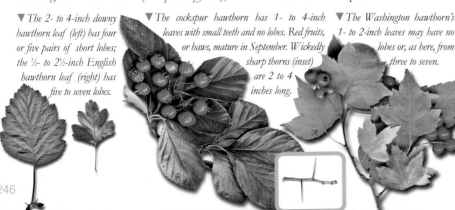

▼ *The 2- to 4-inch downy hawthorn leaf (left) has four or five pairs of short lobes; the ½- to 2½-inch English hawthorn leaf (right) has five to seven lobes.*

▼ *The cockspur hawthorn has 1- to 4-inch leaves with small teeth and no lobes. Red fruits, or haws, mature in September. Wickedly sharp thorns (inset) are 2 to 4 inches long.*

▼ *The Washington hawthorn's 1- to 2-inch leaves may have no lobes or, as here, from three to seven.*

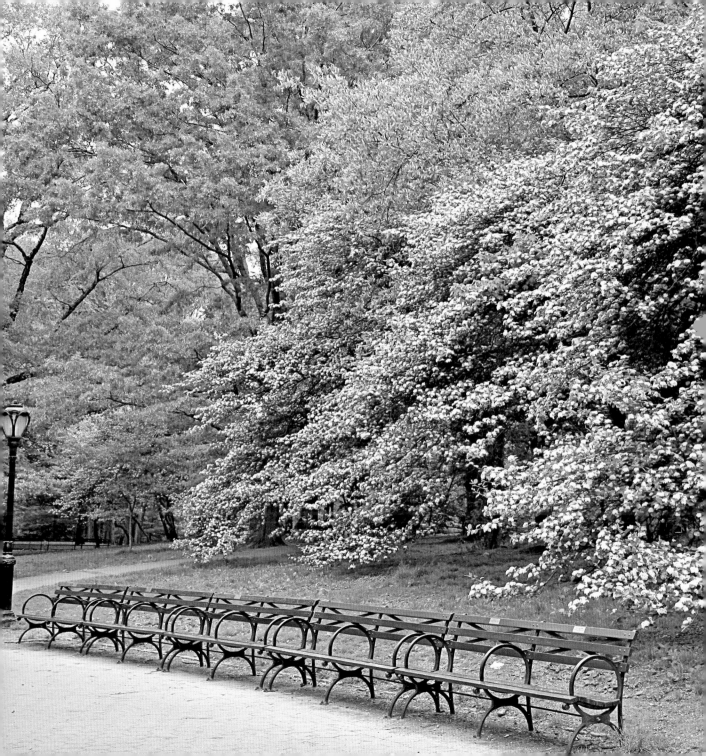

BEECHES

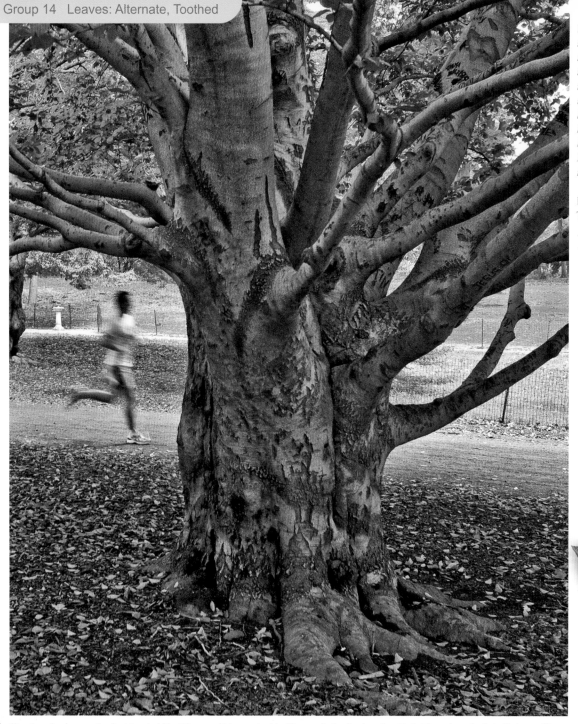

It is an interesting tre[e] me, with its neat, clos[e] tight-looking bark, li[ke] the dress which athlete[s] wear, its bare instep, [its] roots beginning to bra[nch] like bird's feet, showi[ng] how it is planted and holds by the ground. Not merely stuck in the ground like a stic[k]

Henry David Thoreau, *Journal,* May 20, 1853

Fernleaf European beech leaf

248 *European beeches may be short-trunked like this one, which once stood beside several other beeches along the bridle path north of the Delacorte Theater.*

The genus *Fagus,* beech, includes some dozen species of trees native to Europe, North America, and Asia. North America has two indigenous beeches. One grows in the central mountains of Mexico; the other, the American beech, ranges from eastern Canada to Texas and Florida. Europe has just one native species, the European beech.

Both the American beech and the European beech are extremely handsome trees, with silvery-gray bark, dark shiny leaves, and sinuous spreading surface roots. Widespread in the wild on their respective continents, they may grow in pure stands or in association with other species.

The American beech does not do well in stressful urban sites. The European beech, though, thrives in parks, in cemeteries, and on the lawns of suburban homes and is widely cultivated in North America, where it arrived around 1800. Central Park contains about 80 mature European beeches (including several cultivars) but fewer than half a dozen large American beeches. Unlike its variable European close relative, the American beech has no cultivars.

Some European beech cultivars have variegated leaves with pinkish-white margins, like this leaf from a beech tree on the bridle path north of the Delacorte Theater.

Among the most beautiful cultivars of the European beech is the copper or purple beach. These spring leaves are on a young copper beach at the foot of Cedar Hill.

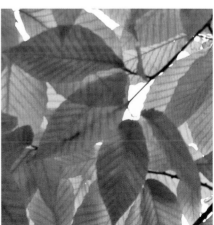

The leaves of the American beech do not exhibit the variations of its European cousin's, but they turn beautiful shades of gold and brown in fall and early winter.

American Beech *Fagus grandifolia.*

The most striking feature of the American beech, and of its cousin the European beech, is its elegant, smooth gray bark.

An engraving from the Royal Octavo edition of John James Audubon's *Birds of America* (1840–1844) shows a female passenger pigeon offering a tidbit to a red-breasted male. Passenger pigeons once travelled in flocks numbering over 1 billion birds.

Beeches are members of the Fagaceae family, a group of trees that developed in the tropics, where their smooth bark protected them from becoming overburdened with clinging epiphytes. The inner bark of most trees grows faster than that of beeches, producing corky layers of dead tissue that split over time. Beech bark has only a very shallow layer of inner corky tissue. The thin outer bark expands throughout the life of the tree, shedding dust-like particles and remaining smooth. The bark's light-gray color reflects the sun's rays in winter, preventing temperature changes that could cause the bark to crack.

Stands of American beech trees mixed with sugar maples, hemlocks, and American lindens covered great swaths of the Northeast and Midwest for nearly 10,000 years. A few tiny fragments of this primeval forest still exist in the Ravine on the northern side of the Loch. Here clusters of clonal beech saplings ring a few mature wild beeches, perhaps descended from trees that existed before the founding of the park.

After the Europeans arrived, the great North American beech forests were cut down, contributing to the extinction of the passenger pigeon, once the most common bird in North America. John James Audubon described the pandemonium that ensued when an immense flock of pigeons descended on a beech forest to feed on beech mast: "The Pigeons, arriving by thousands, alighted everywhere, one above another, until solid masses were formed on the branches all round. Here and there the perches gave way under the weight with a crash, and, falling to the ground, destroyed hundreds of the birds beneath, forcing down the dense groups with which every stick was loaded. It was a scene of uproar and confusion. I found it quite useless to speak, or even to shout to those persons who were nearest to me."

▲ *The smooth gray bark of the American beech has served as a bulletin board and romantic register since before Daniel Boone left this message on a Tennessee beech: "D. Boon killd a bar o this tree 1775." But such cuts in beech bark can provide access for wood-rotting fungi.*

▶ *This American beech in the North Woods glows gold in the sunlight of an afternoon in early November. It likely descended from trees that predated the park.*

▲ *Clonal saplings spring from the roots of an American beech on a path in the Ravine northwest of the Loch. Many wild American beech stands are products of root sprouts and the individual trees may have identical DNA.*

▶ *The 1- to 3-inch oval leaves of the American beech have 11 to 15 parallel veins, each ending with a tooth (inset). Dark bluish-green above and lighter green beneath, in fall they turn yellow-bronze.*

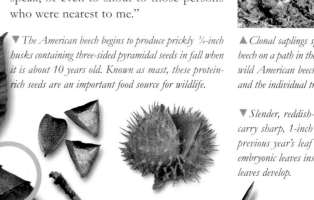

▼ *The American beech begins to produce prickly ¼-inch husks containing three-sided pyramidal seeds in fall when it is about 10 years old. Known as mast, these protein-rich seeds are an important food source for wildlife.*

▼ *Slender, reddish-brown winter American beech twigs carry sharp, 1-inch tapering buds that form next to the previous year's leaf scars. Bud scales protect the folded embryonic leaves inside but drop off in spring as the new leaves develop.*

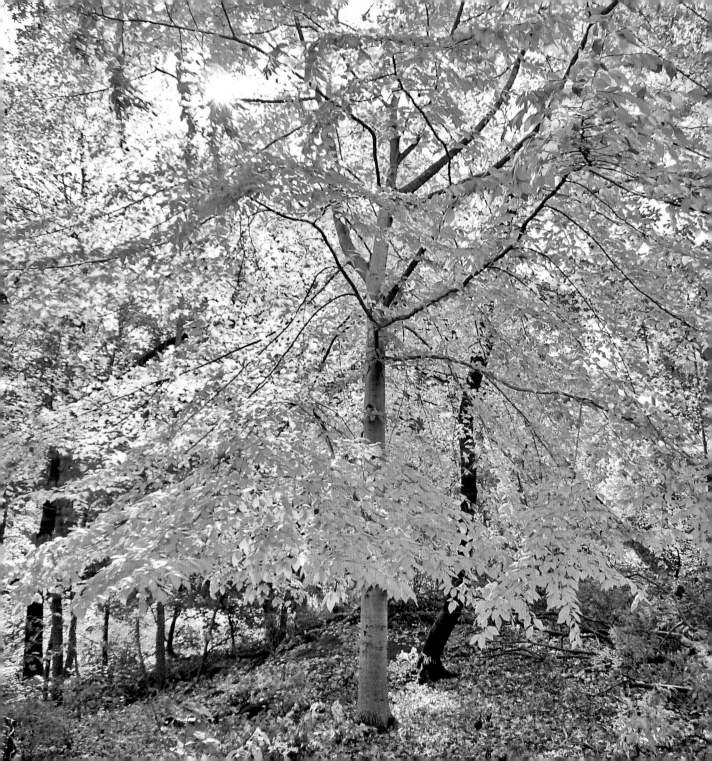

European Beech *Fagus sylvatica.*

With their smooth gray bark like elephant hide; their stout, often short, trunks buttressed by thick tapering roots; and their glossy deep-green leaves held aloft on dozens of spreading boughs casting a shade so deep that grass cannot grow beneath them, the fine old European beeches of Central Park are not easy trees to ignore.

The Fern-leaved beech, commonly so-called, is a great favorite with us, and we hardly know a prettier or more attractive tree, or one less known or planted; if we could plant but a half dozen trees this would certainly be one of the first.
Andrew Jackson Downing
Landscape Gardening

Three groups of the park's mature beeches are particularly noteworthy: a cluster of tall-trunked trees just south of Glade Arch on the path leading from the Glade to Cedar Hill; a line of widespreading individuals skirting the path along the western side of the East Meadow; and an allée of especially intriguing beeches, including fernleaf and variegated cultivars, flanking the bridle path north of the Delacorte Theater.

A disease called *Phytophthora kernoviae* has killed some of the park's finest European beeches. Watering trees during droughts and fencing them off to prevent soil compaction has helped to limit damage.

Louis Harman Peet, in *Trees and Shrubs of Central Park,* commented on the special light that new leaves of European beeches cast in spring: "Come upon them in spring, when they are setting their boughs with that peculiar delicate tender green which only the beech can show. No other tree can compare, in spring leafage, with the tender green of the beech. If you don't believe it, stand under a beech at this season of the year and look up through the young leaves at the sunshine. Can anything equal that glory of illumined green!"

It is hard to find an older beech tree that has not had initials and names carved on its trunk. The beech tree's connection with the written word stretches back for millennia. The English word "book" derives from the Germanic *boks* (piece of writing), which is derived from the Indo-European word *bhagos* (beech tree). The genus name for the beech, *Fagus,* Latin for "beech," also comes from *bhagos.* The almost instinctive urge to carve letters in beech bark is clearly anchored deep in the human psyche.

▶ *The rippled edges of European beech leaves do not have small teeth, as do the leaves of the American beech.*

▼ *Beechnuts, known as beech mast, are nestled in husks protected by bristly recurved hairs. The triangular nuts are high in fat content and yield oil said to be as nutritious and tasty as olive oil.*

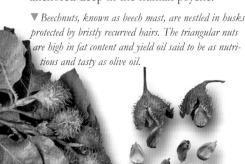

▲ *A young copper beech standing at the base of Cedar Hill flaunts a deep-crimson mantle in mid-May. The leaves of this handsome European beech cultivar will darken and turn greener as the season progresses.*

▶ *Perhaps an original planting from the 1860s, this venerable fernleaf beech brushes a schist outcropping on the northern side of Cherry Hill overlooking the Lake.*

▲ *Cut down in 2012, this triple-trunked giant once stood next to the bald cypress pair at the Harlem Meer's southeastern corner. It was the park's largest European beech.*

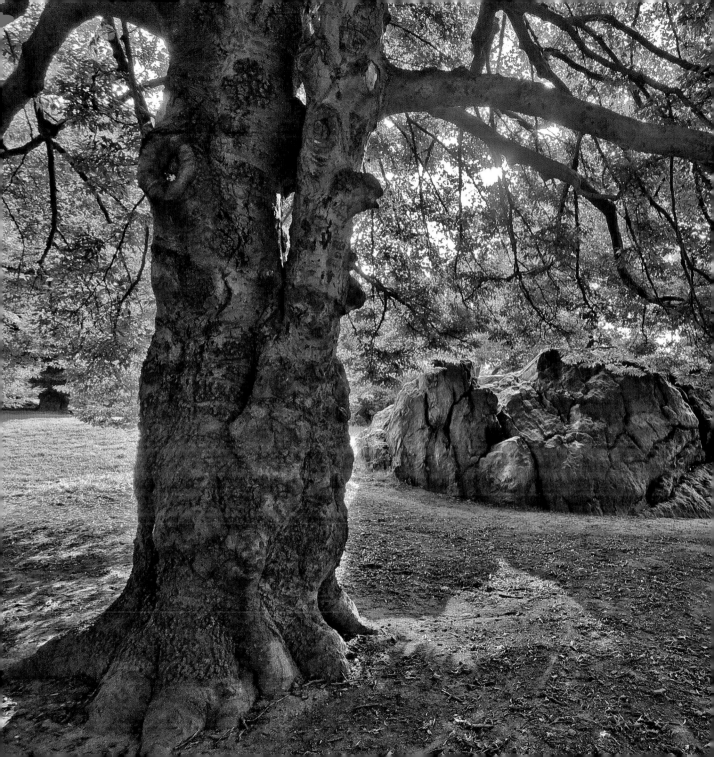

Carolina Silverbell *Halesia tetraptera*

The Carolina silverbell's name refers to the beautiful silvery-white bell-shaped flowers that line its branches in spring just as its leaves begin to unfold. Carolus Linnaeus, the great Swedish botanist, zoologist, and physician, gave the tree its scientific name, *Halesia tetraptera*, at the request of John Ellis, a London merchant, gardener, and amateur botanist, who in 1756 forwarded to Linnaeus a description, an illustration, seeds, and specimens that had been sent to him by Dr. Alexander Garden of Charleston, South Carolina. Ellis asked Linnaeus to name the tree's genus in honor of Stephen Hales, an English curate, physiologist, and inventor, though Hales had no other connection with the tree.

A prolific scientist and experimenter, Stephen Hales (1677–1761) theorized that plants draw "nourishment" from air, performed the first catheterization of a living animal's heart, first measured blood pressure, and invented surgical forceps.

In his description of the silverbell, Garden wrote: "This beautiful tree grows commonly along the banks of the Santee river, and rises often to the size of middling mulberry-trees....The wood is hard, and veined; the bark is of a darkish colour, with many irregular shallow fissures. The leaves are ovated, and sharp pointed....The flowers hang in small bunches all along the branches, each gem producing from four to eight or nine flowers, bell-shaped, and of a pure snowy whiteness. As they blow early in the spring, before the leaves appear, and continue for two or three weeks, they make a most elegant appearance. They are followed by pretty large four-winged fruit, which likewise hang in bunches, each containing four kernels, that are very agreeable to the taste."

The Carolina silverbell has been a popular ornamental tree in England since it was introduced there by Ellis, who sent some of the seeds he received from Garden to several fellow English plant enthusiasts. Indeed, today it has even become naturalized in the English countryside in a few spots.

Although its natural range is centered in the Deep South—the Carolinas, Georgia, and Alabama—the Carolina silverbell is cultivated in the Northeast well into New England. The tree has always been in Central Park. Three were noted in the 1875 survey, but probably more were actually present then. As of 2013, there were over 30 Carolina siverbells in the park.

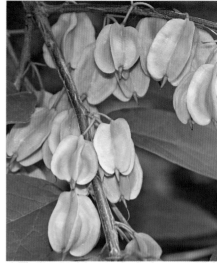

▲ *The 1½- to 2-inch four-winged seed pods mature in fall, dry to a reddish-brown, and remain on the tree into winter.*

▶ *In late April, Carolina silverbells that once grew in front of Dene Rock would burst into bloom, providing a fine view for visitors who climbed to the Summerhouse.*

▼ *Clusters of yellow, pollen-bearing anthers hang like clappers inside each pendulous Carolina silverbell blossom.*

◀ *The alternate, very finely toothed leaves are from 3 to 6 inches long. Medium green above, they are lighter green and somewhat hairy beneath; in fall, they are brown.*

▶ *The four-petalled, ¼- to 1-inch flowers hang from stems in clusters of four or five. The opening petals are greenish or suffused with pink but mature to white.*

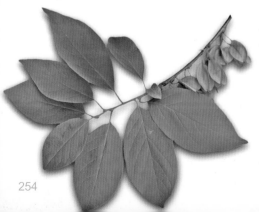

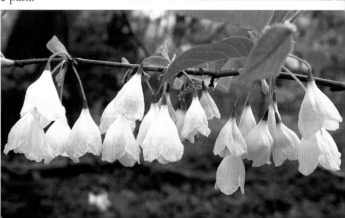

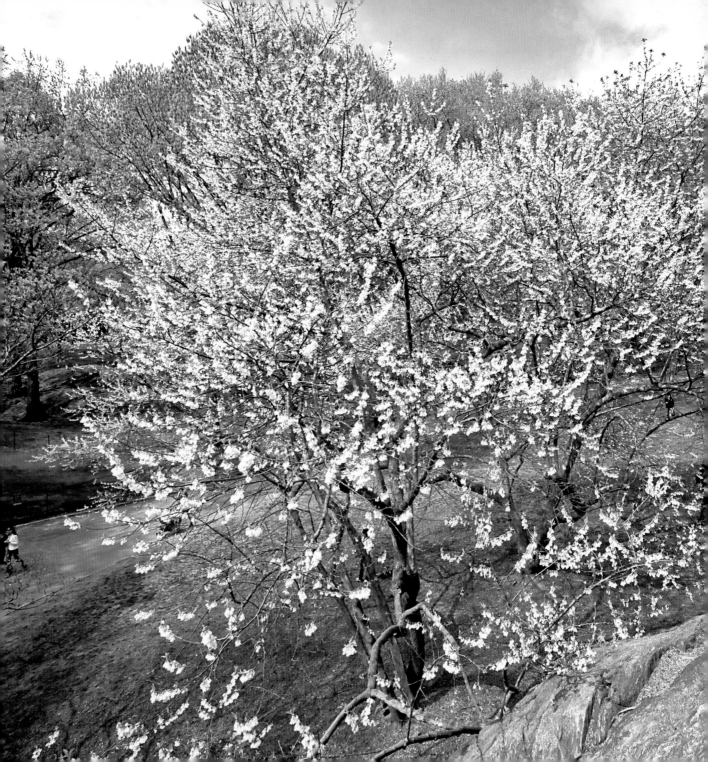

Witchhazel *Hamamelis* spp.

The witchhazel is a shrub or small tree with eccentric habits. It flowers as early as mid-October or as late as early December when most other trees have released their seeds.

Its spidery little blossoms are unusual, too, each with four very thin, yellow, crumpled petals. But its green, twin-beaked seed capsules are the witchhazel's oddest feature. They remain on twigs for a year and then fire their seeds like corks from champagne bottles for 25 or 30 feet.

The "witch" in witchhazel is derived from the Old English word *wice*, meaning "flexible" or "bendable." Early English settlers associated the witchhazel's springy twigs with pliant hazel twigs used in England for divining, and there are still "water diviners" in Appalachia and the Ozarks who claim to be able to locate water in the ground with forked witchhazel branches.

An anti-inflammatory extract used in lotions for shaving and for treating bruises, insect bites, acne, and hemorrhoids is prepared from the witchhazel's young twigs and roots.

The genus *Hamamelis* includes five species: three North American, one Chinese, and one Japanese. The North American witchhazels bloom in fall, winter, or spring; the Asian, only in spring. The most common witchhazel in Central Park is *Hamamelis virginiana*, a species native to eastern North America from Nova Scotia to Florida. Present in the North Woods, the Ramble, and several other places around the park, this shrub flowers in fall usually before all its leaves have dropped, so its small yellow blossoms are easily overlooked. Another North American witchhazel, *Hamamelis vernalis*, a spring-flowering species, as its name *vernalis* suggests, grows in the Ravine on a steep slope overlooking a Loch cascade. Perhaps the park's most flamboyant spring-flowering witchhazel is the *Hamamelis* × *intermedia* located by the Cedar Hill path near the East Drive. The beautiful red-tinged orange flowers of this hardy hybrid, a cross between the Japanese and Chinese witchhazel species, appear in late February before almost any other plant in the park has flowered.

With the blooming of this bush, Nature says, "Positively the last." It is a kind of birth in death, of spring in fall, that impresses me as a little uncanny. All the trees and shrubs form their flower-buds in fall, and keep the secret until spring. How comes the witch-hazel to be the one exception?

John Burroughs
Winter Sunshine

▲ Hamamelis virginiana *flowers appear in November when the shrub's leaves are beginning to turn yellow and seed pods from the previous year are about to release their seeds.*

▶ *A blooming* Hamamelis virginiana *in the Ramble still has most of its leaves in mid-November, so its small flowers, each with four thin petals, are hard to see.*

▼ *Blooming* Hamamelis × intermedia *bushes at the top of the Cedar Hill path attract attention in February.*

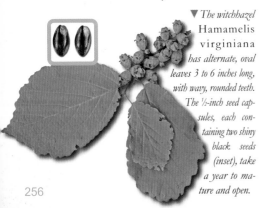

▼ *The witchhazel* Hamamelis virginiana *has alternate, oval leaves 3 to 6 inches long, with wavy, rounded teeth. The ½-inch seed capsules, each containing two shiny black seeds (inset), take a year to mature and open.*

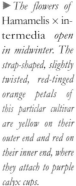

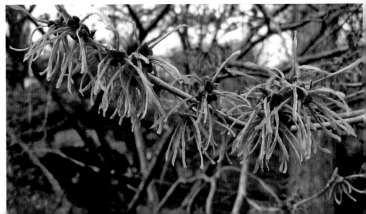

▶ *The flowers of* Hamamelis × intermedia *open in midwinter. The strap-shaped, slightly twisted, red-tinged orange petals of this particlar cultivar are yellow on their outer end and red on their inner end, where they attach to purple calyx cups.*

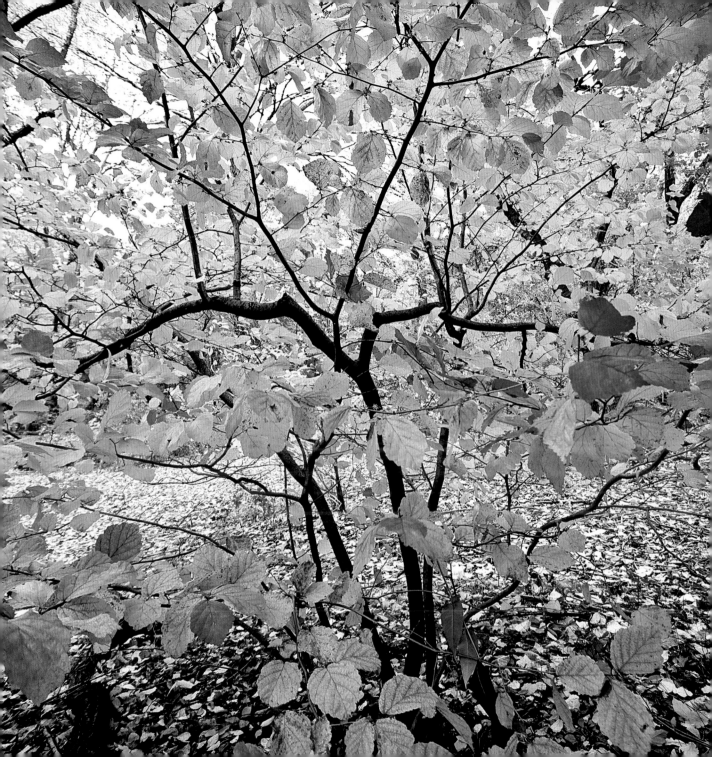

American Holly *Ilex opaca.*

The holly, with its red berries and waxy green leaves, which stay on the tree all winter when most other broadleaf trees shed their leaves, has been a symbol of life's persistence and rebirth for millennia. Wreaths of European holly with shiny leaves were worn by the Romans during their December Saturnalia festival, and holly sprigs adorned Celtic druids' hair during winter solstice ceremonies.

This commemorative stamp reproduces a 19th-century Christmas card design by Louis Prang, with a cherub, a bell, and holly leaves and berries.

After 350, as Christians began to celebrate Christ's birth on December 25, holly wreaths and garlands became Christmas icons. The holly's prickly leaves were associated with Jesus's crown of thorns and its berries with his blood.

When colonists arrived on the East Coast, they were surely comforted by encountering stands of American holly, which resemble the holly trees they knew, though these New World hollies have duller leaves than their Old World cousins. American holly trees in the wild hug the coast from Massachusetts to Delaware and then extend south to Florida and west to Texas.

In 1980, there were only two American hollies in Central Park. One was in the Olmsted Flower Bed at the Mall's southern end; the other stood near the park's exit to Central Park South at Sixth Avenue. During the past 30 years, however, American hollies have been introduced to several newly restored areas, including the Ramble, the East Drive near the Reservoir, and Strawberry Fields. A particularly noteworthy group of hollies borders the path along the eastern side of Strawberry Fields, and a striking conical female tree around 30 feet tall stands near the center of the Strawberry Fields meadow northeast of the Imagine mosaic commemorating John Lennon. By 2013, there were about 140 holly trees spread around the park.

Of the 29 species of North American hollies, American holly is one of the few tree-size hollies to keep its leaves through the winter. The red fruits also persist into the cold months and provide food for birds. Heavy, hard, and close grained, American holly wood is among the whitest woods known, but it is often dyed black to resemble ebony and used for piano keys.

▲ Holly bark is smooth and gray on younger trees but may become shallowly ridged and warty on older specimens. The larger trunk (right) of this old American holly, located north of Artists' Gate on Central Park South, has been deeply grooved by carved initials.

▶ This fine female American holly located north of the Imagine mosaic in Strawberry Fields exhibits the full bushy habit of a specimen growing in full sunlight.

▼ Female American holly flowers have a central sticky green knob, which is an immature ovary. The ovary is fertilized when it captures pollen adhering to an insect that has visited a male holly flower on a nearby tree.

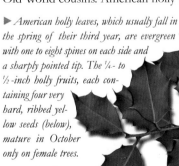

▶ American holly leaves, which usually fall in the spring of their third year, are evergreen with one to eight spines on each side and a sharply pointed tip. The ¼- to ½-inch holly fruits, each containing four very hard, ribbed yellow seeds (below), mature in October only on female trees.

▼ Pollen flowers appear on male holly trees when female flowers develop on female trees. Pollen from yellow-tipped stamens on male flowers is carried by insects to female flowers.

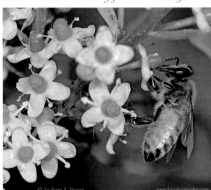

APPLES

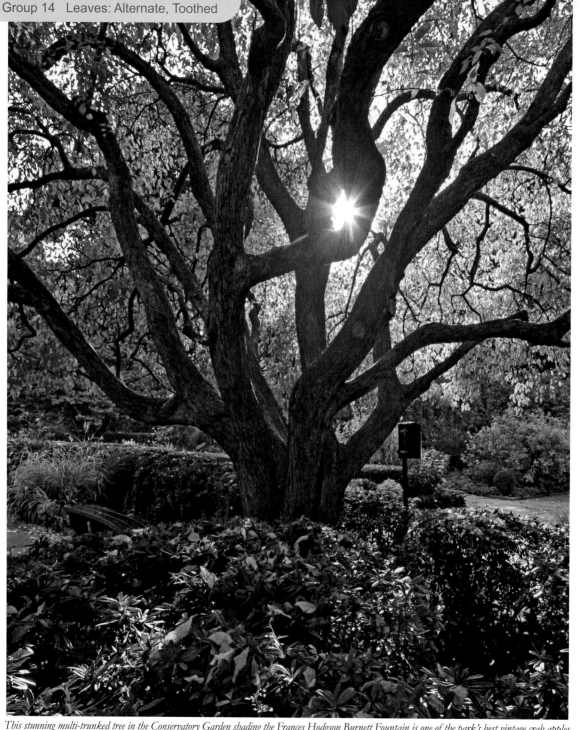

This stunning multi-trunked tree in the Conservatory Garden shading the Frances Hodgson Burnett Fountain is one of the park's best vintage crab apples.

Humans have spent hundreds, if not thousands, of years engaged in the apple's domestication, yet in its true genetic temperament the species is as variable as we are.

Fiona Watt,
"Painting with
Crabapples"

Malus fruits range in size from ¼ inch to almost 4 inches in diameter.

The genus *Malus*, apple, in the rose family, consists of around 55 species and thousands of cultivars and hybrids. Apples are small, deciduous, spring-blossoming trees that bear fruits of varying size in fall. In the wild, apples reproduce from seeds, but each seedling is very different from its parent. Whether a tree is called an apple tree or a crab apple tree depends entirely on the size of its fruit. An apple tree's fruits are 2 inches or more in diameter; a crab apple tree's fruits are less than 2 inches in diameter.

Domestic apple trees, commonly classified as *Malus domestica,* are descended from a wild apple species, *Malus sieversii*, native to the mountains of Kazakhstan. Because apple seeds tend to be genetically diverse, most commercial apple and ornamental crab apple varieties are clones reproduced by grafting or rooted cuttings. All apples are edible, but their seeds are mildly toxic.

Central Park contains an outstanding collection of about 400 individual crab apple trees and at least five apple trees. Many of the crab apples are vintage low-branching, multi-stemmed trees usually wider than they are tall, planted when Robert Moses was parks commissioner.

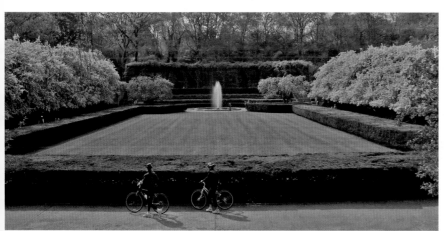

The central lawn of the Conservatory Garden is enclosed by clipped yew hedges and flanked by two treasures of Central Park, a pair of spectacular allées of vintage, low-branching crab apple trees. This section of the park was transformed in the 1930s when Robert Moses razed a decrepit conservatory and replaced it with a three-part formal garden.

The flower buds of Malus floribunda, *the Japanese flowering crab apple, range in color from deep pink to vivid carmine. The five-petalled flowers are white or pale pink.*

Common Apple *Malus domestica*

Perhaps no other fruit is so deeply embedded in myth as the apple. As his health declined during the last weeks of his life, Henry David Thoreau wrote in his essay "Wild Apples": "The apple-tree has been celebrated by the Hebrews, Greeks, Romans, and Scandinavians. Some have thought that the first human pair were tempted by its fruit. Goddesses are fabled to have contended for it, dragons were set to watch it, and heroes were employed to pluck it."

In Lucas Cranach's painting *Adam and Eve* (1526), set in the Garden of Eden, Eve grasps a branch of the Tree of Knowledge as she hands a somewhat bewildered Adam an apple. A serpent symbolizing evil hangs from a branch above them. Surrounding the pair are a menagerie of other animals.

The common apple tree originated in the rugged mountain forests of the Tian Shan Range separating Kazakhstan from China. There the apple's wild ancestor, *Malus sieversii*, still grows, filling the air in fall with the pungent odor of ripening fruit. In some areas within now-fragmented Kazakh forests, multi-trunked apple trees predominate, attaining heights of up to 60 feet and showering the grassy forest floor with an amazing panoply of fruits—some sweet, some sour, some as small as marbles, some as big as plums, some green, some red, some russet. Nowhere else do wild apple forests exist, but they are rapidly shrinking as shopping centers and condominiums spring up and remaining open areas are planted with domestic apples.

Kazakhstan lies on the Silk Road. Early traders passing through carried wild apples east and west. As early as 3800 years ago, the technique of grafting was developed in Mesopotamia whereby a desirable wild apple variety could be propagated by notching cuttings into the rootstocks of other apple trees. This technique spread through Persia and on to the Greeks and Romans. The Chinese may have also discovered grafting on their own because by the second millennium, they were developing apple cultivars. After nearly 4000 years of cultivation, the domestic apple has diversified into some 7500 varieties and is found in temperate zones throughout the world. The first apple orchard in North America was established in the Massachusetts Bay Colony in 1625. About 2500 apple varieties are now cultivated in the United States, but only about 100 are widely available.

Just seven apple trees grow in the park. One stands across the East Drive from the Metropolitan Museum of Art. Its flowers are pink, and its fruits have pink-tinged flesh.

▲ *The apple tree adjacent to the statue of Alexander Hamilton produces tart-tasting shiny red, green, and russet fruits in late August and early September.*

▶ *A pair of apple trees that once stood across the East Drive from the Metropolitan Museum of Art are shown blossoming here, but now only one remains.*

▼ *The apple tree behind the Metropolitan Museum bears carmine buds and pink flowers in April, just as leaves are unfolding. Honeybees and bumblebees pollinate them.*

▼ *The alternate, elliptical deciduous leaves of the common apple are 3 to almost 5 inches long and up to 3 inches wide. Edged with very small, sharp teeth, they are usually dark green above and paler green below.*

▼ *Apple fruits vary from just over 2 to well over 4 inches wide. Apple flesh ranges in color from white to green to orange to pink to beet red. Five carpels at the center of a fruit each contain one to three toxic seeds.*

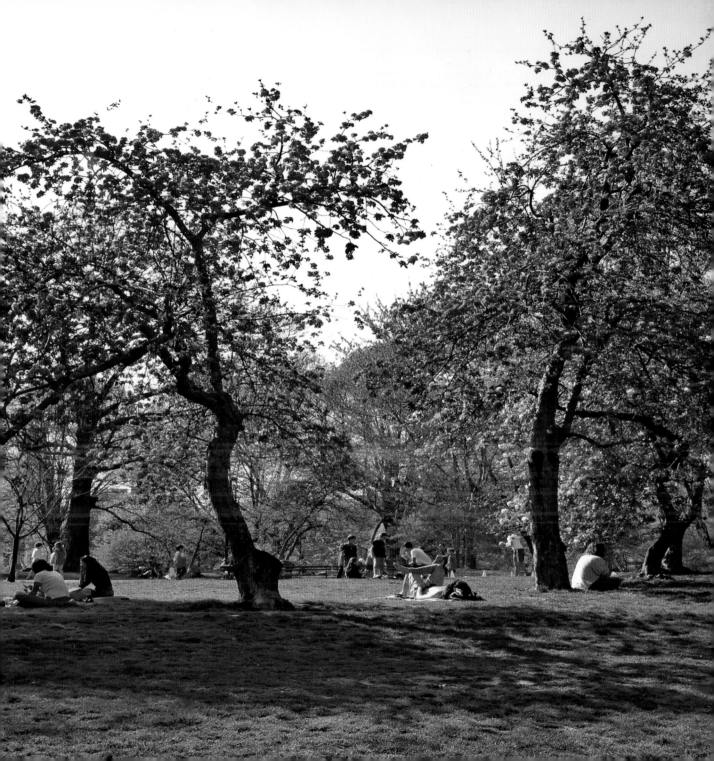

Crab Apple *Malus* spp.

In the Northeast, crab apples produce a profusion of spring blossoms. Over 800 cultivars exist, and new varieties appear every year. The colors of crab apple flowers range from white, yellow, and orange through shades of pink to crimson.

The majority of crab apples in North America are descended from Asian or European species. One of the most widespread foreign species is the Japanese flowering crab apple (*Malus floribunda*), introduced in 1862. Around mid- to late April, its scarlet buds open, unfolding white or pinkish flowers. Among native crab apples, the sweet crab apple (*M. coronaria*) produces showy pink-tinged white flowers.

Crab apples have been widely planted in New York City parks. Diseases such as scab and fireblight have taken a toll, but newer resistant varieties are available.

As Fiona Watt, former chief forester for the New York City Department of Parks & Recreation, writes in "Painting with Crabapples," "The story of the crabapple and the apple in America is the story of the transcendence of sobriety over sustenance, ornament over utility, and beauty over taste." Apple trees were once spread widely, appearing wherever Europeans settlers stopped. Most trees bore fruits too sour for eating but good for cider.

Michael Pollan, in *The Botany of Desire*, debunks the myth of Johnny Appleseed (1774–1845) as an apostle of healthful apple trees. "The reason people in Brilliant wanted John Chapman to stay and plant a nursery," Pollan wrote, "was the same reason he would soon be welcome in every cabin in Ohio: Johnny Appleseed was bringing the gift of alcohol to the frontier." By the mid-19th century, cider orchards were declining as the temperance movement spread, but late in the century crab apples were becoming popular as growing affluence and suburban expansion generated demand for ornamental trees. The early 20th century saw an increase in new crab apple varieties.

The 1930s were a golden age in the city for "vintage" crab apples with low-spreading, twisted branches. Many were planted in the five boroughs, but the most magnificent grouping was established in the Conservatory Garden.

An engraving from François Michaux's *The North American Sylva* pictures leaves, flowers, and fruits of the native sweet crab apple. Michaux remarked of its flowers that "they produce a beautiful effect, and diffuse a delicious odour, by which, in the Glades where the tree is abundant, the air is perfumed to a great distance."

▲ Two varieties of flowering crab apples stand side by side shading blooming daffodils on the West Drive near 93rd Street. A more beautiful juxtaposition would be hard to find.

▶ The magnificent crab apple allées of the Conservatory Garden, first planted in 1937, were trained early in their lives to achieve their gnarled silhouettes. The white-blossoming trees on the right are Japanese flowering crab apples; the pink-blossoming trees on the left are an unknown variety but probably some sort of Asian hybrid.

▼ The crab apple has flowers with five petals and stamens with a yellow tip, like many members of the rose family. The flowers bloom before the leaves are fully unfolded.

◀ Crab apple fruits are often about ½ inch in diameter. Much favored by birds, they can be quite sour. However, when they hang on a tree for a time and become a bit overripe, they can taste sweeter, almost like tart apple sauce. The alternate, very finely toothed leaves are typically about 3 inches long and 1¼ inches wide.

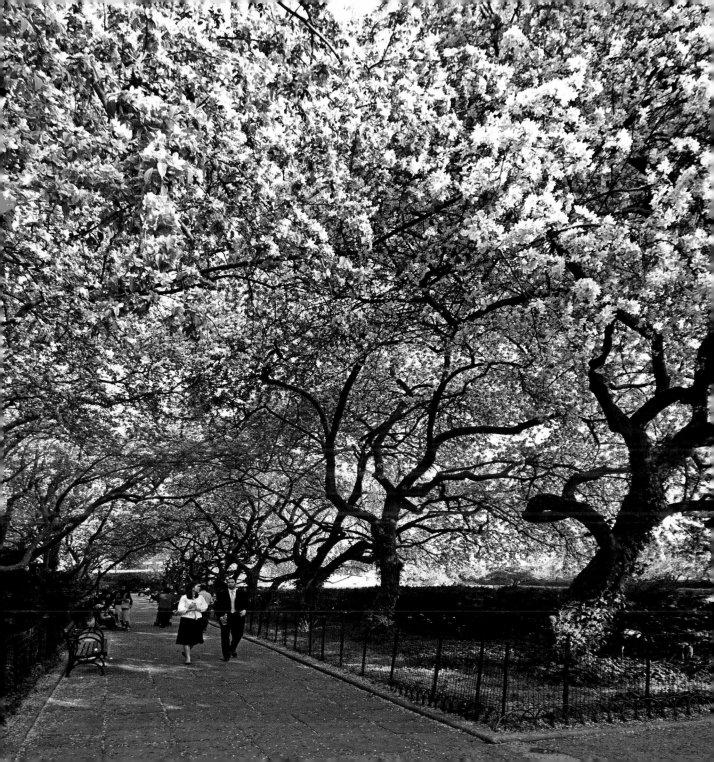

Eastern Cottonwood

Populus deltoides

The Eastern cottonwood is the fastest-growing native tree. In well-watered soil, a cottonwood may grow annually 5 or more feet in height and increase over 1 inch in diameter, ultimately developing a massive trunk and towering over 100 feet. It is a short-lived tree, however. At 75 years it is old, and its heartwood may already be eaten away by decay, providing shelter for wildlife.

This hand-colored engraving of cottonwood leaves is from François Michaux's *The North American Sylva.* The book was based on trips that the author and his father, André, took through the eastern United States in the 1790s.

The Eastern cottonwood is not as prominent in the Northeast as it is in the Midwest and the prairie states, where it often lines stream banks. Its wood is soft and brittle, but pioneers valued the tree nonetheless because it offered shade from the blistering sun in otherwise treeless grasslands and was often the only tree available for lumbering.

Like other poplars, the Eastern cottonwood produces elongated flower clusters, or catkins, in early spring. The reddish male pollen-bearing catkins are borne only on male trees. The female catkins, likewise, are borne only on female trees. Reddish at first, they turn green as they mature and split open to release silky-haired seeds, from which the tree gets its common name. The seeds may sail through the air for hundreds of feet and land in water, since cottonwoods tend to grow along rivers and streams. Floating on their cottony threads, the seeds travel downstream, eventually germinating on mud banks as spring floods recede.

French botanist François Michaux (1770–1855) described the Eastern cottonwood in his three-volume treatise *The North American Sylva*: "I have found this tree in the upper part of the State of New York, on the banks of the river Genesee which empties into Lake Ontario...in some parts of Virginia, and on several islands of the Ohio. I have everywhere seen it on the margin of rivers...exposed to inundation at their overflowing in spring."

In the mid-1980s, over 100 cottonwoods in the park died from a fungal disease that did especially well during several very dry years. A single male tree on the southern side of the 96th Street transverse near the Tennis Center was, until it was cut down, the only one remaining out of a stand of six. In early spring, remnants of male catkins dropped off this tree like snow before the leaves unfolded. As of 2013, there were around a dozen Eastern cottonwoods in the park.

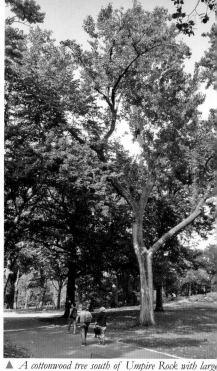

▲ *A cottonwood tree south of Umpire Rock with large ascending limbs is about 70 feet tall. Its leaves are out of reach, but its deeply furrowed bark is a clue to its identity.*

▶ *A cottonwood bends over the park entrance at 59th Street opposite the Ritz-Carlton Central Park Hotel. Leaves that the tree drops on the entrance steps offer a clue to its identity.*

▼ *When female cottonwood fruits mature, they split open and release their seeds. Each capsule contains 30 to 60 seeds 1/10 inch long wreathed in fluff (inset).*

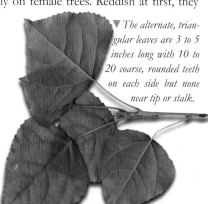

▼ *The alternate, triangular leaves are 3 to 5 inches long with 10 to 20 coarse, rounded teeth on each side but none near tip or stalk.*

▶ *The developing female fruit capsules of the Eastern cottonwood hang on 6- to 12-inch catkins, each with 20 or more capsules.*

▼ *Reddish 3- to 5-inch male flowers are more conspicuous than female flowers when they first appear, but they quickly fade to dark purple (below), shrink to 1 inch or 2 inches, and drop off the tree.*

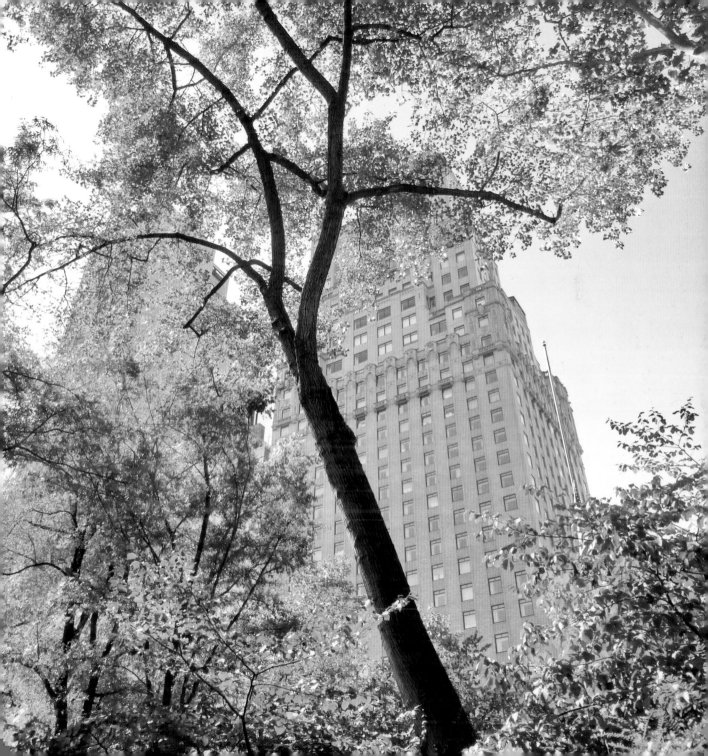

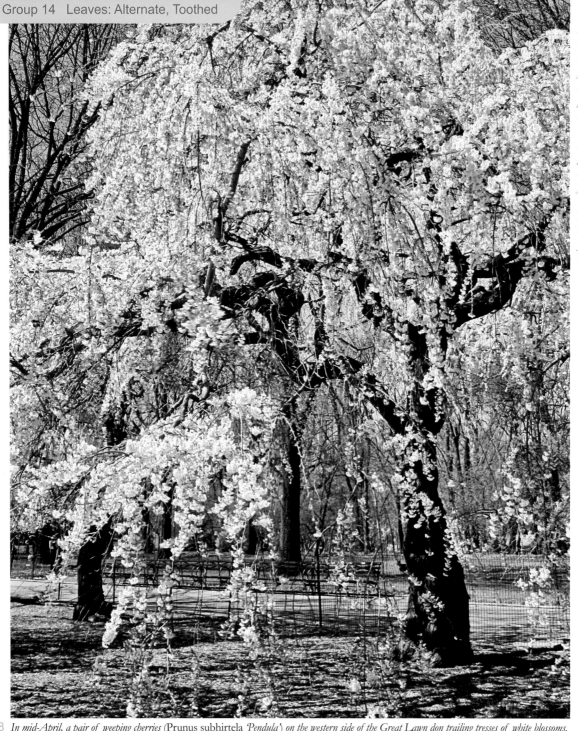

CHERRIES

At the cherry-blossom season especially his inborn passion for flowers and landscapes shows itself in prince, poet, peasant, merchant and coolie. Tattered beggars gaze entranced the fairy trees, and princes and ministers of state go to visit the famous groves.

Eliza Ruhamah Scidmore, *Jinrikisha Days in Japan*

The Japanese kanji symbol for cherry blossom

In mid-April, a pair of weeping cherries (Prunus subhirtela 'Pendula') on the western side of the Great Lawn don trailing tresses of white blossoms.

The genus *Prunus* consists of more than 400 species, including cherries, peaches, nectarines, plums, and almonds. Most cherries have bark with corky horizontal lines called lenticels. Several cherry species, such as *Prunus avium*, are widely cultivated for their tasty fruits. Some wild cherries, such as the black cherry (*Prunus serotina*), produce small fruits with stony seeds that appeal to only birds and other wildlife. Almost all of Central Park's more than 5000 black cherries have sprung up from seeds eaten and excreted by birds. Despite their status as weed trees, black cherries bear attractive clusters of creamy-white flowers in spring.

Japanese flowering cherries, known as *sakura*, were not among the park's original plantings. They first arrived in the park in 1912, as part of a shipment of flowering cherries sent by the mayor of Tokyo to Washington, D.C., and New York City.

Like black cherries, Japanese flowering cherries bear small inedible fruits, but they have been cultivated for centuries in Japan for their lovely blossoms. Yoshino and Kwanzan cherries were the most numerous trees in the shipment, and they remain the park's most common flowering cherries.

Among the park's earliest trees to flower, the little cherry 'Okame' (inset) at the southeastern edge of the Great Lawn displays its carmine-pink blossoms in mid-March.

Native to southern Europe, North Africa, and the Middle East, the St. Lucie cherry in the Shakespeare Garden displays its fragrant white flowers in late April or early May.

A hand-colored photograph taken by Eliza Ruhamah Scidmore (inset) during one of her trips to Japan, probably in the 1880s, shows a large, multi-trunked cherry.

Black Cherry *Prunus serotina*

The black cherry is the most common tree in Central Park. More than 3800 black cherries were counted in the park as of 2013, and this figure does not include thousands of saplings and smaller trees. Not a single black cherry has been intentionally planted in the past 28 years; every one has self-seeded. Birds relish the fruit and spread the seeds in their droppings far and wide.

A drawing by John James Audubon, from about 1808, depicts a wood thrush perched on a fruiting black cherry branch. It was one of several drawings that Audubon sold in 1824 to Edward Harris, a financial benefactor.

The black cherry is the first tree to populate a lawn when mowing stops. Intolerant of shade, it needs full sun to get established. Through the years, the park's gardeners have removed thousands of black cherries 6 inches or less in diameter, and yet the tree has increased in number. If left alone, it would take over many areas of the park.

A mature black cherry is usually a medium-size tree in the city, with an irregular crown of twisting branches, but it can grow more than 100 feet tall in the wild and is much sought after for its hard, reddish-brown wood, which is ideal for fine furniture.

In April or May, shortly after its leaves unfold, the black cherry produces a profusion of fragrant, drooping clusters of white flowers that attract nectar- and pollen-eating insects that, in turn, attract warblers, flycatchers, and other insectivorous birds. In addition, a variety of caterpillars feed on black cherry leaves, providing yet more food for birds. By late summer, when black cherry fruits are fully mature, having ripened from green to dark reddish-black, starlings, robins, and thrushes flit around in the foliage gulping down these small, bittersweet cherries. This tree, more than any other single species, provides food for both resident and migrating birds. Perhaps it is the presence of hundreds of black cherry trees in the Ramble that makes the area such an exceptional place for birding.

That the black cherry is so ubiquitous in Central Park, then, has a lot to do with the park's substantial population of birds. Other reasons for its success in the park are that there are no damaging fires or floods and no large herbivores such as deer to eat its foliage, saplings, and root sprouts. The black cherry is ideally suited to urban-park conditions.

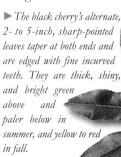

▶ *The black cherry's alternate, 2- to 5-inch, sharp-pointed leaves taper at both ends and are edged with fine incurved teeth. They are thick, shiny, and bright green above and paler below in summer, and yellow to red in fall.*

▶ *The pea-size fruits of the black cherry ripen over the summer, turning from green to dark reddish-black. Bittersweet in taste, these small wild cherries are used to make wine and jelly.*

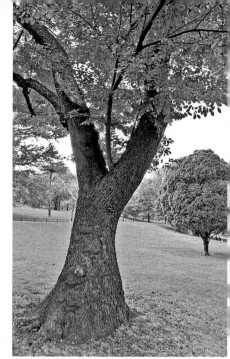

▲ *A large black cherry stands on the hillside south of the Conservatory Water. Likely more than 100 years old, it is one of the park's very few ancient black cherries.*

▶ *Black cherries north of the Reservoir catch October's late-afternoon sun. Though they seldom stand out as fine specimen trees, black cherries still contribute to autumn's beauty.*

▼ *Drooping 4- to 6-inch clusters of white, five-petalled flowers with a yellow center (inset) and up to 20 stamens blanket black cherry trees in mid- and late May.*

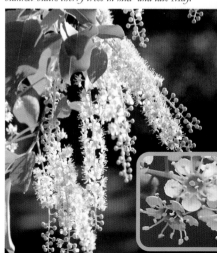

Kwanzan Cherry *Prunus serrulata* 'Sekiyama'

One of the great seasonal spectacles in Central Park is the flowering of the Kwanzan cherries on the western side of the Reservoir. A walk in late April or early May on the wood-chip path beneath bowed Kwanzan branches laden with many-petalled pink flowers is an almost spiritual experience.

Eliza Ruhamah Scidmore described the great anticipation with which the Japanese look forward to the flowering of their beloved cherry trees in her book *Jinrikisha Days in Japan*: "The veriest Gradgrind could not be indifferent to the poetic charm of the Japanese spring-

A mayor of Tokyo, Yukio Ozaki (1858–1954), was responsible for sending 6000 cherry saplings to the United States in 1912 as a gift of friendship. The shipment included 1800 Yoshinos and several hundred Kwanzans.

time, wherein the setting of the buds, their swelling, and the gradual unfolding of *sakura*, the cherry blossoms, are matters of great public concern, the native newspapers daily printing advance despatches from the trees. Even more beautiful than the plum-tree festival is the Tokio [*sic*] celebration of the blossoming of the cherry, and gayer than the brilliant throngs are the marvelous trees. From the wild, indigenous dwarf seedling of the moun-

tains have been developed countless varieties, culminating in that which bears the pink-tinged double blossoms as large as a hundred-leafed rose, covering every branch and twig with thick rosettes. A faint fragrance arises from these sheets of bloom, but the strange glare of pinkish light from their fair canopy dazzles and dizzies the beholder."

The Kwanzan cherry is a variation of *Prunus serrulata*, a wild Japanese cherry species. The ancestral tree likely came from a mountainous area, but which one is unclear. According to W. J. Bean, former curator of the Royal Botanic Gardens, "'Kanzan' (usually spelt 'Kwanzan' in the USA) and 'Sekiyama' are two renderings of the ideogram for a Chinese mountain sacred to Buddhists, the first being for the Chinese name as pronounced in Japan, the second its name in the Japanese language." References to 'Sekiyama' appeared in a Japanese tree catalog published in 1681, so the variety is over 300 years old.

Today, the Kwanzan cherry is common around Tokyo. Since 1912, when it was sent to Washington, D.C., and New York City, it has become the most popular cherry tree in America. It is reproduced from cuttings sometimes grafted onto *Prunus avium* stock. As of 2013, there were around 175 Kwanzan cherries in Central Park.

▲ *Most noticeable during winter, Kwanzan cherry trunks are dark gray with bands of rough, corky horizontal lenticels interspersed with smoother and somewhat shiny areas.*

▶ *Arching over a wood-chip path below the jogging track on the Reservoir's western side, blooming Kwanzan cherry trees provide strollers with dramatically framed views of historic Central Park West apartment buildings, such as the neoclassical, twin-towered San Remo.*

▼ *Kwanzan blossoms develop just as bronze-tinted leaves are beginning to unfold. At first budding, boughs assume a rusty-reddish hue, but as the blossoms fully unfold, the Kwanzan's crowns are transformed into clouds of pink.*

▼ *The Kwanzan cherry's alternate, oval leaf is 4 to 8 inches long and 2 to 4 inches wide. Edged with minute, sharp teeth from its stem to its elongated, sharply tapered tip, it has a central main vein with around 10 curving, parallel secondary veins.*

▶ *The sumptuous pink, 30-petalled flowers of the Kwanzan cherry hang in clusters of two to five blossoms in late April and early May.*

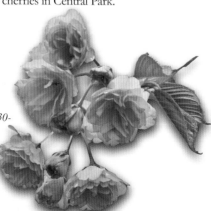

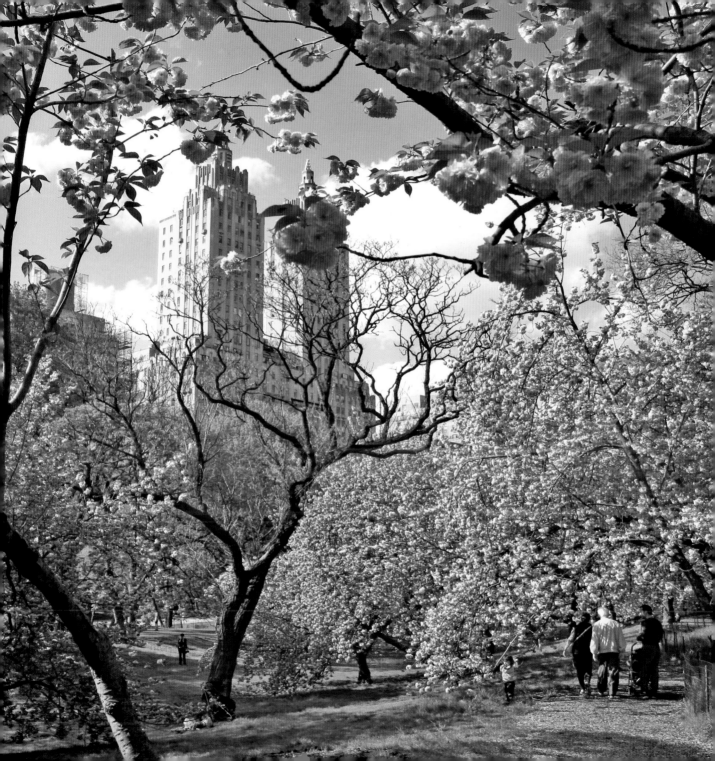

Yoshino Cherry *Prunus × yedoensis*

The Yoshino cherry is fast growing and begins flowering six or eight years after it is planted. Its light-pinkish to white flowers appear before its leaves unfurl. Likely a hybrid between the white-flowered Oshima cherry and a weeping variety of Higan cherry, the Yoshino cherry sets only a few seeds and is propagated largely by grafting.

A detail of a woodcut print by the great ukiyo-e artist Hiroshige Andō (1797–1858), titled *Evening Glow at Koganei Bridge*, pictures what could be Yoshino cherry trees growing by a canal with Mount Fuji in the background. Mount Fuji and the Yoshino cherry's flower are two of Japan's most cherished icons.

Over 30 Yoshino cherries stand along the eastern edge of the Reservoir. The thick, dark, lumpy trunks of a dozen or so of these Yoshinos suggest that they are survivors from a shipment of Japanese cherries sent from Tokyo in 1912. One hundred years, however, is an unusually long time for a Yoshino to live. It is much more likely that most of the older Reservoir Yoshinos were planted in the mid-20th century and that only a very few of them, if any, date from 1912.

The person most responsible for the gift of cherry trees was Eliza Ruhamah Scidmore, a travel writer and photographer with a keen interest in the Far East. Her efforts, beginning in 1885, to bring Japanese cherries to America met with little success. Finally in 1909, she wrote to Helen Taft, wife of President William Howard Taft, outlining her plan to bring Japanese cherries to Washington, D.C. Like Scidmore, Helen Taft had lived in Japan and was familiar with the country's extraordinary flowering cherries. Immediately, arrangements were made for 2000 cherry trees to be sent by the city of Tokyo to Washington.

Unfortunately, this shipment of cherries, which arrived in 1910, was infested with insects and had to be burned. A second, larger shipment of 6000 trees was sent from Tokyo in 1912, this time free of insects. About half of these trees went to Washington and the other half to New York City. A large proportion of the trees were Yoshinos; second most numerous were Kwanzans. Probably many of the more than 115 Yoshinos in Central Park as of 2013 are descended from the trees sent in 1912.

In addition to the Yoshinos along the edge of the Reservoir, many more—mostly younger specimens—are spread throughout the park. Although Yoshinos produce relatively few viable seeds, birds that eat their fruits are helping Yoshinos to self-seed and become naturalized in the park.

▼ *The Yoshino cherry's alternate, oval 2½- to 4-inch leaf is dark green above with downy veins below. Edged with minute, sharp teeth from stem to tapered tip, it has a central main vein with around 12 curving, parallel secondary veins.*

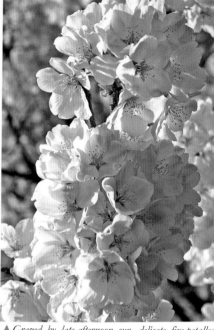

▲ *Grazed by late-afternoon sun, delicate five-petalled Yoshino cherry blossoms glow a dazzling white tinged with pink. The park's Yoshinos are a variety known as Somei Yoshino, named for the village of Somei, now part of Tokyo.*

▶ *The stunning, ethereal beauty of blossoming Yoshino cherries is due in large part to the translucence of their fragile pinkish-white flowers as they are backlighted against the sky without budding leaves to interrupt the sun's rays.*

▼ *The older Yoshino cherries standing along the eastern side of the Reservoir are among the most loved arboreal treasures of Central Park. Part of their unique appeal lies in their arresting beauty not only during their brief spring flowering but also during fall (left) and winter (right).*

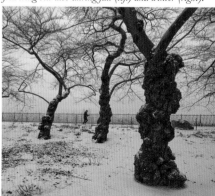

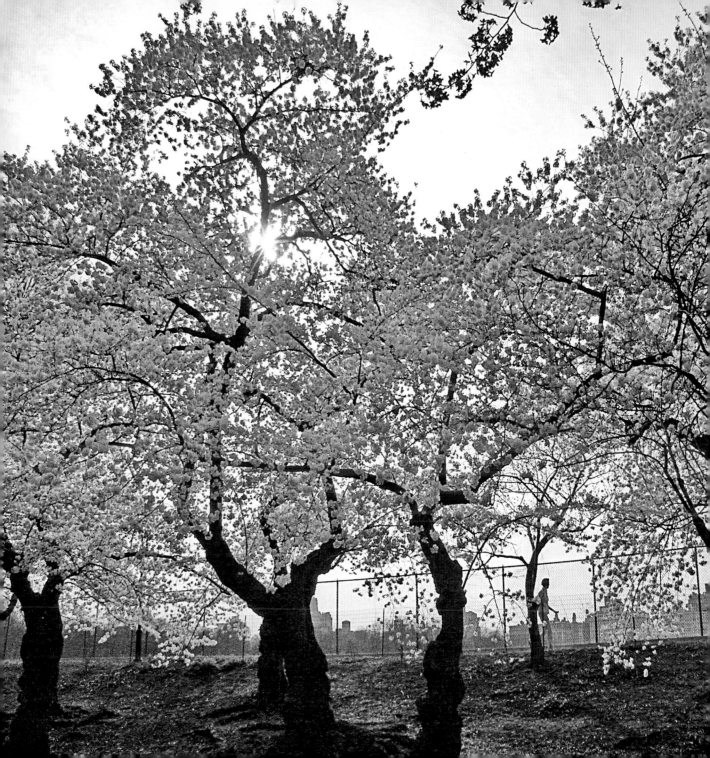

Callery Pear *Pyrus calleryana*

The Callery pear was named for a French Lazarist priest, Joseph Gaetan Pierre-Marie Callery, who collected the species in China in 1858 and introduced it to Europe. The Callery pear was not cultivated in the United the States until the early 20th century after Frank N. Meyer, a Dutch-born plant explorer employed by the Department of Agriculture, and Frank Reimer, a scientist at the Oregon Agricultural Experiment Station, brought home seeds from China's Hubei Province.

This photo shows Frank N. Meyer (1875–1918), a Department of Agriculture plant explorer, in 1909, on his second visit to China. During four expeditions to Asia, he spent years trekking over mountains and through deserts, forests, and farms, sending home more plants than had ever been collected by any other Western botanist.

A man with a deep interest in plants and the stamina to walk thousands of miles looking for them, Meyer led four expeditions to China. His purpose, in his own words, was "to skim the earth in search of things good for man." He was the first plant explorer to work for a government and hunt primarily for economically useful plants.

The Callery pears collected by Meyer and Reimer were used as rootstock for fruiting pears to create strains resistant to fireblight, a contagious bacterial disease capable of destroying an entire orchard in one season. In 1952, during the course of their research, Department of Agriculture plant scientists realized that one particularly hardy thornless cultivar had the potential to become an attractive ornamental tree when grafted onto an original Callery pear seedling. This clonal cultivar was named 'Bradford' in honor of Frederick C. Bradford, a horticulturist in charge of the Plant Introduction Station in Glenn Dale, Maryland, and was widely planted in cities after 1963.

The 'Bradford' pear is a handsome flowering tree with glossy green leaves that turn to deep scarlets and purples in fall. It is disease free and tolerant of air pollution, soil compaction, and salt runoff, but it has one disturbing flaw. As it grows older, its branches tend to break when strained by wind, ice, or snow, often splitting the trunk. Because of this problem, New York City no longer plants the 'Bradford' and prefers cultivars such as 'Aristocrat' and 'Redspire,' with positive traits similar to those of 'Bradford' but with better branching structures. The Callery pear is the second most common street tree in Manhattan. The park's Callery pear tree population numbeed around 30 in 2015.

▲ *Young Callery pear bark is smooth and light gray, but mature tree bark is dark gray, scaly, ridged, and furrowed.*

▲ *Leaves of the Callery pear turn to brilliant golds and intense reds, oranges, and purples in mid-November.*

▶ *A bit taller than typical Callery pears on streets surrounding Central Park, a trio of 35-foot-plus specimens borders the Loeb Boathouse Restaurant's entrance.*

▼ *Bathed by the warming sun of an April morning, blossoming Callery pears on Madison Avenue near 73rd Street herald spring's arrival. These tough trees thrive despite periodic droughts and a host of urban hazards.*

▼ *The Callery pear's alternate, oval, finely toothed leaves are 1½ to 3 inches long with a sharp point. The central main vein has angled, curving secondary veins. The shiny, dark-green leaves turn red, purple, and gold in fall.*

▼ *The hard ⅜-inch fruits ripen from green in spring to dark reddish-brown or black by winter, when they soften and are eaten by birds.*

▼ *Five-petalled ⅜- to ¾-inch pure-white flowers bloom prolifically in clusters of six to 12 in mid-April before the leaves emerge.*

Willow *Salix* spp.

The genus *Salix* consists of some 300 to 400 species of trees and shrubs, of which about 75 are native to North America. Willows are notoriously promiscuous, exceedingly fond of miscegenation. In short, they are very prolific hybridizers, and when they are encountered in the real world, they often resist being fitted into neat species cubbyholes. As W. J. Bean commented in his authoritative *Trees and Shrubs Hardy in the British Isles,* "In no class of plants do types merge into the other, and blur the dividing lines so completely as they do in *Salix.*" There are, however, certain characteristics common to many willow species and to the majority of willow hybrids. They usually grow well in damp places and look best next to water; their wood tends to be weak and soft, but their twigs are pliable and tough, ideal for basket making; they grow fast but are relatively short lived; they are messy with roots that clog drains and with twigs that are constantly dropping off; their male and female flowers often grow

A color plate from Dr. William Woodville's *Medical Botany* (1832) shows a white willow branch with leaves and three male catkins. A female catkin is also shown, along with details of a male flower with two stamens, a seed with silky hairs, a seed closeup, and two pistils with their stigmas.

on separate trees; and their leaves tend to be slender and pointed, though not always.

The willows of Central Park may be hard to identify specifically, but they are very easy to spot because of their frequent proximity to water; their graceful, often weeping, habits; and their narrow lance-like leaves.

A list of trees in Central Park in 1873 includes 11 willow species. Several are shrubs no longer in the park. Among listed willows still present are the black willow (*Salix nigra*); white willow (*S. alba*), which has numerous hybrid forms; and goat willow (*S. caprea*), a small tree with pussy willow–like blossoms.

The black willow is so named because the bark of this largest of native willows is dark gray and, on older trees, deeply furrowed. Some black willows on the southern shores of the Lake and the Harlem Meer exceed 60 feet in height. Their short trunks often support several thick, very long, steeply ascending limbs with branches and twigs that do not weep.

Weeping willows edging the Pool, the Lake near the Loeb Boathouse, and Turtle Pond are mostly hybrid forms of the white willow, a European tree with corky yellowish or reddish-brown bark and yellow branchlets. Weeping habits vary from only slightly pendant twig ends to masses of very long, flexible twigs hanging straight down.

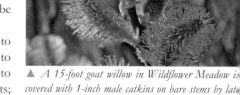

▲ *A 15-foot goat willow in Wildflower Meadow is covered with 1-inch male catkins on bare stems by late March, before most other trees have leafed out.*

▶ *Two large old black willows arch gracefully over the path on the Lake's southern shore west of Bow Bridge.*

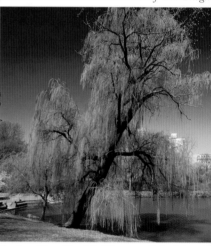

▲ *A weeping willow hybrid leans over the Lake's southern edge near the Boathouse in mid-April. Its pendulous twigs are studded with developing leaves and male catkins.*

▼ *By July, weeping willows near the Boathouse display tiers of swaying leafy curtains. The trees are fine examples of a white willow hybrid known as 'Golden Weeping Willow.'*

▼ *Weeping white willow hybrids have alternate, finely toothed, 3- to 5-inch, lance-shaped leaves (left), tapering gradually at both ends. Black willows have alternate, finely toothed, 3- to 6-inch, lance-shaped, leaves (right), usually tapering somewhat more abruptly at the stem end than at the tip.*

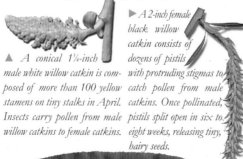

▲ *A conical 1¼-inch male white willow catkin is composed of more than 100 yellow stamens on tiny stalks in April. Insects carry pollen from male willow catkins to female catkins.*

▶ *A 2-inch female black willow catkin consists of dozens of pistils with protruding stigmas to catch pollen from male catkins. Once pollinated, pistils split open in six to eight weeks, releasing tiny, hairy seeds.*

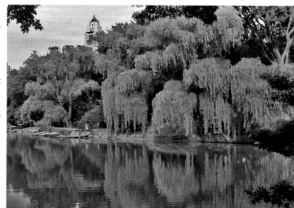

Linden *Tilia* spp.

Lindens, also known as lime trees in England, shade parks and avenues in many cities of Europe and America, perfuming the air in June with the sweet fragrance of thousands of light-yellow blossoms. There are more than 30 species of lindens spread around the world and dozens of hybrids.

A section of a fine carving by the great English wood sculptor Grinling Gibbons (1648–1721) displays the astonishingly fine detail that can be achieved with linden wood. Soft, white, fine grained, and crack resistant, linden wood has always been favored by carvers.

Five linden species planted in Cental Park over the years are the littleleaf linden (*Tilia cordata*), a native of Europe with leaves up to 3 inches long; bigleaf linden (*T. platyphyllos*), another European linden with leaves up to 5 inches long with hairy stems; European, or common, linden (*T. × europaea*), a hybrid of the littleleaf and bigleaf lindens with leaves ranging from 2¼ to 5 inches long; silver linden (*T. tomentosa*), a native of southeastern Europe and southwestern Asia with leaves up to 5 inches long that shimmer in a breeze because of the silvery sheen on their underside created by tiny hairs; and American linden (*T. americana*), or basswood, the only linden native to North America, with leaves up to 10 inches long, larger than those of any other linden species.

Perhaps the easiest of the park's lindens to identify are the silver linden because of its silvery leaf underside and the American linden because of its especially large leaves. The park's other three lindens can be harder to distinguish. The sizes of their leaves overlap, and they have similar growth habits and bark patterns. Also, lindens hybridize easily, with the hybrids displaying characteristics intermediate between those of their parents.

The littleleaf linden and the bigleaf linden, known in Britain as the small-leaved lime and the large-leaved lime, arrived on the British Isles some 8000 years ago after the Pleistocene glaciers had receded. Some of them in ancient woodlands have been repeatedly cut to the ground, or coppiced, for centuries. They now appear as circular, shrubby thickets and are called coppiced stools. The many stems of one of these stools are parts of a single organism. One coppiced stool more than 50 feet in diameter, located near Tetbury in Gloucestershire, has been determined by DNA testing to be over 2000 years old.

▼ *Littleleaf linden leaves are alternate, heart-shaped, 1 to 3 inches long, and toothed, with a sharply pointed tip. Green above, they are paler below, with hairs in vein axils.*

▼ *Silver linden leaves are alternate, oval, 2 to 5 inches long, and coarsely toothed, with a sharply pointed tip and an unequal base. Dark green above, they are light and hairy below.*

▲ *Tiny, round, rock-hard linden fruits hang on a long stem attached to a ribbon-like, yellow-green bract up to 4 inches long. The bract is a distinguishing feature of a linden.*

▲ *The leaves of Central Park's lindens usually turn from deep greens to bright yellows or rich honey-golds in fall. Thin and delicate, they do not cling long to their branches when they are riffled by autumn breezes but shower quickly to the ground.*

▶ *In the waning light of a fall afternoon, a fine pair of silver lindens stand amid circles of fallen leaves on the eastern edge of the Great Lawn. Planted a few years after the Croton Receiving Reservoir was dismantled in 1934, they had to be cut down and replaced in 2015.*

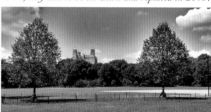

▲ *In time, these two young silver lindens, planted on the Great Lawn in 2015, will achieve the lovely, merging habit of the beloved linden pair (right) that stood here for nearly 80 years.*

▼ *Pale-yellow flowers up to ¼ inch wide hang beneath linden leaves in clusters of five to 11 in mid-June. Pollinated by bees and other insects, linden flowers produce a sweet scent that pervades the air throughout the park.*

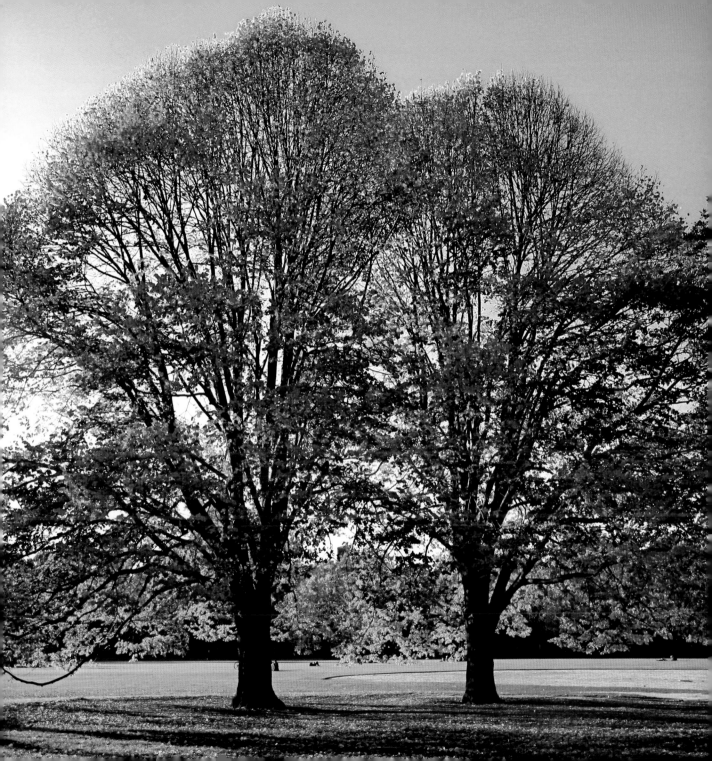

ELMS

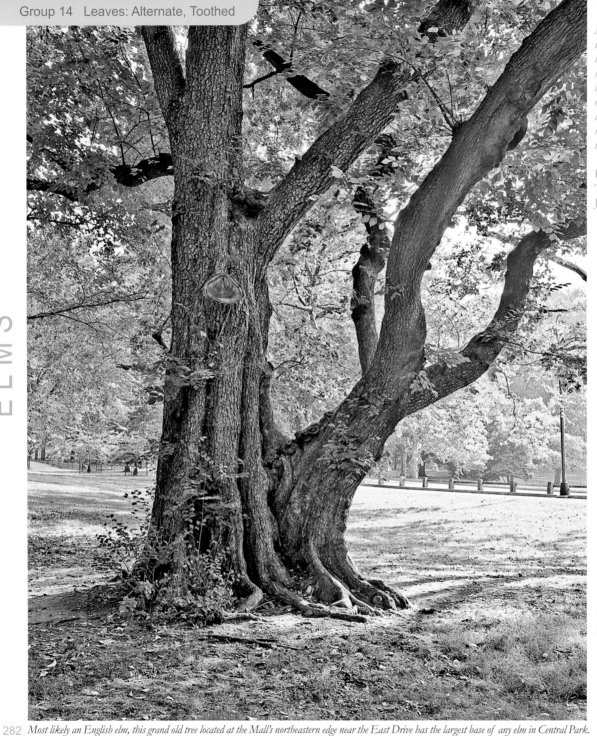

Many times I thought that if the particular tree, commonly an elm, under which I was walking or riding were the only one like it in the country, it would be worth a journey across the continent to see it.

Henry David Thoreau, *Journal,* January 18, 1859

An American elm's hair-fringed, ¼-inch samaras

282 *Most likely an English elm, this grand old tree located at the Mall's northeastern edge near the East Drive has the largest base of any elm in Central Park.*

The genus *Ulmus*, elm, in the family Ulmaceae, consists of some 30 to 40 species. The exact number of species is in question because elms easily hybridize. North America has eight species; Asia has the most, 23; Europe has around five. Some botanists have lumped certain forms of European elms together; other botanists have divided these forms into separate species.

All elm species bear alternate simple leaves, which are usually but not always asymmetrical at their base and doubly toothed. Elm flowers are small, lack petals, and are mostly wind pollinated. The fruits are thin, round or oval, winged samaras. Colored green by chlorophyll, fruits of many elms in temperate areas carry on photosynthesis in early spring before leaves emerge.

Elms have been cultivated for millennia by farmers for shade, fuel, windbreaks, hedgerows, timber, and animal fodder. Major urban trees, they have been planted along streets and in parks since the 14th century. Dutch elm disease has eliminated 50 to 100 million elms during the past 60 years, but Central Park fortunately still contains several hundred trees.

Unlike American elm samaras, European elm samaras, such as these ⅞-inch English elm samaras, have very shallow notches at their tip and lack fringing hairs (inset).

The Chinese elm blooms in late summer, unlike North American elms, which bloom in early spring before their leaves unfold. The Chinese elm's tiny flowers (inset) have hairy pistils.

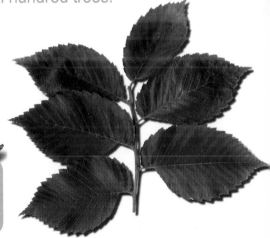

The alternate 3- to 6-inch leaves of the American elm have an unequal base, whereas the smaller leaves of Asian elms, such the Siberian and Chinese, have an equal base.

American Elm *Ulmus americana*

The American elm, also known as the white elm or water elm, is one of the most beautiful of all urban shade trees. Once the

An engraving in François Michaux's *The North American Sylva* shows the American elm's leaves, flowers, and fruits. Michaux noted that American elm wood lacks the "hardness and strength" of European elm wood, but nevertheless judged the tree "the most magnificent vegetable of the temperate zone."

signature tree for downtown America, it was the tree of choice to border wide avenues because of its graceful, vase-shaped form and because its curving limbs arch high enough over adjacent sidewalks to leave clearance for traffic on busy city streets.

The American elm is sometimes confused with its European cousins. The best clues to its identity are its gracefully twisting upper limbs and the tiny white whiskers edging its notched samaras.

In the early 20th century, American elms shaded residential avenues, city parks, and college campuses all over the East and Midwest. Since the 1930s, however, most large native elms and introduced European elms have been destroyed by Dutch elm disease, so named because it was first identified by the Dutch biologist Marie Beatrice

Schol-Schwarz in 1921. This scourge, which arrived in North America in 1928 on imported lumber, is caused by *Ophiostoma* and *Ceratocystis* fungi, which spread through the roots of infected trees to healthy adjacent trees and are carried as spores from tree to tree by bark beetles.

Once infected, a tree responds by growing extensions of its xylem cell walls. These help to slow the progress of invading fungi but also block water and nutrients that normally travel through xylem cells in the trunk. As the disease slowly spreads, more and more of the tree's leaves, cut off from sustenance, begin to wither, turn yellow, and die, and the roots, no longer receiving a flow of sap from the leaves, start to die as well.

In 1980, Dutch elm disease was spreading rapidly through Central Park's elms, especially those lining the Mall. The newly founded Central Park Conservancy established the park's first arboriculture crew, which began assiduously trimming diseased elm limbs, removing dying trees, and restoring turf on both sides of the Mall to reduce compaction, which was stressing the elms. Wire fencing initially diverted grass-trampling foot traffic, but eventually attractive pipe-rail fencing was installed. Now, fully protected and carefully maintained, the Mall's elms are thriving.

▼ *The American elm leaf is alternate, elliptical, and 3 to 6 inches long, with small and large teeth interspersed, a central main vein, and 13 to 18 pairs of parallel secondary veins. Unequal at its base, it is dark green changing to yellow in fall.*

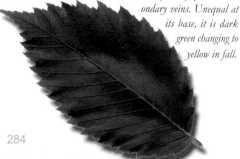

▼ *The American elm usually, but not always, has gray bark with ridges that cross one another. Occasionally, American elm bark is brown without prominent ridges or with vertical ridges that seldom cross. The American elm is a variable species.*

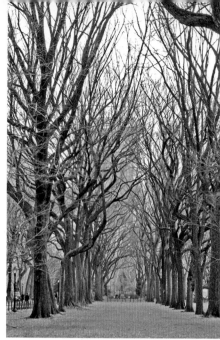

▲ *American elms (with a few European elms interspersed) form an allée on the Mall's western side. Two other rows of elms (not shown) flank the eastern side.*

▶ *A Great Tree of New York City, this imposing American elm stands at the East Meadow's southern end.*

▼ *American elm flower buds begin swelling in February and open in early March. The flowers (bottom), with dark-purple anthers (inset), appear two or three weeks before leaves begin to unfold (top) among clusters of dangling, winged, notched samaras, each rimmed with white hairs (inset).*

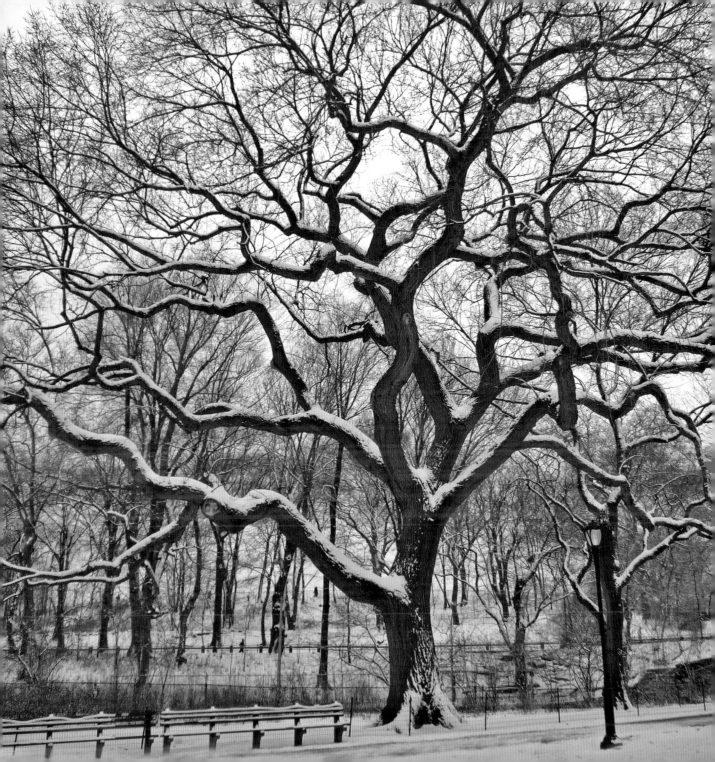

European Elms *Ulmus* spp.

The list of plantings in Central Park compiled in 1873 included five kinds of European elms: the field elm, three varieties of wych elm, and the Dutch elm. That several different European elms were planted early in the park's history is probably due in part to Ignaz Pilat, an Austrian-born gardener who was the chief gardener and superintendent of the park under Olmsted and Vaux until his untimely death at age 50 in 1870.

In Francesco Melzi's painting, Vertumnus approaches Pomona beneath an elm tree bearing a grapevine. The Atinian elm, an elm with DNA identical to that of the English elm, was used by Romans to support grapevines and was likely taken to England for this purpose.

Pilat had studied botany at the University of Vienna and had worked as a gardener at the Imperial Botanical Gardens at the Schönbrunn Palace in Vienna when the western portion of Schönbrunn Park was being redesigned in the English-garden style. He had extensive practical experience with plants and understood how to use trees and shrubs in park landscapes. Olmsted and Vaux relied on him to choose plants to achieve specific landscape effects. Pilat would have been familiar with the various European elms and likely saw to it that these trees were widely planted in the park.

Today, a few great European elms planted during Pilat's tenure as chief gardener remain. Among the most imposing of these old-timers are the English elm at 90th Street and Fifth Avenue and the wide-trunked English elm on the eastern edge of the Mall near the East Drive south of the Memorial Grove and Rumsey Playfield. Also mingled among the rows of American elms flanking both sides of the Mall are a few more very old English elms and wych elms.

Believed by some botanists to be a field elm cultivar, the English elm reproduces by clonal suckers. DNA analysis indicates that it is genetically identical to the Italian Atinian elm, used for centuries to support grapevines. The Romans may have taken it to England.

Another European elm common in the park is the Dutch elm, which is a cross between the wych elm and the European field elm. Most Dutch elms in the park are an English variety known as the Huntingdon elm, which may be distinguished from the scaly-trunked English elm by its vertically fissured trunk. A tall Dutch elm stands along the East Drive near the Loeb Boathouse, and several others line the path running by the eastern side of Cedar Hill to the Metropolitan Museum.

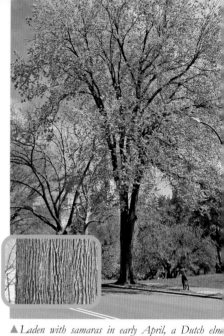

▲ *Laden with samaras in early April, a Dutch elm (Ulmus × hollandica) on the East Drive near the Boathouse exhibits the vertical bark fissuring (inset) typical of a British Dutch elm variety known as the Huntingdon elm.*

▶ *The English elm (U. procera) at 90th Street and Fifth Avenue appears to be leafing out in early April but actually bears only green, photosynthesizing samaras.*

▼ *The curious short tree (left) on the East Green near 72nd Street is a Camperdown elm, consisting of cuttings descended from a ground-hugging wych elm found in Dundee, Scotland, in 1840 grafted onto a normal wych elm trunk. The 70-foot wych elm (right) next to Trefoil Arch just below the Boathouse is probably 100 years old.*

▼ *Alternate, 3- to 7-inch, doubly toothed wych elm (Ulmus glabra) leaves may have extended teeth to the left and right of their sharply pointed tip (inset). Dark green and rough above, the leaves are hairy below with an unequal base and a very short stem. Seeds are centered in their ⅖-inch samaras or displaced slightly toward samara stems.*

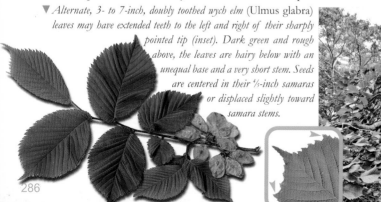

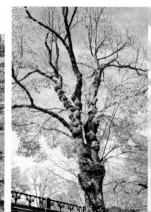

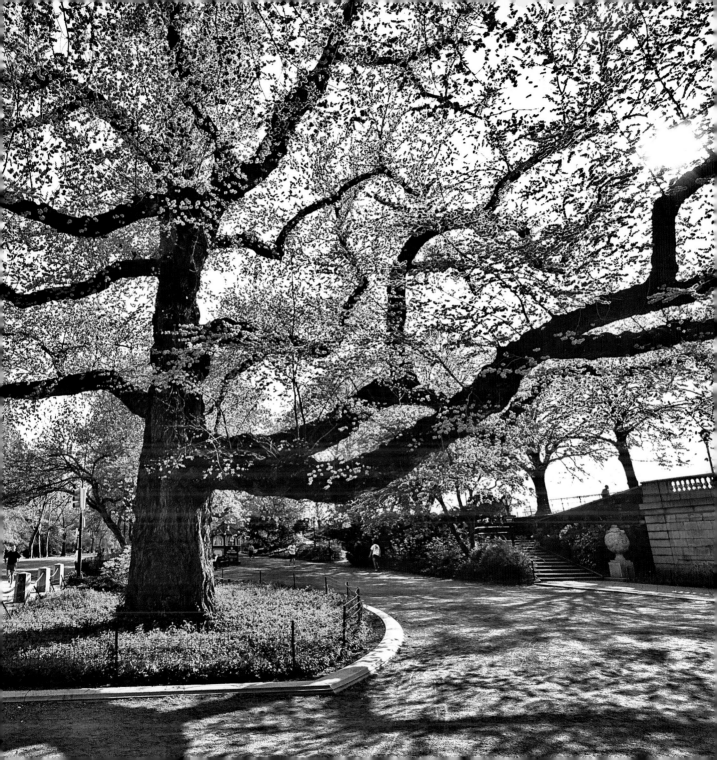

Asian Elms *Ulmus* spp.

Two Asian elm species grow in Central Park, the Siberian and the Chinese elm. According to Michael Dirr, a leading authority on trees, the Siberian elm (*Ulmus pumila*) is "one of, if not, the world's worst trees." But Dirr considers the Chinese elm (*U. parvifolia*) an "excellent, tough, durable tree for about any situation." Yet the two trees are sometimes confused when nurserymen refer mistakenly to the Siberian elm as the "Chinese" elm.

The Siberian elm may be, as Dirr contends, the worst of trees, but it is also the most widely planted elm on the planet. Hardy and fast growing, the tree spreads aggressively, often crowding out native trees wherever it is introduced. Its natural range extends from Turkestan to eastern Russia and into northern China and Korea, where it is extensively cultivated for its heavy, durable wood. First brought as seeds to the United States in 1903, the tree immediately became popular with nurserymen because of its unusually fast growth and tolerance of poor, dry

A miniature grove of Chinese elms exhibits the features that make the species an ideal bonsai tree. Leaves are small, and trunks have pleasing, varied textures. In addition, the species is hard to kill, relatively free from pests and diseases, and able to grow indoors or outdoors in warm or cool temperatures.

soil conditions. It is now found all over the Midwest and Southwest, shading streets and parks, lined up in hedgerows and windbreaks, and growing wild along railroad tracks and streams. Indeed, in some towns in New Mexico and Arizona, it is just about the only tree in sight.

While the Siberian elm is somewhat resistant, though not immune, to Dutch elm disease, it is susceptible to a variety of other diseases, such as powdery mildew and leaf spot, and is host to a number of leaf-eating insects. In addition, the tree often develops narrow crotches between main limbs, causing it to break apart in storms. Several Siberian elms are spread around the park.

Like the Siberian elm, the Chinese elm is somewhat resistant to Dutch elm disease, but it is much less susceptible to fungus diseases and insect pests. Known also as the lacebark elm, the Chinese elm often has beautiful mottled bark and bears fruits in fall, much later than the European and North American elms.

A great old Chinese elm once stood just off Fifth Avenue at the East Green's northern end. When it had to be cut down in the late 1980s, it was over 100 years old. Fortunately, the tree was cloned and is now available in the nursery trade as *Ulmus parvifolia* 'Central Park Splendor.' Offspring of this tree are now planted in the park.

▲ *Two Chinese elms display different aspects of their variable species. The twin-trunked specimen (inset) located south of the Yard near the West Drive has a darker, less variegated trunk than the large, single-trunked tree located farther north on the West Drive south of the Pool.*

▶ *Several mature Siberian elms shade the eastern edge of the Arthur Ross Pinetum's path. Despite their species's bad reputation, they exhibit graceful habits in their middle age.*

▼ *A Chinese elm's trunk (left) may consist of flaking patches of olive, tan, and greenish-yellow bark, but some Chinese elms have darker, less variegated bark. A mature Siberian elm's bark (right) is gray or brown and deeply fissured. A Siberian elm's alternate ¼- to 3-inch, toothed leaf (inset) has a nearly equal base.*

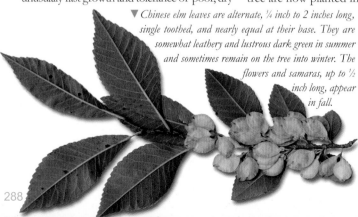

▼ *Chinese elm leaves are alternate, ¼ inch to 2 inches long, single toothed, and nearly equal at their base. They are somewhat leathery and lustrous dark green in summer and sometimes remain on the tree into winter. The flowers and samaras, up to ½ inch long, appear in fall.*

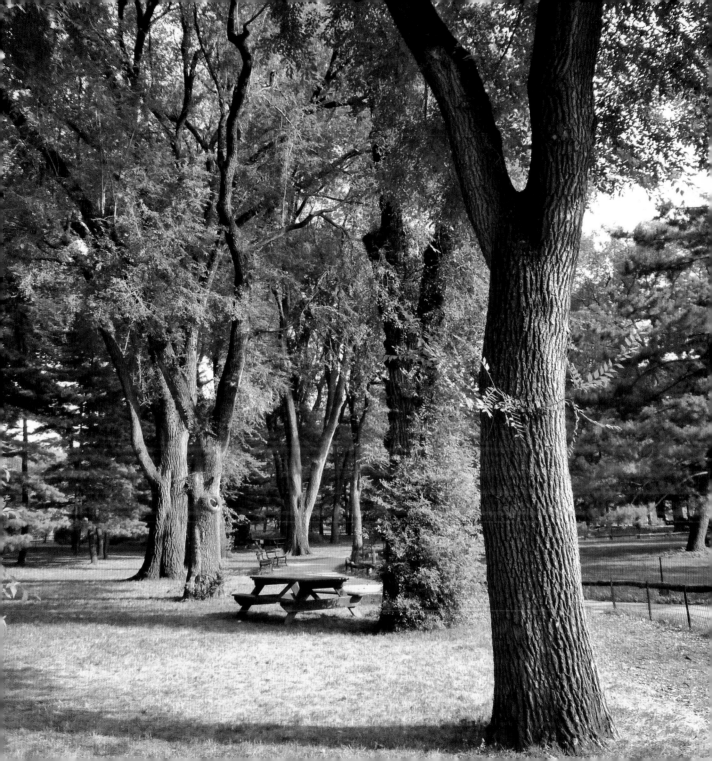

Japanese Zelkova *Zelkova serrata*

A member of the elm family, the Japanese zelkova does not attain the size or sheer magnificence of its American relative, but it is becoming a popular park and street tree in the United States. Its has a graceful vase-shaped habit and handsome mottled bark resembling the Chinese elm's. It is resistant to Dutch elm disease and insect pests, grows well in a variety of climates and soils, and tolerates drought and heat.

The first American to ship plants from Japan to North America, George Rogers Hall (1822–1899) travelled to Asia to practice medicine but made his fortune trading Chinese and Japanese curios and speculating on gold and silver.

The genus *Zelkova* consists of six species native to eastern and southwestern Asia and southern Europe. Discovered only in 1991, one of these species, the Sicilian zelkova, is limited to a few low, stunted shrubs growing on the island of Sicily. No one knows how large or how tall these shrubs might grow if they were not continually eaten by grazing animals. Before the glaciers of the Pleistocene wiped out most of them, zelkovas were widespread across temperate Eurasia.

Zelkova is the common name for the Caucasian zelkova, native to Georgia and the area surrounding the Caucasus Mountains. The name is derived from the Georgian words *dzel* (bar) and *kva* (rock). The tree's very hard, dense wood is used for long supporting beams in buildings.

The Japanese zelkova was brought, along with a number of other Japanese plants, to North America in 1862 by George Rogers Hall, a Rhode Island–born doctor turned trader. Before he set sail from Yokohama for the United States, Hall packed his plants carefully in Wardian cases, glass terrariums that kept the plants damp but protected from salt spray during their 70-day journey. Upon his arrival, Hall brought his plants, including some Japanese zelkova seedlings and seeds, to the famous nursery Parsons & Company in Flushing, Queens, for culture and propagation. The nursery placed a notice in the *Horticulturalist and Journal of Rural Art and Rural Taste* about Hall's visit, comparing its staff's excitement over unpacking his plants to "the eagerness with which a connoisseur in pictures superintends the unpacking some gems of art."

It is highly likely that the 25 Japanese zelkovas listed in the 2008 tree census are direct descendants of the zelkovas that Hall consigned to the delighted staff of Parsons & Company over 150 years ago.

▲ *A mature Japanese zelkova has a vase-shaped habit with a straight 10- to 15-foot trunk topped by a cluster of nearly parallel, sharply ascending branches. This structure makes the tree particularly susceptible to storm damage.*

▶ *A handsome, maturing Japanese zelkova shades the sandbox at the Billy Johnson Playground, near Fifth Avenue and 66th Street north of the zoo.*

▲ *The bark on a mature zelkova is gray-brown and flaking here and there to reveal orange-brown underbark.*

▼ *Japanese zelkova fall foliage can vary in color a good deal, ranging from shades of gold to bronze or russet, or sometimes even flamboyant reds or more subdued purples.*

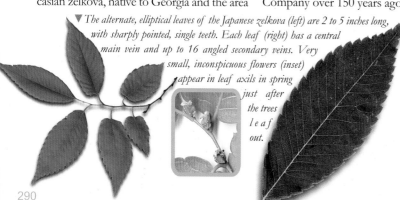

▼ *The alternate, elliptical leaves of the Japanese zelkova (left) are 2 to 5 inches long, with sharply pointed, single teeth. Each leaf (right) has a central main vein and up to 16 angled secondary veins. Very small, inconspicuous flowers (inset) appear in leaf axils in spring just after the trees leaf out.*

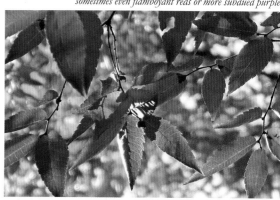

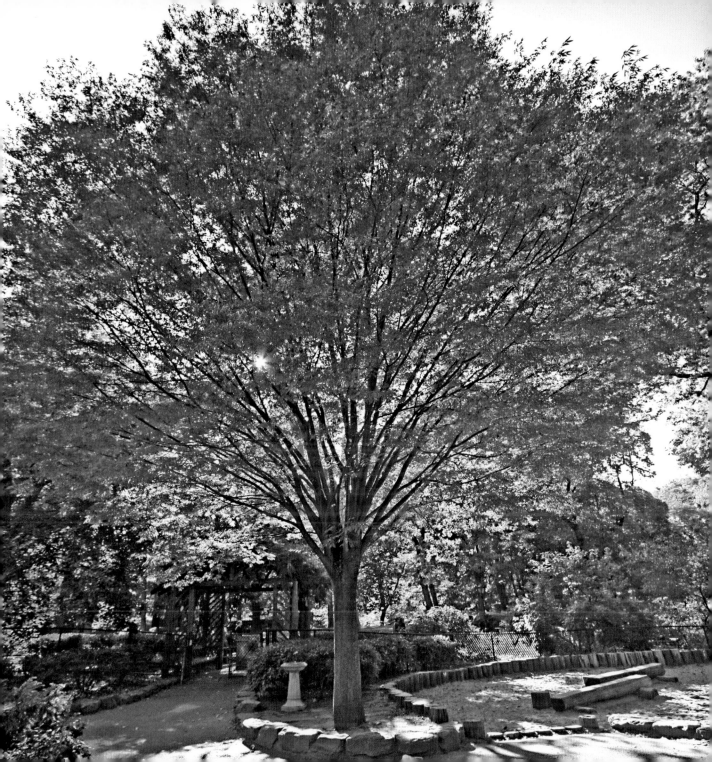

Redbud *Cercis canadensis*

The redbud's time is April and May. Then it flaunts a profusion of purplish-pink blossoms before its leaves unfold, outlining every branch and twig and even punctuating its trunk with bouquets. The rest of the year, it goes unnoticed because, like the dogwood, it is a small, shade-tolerant, understory species overshadowed in its forest habitat by larger trees. Widely planted as an ornamental, it ranges naturally from Florida to Connecticut and west to Kansas and Texas.

Nothing can be more beautiful in April and May than a large round-headed "redbud," twenty or thirty feet high, covered with its beautiful flowers before the bursting of a single leaf. The silvery under-surface of the leaves gives the tree a very light hue.

Thomas Meehan
The American Handbook of Ornamental Trees

Thomas Jefferson, in *Notes on the State of Virginia* (1781), included the redbud in a list of trees native to the state. He was undoubtedly fond of the redbud, for he planted several around Monticello and grouped redbuds with other native trees on his plantation, Poplar Forest, near Lynchburg.

The first detailed description of the redbud by an American botanist appeared in Humphrey Marshall's *Arbustrum Americanum:*

The American Grove: "This grows naturally in several parts of North America, rising to heights of ten or fifteen feet, with a pretty strong trunk covered with a darkish coloured bark; dividing upwards into several irregular branches, furnished with heart-shaped leaves, smooth upon their upper surface and edges, but a little downy underneath, having pretty long footstalks. The flowers come out upon the branches upon all sides, many arising from the same point, with short footstalks; they are of a fine red colour and coming out before the leaves, make a beautiful appearance."

The genus *Cercis* includes a half dozen or so species of small flowering trees, including several Asian species; two North American species; and a European species, *Cercis siliquastrum,* known as the Judas tree because Jesus's betrayer, Judas Iscariot, supposedly hanged himself from the tree.

The redbud has always been in Central Park. Four were included in the 1875 survey; three were located on maps in Louis Harman Peet's *Trees and Shrubs of Central Park*; and 138 were present in 2013. They are scattered throughout the park, but one of the most conspicuous grouping stretches along the East Drive as it curves eastward just north of the Metropolitan Museum.

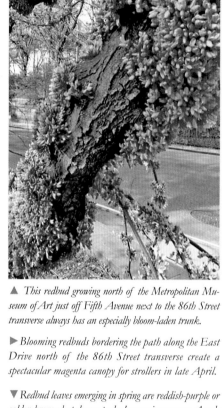

▲ *This redbud growing north of the Metropolitan Museum of Art just off Fifth Avenue next to the 86th Street transverse always has an especially bloom-laden trunk.*

▶ *Blooming redbuds bordering the path along the East Drive north of the 86th Street transverse create a spectacular magenta canopy for strollers in late April.*

▼ *Redbud leaves emerging in spring are reddish-purple or golden-bronze but change to dark green in summer. A redbud cultivar called 'Forest Pansy' has bright-purple leaves.*

▼ *The alternate, broadly heart-shaped, 2- to 5-inch leaves have smooth edges and five to nine branching veins radiating from the stem. They are yellow in fall.*

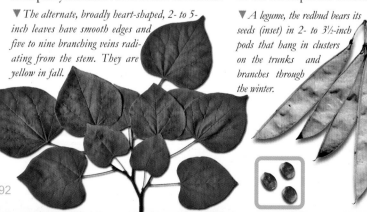

▼ *A legume, the redbud bears its seeds (inset) in 2- to 3½-inch pods that hang in clusters on the trunks and branches through the winter.*

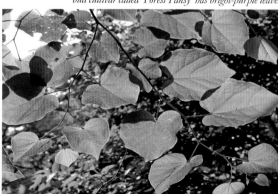

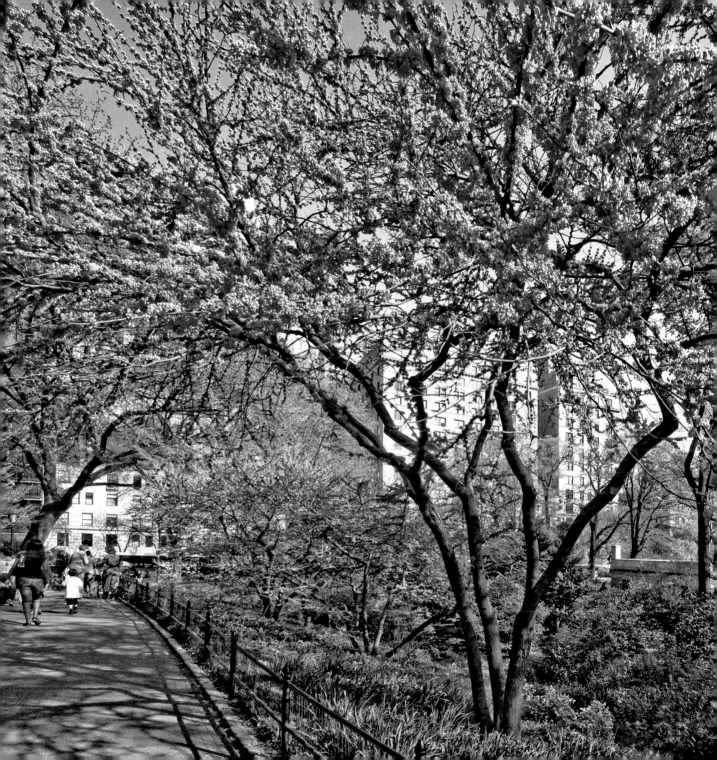

Osage Orange *Maclura pomifera*

Named for its green, heavy, round fruits, which smell a bit like orange peel, the Osage orange is a small thorny tree that rarely exceeds 50 feet in height. It grows naturally only in eastern Texas and portions of adjacent Oklahoma, Arkansas, and Louisiana, a region once inhabited by the Osage Indians.

Charles Willson Peale painted Meriwether Lewis in April 1807, shortly after Lewis returned from his epic trek with William Clark across the continent. Although Lewis was one of the first to describe the Osage orange, it was named for William Maclure, a geologist and social reformer.

The orange and yellow wood of the Osage orange is extremely hard and heavy but also very flexible. The Osage Indians, among other tribes, fashioned the wood into beautiful bows that were highly prized by the Plains Indians. Early European settlers also valued Osage orange wood for its strength and resistance to rot. They used it for railroad ties, pulleys, and wagon wheels, and planted the thorny trees in hedgerows as living fences before the invention of barbed wire.

The Osage orange leafs out in late spring. Greenish clusters of pollen and wind-pollinated seed flowers bloom on separate trees in June and July. By late summer, the seed flowers develop into hairy, coarsely textured, compound fruits 4 to 6 inches in diameter. In September and October, the fruits ripen and fall to the ground.

One of the earliest written descriptions of the Osage orange was in a letter dated March 26, 1804, from Meriwether Lewis to President Thomas Jefferson. Lewis and William Clark were in St. Louis recruiting members for the Corps of Discovery and assembling supplies for their trip across the vast territory that the United States had just acquired from France with the signing of the Louisiana Purchase. Lewis sent with the letter slips of the "Osage Apple" but feared that "the season is too far advanced for their success." Then he went on to note that "Mr. Peter Coteau…obtained the young plants at the great Osage vilage from an Indian of that nation.…[I]t's smaller branches are armed with many single, long & sharp, pinnated thorns.…[S]o much do the savages esteem the wood of this tree, for the purpose of making their bows, that they travel many hundred miles in quest of it."

Central Park has had Osage orange trees since its founding. Louis Harman Peet noted seven in *Trees and Shrubs of Central Park*. As of 2013, there were 35 in the park.

▼ *Osage orange alternate, oval, 2- to 5-inch leaves taper to a slender point. They have smooth edges and a central main vein with angled, parallel secondary veins. Dark to light green, they turn gold in fall.*

▼ *The 4- to 6-inch, green fruit of the Osage orange consists of hundreds of drupes, or fleshy fruits, compressed to form a globe containing oblong seeds (inset).*

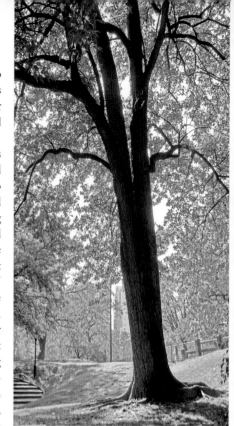

▲ *Likely an early planting, this old male Osage orange stands east of the Drive opposite the Mall's southern end.*

▶ *Much of its trunk is no longer covered with bark, yet this ancient Osage orange south of Sheep Meadow is still vital.*

▼ *The fruits developing on new shoots from female flowers are covered with greenish-white hairs. Male flowers (inset) grow in leaf axils on branches of the previous year.*

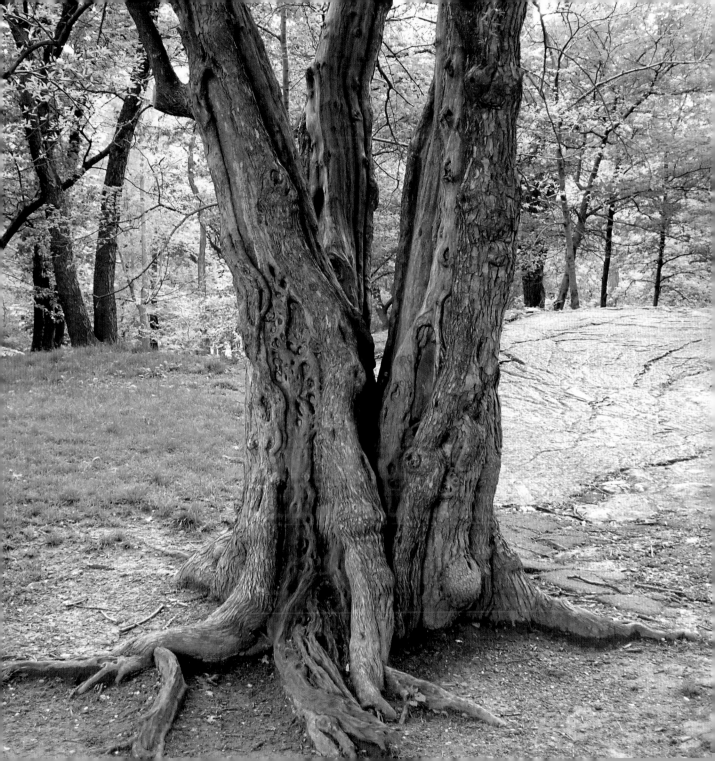

MAGNOLIAS

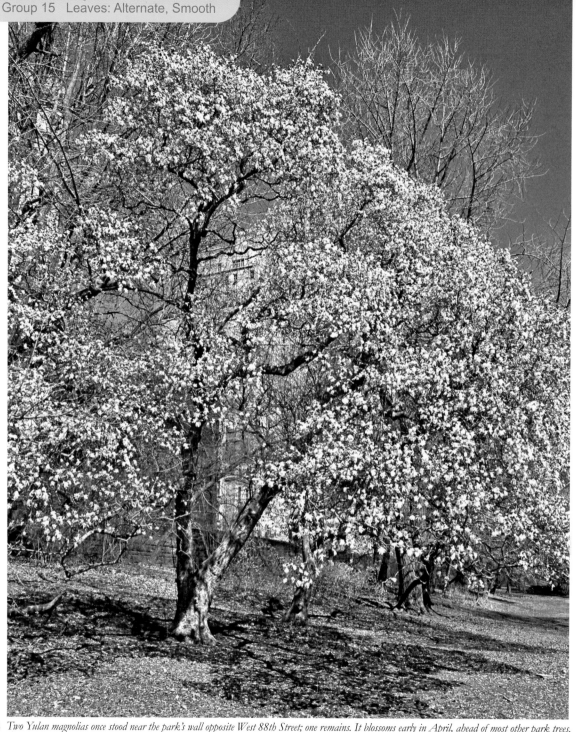

Two Yulan magnolias once stood near the park's wall opposite West 88th Street; one remains. It blossoms early in April, ahead of most other park trees.

No other genus of har
or half-hardy trees and
shrubs can boast so m
excellences as Magnolia
The free-flowering qua
ties and great beauty of
blossoms and foliage ar
only equalled by the ea
with which they may be
cultivated.

Ernest Henry Wils
*The Romance of
Our Trees*

*Yulan
magnolia
leaves*

About 80 species of trees and shrubs from eastern North America and eastern Asia are included in the genus *Magnolia*, named by Carolus Linnaeus in 1737 for the French botanist Pierre Magnol (1638–1715). *Magnolia* is the largest genus in the family Magnoliaceae, which includes *Liriodendron*, the genus of the North American tuliptree.

Most North American magnolia species, such as the cucumber magnolia, flower after their leaves appear, whereas most Asian species, such as the Yulan magnolia, flower in early spring before their leaves appear. Except for the southern magnolia, North American species tend to have less showy blossoms than their Asian relatives.

The genus *Magnolia* dates back over 100 million years. Fossils have been found far beyond the genus's present geographical ranges. Magnolias once were spread across the Northern Hemisphere, including in western North America and Europe.

Central Park contains at least a dozen magnolia species and hybrids. Asian magnolias predominate, but more American species—such as the sweetbay magnolia, umbrella magnolia, and cucumber magnolia—are being planted every year.

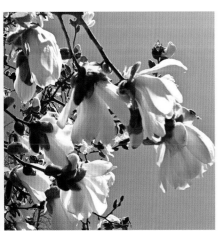

The Yulan magnolia's exquisite blossoms appear just before its leaves unfold. The Yulan has been cultivated for over 1400 years, longer than any other magnolia species.

The saucer magnolia's fuzzy winter buds begin splitting open in early April. If a late snowstorm covers them, their pinkish-purple and white petals become browned at their edges.

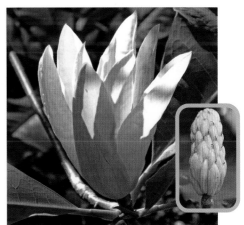

The creamy tepals of the umbrella magnolia blossom unfold in May after large shiny leaves have appeared. Once fertilized, the flower will develop into a red fruit (inset).

Cucumber Magnolia *Magnolia acuminata*

Named for the resemblance of its fruit to a small cucumber or gherkin, the cucumber magnolia is the hardiest of the eight North American magnolias and has the most extensive range. It grows all the way from southern Ontario and central New York down the Appalachian Mountains to Georgia and Alabama and into Mississippi, Arkansas, and Missouri.

This engraving of the cucumber magnolia's leaf, fruit with seeds, and flower is from François Michaux's *The North American Sylva.* A hybrid of the cucumber magnolia and the Yulan magnolia is present in Central Park. Known as *Magnolia* 'Elizabeth,' it bears beautiful yellow flowers.

The cucumber magnolia prefers rich stream valleys and moist forested lower slopes of mountain ranges, where it may grow more than 100 feet tall and over 3 feet wide at its base, with a trunk free of branches for 50 or 60 feet. It is the only tree of its genus to rival the size of its towering relative, the tuliptree.

A relatively rapid grower, it matures at about 120 years and typically may live for 150 or more years. In fact, scientists have counted nearly 350 annual rings in a few old-growth cucumber magnolias. The heartwood is brownish yellow, sometimes with hints of green, and the trunk's encircling ring of sapwood is nearly white. The wood is soft but fairly durable and is easily cut and trimmed. It is used for boxes and crates, furniture, interior molding, and sometimes floor boards.

French botanist François André Michaux described how the settlers in the Alleghenies used the fruit of the cucumber magnolia in his three-volume treatise *The North American Sylva*: "Most of the inhabitants of the country bordering on the Alleghenies gather the cones about midsummer, when they are half ripe, and steep them in whiskey: a glass or two of this liquor, which is extremely bitter, they habitually take in the morning, as a preservative against autumnal fevers. Its efficacy I do not deny, but it has not been made sufficiently evident to induce any physician to attempt its verification."

The cucumber magnolia was planted in Central Park in the early 1860s. In *Trees and Shrubs of Central Park*, Lewis Harman Peet refers to "several stalwart specimens" with "well developed trunks" in the northeasterly part of the Ramble. One of these still stands, but its trunk has been damaged and cut short. Another large cucumber magnolia bends over the path south of the Rumsey Playfield Summer Stage. Several younger trees are scattered

▲ *A mature cucumber magnolia shades the path just south of the Rumsey Playfield Summer Stage. Probably at least 70 years old, this tree could easily survive another 80.*

▶ *A number of cucumber magnolias, like this young West Side specimen, have been planted in the park recently. Ideal for public spaces, the cucumber magnolia is fast growing and pest free, with attractive foliage that turns yellow in fall. It does well in the open or in partial shade.*

▼ *Cucumber magnolia flowers appear on branch ends from April through June after the leaves have appeared. They close at night and last only for three or four days. They are pollinated mainly by insects such as beetles and bees.*

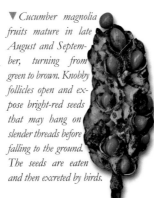

The cucumber magnolia's alternate leaves are 7 to 10 inches long and 4 to 6 inches wide with a sharp point, which gives the tree its Latin species name acuminata. *They are dark green and smooth above and somewhat hairy and lighter beneath.*

▼ *Cucumber magnolia fruits mature in late August and September, turning from green to brown. Knobby follicles open and expose bright-red seeds that may hang on slender threads before falling to the ground. The seeds are eaten and then excreted by birds.*

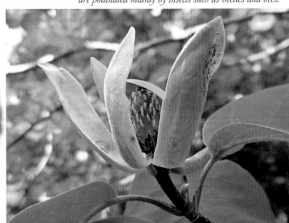

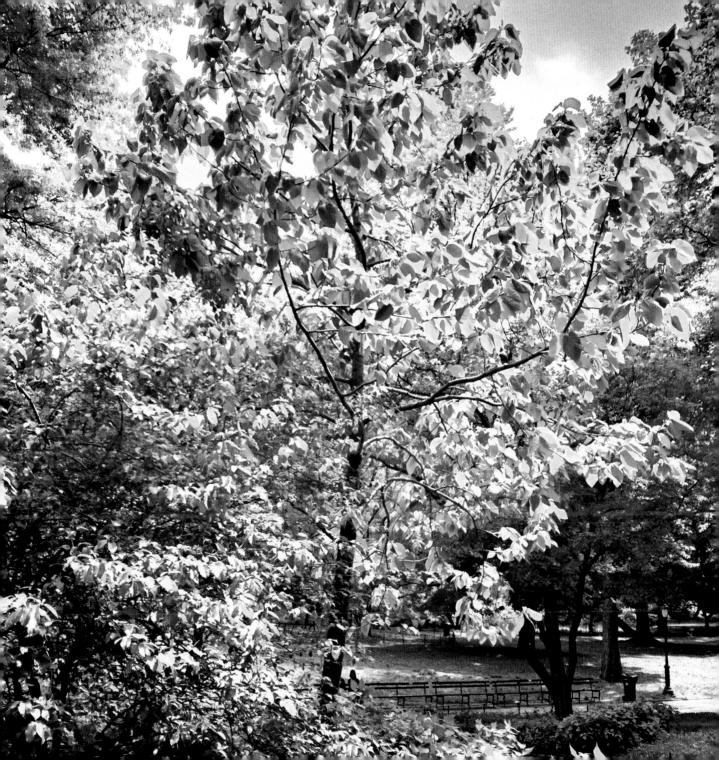

Southern Magnolia *Magnolia grandiflora*

A hand-colored engraving of the southern magnolia's sumptuous white flower and vermilion seeds is the most arresting illustration in English naturalist Mark Catesby's posthumously published *Hortus Europae americanus.*

"Of all the trees able to endure our climate, that have yet been introduced to England," Catesby wrote glowingly in the accompanying text, "there is none that can equal this magnificent evergreen. Its ample and fragrant blossoms, the curious structure and beauty of its purple cones and pendant scarlet seeds successively adorn and perfume the woods from May to October; and justly entitle it to the pre-eminence amongst the varieties in the forests of America."

This engraving of the southern magnolia in Mark Catesby's *Hortus Europae americanus* was labelled with the Latin name "Magnolia altissima, flore ingenti candido," which might be loosely translated as the "ultimate magnolia with the great white flower." Catesby's English name for the tree was "Laurel-tree of Carolina."

The southern magnolia's natural range once extended from Virginia to Florida and west into Oklahoma and Texas in areas near water, such as swamp edges, wooded floodplains, and maritime forests, but it is now cultivated as an ornamental tree successfully in the eastern United States as far north as southern New England and has been planted around the world wherever winters are not too severe.

In the Deep South, a southern magnolia can easily reach a height of 60 or more feet, and specimens with girths of over 17 feet and heights exceeding 100 feet are on record. The tree can live to a very ripe old age, too. In 1828, shortly after his election as seventh president of the United States, Andrew Jackson planted a southern magnolia in memory of his wife, Rachel Donelson Jackson, beside the south portico of the White House. A favorite of Lady Bird Johnson, this tree is now nearly as tall as the White House itself.

The sapwood of the southern magnolia is greenish-yellow, and the heartwood, light to dark brown. Heavy and hard, southern magnolia wood is used for furniture, venetian blinds, window and door sashes, shipping pallets, and veneer. The wood decays quite quickly when exposed to moisture and cannot be used outdoors.

A relative newcomer to Central Park, the southern magnolia was not among the early plantings and is not listed in Lewis Harman Peet's *Trees and shrubs of Central Park.* A warming trend during the past 20 years has allowed the three specimens now in the park to survive.

▲ *Silhouetted by the afternoon sun, the thick, leathery leaves of the small double-trunked southern magnolia across the East Drive from the foot of the Mall appear almost black.*

▶ *A 20-foot southern magnolia planted in 1986 stands in early December amid leafless neighbors at the 66th Street transverse's northern edge near Fifth Avenue. The last rays of the setting sun burnish its topmost leaves.*

▼ *The large-tepalled, ivory-white flowers of the southern magnolia are 7 to 10 inches in diameter. They blossom in summer, exuding a strong lemony fragrance. Pistils with curling tips surrounded by pollen-laden stamens are spirally arranged at the flowers' centers.*

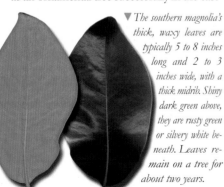

▼ *The southern magnolia's thick, waxy leaves are typically 5 to 8 inches long and 2 to 3 inches wide, with a thick midrib. Shiny dark green above, they are rusty green or silvery white beneath. Leaves remain on a tree for about two years.*

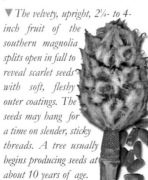

▼ *The velvety, upright, 2¼- to 4-inch fruit of the southern magnolia splits open in fall to reveal scarlet seeds with soft, fleshy outer coatings. The seeds may hang for a time on slender, sticky threads. A tree usually begins producing seeds at about 10 years of age.*

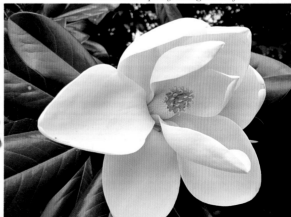

Saucer Magnolia *Magnolia* x *soulangeana*

"Have you never seen in April a small tree in city yards flowering before the leaves, and bearing more than a thousand of fragrant white cuplike flowers six inches across and pinkish outside? Then you have lived in vain, for you have missed the best large-flowered tree in cultivation." So wrote Wilhelm Miller (1869–1938), an American author and professor of horticulture, in the June 1906 issue of the *Garden Magazine*. This first hybrid magnolia of European origin was created in France in 1820 when Étienne Soulange-Bodin, a French army captain and agronomist, fertilized a Yulan magnolia (*Magnolia denudata*) flower with pollen from a purple magnolia (*M. liliiflora*) flower.

Pierre-Joseph Redouté's stipple engraving of *Magnolia* x *soulangeana* was included in *Choix des plus belles fleurs* (1833) published only thirteen years after Étienne Soulange-Bodin created the magnolia hybrid in 1820.

Known as the saucer magnolia because of its large, elegant flowers, *Magnolia* × *soulangeana* is a slow-growing, often multi-trunked, broad-spreading shrub or small tree that seldom grows much taller than 25 feet. It has become one of the most widely planted magnolias in the world for several good reasons. It is very hardy, tolerating a wide variety of climates and soils. It flowers profusely very early in the spring even as a young tree. A single flowering tree typically bears hundreds of blossoms unobscured by leaves and may even continue producing blossoms after its leaves unfold. One of its very few disadvantageous traits is that it may flower so early that its blossoms are damaged by late frosts and snowfalls.

Dozens of saucer magnolia cultivars are available with colors varying considerably from almost white like one of its parents, the Yulan magnolia, to deep purple-red like the other parent, the purple magnolia. Flower shapes also vary from tulip-like configurations to cup-and-saucer arrangements to goblets. One of the most common cultivars is 'Étienne Solange-Bodin,' which exhibits a long pink bud tipped with white, opening to a cup-and-saucer-shaped flower that is white inside but with tepals flushed with pink on the outside, deepening to purple-pink near their bases.

Over 70 saucer magnolias are sprinkled around the park, but those circling Cleopatra's Needle and the group clustered behind the Metropolitan Museum are among the park's most arresting floral spectacles in April.

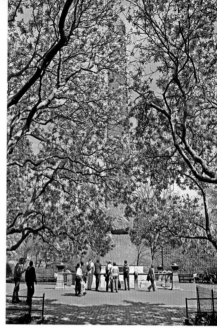

▲ *Every April, a stunning screen of extravagantly blossoming saucer magnolias confronts visitors as they reach the top of the stairs to the terrace at the base of Cleopatra's Needle.*

▶ *The little grove of blossoming saucer magnolias across the East Drive from the Metropolitan Museum offers a welcoming, dappled shade for visitors in mid-April.*

▼ *Commenting on the riotously profligate flowers of the spring-blooming saucer magnolia, Louis Harman Peet wrote in* Trees and Shrubs of Central Park: *"Emblem of dawn, is this lovely blossom. Roseate herald of the flowers that are soon to burn on bush and tree, how incomparably beautiful is thy hue on those bare April days while yet the tang of winter is in the air!"*

▼ *Dark above and somewhat lighter below, saucer magnolia leaves are up to 8 inches long and 4½ inches wide. The asymmetrical beaked fruit is 2 to 4 inches long.*

▼ *The ½- to ¼-inch gray, fuzzy bud at the tip of a saucer magnolia twig protects an already formed but tightly folded and compressed blossom that will rapidly unfold and expand during the first warm days of April.*

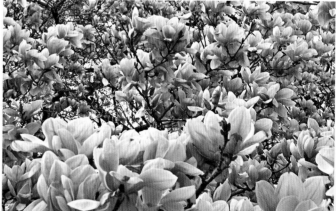

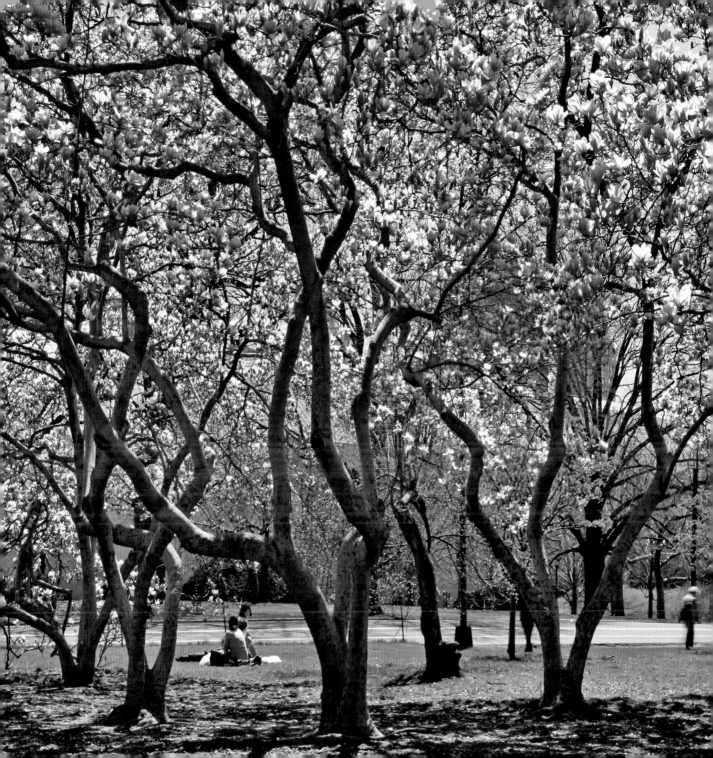

Star Magnolia *Magnolia stellata*

Ernest Henry "Chinese" Wilson, an eminent English explorer who introduced hundreds of Asian plants to Europe and North America, was especially fond of the star magnolia. "This M. Stellata," he wrote in his book *Aristocrats of the Garden* "is the first of all the magnolias to open its blossoms and is always a broad and shapely shrub growing eight to twelve or fifteen feet high and more in diameter; the star-shaped, snow-white flowers are smaller than those of other species but are borne in such profusion as to cover the bush with white. This is one of the most beautiful and most satisfactory of all spring-flowering shrubs and is extremely hardy." The star magnolia was not one of Wilson's plant introductions.

Ernest Henry Wilson (1876–1915) may have gathered more plant species new to western botanists in Asia than any other European collector. He worked first for the storied British Veitch Nurseries and later for Harvard's Arnold Arboretum under the supervision of Charles Sprague Sargent.

An American doctor, George Rogers Hall, brought it to Parsons & Company in Flushing, Queens, in 1861.

A slow-growing, densely branched shrub or small tree, the star magnolia has been cultivated for centuries in Japan. It is closely related to another Japanese magnolia, *Magnolia kobus*, which also has white flowers but with fewer and wider tepals than those of the star magnolia. Native to the lower mountainsides of southern Honshu, Japan's largest island, the star magnolia grows along streams, ponds, lakes, and marshy areas. Its habitat has been reduced and fragmented by development, and its natural populations are not reproducing as well as they once did. Eventually, the species may become very rare or extinct in the wild.

The star magnolia, like other Asian magnolias, blossoms in early spring before its leaves unfold. A young tree begins blossoming at just three years of age. The slightly fragrant, star-shaped flowers are 3 or 4 inches in diameter and have at least 12 strap-like tepals, which may vary in color from white to deep pink. Its twigs are dark brown; its older branches and trunks, like those of many other Asian magnolias, are smooth and light gray.

The star magnolia was not among the park's first plantings, but Louis Harman Peet listed one in *Trees and Shrubs of Central Park*. The 2008 census did not include the star magnolia, but in 2013 there were 20 in the park, including two with white flowers and one with pink flowers growing along the East Drive across from the Metropolitan Museum. They were planted in 1996 during the reconstruction of the Great Lawn.

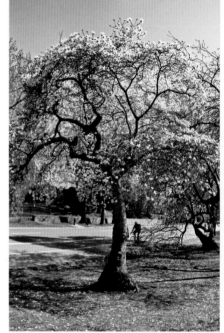

▲ Two kobus *magnolias grow along the East Drive across from the Metropolitan Museum. Closely related to the star magnolia, the Kobus magnolia also grows wild in the lower montane forests of Honshu.*

▶ *A lovely 10-foot high star magnolia close to the East Drive behind the Metropolitan Museum presents strollers with a dazzling, star-studded display every April.*

▼ *The 3- to 5-inch-wide flowers of the star magnolia have 12 to 18 ribbon-like tepals. Buds do not open simultaneously, so this lovely shrub or small tree typically flowers over 10 to 20 days.*

▼ *Star magnolia leaves are 2 to 4 inches long and half as wide, darker green above and lighter green beneath. They may have a sharp tip or blunt incurved end. The 2-inch fruits contain a few orange seeds.*

▼ *There are many star magnolia cultivars. Some have pure-white tepals varying in number and width; others have light-pink to deep-pink tepals; some are slightly fragrant; others are strongly scented.*

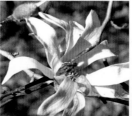

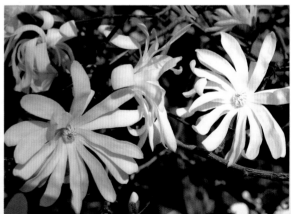

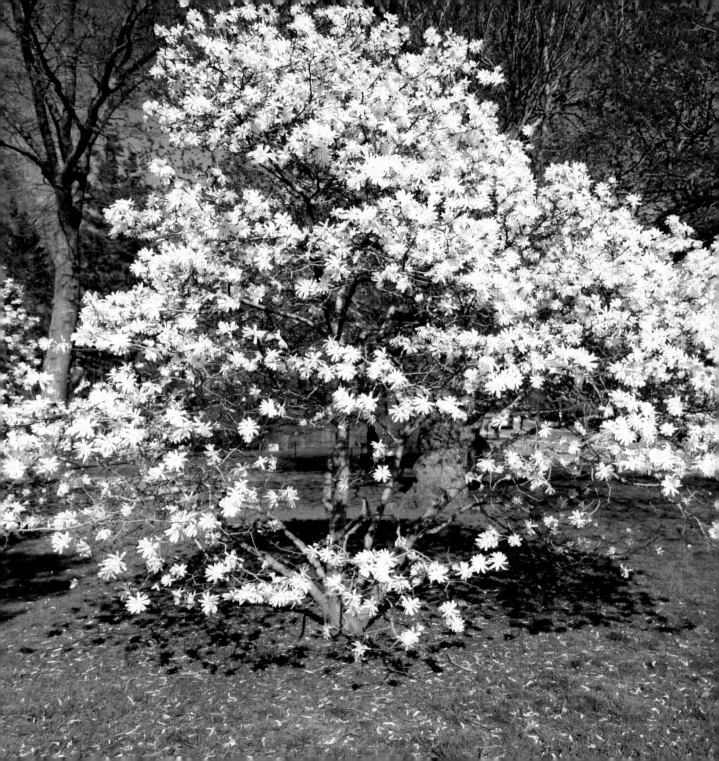

Black Tupelo *Nyssa sylvatica*

In the wild, the black tupelo is most likely to be found in moist bottomlands and wetlands, habitats that are reflected in its names. The word "tupelo" is derived from the Creek Indian words eto opelwu (swamp tree). The tree's Latin genus name, Nyssa, refers to a water nymph in Greek mythology.

The black tupelo grows best in the southern Appalachians but ranges as far north as Ontario and Maine. In spring, it bears inconspicuous, greenish-yellow male and female flowers on separate trees and produces flowers with both male and female parts on each tree. In summer, small, plum-like fruits develop on long stalks. The fruits are green at first but turn blue-black as they ripen. Their thin, oily, acidic pulp is rich in fat, phosphorus, and calcium and appeals to many birds and other animals.

As if to compensate for its lack of showy spring flowers, the black tupelo puts on a spectacular autumn display as its dark-green leathery leaves turn to brilliant shades of burgundy, purple, scarlet, orange, yellow, and gold.

Black tupelo wood is heavy, tough, and hard to split but subject to rot when openings in the bark caused by fire or broken limbs allow fungi spores to enter the heartwood. Large sections of the trunks of older trees often hollow out, providing shelter for nesting birds and mammals and for insect hives. Despite its vulnerability to fungus rot, the black tupelo can live to a very ripe old age. Some wild trees on Long Island are more than 300 years old, and one or two may exceed 500 years.

The black tupelo always has been present in the park. Two were noted in 1875, and nine were counted in 2008. Three or four mature tupelos are in the Ramble, including one of the park's most magnificent trees, the great black tupelo in Tupelo Meadow. Another spectacular black tupelo, especially in the fall when its turning leaves seem to catch on fire in the afternoon sun, is the quadruple-trunked tree near the path leading from the Conservatory Water to Cedar Hill. In the future, there may be more black tupelos in the park as young trees are being planted in the Ramble along the shoreline of the Lake and in other wild areas.

The rough, irregular plates of its bark are signs of the Blydenburgh Tupelo's great age. One expert believes that this tree in Blydenburgh County Park on Long Island may be more than 500 years old—perhaps even as old as 700 years.

▲ *The great black tupelo in Tupelo Meadow may have seeded in on its own, protected from mowers by large boulders.*

▶ *Every tree has its special moment, and a sunny afternoon in fall is perhaps the perfect time to walk beneath the quadruple-trunked black tupelo in the Glade.*

▼ *The clusters of greenish-yellow male flowers are fuller than the clusters of greenish-yellow female flowers. Although not showy, tupelo flowers are excellent nectar sources for bees.*

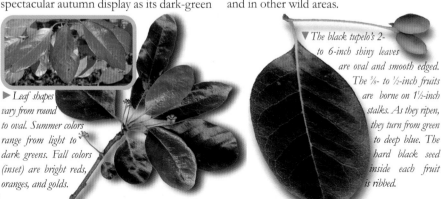

▶ *Leaf shapes vary from round to oval. Summer colors range from light to dark greens. Fall colors (inset) are bright reds, oranges, and golds.*

▼ *The black tupelo's 2- to 6-inch shiny leaves are oval and smooth edged. The ⅛- to ½-inch fruits are borne on 1½-inch stalks. As they ripen, they turn from green to deep blue. The hard black seed inside each fruit is ribbed.*

306

Rhododendron *Rhododendron* spp.

The genus *Rhododendron* includes both rhododendrons and azaleas—altogether around 1000 species native mostly to temperate regions of North America, Europe, and Asia.

A hand-colored engraving in *Curtis's Botanical Magazine* of 1814 illustrates a *Rhododendron catawbiense* flower. In the wild, flowers of this species vary in color from pure white to pink to purple. *Catawbiense* refers to the Catawba, a Native American nation of the Carolinas.

Rhododendrons usually have thick, leathery evergreen leaves and flowers with 10 or more stamens; azaleas usually have smaller, thinner deciduous or evergreen leaves and flowers with five stamens. The genus includes plants with flowers of every hue imaginable. In addition to *Rhododendron* species, there are thousands of hybrids. As Jane Brown notes in *Tales of the Rose Tree*, "Hybrids come and go in unnumbered thousands, beauties with a brief trajectory. The world of the rhododendron is actually limitless." Hybrids are produced when a species is crossed with another species or with a hybrid. Hybrid rhododendrons and azaleas do not reproduce from seed but only from cuttings or grafts. Hybrids are given vernacular names such as 'Lavender Queen' and 'Gertrude Jekyll.'

No group of plants has lured more famous plant explorers than the genus *Rhododendron*. William Bartram, son of Philadelphia botanist John Bartram, discovered the flame azalea (*Rhododendron calendulaceum*) in Georgia in 1776, lauding it in his book *Travels* as "certainly the most gay and brilliant flowering shrub yet known." André Michaux came upon the Catawba rhododendron, a lilac-purple flowering shrub on a southern Appalachian mountaintop and named it *Rhododendron catawbiense* in *Flora Boreali-Americana* (1805). The Catawba rhododendron and the flame azalea are parents of hundreds of hardy garden hybrids.

In the 19th century, plant explorers such as Philipp Franz von Siebold, Sir William Jackson Hooker, and French missionary Father Armand David brought dozens of rhododendron species out of China, India, and Japan. In the 20th century, the trickle of Asian species arriving in the West became a flood as British plantsmen such as Ernest Henry Wilson, George Forrest, and Frank Kingdon Ward found hundreds of *Rhododendron* species in Tibet and China.

More than 100 rhododendron and azalea plants are spread across the park. Many may be seen near the Reservoir along the East Drive between 86th and 89th Streets.

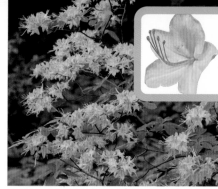

▲ *The orange blossoms of a flame azalea cultivar growing on Strawberry Hill's eastern side open in late May, when nearby Catawba rhododendron purple-flowered cultivars are also blooming. Each flower has five long stamens (inset).*

▶ *At their peak of electric red in early May, the* Rhododendron obtusum *'Hinodegiri' azaleas at the Ramble's Azalea Pond attract ruby-throated hummingbirds.*

▼ *In mid-May, the hybrid rhododendron bushes near the Hans Christian Andersen sculpture west of the Conservatory Water produce a profusion of white, five-petalled blossoms, each with 10 brown-tipped stamens (inset).*

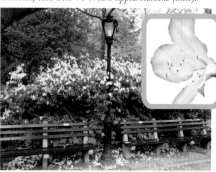

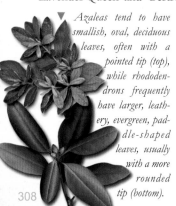

▼ *Azaleas tend to have smallish, oval, deciduous leaves, often with a pointed tip (top), while rhododendrons frequently have larger, leathery, evergreen, paddle-shaped leaves, usually with a more rounded tip (bottom).*

▶ *This flamboyant phalanx of hybrid rhododendrons near the East Drive opposite the southern end of the Mall reaches its peak of magenta magnificence in mid-April, well ahead of the park's several pink-purple–flowered Catawba rhododendron cultivars.*

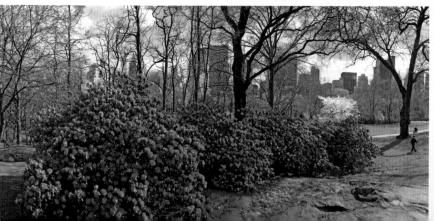

There are those who love to watch birds, to stalk them with binoculars, to record their sightings on lists, and to recount their birding adventures much as big-game hunters once regaled listeners with stories about their stuffed trophies. I don't belittle this hobby one bit, but it appeals to people who like to track down things, collect them, and check them off one by one. I am drawn to another outdoor hobby that is more of a gatherer's than a hunter's avocation. For want of a better term, I call it tree watching and the people who engage in it, tree lovers.

A tree is not like a bird: it does not fly away, it is with you all the time, but it is not static. It is constantly changing with the seasons. So if you are a tree lover, you need not stalk your quarry, but you must look at it very carefully, at the arrangements and shapes of its leaves, at the textures of its bark, at the colors and forms of its flowers and fruits, at the contours of its trunk and branches. Once you become fully aware of the trees around you, no landscape with trees ever looks quite the same.

You enjoy subtle contrasts of

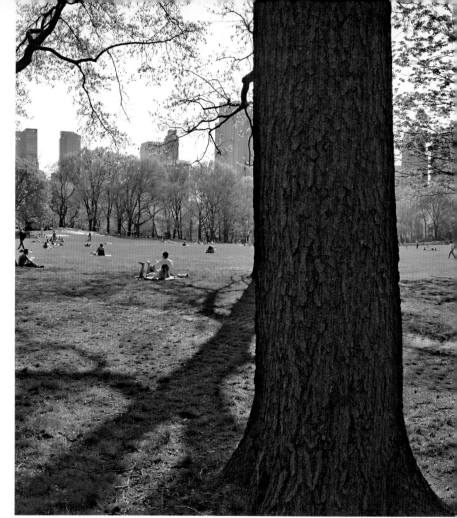

hue and habit where once you saw only masses of green. You perceive a multitude of changes as the seasons progress that you overlooked before. By learning the names of trees in the streets and parks around you, you make them part of your mental landscape, your property in a way.

There was a time, just yesterday geologically speaking, when our relationship with trees was a matter of life and death, and we knew them intimately. They nurtured us in our infancy and gave rise to our opposable thumbs, clever fingers, and binocular vision. They fed us, sheltered us, and hid us from our enemies. A great forest then stretched clear across our natal continent in an almost unbroken band from the

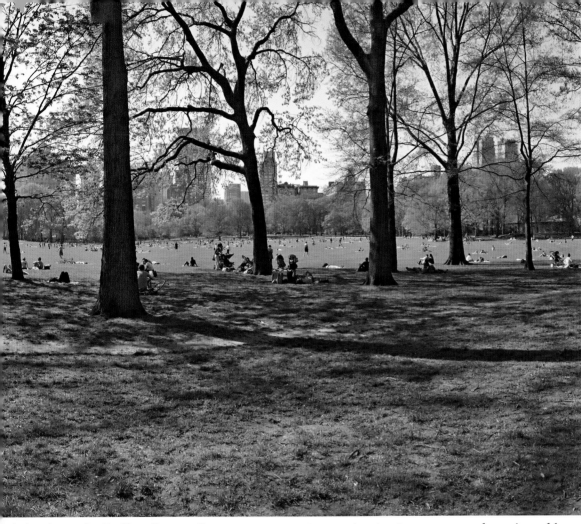

Trees at Sheep Meadow's eastern edge cast long shadows in the late-afternoon sunlight of a beautiful day in April.

Atlantic to the Indian Ocean. It was the breakup of this vast equatorial forest that forced us to descend to the ground, to stand erect on two feet and become wanderers on the savanna, to forsake our arboreal existence in the forest-canopy Eden for the precarious life of big-game hunters.

In our collective memory, we stand there still, poised in the shadows of the forest edge, staring out at the herds grazing warily on the grass under the brilliant tropical sun, reluctant to leave the safety of the trees, yet drawn to the light and the excitement of the chase. So it is that we endlessly re-create the savanna's edge in our urban parks, with their greenswards and playing fields surrounded by trees, and in our suburbs, with their shady streets and manicured lawns. Yes, there is something atavistic about our profound attachment to trees, something deeply satisfying about walking on sun-dappled grass beneath them, seeing them once again with fresh eyes.

Edward Sibley Barnard

NOTES AND SOURCES

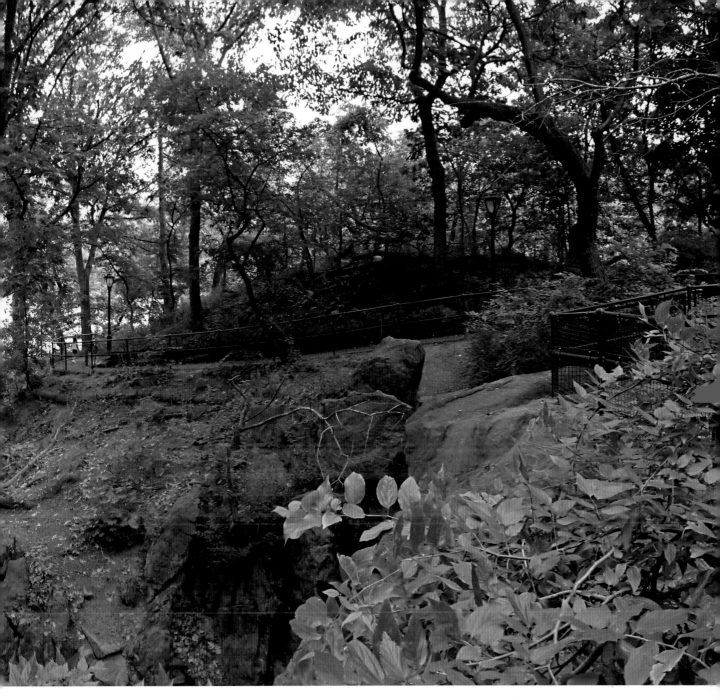

A view of the Lake from the Cave Inlet in the Ramble

Notes

The Landscapes

14 "Five hundred million years ago": Account of Central Park geology based on Colorado Plateau Geosystems, "Paleogeography and Geologic Evolution of North America."

16 "It was an incredibly rich forest mosaic": Sanderson, *Mannahatta*, 10.

16 "A sawmill manned by slaves": Stokes, *Iconography of Manhattan Island*, 6:132.

17 "The island of New York": Stone, *Letters of Brunswick and Hessian Officers During the American Revolution*, 201.

17 "The island is totally stripped of Trees": Quoted in Stokes, *Iconography of Manhattan Island*, 5:1132.

18 "most conducive to the public good": Green, *Communication to the Commissioners of the Central Park*, 25.

18 "all the avenues": Quoted in Cohen and Augustyn, *Manhattan in Maps*, 110.

20 "lungs of the City": Quoted in Burrows and Wallace, *Gotham*, 791.

20 "a beautiful open space": Olmsted and Vaux, *Description of a Plan for the Improvement of the Central Park*, "Greensward," 36.

22 "The general ruggedness of the site": Quoted in Board of Commissioners of the Central Park, *Third Annual Report, January, 1860*, 42–43.

22 "obscurity and picturesque character of detail": Board of Commissioners of the Department of Public Parks, *Second Annual Report, for the Year Ending May 1, 1872*, 83.

23 "the less anything that is seen": Olmsted, *Central Park as a Work of Art and as a Great Municipal Enterprise*, 357.

26 "a playground about ten acres in extent": Olmsted and Vaux, *Description of a Plan for the Improvement of the Central Park*, "Greensward," 20.

27 "urban sublime": Rogers, *Landscape Design*, 340.

28 "[I]t is proposed to form a lake of irregular shape": Olmsted and Vaux, *Description of a Plan for the Improvement of the Central Park*, "Greensward," 21.

32 "Although averse on general principles": Ibid., 17.

32 "For purposes of the avenue": Ibid., 35.

34 "grand promenade": Ibid., 34.

34 "parade ground": Ibid., 19–20.

34 "Such a broad open plane of well-kept grass": Ibid., 20.

36 "a combination of trees and turf": Rogers, *Rebuilding Central Park*, 65.

36 "reminds one of an English lawn": Parsons, *Landscape Gardening*, 277.

40 "To the north and north-west of the promenade": Olmsted and Vaux, *Description of a Plan for the Improvement of the Central Park*, "Greensward," 26.

42 "rough stone outlook": Quoted in Board of Commissioners of the Central Park, *Sixth Annual Report, January, 1863*, 65.

42–43 "We determined that the Ramble": Quoted in Kowsky, *Country, Park, and City*, 122.

43 "The landscape is everything, the architecture nothing": Quoted in ibid., 124.

It is after 6:00 P.M. on a spring evening in April at the Loeb Boathouse. Rental rowboats have been neatly turned on their sides but will be available again at 10:00 A.M. the next day.

43 "The view on an autumn day": Parsons, *Landscape Gardening*, 276–277.

43 "The middle parts of the Ramble": Quoted in Graff, *Men Who Made Central Park*, 34.

44 "commands some of the finest views": Vaux, letter to the editor, *New York Times*, July 6, 1864.

46 "American garden": Olmsted and Vaux, *Description of a Plan for the Improvement of the Central Park, "Greensward,"* 28.

46 "The present growth": Ibid.

47 "selection and special treatment": Olmsted, *Central Park as a Work of Art and as a Great Municipal Enterprise*, 344.

47 "tropical character": Ibid., 343.

47 "we must make much of trees": Ibid., 347.

48 "large basin for a fountain": Olmsted and Vaux, *Description of a Plan for the Improvement of the Central Park, "Greensward,"* 24.

54 "blank uninteresting object": Ibid., 26.

56 "Dense evergreen planting": Quoted in Olmsted, *Creating Central Park*, 185.

56 "The evergreens bowed to the southeast": *New York Times*, December 26, 1902.

57 "One by one": Graff, *Tree Trails in Central Park*, 159.

59 "the largest artificial lake in the world": *New York Times*, August 20, 1862.

59 "The new reservoir": Olmsted and Vaux, *Description of a Plan for the Improvement of the Central Park, "Greensward,"* 30–31.

60 "A Plan for the Improvement of the Central Park": Heckscher, *Creating Central Park*, 17–20.

60 "There is little of interest to be found": Parsons, *Landscape Gardening*, 284.

61 "The round of this Reservoir": Cook, *Description of the New York Central Park*, 165.

63 "one of the best examples we have of good park-work": Parsons, *Landscape Gardening*, 286.

64 "The central portion": Olmsted and Vaux, *Description of a Plan for the Improvement of the Central Park, "Greensward,"* 32–33.

64 "It is a wonderful effect": Parsons, *Landscape Gardening*, 284, 286.

66 "The north-east section": Olmsted and Vaux, *Description of a Plan for the Improvement of the Central Park, "Greensward,"* 33.

66 "so planned that it may present": Ibid.

66 "It became a meadow": Rogers, *Rebuilding Central Park*, 102.

72 "On a rocky summit": Cook, *Description of the New York Central Park*, 172–173.

74 "The northwesterly corner": Quoted in *First Annual Report of the Improvement of the Central Park*, 72.

74 "In time this pretty picturesque spot": Cook, *Description of the New York Central Park*, 174–175.

74 "This Section embraces": Peet, *Trees and Shrubs of Central Park*, 345.

74 "[T]he high ground": Ibid.

76 "furnished himself with a dugout": Pierce, *New Harlem Past and Present*, 4.

77 "entirely devoid of trees": Quoted in *First Annual Report of the Improvement of the Central Park*, 72.

78 "There are but few trees": Quoted in Ibid., 74.

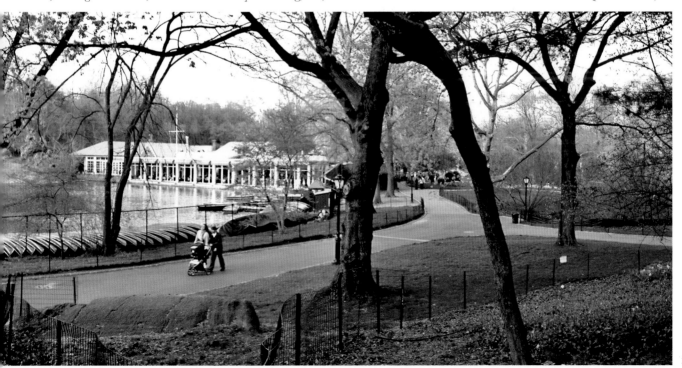

79 "It cannot fail to add to the interest of the visitor": Hall, *McGown's Pass and Vicinity*, 3–4.

The Tree Guide

96 "[T]he stiffer forms of evergreen trees": Quoted in Board of Commissioners of the Central Park, *Annual Report, for the Year Ending April 30, 1858*, Document 11, 2.

100 "Chinese botanist have traced": Qiao et al., "Phylogeny and Biogeography of *Cedrus*."

102 "the largest tree ever seen at Rome": Ulrich, *Roman Woodworking*, 254.

104 "We had left the highest point": Quoted in Murray, *Pines and Firs of Japan*, 106.

110 "For better providing and furnishing of Masts": Charter of Massachusetts Bay.

126 "The roses all died": Quoted in Darlington, *Memorials of John Bartram and Humphrey Marshall*, 381.

132 "drainage of the entire area": Quoted in *First Annual Report of the Improvement of the Central Park*, Document 5, 12.

136 "more unknown plants have been found": Quoted in Rowell, "Linnaeus and Botanists in Eighteenth-Century Russia," 24.

138 "a very singular and beautiful shrub": Bartram, *Travels*, 308.

142 "[T]he Leaves [are] shaped like those of the *Lilax*": Catesby, *Natural History of Carolina, Florida, and the Bahama Islands*, 1:49.

146 "Stepping delicately out of the dark woods": Peattie, *Natural History of Trees of Eastern and Central North America*, 503.

146 "We now enter a very remarkable grove": Bartram, *Travels*, 321.

152 "Ask any resident of the South": Willard Nelson Clute, editorial, *American Botanist*, November 1922, 174.

154 "You have forgotten your Eastern origin": Lowell, *Complete Poetical Works*.

158 "The whole plant is foetid": Baxter, *British Phaenogamous Botany*, 2:123.

158 "one of the finest landscape plants," Dirr, *Manual of Woody Landscape Plants*, 355.

162 "A garden without a viburnum": Ibid., 1055.

168 "A species of chestnut": Quoted in Lack, "Discovery and Rediscovery of the Horse Chestnut," 15.

172 "tall thin tree about thirty feet high": Peet, *Trees and Shrubs of Central Park*, 329.

178 "Snow covered the ground": Michaux, "Journal of André Michaux," 96.

178 "[I]n the year 1812": Michaux, *North American Sylva*, 2:135.

180 "a tower of strength": Peet, *Trees and Shrubs of Central Park*, 29.

182 "Eight Nuts from a tree": Washington, *Di-*

The European copper beech near the boat landing on the Lake south of Hernshead begins to leaf out in early April.

aries of George Washington, 118.

182 "Bartram is extremely anxious": Jefferson, *Papers of Thomas Jefferson*, 167–168.

182 "Planted 200 pacan nuts": Jefferson, "Garden Book," 29.

184 "This resource must fail in time": Michaux, *North American Sylva* (1859), 1:107.

184 "the south side of Lake Erie": Loudon, *Arboretum et fruticetum britannicum*, 3:1438.

186 "whose nuptials": Quoted in Meyer, "Revision of the Genus *Koelreuteria*," 131–132.

186 "Since I had last the pleasure": Thomas Jefferson to Adrienne-Catherine de Noailles, comtesse de Tessé, March 27, 1811.

186 "strings of miniature Chinese lanterns": Graff, *Tree Trails in Central Park*, 106.

188 "[T]hey preserved its perfect blackness": Bartram, "Observations on the Creek and Cherokee Indians."

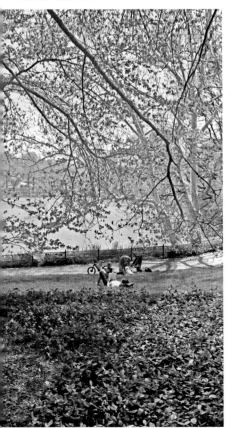

194 "one of the most appealing plants of all time": Valder, *Wisterias*, 41.

196 "Whoever has once seen the Tulip tree": Downing, *Treatise on the Theory and Practice of Landscape Gardening*, 256–257.

198 "From this tree there oozes": Castiglioni, *Viaggio*, 401.

200 "At this plantation I observed a large orchard": Bartram, *Travels*, 254.

206 "the fruit of the sycamore": Quoted in Evans, *Natural History of the Long Expedition*, 32.

206 "a huge sycamore tree": Quoted in McKinley, "Records of the Carolina Parakeet in Ohio," 8.

210 "In the Northern States": Michaux, *North American Sylva*, 1:95.

212 "is more happily named than most of its kin": Seton, *Forester's Manual*, 73.

212 "very prettily marked": Thoreau, *Wild Fruits*, 185.

212 "deserves a conspicuous place in parks and gardens": Michaux, *North American Sylva*, 1:101.

216 "This oak is one of the easiest to identify": Gibson, *American Forest Trees*, 271.

220 "The swamp white oak loves the waterside": Rogers, *Tree Book*, 205.

222 "[T]here is no acorn": Pliny the Elder, *Natural History*, chap. 8, 3.

224 "stand in copses": Cooper, *Oak Openings*, 5.

228 "combines great irregularity with beauty": Thomas Jefferson to Adrienne-Catherine de Noailles, comtesse de Tessé, October 26, 1805.

228 "He was rarely seen returning": Rayner, *Sketches of the Life, Writings, and Opinions of Thomas Jefferson*, 488.

230 "greevous and variable diseases": Quoted in Vogel, *American Indian Medicine*, 76.

236 "On the trunk and on the largest limbs": Michaux, *North American Sylva*, 2:100.

238 "one of the most beautiful trees": Dirr, *Manual of Woody Landscape Plants*, 140.

240 "This grows common": Marshall, *Arbustrum Americanum*, 25.

242 "The bark varies as much in appearance": Gibson, *American Forest Trees*, 404.

250 "The Pigeons, arriving by thousands":

Audubon, *Ornithological Biography*, 5:324.

252 "Come upon them in spring": Peet, *Trees and Shrubs of Central Park*, 289.

254 "This beautiful tree grows commonly": Quoted in "Account of the Plants Halesia and Gardenia," 930–931.

262 "The apple-tree has been celebrated": Thoreau, "Wild Apples," 513.

264 "The story of the crabapple": Watt, "Painting with Crabapples," 6.

264 "The reason people in Brilliant": Pollan, *Botany of Desire*, 9.

266 "I have found this tree": Michaux, *North American Sylva*, 2:227.

272 "The veriest Gradgrind could not be indifferent": Scidmore, *Jinrikisha Days in Japan*, Kindle ed., location 196.

272 "'Kanzan' (usually spelt 'Kwanzan' in the USA)": Bean, *Trees and Shrubs Hardy in the British Isles*, 3:403.

276 "to skim the earth": Quoted in Kamps, "New Archives."

278 "In no class of plants": Bean, *Trees and Shrubs Hardy in the British Isles*, 2:472–473.

288 "one of, if not, the world's worst trees": Dirr, *Manual of Woody Landscape Plants*, 1048.

288 "excellent, tough, durable tree": Ibid., 1042.

290 "the eagerness with which a connoisseur in pictures": Parsons & Company, "Japanese Trees," 186.

292 "This grows naturally": Marshall, *Arbustrum Americanum*, 32.

294 "the season is too far advanced for their success": Lewis and Clark, *Original Journals of the Lewis and Cark Expedition*, 7:294–295.

298 "Most of the inhabitants of the country": Michaux, *North American Sylva*, 2:14.

300 "Of all the trees able to endure our climate": Catesby, *Hortus Europae americanus*, 1.

302 "Have you ever seen in April a small tree": Miller, "All the Magnolias Worth Growing," 266.

304 "This M. Stellata": Wilson, *Aristocrats of the Garden*, 185.

308 "Hybrids come and go": Brown, *Tales of the Rose Tree*, 12.

308 "certainly the most gay": Bartram, *Travels*, 264.

Bibliography

"An Account of the Plants Halesia and Gardenia: In a Letter from John Ellis to Philip Carteret Webb." *Philosophical Transactions of the Royal Society of London* 51 (1759): 929–925.

Alvarez, Regina V. "The Ecology of the Woodlands of Central Park, New York City." Ph.D. diss., City University of New York, 2012. [ProQuest (101842069)]

Audubon, John James. *Ornithological Biography, or An Account of the Habits of the Birds of the United States of America.* 5 vols. Edinburgh: Black, 1831–1839.

Barlow, Elizabeth. *Frederick Law Olmsted's New York.* New York: Praeger, 1972.

Barnard, Edward S. *New York City Trees: A Field Guide for the Metropolitan Area.* New York: Columbia University Press, 2002.

Bartram, William. "Observations on the Creek and Cherokee Indians." 1789. *Transactions of the American Ethnological Society* 3, pt. 1 (1853).

——. *Travels of William Bartram.* Edited by Mark van Doren. New York: Dover, 1928.

——. *Travels Through North and South Carolina, Georgia, East and West Florida, the Cherokee Country, the Extensive Territories of the Muscogulges or Creek Confederacy, and the Country of the Chactaws.* Philadelphia: James & Johnson, 1791.

Baxter, W. *British Phaenogamous Botany, or, Figures and Descriptions of the Genera of British Flowering Plants.* 6 vols. Oxford: Published by the author, 1834–1843.

Bean, W. J. *Trees and Shrubs Hardy in the British Isles.* 2nd ed. 2 vols. London: Murray, 1919.

——. *Trees and Shrubs Hardy in the British Isles.* Edited by George Taylor. 8th ed., rev. 4 vols. London: Murray, 1970–1980.

Birnbaum, Charles A. *Pioneers of American Landscape Design.* New York: McGraw-Hill, 2000.

Board of Commissioners of the Central Park. *Annual Report of the Board of Commissioners of the Central Park.* New York: Bryant, 1857–1870.

Board of Commissioners of the Department of Public Parks. *Annual Report of the Board of Commissioners of the Department of Public Parks.* New York: Bryant, 1871–1874, 1898–1931.

Bonnicksen, Thomas M. *America's Ancient Forests: From the Ice Age to the Age of Discovery.* New York: Wiley, 2000.

Brown, Jane. *Tales of the Rose Tree: Ravishing Rhododendrons and Their Travels Around the World.* Boston: Godine, 2004.

Burrows, Edwin, and Mike Wallace. *Gotham: A History of New York City to 1898.* New York: Oxford University Press, 1999.

Burton, Dennis. *Nature Walks of Central Park.* New York: Holt, 1997.

Callaway, Dorothy J. *The World of Magnolias.* Portland, Ore.: Timber Press, 1994.

Campbell-Culver, Maggie. *A Passion for Trees: The Legacy of John Evelyn.* London: Transworld, 2006.

Cappiello, Paul, and Don Shadow. *Dogwoods: The Genus Cornus.* Portland, Ore.: Timber Press, 2005.

Castiglioni, Luigi. *Viaggio: Travels in the United States of North America, 1785–1787.* Translated and edited by Antonio Pace. Syracuse, N.Y.: Syracuse University Press, 1983.

Catesby, Mark. *Hortus Europae americanus: or, A Collection of 85 Curious Trees and Shrubs, the Produce of North America; Adapted to the Climates and Soils of Great-Britain, Ireland, and Most Parts of Europe, &c.* London: Printed for J. Millan, 1767.

——. *The Natural History of Carolina, Florida, and the Bahama Islands.* 2 vols. London: Printed for B. White, 1771.

The Charter of Massachusetts Bay. 1691. Lillian Goldman Law Library, Yale Law School, Yale University, New Haven, Conn.

Cohen, Paul E., and Robert T. Augustyn. *Manhattan in Maps, 1527–1995.* New York: Rizzoli, 1997.

Collingwood, G. H., and Warren D. Brush. *Knowing Your Trees.* Washington, D.C.: American Forestry Association, 1964.

Colorado Plateau Geosystems. "Paleogeography and Geologic Evolution of North America." https://www2.nau.edu/rcb7/nam.html.

Connor, Sheila. *New England Natives.* Cambridge, Mass.: Harvard University Press, 1994.

Constantine, Albert J., Jr. *Know Your Woods: A Complete Guide to Trees, Woods, and Veneers.* Edited by Harry J. Hobbs. New York: Scribner, 2005.

Cook, Clarence A. *A Description of the New York Central Park.* New York: Huntington, 1869.

Cooper, James Fenimore. *Oak Openings. Satanstoe. Mercedes of Castile.* Volume 8 of *The Works of J. Fenimore Cooper.* New York: Greenwood Press, 1969.

Cope, Edward A. *Native and Cultivated Conifers of Northeastern North America: A Guide.* Ithaca, N.Y.: Comstock, 1986.

Corner, E. J. H. *The Life of Plants.* Chicago: University of Chicago Press, 1964.

Crane, Peter R. *Ginkgo: The Tree That Time Forgot.* New Haven, Conn.: Yale University Press, 2013.

Cronon, William. *Changes in the Land: Indians, Colonists, and the Ecology of New England.* New York: Hill and Wang, 1983.

Darlington, William, ed. *Memorials of John Bartram and Humphrey Marshall, with Notices of Their Botanical Contemporaries.* Philadelphia: Lindsay & Blakiston, 1849.

DeCandido, Robert, Neil Calvanese, Regina V. Alvarez, Mathew I. Brown, and Tina Nelson. "The Naturally Occurring Historical and Extant Flora of Central Park, New York City, New York, 1857–2007." *Journal of the Torrey Botanical Society* 134 (2007): 552–569.

"Delicate Flavor of Wildness": A History of the Woodlands in Central Park. New York: Central Park Conservancy, 2012.

Dirr, Michael. *Dirr's Encyclopedia of Trees and Shrubs.* Portland, Ore.: Timber Press, 2011.

——. *Manual of Woody Landscape Plants: Their Identification, Ornamental Characteristics, Culture, Propagation, and Uses.* 5th ed. Champaign, Ill.: Stipes, 1998.

Downing, Andrew Jackson. *A Treatise on the Theory and Practice of Landscape Gardening, Adapted to North America.* New York: Wiley and Putnam, 1841.

Eastman, John. *The Book of Forest and Thicket: Trees, Shrubs, and Wildflowers of Eastern North America*. Harrisburg, Pa.: Stackpole, 1992.

Evans, Howard Ensign. *The Natural History of the Long Expedition to the Rocky Mountains (1819–1820)*. New York: Oxford University Press, 1997.

Farrar, John Laird. *Trees of the Northern United States and Canada*. Ames: Iowa State University Press, 1955.

First Annual Report of the Improvement of the Central Park, New York, January 4, 1857. New York: Baker, 1857.

Gardiner, Jim. *Magnolias: A Gardiner's Guide*. Portland, Ore.: Timber Press, 2000.

Gibson, Henry H. *American Forest Trees*. Edited by Hu Maxwell. Chicago: Hardwood Record, 1913.

Graff, M. M. *The Men Who Made Central Park*. New York: Greensward Foundation, 1982.

——. *Tree Trails in Central Park*. New York: Greensward Foundation, 1970.

Gray, Asa. *The Forest Trees of North America*. Washington, D.C.: Smithsonian Institution, 1891.

Green, Andrew Haswell. *Communication to the Commissioners of the Central Park*. New York, 1866.

Hall, Edward Hagaman. *McGown's Pass and Vicinity*. New York: American Scenic and Historic Preservation Society, 1905.

Hanley, Thomas, and M. M. Graff. *Rock Trails in Central Park*. New York: Greensward Foundation, 1976.

Harlow, William M., Elwood S. Harrar, James W. Hardin, and Fred M. White. *Textbook of Dendrology*. 8th ed. New York: McGraw-Hill, 1996.

Heckscher, Morrison H. *Creating Central Park*. New York: Metropolitan Museum of Art, 2008.

Heinrich, Bernd. *The Trees in My Forest*. New York: Cliff Street, 1997.

Hiss, Tony, and Christopher Meier. *H2O: Highlands to Ocean: A First Close Look at the Outstanding Landscapes and Waterscapes of the New York/New Jersey Metropolitan Region: Water, Land, Air, and the 14 Regional Indicators*. Morristown, N.J.: Geraldine R. Dodge Foundation, 2004.

Hoadley, R. Bruce. *Identifying Wood: Accurate Results with Simple Tools*. Newtown, Conn.: Taunton Press, 1990.

Homberger, Eric. *The Historical Atlas of New York City: A Visual Celebration of Nearly 400 Years of New York City's History*. New York: Holt, 1994.

Jackson, Kenneth T., ed. *The Encyclopedia of New York City*. New Haven, Conn.: Yale University Press, 1995.

Jefferson, Thomas. "Garden Book." Manuscript, 1766–1824. Coolidge Collection. Massachusetts Historical Society, Boston.

——. *Thomas Jefferson's Garden Book*. Edited by Edwin Morris Betts. Charlottesville: University of Virginia Press, 1999.

——. *Papers of Thomas Jefferson*. Vol. 26, *11 May to 31 August 1793*. Edited by John Catanzariti. Princeton, N.J.: Princeton University Press, 1995.

——. Thomas Jefferson Collection. Boxes 6 (August 1805–June 1807) and 8 (1810–April 1813). Missouri Historical Society Archives, St. Louis.

Jellicoe, Geoffrey, and Susan Jellicoe. *The Landscape of Man: Shaping the Environment from Prehistory to the Present Day*. 3rd ed. New York: Viking, 1995.

Johnson, Hugh. *Hugh Johnson's Encyclopedia of Trees*. 2nd ed. New York: Gallery Books, 1984.

Kamps, Alice. "New Archives Exhibit Examines Government's Effect on the American Diet." *Prologue Magazine* 43, no. 2 (2011).

Kershner, Bruce, Daniel Mathews, Gil Nelson, and Richard Spellenberg. *National Wildlife Federation Field Guide to Trees of North America*. New York: Sterling, 2008.

Kieran, John. *A Natural History of New York City*. 1959. New York: Fordham University Press, 1995.

Koeppel, Gerard T. *Water for Gotham: A History*. Princeton, N.J.: Princeton University Press, 2000.

Kowsky, Francis. *Country, Park, and City: The Architecture and Life of Calvert Vaux*. New York: Oxford University Press, 1998.

Lack, H. Walter. "The Discovery and Rediscovery of the Horse Chestnut." *Arnoldia* 61 (2000): 15–19.

Lassoie, James P., Valerie A. Luzadis, and Deborah W. Grover. *Forest Trees of the Northeast*. Ithaca, N.Y.: Cornell Cooperative Extension, 1996.

Levy-Yamamori, Ran, and Gerard Taaffe. *Garden Plants of Japan*. Portland, Ore.: Timber Press, 2004.

Lewis, Meriwether, and William Clark. *Original Journals of the Lewis and Clark Expedition, 1804–1806*. Edited by Reuben Gold Thwaites. 8 vols. New York: Dodd, Mead, 1904–1905.

Little, Charles E. *The Dying of the Trees: The Pandemic in America's Forests*. New York: Penguin, 1995.

Little, Elbert L. *National Audubon Society Field Guide to North American Trees: Eastern Region*. New York: Chanticleer, 1996.

Loeb, Robert E. "Diversity Gained, Diversity Lost: Long-term Changes in Woody Plants in Central Park, New York City, and Fairmount Park, Philadelphia." *Studies in the History of Gardens & Designed Landscapes* 30 (2010): 124–151.

Logan, William Bryant. *Oak: The Frame of Civilization*. New York: Norton, 2005.

Loudon, J. C. *Arboretum et fruticetum britannicum; or, The Trees and Shrubs of Britain*. 8 vols. London: Longman, Orme, Brown, Green, and Longman, 1838.

Lowell, Amy. *The Complete Poetical Works of Amy Lowell*. Boston: Houghton Mifflin, 1955.

Marshall, Humphrey. *Arbustrum Americanum: The American Grove, or, An Alphabetical Catalogue of Forest Trees and Shrubs, Natives of the American United States*. Philadelphia: Crukshank, 1785.

McKinley, Daniel. "Records of the Carolina Parakeet in Ohio." *Ohio Journal of Science* 77, no. 1 (1977), 3–9.

Meehan, Thomas. *The American Handbook of Ornamental Trees*. Philadelphia: Lippincott, Grambo, 1853.

Meyer, F. G. "A Revision of the Genus *Koelreuteria* (Sapindaceae)." *Journal of the Arnold Arboretum* 57 (1976): 129–166.

Michaux, André. "Journal of André Michaux, 1793–1796." In *Early Western Travels, 1748–1846*, edited by Reuben Gold Thwaites. Vol. 3. Cleveland: Clark, 1906.

Michaux, François André. *The North American Sylva; or, A Description of the Forest Trees of the United States, Canada, and Nova Scotia.* Translated by Augustus Lucas Hillhouse. Vol. 1. Paris: Printed by C. D'Hautel, 1819.

——. *The North American Sylva; or, A Description of the Forest Trees of the United States, Canada, and Nova Scotia.* Translated by Augustus Lucas Hillhouse. Vol. 2. Philadelphia: Dobson and Conrad; printed by C. D'Hautel, Paris, 1818.

——. *The North American Sylva; or, A Description of the Forest Trees of the United States, Canada, and Nova Scotia.* Translated by Augustus Lucas Hillhouse. Vol. 3. Philadelphia: Dobson and Conrad; printed by C. D'Hautel, Paris, 1819.

——. *The North American Sylva; or, A Description of the Forest Trees of the United States, Canada, and Nova Scotia.* Translated by Augustus Lucas Hillhouse. Additions by Thomas Nuttall. Notes by John Jay Smith. 3 vols. Philadelphia: Rice & Hart, 1859.

Miles, Archie. *Silva: The Tree in Britain.* London: Ebury Press, 1999.

Miller, Howard A., and Samuel H. Lamb. *Oaks of North America.* Happy Camp, Calif.: Naturegraph, 1985.

Miller, Lynden B. *Parks, Plants, and People: Beautifying the Urban Landscape.* New York: Norton, 2009.

Miller, Sara Cedar. *Central Park, an American Masterpiece: A Comprehensive History of the Nation's First Urban Park.* New York: Abrams, 2003.

——. *Seeing Central Park: The Official Guide to the World's Greatest Urban Park.* New York: Abrams, 2009.

——. *Strawberry Fields: Central Park's Memorial to John Lennon.* New York: Abrams, 2011.

Miller, Wilhelm. "All the Magnolias Worth Growing." *Garden Magazine*, June 1906, 266–269.

Mittelbach, Margaret, and Michael Crewdson. *Wild New York: A Guide to the Wildlife, Wild Places, and Natural Phenomena of New York City.* New York: Crown, 1997.

Murray, Andrew. *The Pines and Firs of Japan.* London: Bradbury & Evans, 1863.

Newsholme, Christopher. *Willows: The Genus Salix.* London: Batsford, 1992.

Niklas, Karl J. *The Evolutionary Biology of Plants.* Chicago: University of Chicago Press, 1997.

Olin, Laurie. *Across the Open Field: Essays Drawn from English Landscapes.* Philadelphia: University of Pennsylvania Press, 2000.

Olmsted, Frederick Law. *Central Park as a Work of Art and as a Great Municipal Enterprise, 1853–1895.* Vol. 2 of *Frederick Law Olmsted, Landscape Architect, 1822–1903*, edited by Frederick Law Olmsted, Jr., and Theodora Kimball. New York: Putnam, 1928.

——. *Creating Central Park, 1857–1861.* Edited by Charles E. Beveridge and David Schuyler. Vol. 3 of *The Papers of Frederick Law Olmsted*, edited by Charles Capen MacLaughlin. Baltimore: Johns Hopkins University Press, 1983.

——. *The Spoils of the Park: With a Few Leaves from the Deep-laden Note-books of "a Wholly Unpractical Man."* N.p., 1882.

Olmsted, Frederick Law, and Calvert Vaux. *Description of a Plan for the Improvement of the Central Park, "Greensward."* New York, 1858.

Orange, Herbert J. "Frederick Law Olmsted: His Horticultural Philosophy and Practice." Master's thesis, University of Delaware, 1973.

Pakenham, Thomas. *Meetings with Remarkable Trees.* New York: Random House, 1997.

——. *Remarkable Trees of the World.* New York: Norton, 2002.

Parsons & Company. "Japanese Trees." *Horticulturist and Journal of Rural Art and Rural Taste* 17 (1862): 186–187.

Parsons, Samuel, Jr. *The Art of Landscape Architecture, Its Development and Its Application to Modern Landscape Gardening.* New York: Putnam, 1915.

——. *Landscape Gardening.* New York: Putnam, 1900.

Pavord, Anna. *The Naming of Names: The Search for Order in the World of Plants.* New York: Bloomsbury, 2005.

Peattie, Donald Culross. *A Natural History of Trees of Eastern and Central North America.* Boston: Houghton Mifflin, 1991.

——. *A Natural History of Western Trees.* Boston: Houghton Mifflin, 1991.

Peet, Louis Harman. *Trees and Shrubs of Central Park.* New York: Manhattan Press, 1903.

Peterson, Russell Francis. *The Pine Tree Book: Based on the Arthur Ross Pinetum in Central Park.* New York: Brandywine Press, 1980.

Petrides, George A., and Janet Wehr. *A Field Guide to Eastern Trees: Eastern United States and Canada, Including the Midwest.* Boston: Houghton Mifflin, 1998.

Pierce, Carl Horton. *New Harlem Past and Present: The Story of an Amazing Civic Wrong, Now at Last to Be Righted.* New York: New Harlem, 1903.

Platt, Rutherford. *The Great American Forest.* Englewood Cliffs, N.J: Prentice-Hall, 1965.

——. *This Green World.* New York: Dodd, Mead, 1988.

Pliny the Elder. *Natural History.* Translated by John Bostock and Henry Thomas Riley. In *Complete Works.* Delphi Classics. Hastings, Eng.: Delphi, 2015.

Plotnik, Arthur. *The Urban Tree Book: An Uncommon Field Guide for City and Town.* New York: Three Rivers Press, 2000.

Pollan, Michael. *The Botany of Desire: A Plant's-Eye View of the World.* New York: Random House, 2001.

Pollet, Cédric. *Bark: An Intimate Look at the World's Trees.* London: Frances Lincoln, 2010.

Prance, Ghillean Tollmie, and Anne E. Prance. *Bark: The Formation, Characteristics, and Uses of Bark Around the World.* Portland, Ore.: Timber Press, 1993.

Qiao, Cai-Yuan, Jin-Hua Ran, Yan Li, and Xiao-Quan Wang. "Phylogeny and Biogeography of *Cedrus* (Pinaceae) Inferred from Sequences of Seven Paternal Chloroplast and Maternal Mitochondrial DNA Regions." *Annals of Botany* 100, no. 3 (2007): 573–580.

Rackham, Oliver. *Trees and Woodland in the British Landscape: The Complete History of Britain's*

Trees, Woods and Hedgerows. London: Phoenix Press, 2001.

Raven, Peter H., and Ray Franklin Evert. *Biology of Plants*. 4th ed. New York: Worth, 1986.

Rawolle, Charles, and Ignaz A. Pilat. *Catalogue of Plants Gathered in August and September 1857, in the Ground of the Central Park*. New York: Siebert, 1857.

Rayner, B. L. *Sketches of the Life, Writings, and Opinions of Thomas Jefferson. With Selections of the Most Valuable Portions of His Voluminous and Unrivaled Private Correspondence*. New York: Francis and Boardman, 1832.

Richens, R. H. *Elm*. Cambridge: Cambridge University Press, 1983.

Rogers, Elizabeth Barlow. *The Central Park Book*. New York: Central Park Task Force, 1977.

———. *Landscape Design: A Cultural and Architectural History*. New York: Abrams, 2002.

———. *Rebuilding Central Park: A Management and Restoration Plan*. Cambridge, Mass.: MIT Press, 1987.

Rogers, Julia Ellen. *The Tree Book: A Popular Guide to a Knowledge of the Trees of North America and to Their Uses and Cultivation*. New York: Doubleday, Page, 1905.

Rosenzweig, Roy, and Elizabeth Blackmar. *The Park and the People: A History of Central Park*. Ithaca, N.Y.: Cornell University Press, 1992.

Ross, Prudence. *The John Tradescants: Gardeners to the Rose and Lily Queen*. London: Peter Owen, 2006.

Rowell, Margery. "Linnaeus and Botanists in Eighteenth-Century Russia." *Taxon* 29 (1980): 15–26.

Rybczynski, Witold. *A Clearing in the Distance: Frederick Law Olmsted and America in the Nineteenth Century*. New York: Scribner, 1977.

Sanders, Brad. *Guide to William Bartram's 'Travels': Following the Trail of America's First Great Naturalist*. Athens, Ga.: Fevertree Press, 2002.

Sanderson, Eric W. *Mannahatta: A Natural History of New York City*. New York: Abrams, 2009.

Sargent, Charles Sprague, and Charles Edward Faxon. *Manual of the Trees of North America (exclusive of Mexico)*. 2nd ed. 2 vols. Reprint. New York: Dover, 1965.

Schama, Simon. *Landscape and Memory*. New York: Knopf, 1995.

Schuberth, Christopher J. *The Geology of New York City and Environs*. New York: Natural History Press, 1968.

Scidmore, Eliza Ruhamah. *Jinrikisha Days in Japan*. New York: Harper, 1891.

Seton, Ernest Thompson. *The Forester's Manual; or, The Forest Trees of Eastern North America*. Garden City, N.Y.: Doubleday, Page, 1912.

Shorto, Russell. *The Island at the Center of the World: The Epic Story of Dutch Manhattan and the Forgotten Colony That Shaped America*. New York: Doubleday, 2004.

Sibley, David. *The Sibley Guide to Trees*. New York: Knopf, 2009.

Spongberg, Stephen A. "The First Japanese Plants for New England." *Arnoldia* 50, no. 3 (1990): 2–11.

———. *A Reunion of Trees: The Discovery of Exotic Plants and Their Introduction into North American and European Landscapes*. Cambridge, Mass.: Harvard University Press, 1990.

Stevenson, Elizabeth. *Park Maker: A Life of Frederick Law Olmsted*. New York: Macmillan, 1977.

Stokes, I. N. Phelps. *The Iconography of Manhattan Island, 1498–1909: Compiled from Original Sources and Illustrated by Photo-Intaglio Reproductions of Important Maps, Plans, Views, and Documents in Public and Private Collections*. 6 vols. New York: Dodd, 1915–1928.

Stone, William L., trans. *Letters of Brunswick and Hessian Officers During the American Revolution*. Albany, N.Y.: Munsell, 1891.

Stuart, David C. *The Plants That Shaped Our Gardens*. Cambridge, Mass.: Harvard University Press, 2002.

Thomas, Graham Stuart. *Trees in the Landscape*. London: Cape, 1983.

Thomas, Peter. *Trees: Their Natural History*. Cambridge: Cambridge University Press, 2000.

Thoreau, Henry David. "Wild Apples." *Atlantic Monthly*, November 1862, 513–526.

———. *Wild Fruits: Thoreau's Rediscovered Last Manuscript*. Edited by Bradley P. Dean. New York: Norton, 2000.

Ulrich, Roger B. *Roman Woodworking*. New Haven, Conn.: Yale University Press, 2007.

Valder, Peter. *Wisterias: A Comprehensive Guide*. Portland, Ore.: Timber Press, 1995.

Van Gelderen, D. M., and J. R. P. van Hoey Smith. *Conifers: The Illustrated Encyclopedia*. Vol. 1, *A–K*. Portland, Ore.: Timber Press, 1996.

———. *Conifers: The Illustrated Encyclopedia*. Vol. 2, *L–Z*. Portland, Ore.: Timber Press, 1996.

Van Gelderen, D. M., P. C. de Jong, and H. J. Oterdoom. *Maples of the World*. Portland, Ore.: Timber Press, 1994.

Vogel, Virgil J. *American Indian Medicine*. Norman: University of Oklahoma Press, 1970.

Washington, George. *The Diaries of George Washington*. Vol. 4, *1784–June 1786*. Edited by Donald Jackson and Dorothy Twohig. Charlottesville: University of Virginia Press, 1978.

Watt, Fiona. "Painting with Crabapples." 2003. New York City Department of Parks & Recreation.

Wessels, Tom. *Reading the Forested Landscape: A Natural History of New England*. Woodstock, Vt.: Countryman Press, 1997.

Willis, K. J., and J. C. McElwain. *The Evolution of Plants*. New York: Oxford University Press, 2002.

Wilson, Ernest Henry. *Aristocrats of the Garden*. New York: Doubleday, Page, 1917.

Winn, Marie. *Central Park in the Dark: More Mysteries of Urban Wildlife*. New York: Farrar, Straus and Giroux, 2008.

———. *Red-Tails in Love: A Wildlife Drama in Central Park*. New York: Pantheon, 1998.

Yates, Sharon Fass, ed. *American Nature: Our Intriguing Land and Wildlife*. Pleasantville, N.Y.: Reader's Digest, 1997.

Young, James A., and Cheryl G. Young. *Seeds of Woody Plants in North America*. Portland, Ore.: Dioscorides Press, 1992.

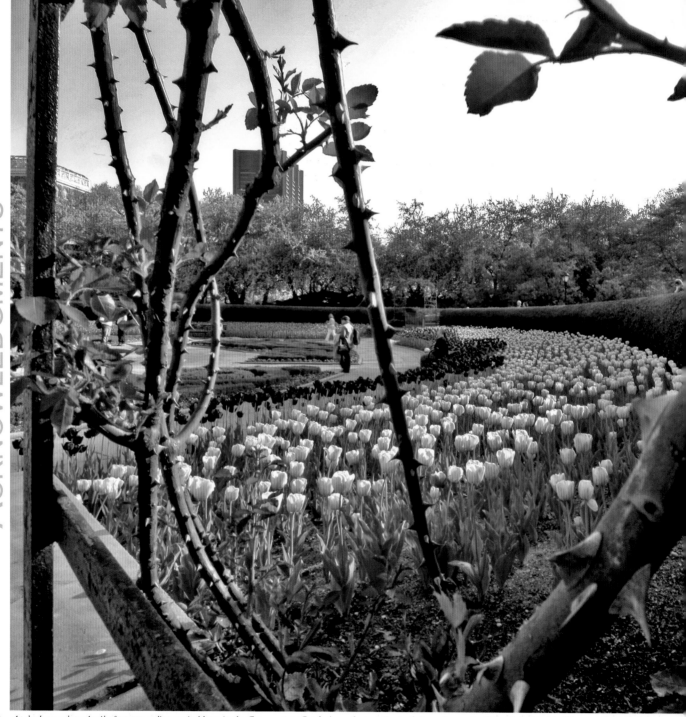

At dusk on a late April afternoon, tulips are in bloom in the Conservatory Garden's northern section and, beyond, a crab apple allée is decked with a mantle of pink bossoms.

Given enough space, authors often thank nearly everyone under the sun. I don't plan to be an exception, especially since I am 80 years old and may not have many more opportunities to thank people. I'll start at the beginning with my parents. Of all the things they gave me besides lots of love was lots of free time—free time to wander through the woods on my own, to tinker with old radios, to take pictures with a box camera, to climb trees, to fish in Trinity Pass Lake, to find ingenious ways to get in trouble. I look at young children today as they rush from one planned activity to another, and I think how different my childhood was. Summer vacations were an endless succession of days buzzing with cicadas, days during which one could do pretty much whatever one pleased.

But on to much more recent times. As a book editor, I was lucky to have employers and bosses like Bob Cousins, Gorton Carruth, John Pope, and Sharon Yates. They gave me the priceless opportunity to edit books on natural history, to spend literally years working on topics that I loved. It was as if I were taking a string of graduate courses on ecology, entomology, marine biology, and botany and getting paid for it.

I also have been extraordinarily lucky to have been accompanied by wives and children who have supported me and often shared my interests. It was my first wife, Carolyn Maple Barnard, who offered sage advice throughout my career in publishing and finally gave me the opportunity to pursue my interests into retirement. Along the way, my children and their partners— Bonnie and Roberto, Jonathan and Jessie, Stephen and Nava, and Abigail and Chris—and my grandchildren—Natalie, Ted, Chloe, Emily, Ori, and Quinn—have been ever interested, involved, and ready to help. And in recent years, I had the ex-traordinary good fortune to have married Pauline Gray, who has given me space and time to work on this book and brought with her new, very congenial, and helpful family members—Annabel Briger, Nicolò de Vergottini, and their son, Emilio; Austin Keyes and Anne Ternes; and Catriona and Sam Briger and their children, Oliver and Hazel. Catriona, with her knowledge of plants and landscape design, has become an indispensable partner in my book projects.

I may never have undertaken my first retirement book project, *New York City Trees*, if I had not met Fiona Watt and Jennifer Greenfeld of the New York City Department of Parks & Recreation. A large portion of that book's introductory essay was written by Fiona and is now embedded in the early pages of this book. Fiona said it well, and I didn't see any reason to change anything. Jennifer was a great editor of that book and has been a good friend since its publication in 2001. Other people at Parks & Recreation who have been tremendously helpful include Mike Feller and Adrian Benepe, who was very generous on so many occasions. Another person I must thank heartily for getting me started on my sylvan retirement path is Robin Smith, who liked the pages of *New York City Trees* as soon as he saw them and persuaded his colleagues at Columbia University Press to publish the book. Patrick Fitzgerald soon took over Robin's role at Columbia and has been my advocate and adviser there for 10 years, which means that he has had to put up with my frequent moans and groans and keep me on track. Irene Pavitt, Patrick's colleague and one of the finest editors I have ever encountered, caught countless inconsistencies and an enormous number of errors—including some that could have been very embarassing—making my text read much more clearly and smoothly. Many friends also continually offered advice; newspaper clippings; their presence at lectures, walks, and presentations; and their cash for books and maps. Among them are Benjamin Swett, an expert on New York City's trees; Curtice Taylor, a peerless landscape photographer; Richard Milner, an expert on Charles Darwin; Linda Corson, a fine landscape designer; Sally Benton, a distinguished portrait painter; Tony Aiello, the Gayle E. Maloney Director of Horticulture and Curator at the Morris Arboretum; and David Hewitt, president of the Philadelphia Botanical Club; as well as Odyssia Quadrani, Marge and Jim Ternes, Susan and Bill Morris, Linda and John Young, Syd and Peter Uhry, Evi and Peter Kraus, Monika and Brian Dillon, Karen and Alan Hartnick, Jody and Tom O'Rourke, Isabelle and Bernard Manuel, Helen and Michael Goodkin, and Susan and Rob Fleming. A distinguished landscape architect, Rob was kind enough to read and comment on many of this book's pages during the 10 years that I have been working on it. Daniel Karpen, an expert on Long Island old-growth trees, also took the time to read many pages and provide helpful comments. Ron Blakey, one of the world's experts on continental drift, very kindly read and commented on my geological account of Manhattan. Neil Pedersen, an expert on eastern old-growth forests, was always available for sage advice and support.

For this project I depended heavily, of course, on my friend and co-author Neil Calvanese. He read and critiqued every page, providing innumerable suggestions, additions, and corrections. Our friendship started over 18 years ago when I approached Neil for help with *New York City Trees*. He pointed to an oversize tome on his office bookshelf (Michael Dirr's *Man-*

ual of *Woody Landscape Plants*) and suggested that if I was writing a guidebook on trees, I had better become familiar with Dirr. Another close colleague whose help was absolutely essential during the writing of this book is Ken Chaya, whose map plays such a major role. Without his map and his work of four years creating and revising it, this book would be far less useful and accurate. The two men who know the most about the trees of Central Park as they exist now, in the early 21st century, are without doubt Neil and Ken. Another friend with deep knowledge of the park who was tremendously generous with his time is Richard Lieberman.

Finally, I must thank the amazing staff of the Central Park Conservancy, starting with its inspiring founder and guiding hand, Elizabeth Barlow Rogers. She has always been tremendously thoughtful, kind, and forthcoming. A gifted historian of landscape design, she wrote a book that I consider the single greatest work on the topic—*Landscape Design: A Cultural and Architectural History*.

This book likely would never have been written if Doug Blonsky, president of the Central Park Conservancy, had not early on agreed to put the authority of the Central Park Conservancy behind it. Fortunately for Neil and me, he gave it his blessing, and we have tried to live up to his expectations. Another inspiration for both of us has been the conservancy's brilliant photographer and historian, Sara Cedar Miller. Her books are the most authoritative and beautiful works on Central Park. She offered help from the very inception of this project and always supplied valuable assistance whenever we needed it. Many other staff members have gone out of their way to help with this book. Six that come immediately to mind are Diane Schaub, Lane Addonizio, Regina Alvarez,

Maria Hernandez, Russell Fredericks, and Dennis Burton, but there are dozens of others. I thank them all for their help and dedication to this amazing park.

In conclusion, I must thank the many individuals whose photographs and other illustrations grace this book. There are far too many to list here; all of them are included in the picture credits. However, ten who were especially generous deserve special mention: Peter P. Grima, Kathryn W. Armstrong, Steve Baskoff, Sara Cedar Miller, Maria Hernandez, Dr. Henry Domke, Karren Wcisel, Jim Conrad, Zachary Y. Wang, Robert Klips, and John Gwaltney.

I'm sure that there are many others whom I have inadvertently forgotten to thank due to my increasingly faulty memory. To them, I tender my sincerest apologies.

Edward Sibley Barnard

There are so many people to thank. I could not possibly include them all here, but I will name a few of those who contributed to the writing of this book and to the stewardship of some of the greatest assets of New York City—the trees of Central Park.

First, I would like to thank Doug Blonsky, who backed this project from the moment Ned Barnard brought the idea to him. Doug has been a close friend, a colleague, and an inspired leader who has made the park's reputation for good management internationally recognized. Doug has felt that the preservation of this New York City treasure is best achieved by bringing the park's attributes to the forefront of public awareness. We hope that this book serves that purpose.

I met Ned when he was writing *New York City Trees*. He and I spent many an hour walking through Central Park and

sharing observations, insights, and ideas about the park and its trees. When he approached Doug with the idea for this book, Doug urged me to join in and help. There was never any question that Ned was the perfect person to write a book about the trees of Central Park. Not being a writer, I was not certain about what my role would be, but Ned insisted that I could make a vitally important contribution. Working with him has proved to be a great experience.

Russell Fredericks, as chief of operations, kept the park's day-to-day operations running smoothly when I was working on the book. Maria Hernandez, John Dillon, Vanthon Keo, and Gal Lavid helped track down details about particular trees in the park. Michael Riccio assisted with the gathering of information from our tree database. Hannah Ryan transcribed my notes, and Nicole Sexton provided edits. Caroline Greenleaf, my editor-in-chief, worked with me throughout the project, critiquing and refining my ideas and words.

My very special thanks go to Elizabeth Barlow Rogers, founder and first administrator of the Central Park Conservancy, for hiring me as an arborist in the fledgling years of the conservancy. It was then that my love affair with the trees of the park began.

Many thanks also go to the entire staff of the Central Park Conservancy, too many people to name individually here, who have persevered over the years to make Central Park as beautiful as it is.

And finally, to my wife, Eileen, I extend my deepest gratitude for her patience and persistence in keeping me on track, especially after I retired from Central Park.

Picture Credits

All photographs and illustrations are by Edward Sibley Barnard except for the following.

The Landscapes

14 (*bottom left*): © Ron Blakey, Colorado Plateau Geosystems.

14–15 (*bottom*): "Nicolls Map of Manhattan, 1664–1668," Dunreath Publishing Co., 1890, Norman B. Leventhal Map Center, Boston Public Library.

15 (*top*): "Manatus Map of Manhattan, Manatus gelegen op de Noot Rivier, 1639," Library of Congress.

16–17 (*bottom*): "B. F. Stevens's Facsimile of the Unpublished British Head Quarters Coloured Manuscript Map of New York & Environs (1782)," a reproduction from the original drawings in the War Office, London, 1900, author's collection. Stokes commented on this version of the British Headquarters Map: "The original of this fine map of Manhattan Island, made during the English occupation, is in so bad a state of repair that authorities at the War Office recommended that the reproduction be made from the facsimile lithograph published in 1900 by Mr. B. F. Stevens of London. This facsimile is in twenty-four sheets, and in making the reproduction it was thought best to obliterate the joints and to rearrange somewhat the position of the descriptive matter. The reference numbers have been enlarged so as to be more distinctly discernible (*Iconography of Manhattan Island*, 1:363).

17 (*top*): "View of Harlaem from Morisania in the province of New York Septemr. 1765," Miriam and Ira D. Wallach Division of Art, Prints, and Photographs, New York Public Library.

18 –19 (*bottom*): J. H. Colton, "Topograpical map of the City and County of New-York, and the adjacent country: with views in the border of the principal buildings, and interesting scenery of the island," Norman B. Leventhal Map Center, Boston Public Library.

19 (*top*): Randel Farm Map, Manhattan Borough President's Office.

20 (*bottom left*): "View of the crossing in connection with 8th Ave. and 96th St. October 18, 1862," Rare Book Division, New York Public Library.

20–21 (*bottom*): "Map of the Central Park, January 1st, 1870," Board of Commissoners of the Central Park, *Thirteenth Annual Report, for the Year Ending December 31, 1869*.

21 (*top*): "Map Showing the Original Topography of the Site of the Central Park with a Diagram of the Roads and Walks now under construction, 1859," Board of Commissioners of the Central Park, *Second Annual Report, January, 1859*.

21 (*middle*): "Map of the Central Park Showing the Progress of the Work up to January 1st 1862," Board of Commissioners of the Central Park, *Fifth Annual Report, January, 1862*.

22–23: Copyright © 2013 Ken Chaya.

24–25: Copyright © 2013 Ken Chaya.

26 (*bottom*): "Central Park, New York City, bird's-eye view," Library of Congress.

28 (*bottom*): "View Northeast across Pond from Park Border near 59th Street and Sixth Avenue," Olmsted, *Creating Central Park*.

29 (*bottom*): "Greensward Plan for Central Park, presentation board 'Effect Proposed' No. 1 from Point A (view at 5th avenue entrance), 1858," New York City Municipal Archives.

30–31: Copyright © 2013 Ken Chaya.

32 (*bottom*): "The Mall, Central Park" (1902), Library of Congress.

34 (*bottom*): "Sheep in Central Park, New York City," Library of Congress.

36 (*bottom*): "View of the arbor on the east-side near 5th Avenue," *Central Park Album* (1862), New York Public Library.

38–39: Copyright © 2013 Ken Chaya.

40 (*bottom*): "Central Park, skating, distant view, New York, NY," Library of Congress.

42 (*bottom*): Frederick Law Olmsted and Calvert Vaux, "Central Park Competition Entry No. 33: The Greensward Plan of the Central Park" (1858), New York City Department of Parks & Recreation.

46 (*bottom left*): "View Showing Plantings in the Vicinity of Schiller Statue," Olmsted, *Creating Central Park*.

46 (*bottom right*): "New York City—Central Park: The Ramble," Library of Congress.

52–53: Copyright © 2013 Ken Chaya.

54 (*bottom*): "The City of New York. Will L. Taylor, chief draftsman," Library of Congress.

58–59: Copyright © 2013 Ken Chaya.

62–63: Copyright © 2013 Ken Chaya.

70–71: Copyright © 2013 Ken Chaya.

72 (*bottom*): "One of a pair of photographs of the site of Central Park looking south from 110th Street, probably taken in the late 1850's," Barlow, *Frederick Law Olmsted's New York*.

73 (*bottom left*): "Another view of the site at the same time by photographer G. Rockwood [George G. Rockwood]," Barlow, *Frederick Law Olmsted's New York*.

73 (*bottom right*): "Block House War of 1812," Cook, *Description of the New York Central Park*.

74 (*bottom*): Copyright © 2009 Central Park Conservancy.

75 (*bottom*): Copyright © 2009 Ken Chaya.

76 (*bottom*): "Sanitary and topographical map of the City and Island of New York; prepared for the Council of Hygiene and Public Health of the Citizens Association under the direction of Egbert L. Viele, Topographical Engineer," New York Public Library.

80 (*bottom*): "The Conservatories, Central Park," Board of Commissioners of the Department of Public Parks, *Annual Report for the Year 1902*.

The Tree Guide

86 (*top left*): Audubon, "Cedar bird, or Cedar Wax-wing. 1. Male. 2. Female. (Red Cedar. [Juniperus Virginiana])," New York Public Library.

88 (*top left*): "Zhan Wang's portrait (1979)," Guofan Shao et al., "Zhan Wang (1911–2000)," *Taxon* 49 (2000).

90 (*top left*): "Mr. David Douglas," *Curtis's Botanical Magazine*, n.s., 10 (1836), Biodiversity Heritage Library.

92 (*top left*): Copyright © 2013 Ken Chaya.

94 (*top left*): Otto Wilhelm Thomé, *Flora of Germany, Austria, and Switzerland* (Gera, 1885).

96 (*top left*): "Hemlock Spruce (Abies canadensis)," New York Public Library.

96 (*bottom, inset*): U.S. Department of Agriculture.

99 (*bottom right*): Edward Lear, *The Cedars/Lebanon, May 1858*, private collection.

102 (*top left*): Aylmer Bourke Lambert, *A Description of the Genus Pinus* (London: Printed for J. White, 1803).

102 (*bottom right middle*): Photo by Rüdiger Kratz/CC BY.

102 (*middle right*): Photo by Dr. Amadej Trnkoczy, Wildscreen Arkive.

108 (*top left*): "Amphorae stacking. Suggestion on how amphorae may have been stacked on a galley," photo by Ad Meskens/CC BY.

110 (*top left*): *The True Portrait of His Majesty's Royal Ship the Sovereign of the Seas*, National Maritime Museum, Greenwich, London.

112 (*top left*): "Nathaniel Wallich, Lithograph by T. H. Maguire, 1849," Welcome Trust/CC BY.

112 (*bottom right*): Photo by Atif Gulzar/CC BY.

112 (*bottom right, inset*): Photo by Soham Pablo/CC BY.

114 (*top left*): Musikinstrumenten-Museum, Berlin, photo by Husky/CC BY.

116 (*top left*): "C. C. Parry M.D." [frontispiece], *Proceedings of the Davenport Academy of Natural Sciences* 6 (1897).

116 (*bottom middle*): Photo by J. J. Harrison/CC BY.

118 (*top left*): User Tangopaso (transfer to Commons)/CC BY.

118 (*bottom middle*): Photo by Imc at en.wikipedia/CC BY.

122 (*top left*): James Edward Smith, *English Botany* (London: Printed by J. Davies, 1790–1813).

124 (*top left*): "Yokohama Nursery Co., Ltd. *Maples of Japan*," Smithsonian Institution Libraries.

126 (*top left*): Abraham Munting, *Accurate Description of Terrestrial Plants* (Leyden, 1696).

128 (*top left*): Musikinstrumenten-Museum, Berlin, photo by Husky/CC BY.

130 (*top left*): Gray, *Forest Trees of North America*.

132 (*top left*): John Torrey, *A Flora of the State of New-York* (Albany: Carroll and Cook, 1843).

132 (*bottom right*): Courtesy of Peter P. Grima.

134 (*top left*): Michaux, *North American Sylva*.

136 (*top left*): Photo by Frank Schulenburg.

138 (*top left*): Bartram, *Travels Through North and South Carolina, Georgia, East and West Florida*.

140 (*top left*): Jean-Baptiste Van der Hulst, *Queen of the Netherlands, Anna Pavlovna of Russia (1795–1865)*, private collection.

140 (*top right*): Englebert Kaempfer, *Amoenitatum exoticarum politico-physico-medicarum fasciculi quinque quibus* (Lemgo, 1712).

142 (*top left*): Catesby, *Natural History of Carolina, Florida, and the Bahama Islands*.

144 (*top left*): William Gardener, "Robert Fortune and the Cultivation of Tea in the United States," *Arnoldia* 31 (1971).

146 (*top left*): Catesby, *Natural History of Carolina, Florida, and the Bahama Islands*.

148 (*top left*): Philipp Franz von Siebold and Joseph Gerhard Zuccarini, *Flora Japonica* (Leiden, 1875).

148 (*bottom right, inset*): Photo by Dunrakin/CC BY.

150 (*middle right*): Photo by and © 2007 Derek Ramsey (Ram-Man), used under CC BY/original cropped.

152 (*top left*): "Indian Lagerstromia, Crape Myrtle, Crepe Flower," *Curtis's Botanical Magazine* 12 (1798), University of Iowa Libraries.

154 (*top left*): Joseph Blackburn, *Benning Wentworth*, New Hampshire State Parks.

154 (*bottom middle above*): Photo by US Nessie/CC BY.

154 (*bottom middle below*): Photo by Kathryn W. Armstrong, website "Summer Setting."

154 (*bottom right*): Photo by Marisa DeMeglio from NYC, USA/CC BY.

156 (*top left*): "Cercidiphyllum japonicum," *Addisonia* 11 (1926), Biodiversity Heritage Library.

156 (*right, second from bottom*): Photo by Paul Meyer, Morris Arboretum.

158 (*top left*): Baxter, *British Phaenogamous Botany*.

158 (*top right, inset*): *Euonymus fortunei* flower, photo by John R. Gwaltney, website "Southeastern Flora."

160 (*top left*): "Mr. William Forsyth, head-and-shoulders portrait," Library of Congress.

162 (*top left*): Philipp Franz von Siebold and Joseph Gerhard Zuccarini, *Flora Japonica* (Leiden, 1875).

166 (*top left*): Michaux, *North American Sylva*.

168 (*top left*): Pietro Andrea Mattioli, *Commentarii in libros sex Pedacii Dioscoridis De materia medica* (Venice: Ex Officina Valgrisiana, 1565).

170 (*top left*): "[Babe Ruth, full-length portrait, standing, facing slightly left, in baseball uniform, holding baseball bat] /Irwin, La Broad, & Pudlin," Library of Congress.

170 (*middle right*): "Inflorescensce of *Fraxinus pennsylvanica*," photo by Kenraiz/ CC BY.

172 (*top left*): Rybinsk State History, Architecture and Art Museum-Preserve, Rybinsk, Russia.

172 (*bottom middle*): Photo by Kurt Stüber/CC BY.

174 (*top left*): Betty Smith, *A Tree Grows in*

Brooklyn (1943), Herman Finkelstein Collection, Rare Book and Special Collections Division, Library of Congress.

178 (*top left*): Michaux, *North American Sylva.*

180 (*top left*): Michaux, *North American Sylva.*

182 (*top left*): Robert Edge Pine, *George Washington*, National Portrait Gallery, Smithsonian Institution.

184 (*top left*): Michaux, *North American Sylva.*

184 (*bottom right*): Photo © Steve Baskauf (http://bioimages.vanderbilt.edu).

184 (*bottom right, inset*): Photo © Steve Baskauf (http://bioimages.vanderbilt.edu).

186 (*top left*): Universität Tübingen, Universitätsbibliothek.

188 (*top left*): Catesby, *Natural History of Carolina, Florida, and the Bahama Islands.*

190 (*top left*): "Le plus ancien arbe de Paris, un robinier planté en 1601 par Robin," photo by Ordifana75/CC BY.

192 (*top left*): Rembrandt Peale, *David Hosack*, photo by P. S. Burton/CC BY.

194 (*top left*): "Glycine sinensis Chinese Glycine [Wisteria sinensis]," *Curtis's Botanical Magazine* 46 (1819), Biodiversity Heritage Library.

195: Sara Cedar Miller, Central Park Conservancy.

196 (*top left*): Michaux, *North American Sylva.*

198 (*top left*): Michaux, *North American Sylva.*

200 (*top left*): "Morus alba L. [as Morus alba]," Johann Weimann, *Phytanthoza iconographia,* vol. 3 (Regensburg: Lentz and Newbauer, 1742), Biodiversity Heritage Library.

202 (*bottom right*): Courtesy of New York City Department of Parks & Recreation.

204 (*top left*): Thomas de Critz (attr.), *John Tradescant the Younger,* Ashmolean Museum, University of Oxford.

206 (*top left*): Audubon, "Carolina Parrot, or Parrakeet. 1. 2. Males. 3. Female. 4. Young. (Cockle bur [Xanthium Strumarium])," New York Public Library.

210 (*top left*): Ninth-plate daguerreotype of Henry David Thoreau by Benjamin D. Maxham (1856), retouched and modified by Scewing, original at National Portrait Gallery, Smithsonian Institution.

210 (*bottom right, inset*): Photo © Steve Baskauf (http://bioimages.vanderbilt.edu).

212 (*top left*): "Ernest Thompson Seton, head-and-shoulders portrait, facing slightly left," Library of Congress.

214 (*top left*): Gibson, *American Forest Trees.*

216 (*top left*): "Cornelius Weygandt (1871–1957)," University Archives Digital Image Collection, University of Pennsylvania.

216 (*bottom right*): Photo by Dr. Henry Domke, website "Nature Art for Healthcare."

216 (*bottom right, inset*): Photo by Jim Conrad, website "Backyard Nature."

218 (*top left*): Charles De Wolf Brownell, *The Charter Oak,* Wadsworth Atheneum, Hartford, Connecticut.

218 (*bottom right*): Photo by Karren Wcisel, website "Tree Topics."

220 (*top left*): "François André Michaux daguerreotype, 1851," Gray Herbarium Archives, Harvard University Library.

220 (*bottom right*): Photo by Karren Wcisel, website "Tree Topics."

222 (*top left*): "John Claudius Loudon," National Portrait Gallery, London.

224 (*top left*): "James Fenimore Cooper," National Archives, College Park, Maryland.

226 (*top left*): Issac Fuller, *King Charles II and Colonel William Carlos in the Royal Oak,* National Portrait Gallery, London.

226 (*bottom middle*): "Picture of the Major Oak in Sherwood Forest," photo by Marcin Floryan/CC BY.

228 (*top left*): Rembrandt Peale, *Thomas Jefferson,* New-York Historical Society.

230 (*top left*): Michaux, *North American Sylva.*

232 (*top left*): Deborah Passmore, *Amelanchier canadensis var. obovalis,* Pomological Watercolor Collection, U.S. Department of Agriculture, National Agricultural Library.

236 (*top left*): Michaux, *North American Sylva.*

238 (*top right*): Copyright © 2013 Ken Chaya.

240 (*top left*): Michaux, *North American Sylva.*

242 (*top left*): Photo by Bruce Marlin/CC BY.

242 (*bottom middle, inset*): Photo by Sten Porse/CC BY.

244 (*top left*): Otto Wilhelm Thomé, *Flora of Germany, Austria, and Switzerland* (Gera, 1885).

246 (*top left*): "Hawthorn, Saint Mars sur la Futaie, Feb 2010," photo by Ptelea/PD.

250 (*top left*): Audubon, "Passenger Pigeon. 1. Male. 2. Female," New York Public Library.

252 (*top left*): Downing, *Treatise on the Theory and Practice of Landscape Gardening.*

254 (*top left*): George Knapton (attr.), *Stephen Hales,* Corpus Christi College, University of Cambridge.

256 (*top left*): "John Burroughs, author and naturalist, full-length portrait, standing, facing front, outside his home," Library of Congress.

258 (*bottom middle*): Photo by Jim Conrad, website "Backyard Nature."

258 (*bottom right*): Photo by Zachary Y. Wang.

262 (*top left*): Lucas Cranach the Elder, *Adam and Eve,* Courtauld Gallery, London.

264 (*top left*): Michaux, *North American Sylva.*

266 (*top left*): Michaux, *North American Sylva.*

266 (*bottom middle right*): Photo by Karren Wcisel, website "Tree Topics."

266 (*bottom right, inset*): U.S. Department of Agriculture.

269 (*bottom right, inset*): Anchorage Museum of History and Art.

269 (*bottom right*): "Hand-colored photo of cherry trees in Japan, by Eliza Scidmore (Source: National Geographic)," website "A Great Blooming."

270 (*top left*): Audubon, "Wood thrush. A. Wilson. Turdus Melodus. La Grivette d'Amerique de Buffon," Harvard University.

272 (*top left*): "Ozaki, Yukio," National Diet Library, Tokyo.

274 (*top left*): Hiroshige, *Koganei hashi sekisho*

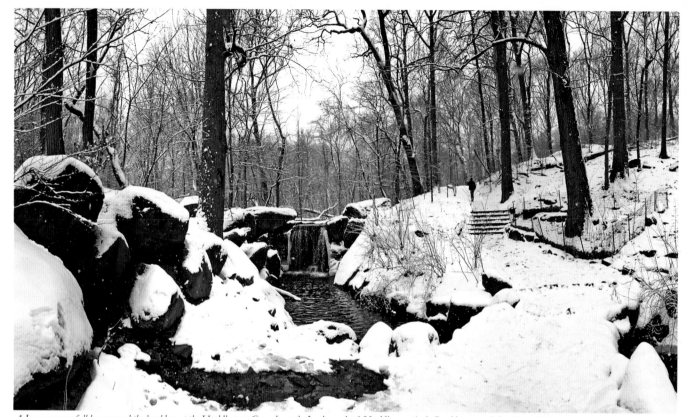

A January snowfall has covered the boulders at the Huddlestone Cascade on the Loch north of Huddlstone Arch. Boulders are piled at three places along the Loch to create cascades.

(*Evening Glow at Koganei Bridge*), British Museum, London.

276 (*top left*): "Portrait of Frank N. Meyer," U.S. Department of Agriculture, National Agricultural Library.

278 (*top left*): "Salix alba," William Woodville, *Medical Botany*, vol. 5 (London: Bohn, 1832).

280 (*top left*): "Wood carving by Grinling Gibbons in the apartments of King William III at Hampton Court Palace," photo by Camster2/CC BY.

280 (*middle right*): Maria Hernandez, Central Park Conservancy.

284 (*top left*): Michaux, *North American Sylva*.

286 (*top left*): Francesco Melzi, *Vertumnus and Pomona*, Gemäldegalerie der Staatlichen Museen zu Berlin.

288 (*top left*): "Wind on the Mountain is a

Chinese Elm (Ulmus parvifolia) on display at the North Carolina Arboretum," photo by Ken Thomas.

290 (*top left*): "George Rogers Hall (1826–1899) of Bristol, Rhode Island, the physician turned trader who first sent living plants in Wardian cases from Japan directly to New England. (Archives of the Arnold Arboretum)," Stephen A. Spongberg, "Exploration and Introduction of Ornamental and Landscape Plants from Eastern Asia," in *New Crops*, ed. J. Janick and J. E. Simon (New York: Wiley, 1993).

292 (*top left*): John W. Harshberger, *The Botanists of Philadelphia and Their Work* (Philadelphia: David, 1899).

294 (*top left*): Charles Willson Peale, *Meriwether Lewis*, Independence National Historical Park, Smith-

sonian Center for Learning and Digital Access.

294 (*bottom right*): Photo © Steve Baskauf (http://bioimages.vanderbilt.edu).

298 (*top left*): Michaux, *North American Sylva*.

300 (*top left*): Catesby, *Hortus Europae americanus*, Biodiversity Heritage Library.

302 (*top left*): Pierre-Joseph Redouté, *Choix des plus belles fleurs: et des plus beaux fruits* (Paris: Panckoucke, 1833), Biodiversity Heritage Library.

304 (*top left*): "Ernest Wilson with walking stick standing outside inn with wooded hillsid," Harvard University Library.

308 (*top left*): "Rhododendron catawbiense Michx.," *Curtis's Botanical Magazine* 40 (1814) (www.plantillustrations.org).

Index

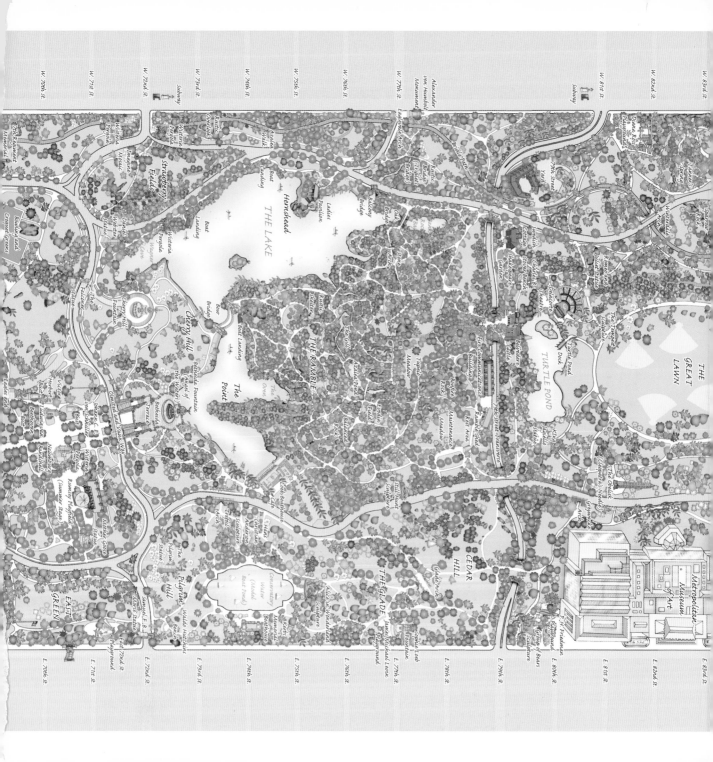

Central Park

Columbus Circle

7th Avenue

Central Park South (West 59th Street)

Avenue of the Americas

Pulitzer Fountain

E. 59th St.

Maine Monument

Merchants' Gate

West Drive

Central Park West

W. 61st St.
W. 62nd St.
W. 63rd St.
W. 64th St.
W. 65th St.
W. 66th St.
W. 67th St.
W. 68th St.

Subway

Tavern on the Green

Adventure Playground

Bridle Path

Dalehead Arch

Greyshot Arch

Pine Bank Arch

Heckscher Playground

Umpire Rock

Spur Rock

Heckscher Ballfields

Dupont Arch

Drip Rock

Diapered Rock

Diapered Arch

SHEEP MEADOW

62nd Street Transverse

Balto Statue

Ballplayer's House

Center Drive

Carousel

Cop Cot

Glenn's Checkers House

Dairy Visitor Center

Playmates Arch

The Dairy

The Indian Hunter Statue

Lilac Walk

Naturalists' Gate

Nell Singer Lilac Walk

Mother Goose Statue

Mall Playground

William Shakespeare Statue

Robert Burns Statue

Sir Walter Scott Statue

Fitz-Greene Halleck Statue

Columbus Statue

Willowdell Arch

Denesmouth Arch

THE MALL

THE DENE

Summerhouse Rustic Shelter

107th Infantry Memorial

Wollman Rink

Hallett Nature Sanctuary

José de San Martín Monument

José Martí Monument

Simón Bolívar Monument

The Pond

Gapstow Bridge

Green Gap Arch (Closed)

Umpire Rock

Hallett Arch

Lovelace Lawn

Inscope Arch

Outset Rock

Grand Army Plaza

Doris C. Freedman Plaza

William Tecumseh Sherman Statue

Subway

E. 60th St.
E. 61st St.
E. 62nd St.
E. 63rd St.
E. 64th St.
E. 65th St.
E. 66th St.
E. 67th St.
E. 68th St.

5th Avenue

CENTRAL PARK ZOO

The Arsenal

Tisch Children's Zoo

Delacorte Clock

Dancing Goat Rock

Willowdell Billy Johnson Playground

Wild West Playground

Pat Hoffmann Friedman Playground

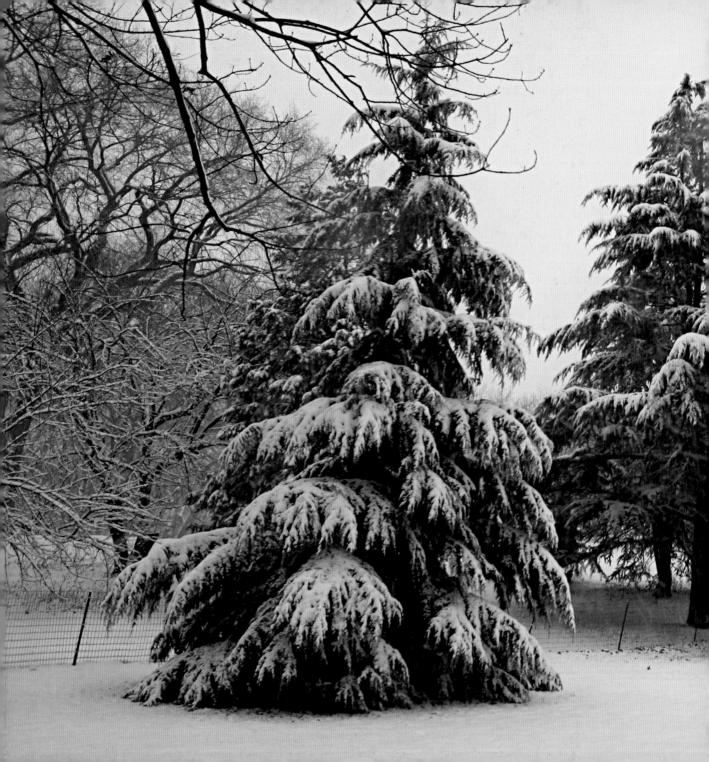

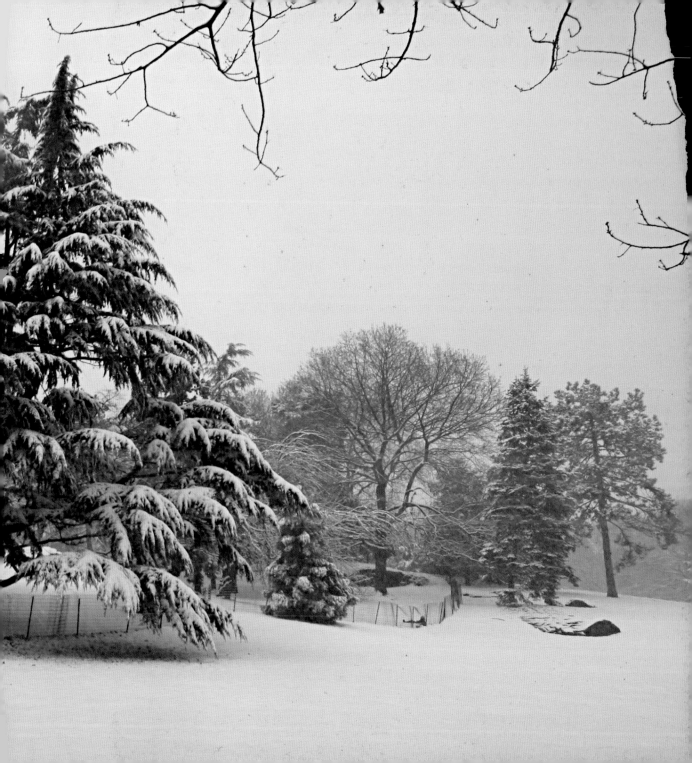

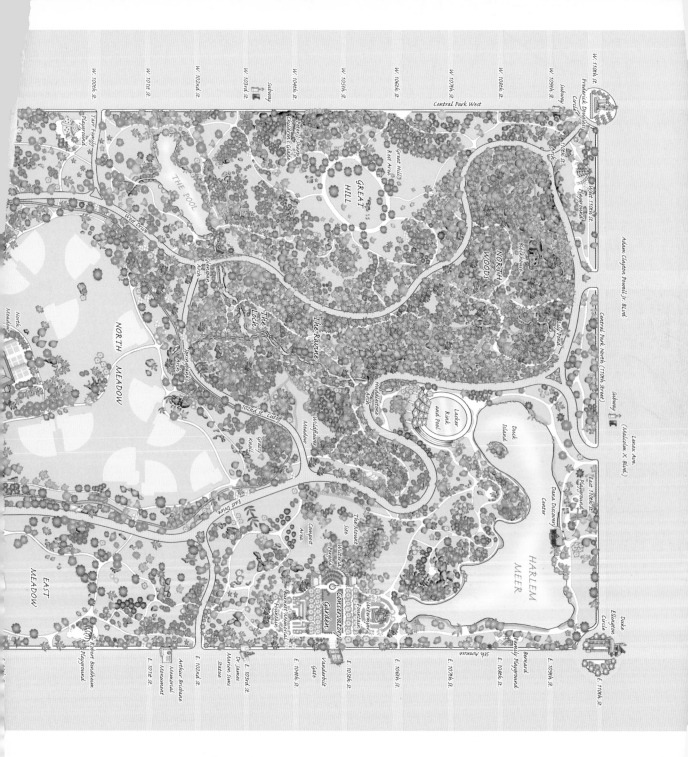

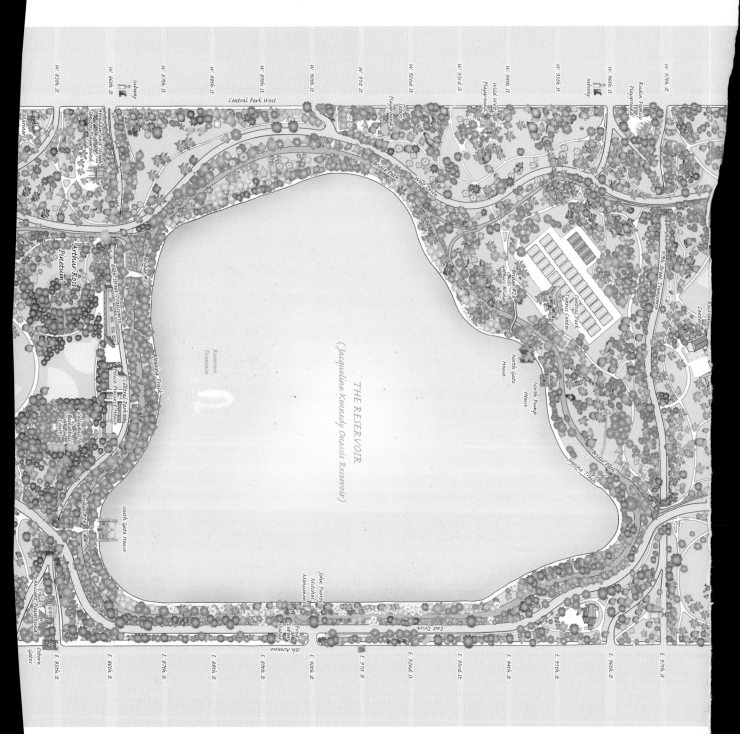

THE RESERVOIR

(Jacqueline Kennedy Onassis Reservoir)

Central Park West

5th Avenue

East Drive

West Drive

Bridle Path

Jogging Track

Reservoir Fountain

Arthur Ross Pinetum

Central Park Police Precinct House

North Gate House

North Pump House

Central Park Tennis Center

South Gate House

John Purroy Mitchel Monument

Fred Lebow Statue

Bridle Path

Jogging Track

Bridge #29

Bridge #27

86th Street Transverse

Bridge #28 Gothic Bridge

Bridge #24

97th Street Transverse

Subway

Subway

Mariners' Gate

Abraham And Joseph Spector Playground

Safari Playground

Wild West Playground

Rudin Family Playground

Volleyball/Basketball Courts

Osborn Gates

Mariners' Playground

W. 85th St.

W. 86th St.

W. 87th St.

W. 88th St.

W. 89th St.

W. 90th St.

W. 91st St.

W. 92nd St.

W. 93rd St.

W. 94th St.

W. 95th St.

W. 96th St.

W. 97th St.

E. 85th St.

E. 86th St.

E. 87th St.

E. 88th St.

E. 89th St.

E. 90th St.

E. 91st St.

E. 92nd St.

E. 93rd St.

E. 94th St.

E. 95th St.

E. 96th St.

E. 97th St.

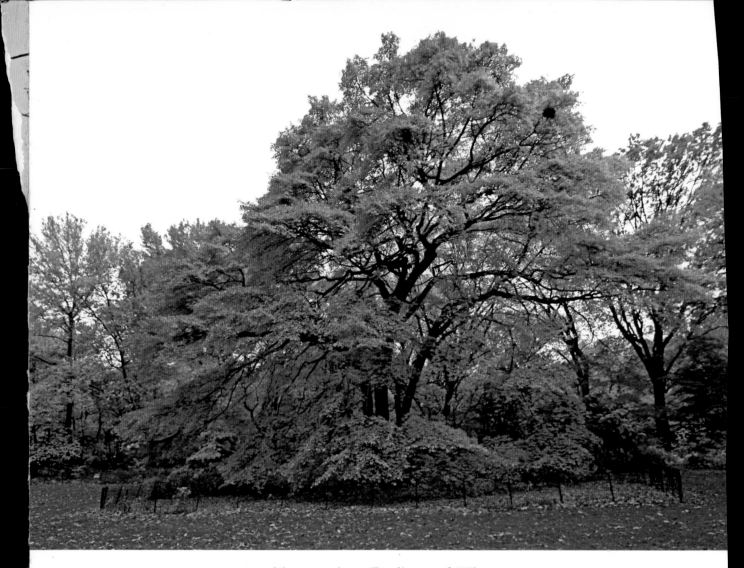

To our wives, Pauline and Eileen